MAGNETIC LOS ANGELES

CREATING THE NORTH AMERICAN LANDSCAPE

Gregory Conniff
Bonnie Loyd
Edward K. Muller
David Schuyler
CONSULTING EDITORS

Published in cooperation with the Center for American Places,
Harrisonburg, Virginia

LOS ANGELES

Planning the Twentieth-Century Metropolis

GREG HISE

The Johns Hopkins University Press Baltimore and London

© 1997 The Johns Hopkins University Press
All rights reserved. Published 1997
Printed in the United States of America on acid-free paper

Johns Hopkins Paperbacks edition, 1999
9 8 7 6 5 4 3 2 1

The Johns Hopkins University Press
2715 North Charles Street
Baltimore, Maryland 21218-4363
www.press.jhu.edu

THE LIBRARY OF CONGRESS HAS CATALOGED THE HARDCOVER EDITION OF THIS
BOOK AS FOLLOWS:

Hise, Greg.
 Magnetic Los Angeles : planning the twentieth-century metropolis /
Greg Hise.
 p. cm. — (Creating the North American landscape)
 Includes bibliographical references and index.
 ISBN 0-8018-5543-8 (alk. paper)
 1. regional planning—California—Los Angeles Metropolitan Area.
2. Land use—California—Los Angeles Metropolitan Area—Planning.
I. Title. II. Series.
HT394.L67H57 1997
307.1´216´0979494—dc21 96-50423

ISBN 0-8018-6522-8 (pbk.)

A catalog record for this book is available from the British Library.

Illustration credits will be found at the end of this book.

for Lisa and for Lucille K. Hise (1918–1976)

CONTENTS

ACKNOWLEDGMENTS

As a genre, scholarly academic writing veils the "I," which, when revealed prefatorially, turns out to be a "we." I profess I have always read acknowledgments with interest and pleasure. I drafted the initial sketch of this project in 1990. Seven years, fieldwork, travel to archives, and an expanding topic have left me on the receiving end of many favors. From this collective endeavor my appreciation for acknowledgments as a form of debt payment has been enhanced considerably. It is a pleasure for me to cite these individuals and institutions and begin repaying debts so deep they are better understood as revolving.

Friends, colleagues, and advisors provided encouragement, leads, queries, and the example of their own work. I thank them all and note especially Annmarie Adams, Robert Bruegmann, Clark Davis, Philip Ethington, Paula Fass, Douglas Flamming, James Gregory, Richard Harris, Carter Hudgins, Martin Krieger, Robert Lewis, Richard Longstreth, Roger Montgomery, Ted Muller, Becky Nicolaides, Christopher Silver, Tom Sitton, Kevin Starr, Abigail Van Slyck, Leonard Wallock, and Marc Weiss. Elizabeth Cromley, Robert Fishman, Gretchen Lemke-Santangelo, Nancy Quam-Wickam, Eric Sandweiss, Mary Corbin Sies, David Sloane, and David Vanderburgh read and commented on sections of the text as drafts, essays, or book chapters. Michael Dear, William Deverell, and David Schuyler read the entire manuscript, each offered suggestions that helped me restructure and refine the argument and presentation. David Schuyler read it twice and I thank him for bringing it to George Thompson's attention. Paul Groth, Dell Upton, and Richard Walker helped me formulate this project and a standard for scholarship. They deserve credit for its value; readers will recognize their contributions.

During the course of the project I met individuals whose ideas and actions shaped Los Angeles, twentieth-century California, and America's postwar metropolitan landscapes. Vernon DeMars, Garrett Eckbo, Wil-

liam Hannon, Ken Skinner, and the late Fred Marlow educated me about their work during multiple interviews; each made available clippings, photographs, plans, and other documentation from their personal collections.

I benefited as well from comments and questions following presentations at the American Studies Association, the Association of American Geographers, the Association of Collegiate Schools of Planning, the California Historical Society, the Huntington Library, the Society of Architectural Historians, the joint Society for American City and Regional Planning History / Urban History Association conferences, and the Vernacular Architecture Forum. I want to thank these groups for inviting me and session participants for pushing me to clarify the analysis. The Society for American City and Regional Planning History awarded my dissertation, the antecedent for this book, its John Reps Prize and I thank the Society and its members for this recognition.

Investigating Los Angeles, modern community planning, community building, the aircraft industry, and federal policy led me to numerous archives, libraries, institutions, and other repositories. The depth of this debt should be evident in the notes and bibliography. It is a pleasure to recognize Peter Blodgett (Huntington Library), Walter Brem (Bancroft Library), Elizabeth Byrne (Environmental Design Library, University of California–Berkeley), Carolyn Cole (Los Angeles Public Library), Masoud Farajpour (East Library, University of Southern California), Alan Jutzi (Huntington Library), Irene Moran (Bancroft Library), and Jennifer Watts (Huntington Library) and the contributions they made to this project. Dace Taube (University of Southern California, Regional History Center) deserves special mention. The Interlibrary Loan staff at the University of Southern California provided access to an array of documents. Howard Smith (Architecture and Fine Arts Library, University of Southern California) secured copywork on short notice.

Financial support from the College of Environmental Design (University of California–Berkeley), the Franklin Delano Roosevelt Library, the Graduate Division (University of California–Berkeley), the Hill Family (Bancroft Library), the Huntington Library, and the School of Urban Planning and Development (University of Southern California) funded travel to collections and freed time for writing. At USC, the school's former and current deans, Alan Kreditor, Peter Gordon, and Edward Blakely funded research assistants Chang-Mii Bae, Clarence Eng, Steven Flusty, Assem Inam, Kathy Kolnick, Kiran Lalloo, Scott Leonard, and Patrick Wirtz. Simon Cushing and Robert Dhondrup provided technical assistance.

George Thompson brought the manuscript to the Johns Hopkins University Press and shepherded it through revisions and production. I appreciate his professionalism and friendship. Katherine Kimball vetted the notes and bibliography. At Johns Hopkins, Carol Zimmerman orchestrated production and Martha Farlow executed the design. The University of Tennessee Press and Sage Publications granted permission to reprint text that appears in chapters three and four, respectively.

Lisa Padilla, whose magnetism equals that of Los Angeles, has lived with this project since its inception. The dedication is small tribute given our professional collaboration, her sustained enthusiasm, and her sustaining confidence in my ability. But I thank her most for sharing her love, her life, and her family with me.

MAGNETIC LOS ANGELES

SUBURBANIZATION AS URBANIZATION

One theory is that the suburbanization movement is simply an expansion of parts of the city outward and the suburbs are thus diversified just as are the wards within the city. In Chicago, for example, there are cities within the city[.] Are not the suburbs a repetition of the same phenomena outside the city's gates rather than within them? WILLIAM F. OGBURN

Cities do not grow by accretion or by the obtrusion of excrescences at the periphery, but by the establishment of nuclei in the penumbra and the gradual filling in of the interstices between the nuclei. DR. ERNEST M. FISHER

Necessity has brought us to the threshold of the day when in the design and construction of cities, just as in the design and construction of the individual building, we are being forced to consider the whole from a functional standpoint and then to design the component parts for the specific uses to which they are to be put. GORDON G. WHITNALL

If ever a region lived and planned for the future, that region is Southern California. Not only was development consistently anticipatory, but it was, to a large extent, carefully organized, plotted, and manipulated.

 CAREY MCWILLIAMS

In July 1953, *Life* magazine ran a photo-essay, ". . . And 400 New Angels Every Day." The title captioned an oblique aerial view of a residential street crowded with twelve moving vans. In the foreground, workers, followed by young children, are unloading an armchair; twin toddlers clutch a woman focused intently on the movers. Assorted furnishings—a metal laminated kitchen table, a wooden dining chair, and a lamp—are distributed across a recently seeded yard. A similar scene is under way at each house in the photograph. The accompanying text proclaims that every day,

seven days a week, is moving day in Los Angeles: "The scene above represents a single day [in] just one of the district's many such housing developments, the suburb of Lakewood." On the facing page, great vertical extrusions graph population hot spots; Encino, West Covina, Duarte, and Norwalk dwarf other communities in the region. Lakewood looms like an architect's skyscraper fantasy. *Life* set the population at one hundred thousand in 1953, up from two thousand residents in 1940. On the following page, readers are introduced to the Ferguson family and the more than one hundred salespeople who called on the couple during their first week in residence. A backyard view reveals sixty-eight hundred dollars' worth of newly purchased goods, ranging from a Ford sedan and appliances to bicycles and a trumpet.[1]

These images are familiar. They can be catalogued under post–World War II suburbanization, a moment and milieu neatly indexed by family-centered lifestyles, new, single-family tract housing, consumerism, life-cycle homogeneity, the baby boom, commuting fathers, and stay-at-home spouses. What these artifacts and social patterns signify is equally familiar: they are generally seen as indicators of a rejection of cities and civic life and the emergence of a homogeneous and transformative culture.

However, if we keep reading this journalistic account, we find that the Fergusons, who until recently had resided in Alton, Illinois, arrived in Lakewood in response to a want ad. When Leo Ferguson read, in a St. Louis newspaper, North American Aviation's call for engineers to work on its F-86 fighter, they sold their household belongings and headed for Southern California. Had the reporters and editors at *Life* paid as much attention to what surrounded Lakewood as its developers did, they would have recognized how significant employers like Douglas–Long Beach, North American, and ancillary manufacturers were for home buyers like the Fergusons. When builders Louis H. Boyer and Ben Weingart (Aetna Construction Company) and Mark Taper (Biltmore Homes) purchased a 3,475-acre tract of land in January and February 1950, proximity to aviation and emergent aerospace contractors was a principal selection criterion. These entrepreneurs planned for seventeen thousand housing units and a population of sixty-five thousand residents. Five months later, six thousand dwellings were under construction; the first units were occupied on July 17. Jobs and housing provided the basis for a comprehensive development plan that included multifamily garden apartments and a regional shopping center, which, at the time of completion, was one of the largest of its type in the nation. When residents approved incorporation in

March 1954, the city adopted "Lakewood—Tomorrow's City Today" as its motto, a phrase redolent of the inclusive land use mix.

For years, Lakewood and similar community projects throughout the country have been relegated to the academic backlist, marginalized in a rash of studies devoted to social groups and social organization. Scholarly and armchair sociologists invented suburbia, a state of mind, and excoriated the residents of Lakewood, Park Forest, Illinois, and the Levittowns in New York, Pennsylvania, and New Jersey for both their conformity and a resultant malaise in a purported national culture. Peter Blake featured Lakewood prominently in his suburban screed, *God's Own Junkyard* (1964). More recently, suburbs, suburbanization, and suburbia have become attractive intellectual property, and revisionist studies are appearing faster than the proverbial sprawl researchers seek to portray. Current interest spans the disciplinary spectrum. In March 1994, *American Quarterly*, for example, offered a forum with an introductory essay and responses from architectural, social, planning, and urban historians.[2]

To date, most narratives that trace the extension of American cities have charted a progressive course, a linear and ascendant interpretation fixed by transit and enhanced personal mobility. Their itinerary, set by the railway, streetcar, and automobile, can be mapped summarily. They begin, invariably, with English villas and parks, continue on to Andrew Jackson Downing and the romantic cottage suburb, and then stop off at Riverside, Illinois, and Glendale, Ohio. Following a brief transatlantic sojourn and intellectual infusion from the British garden city movement, this historiographic beltline proceeds to Radburn and the Resettlement Administration's experimental greenbelts before arriving at a final destination—Levittown, the paradigm for post–World War II suburban expansion.

Scholars have treated elite, restrictive, residential enclaves—the traditional suburb—to sustained analysis. Urban historians, most notably Kenneth Jackson and Robert Fishman, have fostered an academic industry documenting the temporal and spatial boundaries of this predominantly middle-class retreat. Generally speaking, these analysts focus on discrete places—the suburb as isolated, sylvan idyll, the product of ideology and means—and the emergence of a suburban ideology—a normative discourse developed to advance a melding of the city and country, the objective a morally superior setting for an idealized domestic sphere. Over time, historical and industrial geographers, building upon Harlan Paul Douglass's and Chauncey Harris's early interest in the subject, have mapped and analyzed population and manufacturing dispersion. Their focus on em-

ployment and the journey to work has extended the intellectual terrain considerably, as has their insistence on suburbanization as historical process. Collectively, these accounts chronicle the demise of a walking city with distinct districts and certain boundaries. However, their restricted field reveals only a small percentage of the landscape that developed in its wake, leaving whole swaths of the metropolitan region unexplored.[3]

In the past decade, critics and urban theorists who examine contemporary spatial patterns have begun staking the contours of a postmodern urbanism, presenting evidence that urban regions, such as the five-county Los Angeles conurbation, represent a new kind of city, a landscape with indeterminate coordinates, loosely anchored by speculative office parks, big-box retail, and gated residential enclaves. In *The 100 Mile City*, Deyan Sudjic conjures the metropolis as force field, an endless low-density settlement spreading across vast tracts where occasional, and seemingly random, power surges produce sudden, shocking constructions.[4]

These scholarly and popular assessments suggest that we need to reconsider basic principles of suburban history in order to describe, analyze, and interpret American metropolitan landscapes. In this study I address two of these tenets. The first concerns the nature of post–World War II development, which is generally perceived and depicted as unplanned, chaotic sprawl. My close-grained investigation of the community builders' spatial logic has revealed the opposite.

As an initial step, we must set aside the accepted wisdom that housing production, not employment, led and continues to lead urban expansion. Excluding industry from our explanatory schema violates one of the basic principles advanced by each generation of community builders, who knew that all raw land is not prima facie subdividable. Although lower land costs, mobility, and attractive financing were significant factors, community builders thought more broadly and synthetically. Their objective, advocated by planners and endorsed by home buyers, was the creation of complete communities with a mix of uses, planned for internal coherence and with the requisite connections to an urban region. Stated differently, I have found that the so-called new city is the product of a planned dispersion of jobs, housing, and services throughout metropolitan regions.

The second common principle I examine is the hierarchical and oppositional pairing of city and suburb, both terms defined in the traditional sense.[5] Throughout the twentieth century, urbanists have been engaged in a series of interrelated debates over urban form, its implications, and mean-

ing. One tangent is a narrative of centers and edges, urban and suburban, with explicit moral and social norms ascribed to each, the core an anchor of stability, the periphery an unplanned sprawl. A postwar formulation can be found in the suburban critique of the 1950s and 1960s, launched and sustained by critics, sociologists, and urbanists with an avowed preference for the diagrammatically comprehensible monocentered city. Subsequently, scholars and pundits have presented postwar development as an outright, universal rejection of urbanism and the city.[6] In practice, these boundaries were, and continue to be, far more porous than the simple city / suburb dichotomy suggests. I have found that community builders and practicing planners recognized the intrinsic relationships among developments across the metropolitan region. Gordon G. Whitnall spoke to this point when he described city building as an exercise in balancing parts, such as an individual building, within the urban whole.

Given these concerns, it should be apparent that this account is practice based. One foundation for a revisionist, or alternative, formulation is a recognition that development and planning are collaborative enterprises and that there has been considerable overlap between these domains. Mansel Blackford and Marc A. Weiss have reconstructed the nature and depth of this exchange in Pacific Coast, especially California, cities from the turn of the century up to 1940.[7] In this volume I consider real estate development and community planning through an investigation of residential construction and urban land use and extend the temporal framework into the post–World War II era.

Unlike urban histories that examine city wards, functionally discrete districts, local communities, or distinct enclaves, the unit of analysis for this study is large-scale community projects with infrastructure, community facilities, residences, and commercial centers planned, designed, and constructed by community builders. Included in this configuration is the ancillary manufacturing or other industry that provided an employment base for wage-earning home buyers.

The intention is to treat community-scale projects as elements within an expansive and expanding metropolitan region rather than viewing them as scattered bits of urban flotsam or attempts to create isolated counterparts to a center city. Contemporaries recognized that large-scale developments were units in an urban plan. As John R. Prince, regional chairman of subdivisions for the Los Angeles County Regional Planning Commission, noted in the proceedings from the commission's first conference (1922):

The subdivision is the most important unit that enters into the development and expansion of a community. It is that upon which a city is fashioned or moulded and contains practically all the elements for the successful planning thereof. The formation of a city plan can hardly be conceived to be complete in itself at its inception, but by the coalescing or joining together of subdivisions a city or town is gradually erected, and to the extent that co-operation among subdividers is maintained, will the ultimate ambitions of the community be realized.[8]

Note that in his analysis Prince conceptualized the city-building process as a set of relationships operative at multiple scales: internal and external, local and regional, the neighborhood and the city. Note, too, that he situated design and planning with production and coordination. The city's zoning engineer Huber E. Smutz spoke to this point in 1930 when he suggested that realizing a well-devised city plan required fitting together the many subdivisions as "blocks in a metropolitan mosaic."[9]

In this book I examine twentieth-century planning and development with three objectives that correspond to these concerns. Each is reflected in the title. First, I consider the rise of modern community planning, a set of principles, articulated over time, that addressed the design of infrastructure, street layouts, lot patterns, building types, and access to amenities and services—in other words, progressive land use planning. This package and a preferred configuration, which Lewis Mumford designated "modern housing," had roots in Ebenezer Howard's garden city, and builders and planners drew both formal elements and a functional mix from English precedents such as Letchworth and Welwyn. Howard's diagram of "The Three Magnets" showing town, country, and the alternative, a hybrid town-country, can be seen as a touchstone for this lineage. The coveted third magnet, town–county, would provide residents both beauty of nature and social opportunity, low rent and high wages, individual freedom and cooperation. Activating it required more than a simple blending of city and country, most likely achieved through an indiscriminate diffusion of factories, dwellings, stores, and services into the urban periphery. Instead, Howard and other garden city exponents had in mind a series of well-planned clusters surrounded by greenbelts, the proper setting for a "new form of life."[10]

The influence of Howard's utopian vision on our everyday urban landscape is not readily apparent. In the first chapter, I trace this genealogy thematically and suggest its implications for Southern California by dem-

onstrating how garden city ideals were distilled down to a set of principles and practices, modern community planning, and given a standard form, the neighborhood unit. Together these formal types became a replicable module, the basic building block for rational planning and the creation of a new kind of city. Over time, people came to see modern community planning and the neighborhood unit as an essential "infrastucture for community." In the immediate postwar years, Hugh Potter, president of the Urban Land Institute (ULI), a national organization for real estate entrepreneurs, developers, and builders, could proclaim simply: "Nobody should undertake to develop less than a neighborhood. This means not only the home but transportation, churches, schools, parks, recreational areas, and . . . shopping centers."[11]

It is essential to note, however, that an important aspect of Howard's proposal was altered in translation. Howard imagined garden cities as socially inclusive. He shared the reformers' antipathy for increasing social distance and presented his scheme as a means for encouraging the intermixing of classes, which was seen at the time as an antidote to polarization and spatial segregation. Although Howard did not speak directly to issues of race and ethnicity, the general tenor of his writing suggests his thinking and model were sufficiently flexible to accommodate persons other than the oppressed, slum-dwelling, English working classes he portrayed in his book.

Like Howard, the community builders and planners chronicled in this study placed particular emphasis on social class. One of their primary objectives was to extend home ownership down the economic ladder and make every wage earner a home buyer. More critically, they set out to fashion neighborhoods with residents drawn from different occupational groups. I have found that their success at the latter was greater than we have recognized to date. However, unlike Howard, they were explicit about race and ethnicity, and through the instrument of restrictive covenants, community builders excluded anyone "non-Caucasian" from purchasing dwellings in their developments. This strategy was a product of personal beliefs mixed, in many cases, with a biased perception of a market they in effect created. In tandem with other aspects of community building, racial exclusion was planned and, as Kenneth Jackson, Lawrence DeGraaf, and others have shown, embedded in government policy at the local, state, and national levels.[12]

Home builders, developers, and government officials recognized that turning wage-earning renters into homeowners would require innovation

in housing production. During the 1920s, concern with rising house costs and declining ownership rates heightened interest in identifying and codifying a standard, minimum-house type and transforming home building into a modern industry, fine-tuned for the quantity production of efficient dwellings. Although precedents for these innovations can be traced to better-known national and international studies and prototypes, California was an important locale and milieu. Self-builders, tradespeople, and home builders raised popular housing types such as the bungalow and mail-order kit houses. Californian Herbert Hoover carried the small house ideal to Washington, D.C. As commerce secretary and president he formulated, endorsed, and enacted policy and programs designed to encourage residential construction, extend home ownership, and set neighborhood standards. And California's speculative developers and builders, many of whom headed comparatively large firms given national standards, devised critical advances in construction practices and community planning. Entrepreneurs such as David D. Bohannon in the San Francisco Bay Area, Walter H. Leimert, active in Oakland and Los Angeles, and Southland developers Fritz B. Burns and Fred W. Marlow successfully consolidated land subdivision, construction, and sales into a single organization.

A second, related line of inquiry considers California itself as a magnet. During the interwar and post–World War II years, people like the Fergusons left other parts of the country for a place where they might benefit from an expanding economy, enjoy a moderate climate, and imbibe the mythical California lifestyle. The defense emergency accelerated this migration when the promise of high-paying jobs in shipbuilding and the aircraft industry lured more than one and one-half million people to the state as the number of employed persons increased almost 50 percent. This influx taxed the existing urban infrastructure beyond its carrying point, and the demand for housing far exceeded inventory in primary employment centers such as Los Angeles, the San Francisco Bay Area, and San Diego as well as in smaller cities and towns throughout the state.

The federal government, design professionals, and home builders devised a number of strategies to house defense workers, ranging from impermanent, even mobile, accommodations to the planning and construction of entire new towns. Whether sponsored by the public-sector or the private-sector, these large-scale projects often followed the dictates of modern community planning and were constructed quickly and efficiently through the application of building techniques fine-tuned during the preceding two decades. In a series of case studies I detail the factors and means

through which these ideas and ideals were implemented and how they were transformed in the process.

The third consideration is urban patterns, more specifically, the spatial relation among different land uses or activities. In 1930, Secretary of Commerce Robert P. Lamont suggested: "Home building . . . include[s] not only the construction of houses, but the layout of subdivisions and the relationships between home neighborhoods, the location of business and industrial centers, and the whole problem of industrial decentralization."[13] Lamont's statement alerts us to the fact that he and his contemporaries recognized the magnetic properties of urban functions and planned accordingly. The purposeful linking of industrial and residential development was a long-held axiom in 1930. What has often been overlooked is how important it remained in the post–World War II years. In the opening vignette, I asserted that proximity to employment was a critical factor in Boyer, Wiengart, and Taper's decision to purchase land and develop Lakewood; the following chapters will situate their thinking and actions in a lineage reaching back half a century and demonstrate how these entrepreneurs and self-described city builders capitalized on fifty years of innovation in physical planning, real estate development, finance, and construction.

A primary objective of this text is to situate the unfolding of these processes in California within a national context. This requires setting aside both an exceptionalist and a prefigurative thesis. On the one hand, California generally, and more specifically Southern California and Los Angeles, have been perceived and presented as outliers or anomalies, the nation's most populous state and second largest metropolis reduced to a sideshow. Reporters, pundits, critics, and professional and academic commentators, the majority exogenous, routinely compare the region with cities on the East Coast, in the Midwest, and in Europe and have found and continue to find it wanting. Because Los Angeles has been seen as exceptional, the city has been excluded from general narratives regarding American metropolitan development.

The prefigurative thesis sets multicentered, dispersed Los Angeles as *the* prototype for a distinctively twentieth-century metropolis. Given this formulation, cities across the United States and elsewhere become caricatures, Los Angeles writ large. Joel Garreau's assertion that "every city that is growing, is growing in the fashion of Los Angeles" is simply the most recent example. More critical observers, exponents of an emergent Los Angeles School are, in a way, the fin-de-siecle bookend to the Chicago sociologists, making a case for the region as an ur-site for postmodern urbanism.[14]

It is, however, instructive to consider events in California compara-
tively. A relational analysis reveals the often subtle nuances of timing or
type. Recognizing and interpreting contemporary patterns in California,
and elsewhere, requires that we first uncover the intentions and percep-
tions of historical agents of urban change. Gordon G. Whitnall, an early
proponent of regional planning and later secretary for the Regional Plan-
ning Commission and director of the City Planning Commission, used
these posts to promote a vision of Los Angeles as a new kind of city.
Speaking in Los Angeles before the Sixteenth National Conference on
Planning in 1924, he presented his audience a comparative framework
drawn from surveys and observation. "We know," he stated, "where the
reservoirs of population are, and the topographical restrictions . . . make it
easy to say where the great flow of population must occur."

> In other words, we find ourselves in the peculiar position of being a com-
> munity in its inception, and yet with a fair realization of what the future
> holds. This knowledge places upon our shoulders an obligation to pre-
> vent the recurrence of those mistakes which have happened in the
> growth of metropolitan areas in the east. We know too the mistakes that
> were made in the east[.] We still have our chance, if we live up to our
> opportunities, of showing the right way of doing things. It will not be
> the west looking back to the east to learn . . . but the east looking to the
> west to see how it should be done.[15]

Whereas most accounts refer to urban expansion and dispersion in
terms of restrictive, residential neighborhoods, Whitnall and his colleagues
envisioned growth and development occurring in urbanized clusters with-
in the metropolitan region. And, most significantly, they based their pro-
jections on analyses of existing conditions. They knew that the city was
polynucleated; Whitnall and other regionalists argued for improving tran-
sit connections between existing centers. In other words, Los Angeles
design professionals, industrialists, developers, and residents viewed and
understood dispersion as an advantage, something to be planned for.

In 1949, ever prescient Carey McWilliams indexed the ways and means
through which Southern Californians had planned for the future. Sur-
veying the postwar regional landscape, he discovered the "first modern,
widely decentralized industrial city in America."[16] Here and in other texts
McWilliams rejected outright Boyle Workman's 1935 account of Los An-
geles as a city that grew. McWilliams recognized that city building in

Southern California was a gamble that boosters made on the future. Expansion was the region's primary business; a growing population opened opportunities in construction, manufacturing, and commerce, and if inmigration had diminished the result would have been as "disastrous as a drought." His principal examples of this growth paradigm were subdivisions "planned years in advance of population." Although planning and Los Angeles are not terms that couple easily, McWilliams knew that Los Angeles, like other cities and all artifacts, is a historical phenomenon, the product of human intention, and therefore highly planned.[17]

In fact, California and Southern California were the site for important experiments in housing and community planning. Although aspects of this history are well known, for example the bungalow and turn-of-the-century Arroyo culture, these were relatively minor strains in a milieu whose implications for twentieth-century American culture and landscapes remains largely unexamined. Experimentation took place in various domains—land use planning and the provision of infrastructure, house and neighborhood design, construction techniques and building practice, and the financing and marketing of community-scale projects.

In short, urban development is a complex system or, more precisely, set of interrelated and interdependent systems. Unfortunately, postwar urbanism is generally considered in its parts: automobiles, highways, and freeways; economic prosperity, consumerism, and single-family housing; white flight and inner-city decline. Uncovering the loosely knit but mutually reinforcing decisions and actions of home builders, industrialists, financiers, home buyers, and government offers us a different history. Viewed from this vantage point, Westchester, Panorama City, Lakewood, and the Levittowns were not part of a suburban strategy. Through institutions such as the Urban Land Institute and the Community Builders' Council, mass builders forged a regional vision; they thought in terms of a coordinated metropolitan system, a network of integrated communities. They did not dichotomize the urban landscape into a core and periphery, a city and suburb. And I have found it useful to view the American city from this perspective.

In an essay analyzing contemporary spatial patterns, Peirce Lewis reminds us how language shapes interpretation and offers a powerful brief for vetting overworked and undertheorized terms such as *suburban sprawl* that never have described accurately what we find on the ground. These terms are not abstractions, they have a history and represent traditions of

thought. What we need is an enhanced vocabulary that describes and defines real material places and an alternative conceptual framework that recognizes and interprets this complexity, rather than simply critizing or ignoring postwar cities and urbanism.[18]

Constructing this alternative framework requires a reassessment of the suburban critique and its intellectual legacy. On one hand, this has led to a "name game": we now have the "outer city," "exopolis," and the "post-suburb." However, the dualism of core and periphery is residual in these appellations. What is needed is an elastic analytical and interpretive framework that can expand to the region and contract to the district or neighborhood level and encompass all points in between. Elasticity is important because as the community builders realized, no event or intervention takes place at only one scale.

Today we survey a landscape pieced together from discrete fragments, an urban collage rather than an urban mosaic. In his well-known "edge city" thesis, Joel Garreau asserts that in the past thirty years Americans have "launched the most sweeping change in a hundred years in how they live, work, and play." According to Garreau, edge cities are the "third wave" in a causal ocean that has inundated the postwar landscape. The first wave of development was residential, followed in turn by retail and services and, more recently, business and jobs. Business and jobs, he argues, followed people "weary of returning downtown for the necessities of life."[19]

The historical record suggests otherwise. Edge cities are not a new phenomenon. We can trace conceptual roots back to Ebenezer Howard's garden city and the planned dispersion of the industrial city. America's World War II defense programs accelerated this distinctive urban pattern at a time of epochal migration and a rapid expansion in aircraft and other industry. These spatially dispersed and functionally mixed developments were dynamic hubs of manufacturing and job creation, the foundation necessary for large-scale builders' experiments in modern community planning.

I might add a final note. In challenging the prevailing suburban history I am not advocating relativism, nor am I promoting contemporary spatial form; its shortcomings are legion, they are real, and they demand our attention. What I am advocating is that we analyze American urban expansion inclusively. We need to look beyond the well-documented extension of middle- and upper-class residential enclaves and account for the manifest ways in which American cities were extended. To construct a historically based and theoretically informed account of postwar urbanization, we

need to broaden our focus to encompass the location of industry in the new spatial pattern, the role of home builders and developers in city building, the aspirations of those who chose to move to emergent zones, and the ways in which all these agents contributed to the ongoing process of community formation.

MODERN COMMUNITY PLANNING

A natural forerunner to the construction of any plan is a consideration of
what that plan . . . is going to accomplish. The builder visualizes . . . a com-
pleted building. The engineer visualizes . . . a completed bridge. The de-
veloper visualizes . . . a complete community. WALTER W. ROSE

This new housing method recognizes that the integral unit for planning, the
economical unit for construction and administration, and the social unit for
living is the complete neighborhood, designed and equipped as such.
 CATHERINE BAUER

Big cities do not need to lose the pleasant amenities of daily living enjoyed by
smaller communities if they will design their component parts into neighbor-
hoods, each provided with all the essential requisites to make it a complete
unit, and then correlate all such units into a complete city plan, well balanced
and functionally sound. GORDON G. WHITNALL

Another factor of importance to city development is the change over the last
few decades in factory structures. . . . New factories no longer crowd into cen-
tral cities, hemmed in by commercial or residential districts. In this respect, the
interests of manufacturers and the objectives of metropolitan planning au-
thorities are usually not difficult to reconcile. Improvements and changes in
design have improved the factory . . . as a unit in the community.
 GLENN E. MCLAUGHLIN

Leimert Park

On Saturday, November 17, 1928, Los Angeles planning luminaries Gor-
don G. Whitnall, Charles H. Cheney, and Hugh R. Pomeroy addressed a
crowd assembled for the dedication of the first completely improved civic

park ever granted to that city (fig. 1.1). The one-and-one-half acre Leimert Park, abutting the eastern flank of Baldwin Hills, was the focal point for a new community project planned and developed by the Walter H. Leimert Company. Promotional brochures, with text and images carefully crafted to attract potential lot buyers, highlighted the proximity to Exposition Park Stadium, the University of Southern California, and downtown: "17 Minutes by Auto!" The plaza, planted following specifications drawn by Olmsted Brothers, a prominent landscape and planning firm in Brookline, Massachusetts, featured a pool with water lilies and pedestal fountain. The fountain fixed an axis along Degnan Boulevard, a major arterial with landscaped median. The Leimert Business Center, a neighborhood commercial district, had frontage along the three sides of a triangular block formed by the confluence of Leimert and Degnan at Angeles Mesa Drive. Two-story apartments and flats, set close to the property line, maintained Degnan Boulevard's formal character after the land use changed from commercial to residential (fig. 1.2).[1]

Walter Leimert began his career as a land subdivider in the San Francisco East Bay cities Oakland and Piedmont. His move to Los Angeles in 1923 coincided with an upswing in development and building, and Leimert coordinated and financed a series of industrial and residential ventures. After purchasing a 230-acre tract from a descendant of Elias Jackson "Lucky" Baldwin in 1927, he decided to create a planned subdivision for moderate-income buyers, with attributes and amenities comparable to Beverly Hills or Palos Verdes. When Leimert purchased the property it was planted in beans. North of the site, across Santa Barbara Avenue, was Rogers Field, an unimproved runway with an open shed for a hangar.

Within this one-half-by-three-quarter-mile parcel, Leimert's site planner Franz Herding set a formal street system. The centerpiece was a boulevard running diagonally from the northeast to southwest corners. In engineering and improving this boulevard, Leimert followed a pattern first set by the Los Angeles Railway. On either side of the railway's right-of-way he constructed a fifty-foot roadbed with a planting median for pine and palms. Two avenues, Creed and Garthwaite, paralleled Leimert Boulevard. They were bisected at midpoint by a short cross-axis, with Audubon Junior High School and Stocker Plaza as termini. Degnan Boulevard, anchored by the plaza to the south, formed a second axis. Walkways laid out at the back of lots and at midblock complimented the elegant street geometry and provided children an alternative passage to schools, safe from traffic. In the first year the Leimert Company completed three hundred thousand

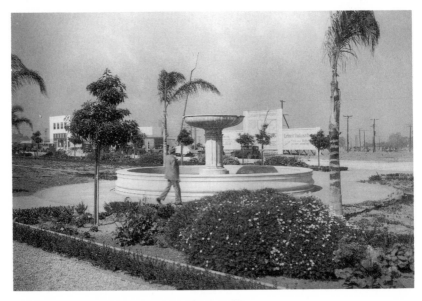

FIGURE 1.1 Leimert Park, Los Angeles (1928)

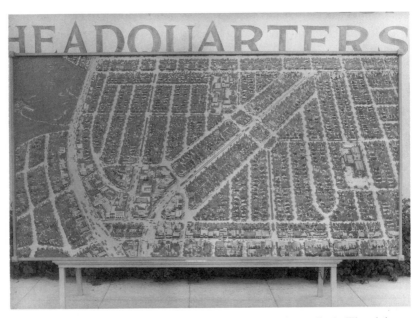

FIGURE 1.2 Rendering showing community plan for Leimert Park. The civic park and commercial center were sited at the convergence of Angeles Mesa Drive, Degnan Boulevard, Leimert Boulevard, and Vernon Avenue (*from left to right*). Note the primary school (*right center*) and high school (*top center*).

dollars' worth of public improvements, pouring five miles of concrete streets and ten miles of sidewalks, lining these with cast double-standard electroliers, placing underground utilities, and planting over five thousand street trees, including elm, maple, magnolia, and sycamore.[2]

Four years prior to Leimert's purchase Charles Cheney, in concert with Frederick Law Olmsted Jr. and Harland Bartholomew, had drafted the organizing diagonal in their *Major Traffic Street Plan for Los Angeles* (1924). These expert consultants to the city and county traffic commission proposed a "distributor" street, a convenient north-south connector linking Santa Barbara Avenue, a major east-west route, with Angeles Mesa Drive. From there, auto traffic could continue on to Inglewood-Redondo Boulevard (in later plans renamed the Palos Verdes Parkway), a great diagonal trajectory set by an engineer's straight edge, designed for maximum efficiency of traffic flow, and intended to open the southwest portion of the city for further development. In August the *Los Angeles Examiner* reported that the developer was rushing Leimert Boulevard to completion in time to provide residents and visitors a direct route out to Mines Field for the upcoming National Air Races set to open the following month.[3]

Although generating and sustaining a sizable traffic count was an important consideration for the Leimert Company's subdivision strategy, the plat they filed for the district reveals design principles chosen to expedite more than convenient and comely passage through the development and efficient connection to other areas in the Los Angeles Basin. The precise interplay of broad boulevards and avenues, infilled with a regular, smaller-scale grid of picturesque streets, created vistas leading to focal points for important buildings and functions.

Before the first dwellings were constructed, Leimert completed an elementary school on Forty-second Street, a throughway with median radiating off Stocker Plaza. To the northwest, across Leimert Boulevard, sat a ten-acre parcel, deeded for a new junior high school. The Mesa-Vernon Market, a neighborhood convenience center with a meat-and-produce market, delicatessen, beauty parlor, and drug store opened within the project's first year in the Leimert Business Center (fig. 1.3). A Citizens National branch bank followed in 1930. By 1932 the Leimert Park Chamber of Commerce boasted fifty member businesses ranging from clothing stores and beauty shops to a tea room and a mortuary. The business district's centerpiece, the Leimert Theater, opened in April 1932. Reporting on the gala premier, the *Southwest Wave* called the movie house the "finest neighborhood theatre in the world" and praised Stiles O. Clements,

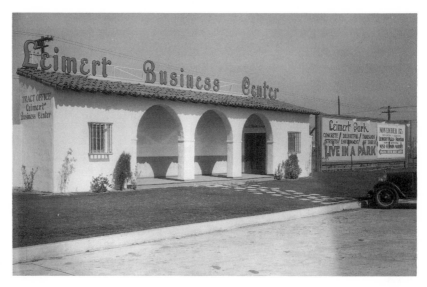

FIGURE 1.3 Tract office for Leimert Business Center with billboard advertising benefits of modern community planning.

a well-known Los Angeles architect, for incorporating "every feature of modern theatrical development."[4]

Leimert and Herding zoned residential construction by type and arrayed it along the appropriate corridors. Duplexes, fourplexes, and six-family flats lined the boulevards; interior streets were ceded for single-family housing. Lots fronted long blocks, up to nine hundred feet in length, dimensioned to reduce the total site area given over to vehicle circulation, discourage through traffic, provide additional residential parcels, and increase the area for shared amenities. To insure a consistent formal character, Leimert established a commission for reviewing residential and commercial designs. The company also formed a Community Improvement Association. Lot and house buyers became voting members and assumed a self-imposed annual tax. Revenues were dedicated for common landscape upkeep and maintaining unimproved parcels. To promote lot sales the Leimert Company hired design professionals and builders who constructed demonstration single-family and multifamily units. Cooperation between the trades and the development team went both ways; the company also encouraged local contractors to build speculative houses for sale.

Between August 18 and October 15, 1928, the district hosted Los Angeles's first Small Homes Exhibition. The Leimert Company cosponsored

the event with Southern California Gas, Barker Brothers furniture, and materials suppliers, including the noted tile manufacturer Gladding, Mc-Bean, and Company. Thirty-five units were on display. The Casa de Encanto, Modern Art House, and Casa de Alegria lined Ninth Avenue, along with dwellings by prominent local architects Gordon B. Kaufmann, Roland E. Coate, and George J. Adams. Bottlebrush trees, planted by the developer, completed this model block.

Leimert's design, construction, and marketing strategies epitomized modern community planning. Civic boosters, physical planners, and real estate entrepreneurs realized that Leimert had engineered a community-scale development based on shared standards and constructed according to the most up-to-date practices, a point underscored by the prominent representatives from local and regional agencies who presided at the dedication. Whitnall was director of the Los Angeles City Planning Commission and sat on the Chamber of Commerce's civic improvement committee. Pomeroy held a position on the citizen's committee studying parks, playgrounds, and beaches and was past secretary for the county Regional Planning Commission (RPC). In addition to his work on the 1924 street plan, Cheney had consulted on the master plan for Palos Verdes.

Recognition and praise came from outside the domains of planning and design as well. Publisher and journalist B. C. Forbes (of *Forbes* magazine) singled out the district in his syndicated column for the Hearst papers, where he alerted a national audience to Leimert's skill at developing a "place for modest homes . . . as attractive, orderly, and well arranged as exclusive sections."[5] Forbes was also a highly regarded investor, and his interest and endorsement typified the intersection of community design and business at this time. The quality of Leimert's development commanded continued notice, and later commentators reinforced these initial enthusiastic assessments. A decade after the dedication, L. Deming Tilton chose the district's commercial center to illustrate "Civic Beauty" in a photoessay accompanying his chapter in *Los Angeles: Preface to a Master Plan*. Businesspeople and planners found Leimert Park a significant project, and both believed modern community planning might promote civic and commercial value that would increase over time.[6]

Agreement among planners and businesspeople on the relative merits of Leimert Park and similar projects throughout the country was neither a coincidence nor an anomaly. Like their City Beautiful progenitors, advocates for modern community planning hoped to couple civic betterment with financial benefits. Contemporaries thought strict zoning by function

would ensure the character of each district and stabilize residential lot and property value. In terms of technique, they promoted a hierarchical and functionally segregated street system in place of the regular grid. The former, designed to limit circulation and maximize recreation, would also provide construction economies by reducing first costs and maintenance. In addition, narrower streets and longer blocks in residential zones meant that engineers could survey more lots drawn according to current standards and set aside more land for parks and community facilities. Wider and shallower lots would, theoretically, enhance privacy and permit more varied house design, amenities developers trumpeted when selling lots or units. These developers converted lower initial improvement costs into profits, but they also capitalized on those savings to reach a new clientele, people whose income had not been sufficient to secure home ownership in the past. Cumulatively these advantages furthered objectives dear to civic elites, city planners, and real estate professionals who had been advocating the extension of home ownership generally but were also concerned with promoting the construction of quality subdivisions.

Boosters argued for the benefits of modern community planning beyond an individual project's boundaries, since each new tract became a "block in the metropolitan mosaic" and incompatible projects marred the overall composition. Design professionals and developers promoted good planning, pushed for increased regulations, and agitated for the controls necessary to "correlate and unify" numerous subdivisions into a rational, efficient city.[7] In Los Angeles, Leimert's design was exemplary. The site plan he adopted fit within the general dictates of a regional highway and parkway system. More specifically, he fixed Leimert Boulevard according to a path and criteria articulated in the *Major Traffic Street Plan.*

Walter Leimert's careful planning and development strategy also met the firm's immediate and long-term objectives. Crafting a community-scale project was a complex and risky endeavor, and realty brokers like Leimert were motivated to minimize risk and maximize the return on investment. At the same time, development is future oriented, and Leimert and his colleagues bet on continued population growth, continued or increased prosperity, and ongoing physical and spatial extension. When surveying raw land for purchase, developers analyzed the general pattern of development locally and regionally for clues concerning the likely path of expansion. In turn, their speculation or commitment to a particular property fueled the city-building process.

Examined relationally, Leimert and his professional peers were not

mavericks. Real estate development has been and remains a conservative enterprise. Practitioners have long recognized that their practice changes incrementally; their creed might be stated simply as "Stay just ahead of the pack." In this milieu, innovation begins with a close study of what competitors have done. A reasoned synthesis might lead to minor adjustments in building type, project scale, or marketing strategy.

In other words, Walter Leimert was adhering to principles his colleagues had defined over time. He could find these in trade journals such as *Building Age* or the conference papers the National Association of Real Estate Boards (NAREB) compiled, as well as in technical articles in *American City* and subdivision regulations the Department of Commerce's National Bureau of Standards sanctioned and then distributed to cities and municipalities. Comparing Leimert Park with contemporary developments reveals the reach of this shared learning. Locally, the project was consistent with the Janss Investment Company's commercial district, Westwood Village (1928), planned by Harland Bartholomew, or a residential district like Carthay Circle. Nationally, Leimert Park warrants comparative analysis with such well-known exemplars as J. C. Nichols's Kansas City subdivision, the Country Club District, and Hugh Potter's River Oaks in Houston. Together these two projects underscore the degree to which real estate entrepreneurs traded design ideas and development strategies.[8]

When marketing his product Leimert also chose to blend the tried and true with a dash of innovation. Advertisements for Leimert Park sited the project "square in the path of growth."[9] Investors recognized that Leimert's business center at a well-trafficked intersection would attract commercial tenants and improve the likelihood of return. At the same time, he coupled retail with residential and offered middle-income buyers more than an individual plot of land. Leimert was selling potential home owners a stake in a comprehensively planned district with many amenities already in place. The company engineered and financed street improvements, schools, and parks. By putting all these strategies together in one package Leimert authored a noteworthy venture.

In a 1930 article in the *Los Angeles Realtor,* Stanley McMichael began his projection of future subdivision practice by noting that the "mere selling of vacant lots has about run its day." According to the author, in ten years' time developers would be capitalizing on new construction practices and intelligent planning to produce complete dwellings "within the reach of the humblest."[10] McMichael was prescient beyond what even he might

have imagined. A decade after Leimert began his development Fred W. Marlow and Fritz B. Burns sketched out and constructed Windsor Hills, a residential project with associated commercial district located adjacent to Leimert Park in the Baldwin Hills. For their project the Marlow-Burns company clearly drew upon the principles and standards Walter Leimert had synthesized.[11]

Even though Windsor Hills was typical in terms of a type, three factors warrant particular consideration. The first is timing. In 1938 housing starts had just begun to increase following a down cycle that spanned the entire decade separating these two developments. The second factor is scale. Windsor Hill's three hundred acres and 587 lots made it one of the largest tracts in Southern California that year. Third, and most important, at Windsor Hills, Marlow and Burns made the transition from lot sales to home building, successfully consolidating land subdivision, construction, and sales into a single organization. As such, the project was an important proving ground for subsequent community-scale development. Two years later these entrepreneurs would respond creatively to the home-front mobilization and institute another incremental adjustment into the development process, fleshing out Leimert Park's spatial and formal precedent in Westchester, a new district for wage-earning defense workers adjacent to the aircraft industry clustered at Mines Field. Although Leimert Park was a denouement for the 1920s development and building up cycle, it set a pattern that, with modifications, formed a basis for community projects in the immediate pre–World War II period and into the postwar era.

Environmental Reform

Modern community planning, and examples such as Leimert Park, figured in contemporary debates about the nature of cities and the nation's urban future. It is instructive, therefore, to examine the project within a lineage that stretches from nineteenth-century alternatives for industrial cities such as Ebenezer Howard's garden city to current town-planning debates. Uncovering this physical planning and social reform legacy through theory, paper projects, and constructed examples is a prerequisite for understanding modern community planning and contemporary metropolitan landscapes.

Broadly speaking, reformers, social scientists, and progressive planners were investigating and debating two correlative subjects, metropolitan spatial patterns and housing conditions. Based on a host of interrelated

changes ranging from new communication and transportation technologies to the location of industry, contemporary observers strove to anticipate and forecast urban futures. The crux of this debate centered around the relative merits of agglomeration and dispersion. Questions concerning spatial patterns overlapped to a considerable degree with an ongoing examination into tenement housing, overcrowding, and housing affordability. Modern community planning, then, was a composite response to contemporary spatial patterns and the perceived disadvantages of urban life.

Reformers identified and worked to ameliorate the perceived malignancy of crowded, congested, unhealthy cities. Mounting data from government reports, social science surveys, and photojournalistic exposés revealed material conditions. The number and scope of quantitative studies increased exponentially in the 1930s, when Works Progress Administration (WPA) relief workers undertook detailed enumerations of tenancy, living conditions, and housing stock. Their efforts culminated in the 1940 Census of Housing, the first comprehensive national accounting of dwelling units and living conditions. Through tables and graphs these studies rendered a high percentage of dwellings unfit for habitation or in need of major repair and a great number of American citizens living without basic services.[12]

While these investigations heightened awareness of poor living conditions and inadequate shelter, other studies focused attention on the shortfall between housing need and new residential construction. Economists and forecasters who tracked real estate business fluctuations created statistical indexes of sales prices, the volume of realty transactions, the number of housing starts, the value of building permits, and mortgage lending. Nationally, inflation curtailed housing production from the Armistice through 1921. Residential building starts jumped dramatically in 1922. Over the next four years residential construction was a key component in the economic boom, and new housing starts peaked at 937,000 in 1925.

In the city of Los Angeles these figures translated into 16,400 permits for new dwelling units issued by the Department of Building and Safety during the 1924–25 fiscal year; 13,255 of these were for single-family units. Tracing annual subdivision records presents an important correlative trend. For the four years prior to World War I, new subdivisions averaged approximately two hundred a year. During the war years this figure dropped significantly. Subdivision activity increased dramatically in 1921, when developers filed 607 tract maps, double the number for the previous year. This pattern continued until 1923, when subdividers re-

corded 1,434 tracts. Two years later, the number had dropped to 684, an indicator, in retrospect, that housing starts, which tend to lag behind tract filings, would begin trailing off.[13]

Few predicted the depth and longevity of the subsequent home-building downturn that preceded the general economic collapse and has, in fact, often been cited as a cause. However, even during the relative boom years at the beginning of the 1920s new residential construction on average equaled just over 2 percent of the nation's housing stock, a rate that barely met the growth in family units and population. Keeping pace with additional need meant there was little replacement of existing housing stock. As contemporary observers noted, there had been no replacement for obsolete or uninhabitable dwellings for almost forty years stretching back to the 1880s. More critically, the typical dwelling units completed during the 1920s boom were designed almost exclusively for buyers whose incomes placed them in the upper third nationally.[14]

Surveys conducted by government and philanthropic agencies as well as planners and home builders provided more than graphic evidence of need. Taken together, they presented officials and general readers a chilling condemnation of existing conditions. Statistics and photographic documentaries were powerful tools, and policy makers, planners, and housing advocates cited these reports to support a wide array of initiatives. Many questioned the moral fiber of individuals and groups inhabiting substandard housing in obsolete neighborhoods. Others searched for underlying causes. Progressive housers—reformers who considered improved housing and living conditions as a primary vehicle for uplift and betterment—and activists pointed to a political economy based on private investment and driven by the profit motive and sought to engage and mobilize support for government intervention into housing production, the implementation of national health and safety standards, and the regulation of supply. While most pundits agreed that overcrowding and congestion were core issues and that some form of population redistribution was desirable, there was little agreement as to the spatial framework within which dispersion would take place and how it would be effected.[15]

At the same time, the alluring pitch of technology and industry, which promised consumers improved housing through new building materials, new construction methods, and a dazzling array of home products, magnified the discrepancy between existing conditions and the threshold of basic need and decency. Throughout the 1920s and 1930s, a profusion of

"homes of the future" had their day in the spotlight. Local gas and utility companies outfitted exhibit and model housing with up-to-date appliances, department stores dressed full-scale room and unit mock-ups in the latest furnishings, and national associations organized demonstrations of better dwellings and improved housekeeping.[16]

Paradoxically, the fanfare surrounding exhibition housing only intensified during the 1930s, when home building collapsed and the Depression dimmed most everyone's chance to attain a "machine for living." Housing displays at both Chicago's 1933 Century of Progress and the New York World's Fair of 1939–40, as well as regional exhibits such as the Golden Gate International Exhibition in San Francisco and the California Pacific International Exposition in San Diego, kept the latest housing iterations in constant focus. New Deal agencies such as the Federal Housing Administration (FHA), which sponsored their own exhibits, contributed to the promotional frenzy. Advertisements transmitted images and ideals beyond the exhibitions' domain. No matter how fantastic the product or how bombastic its presentation, model housing and mass advertising set new standards that contrasted markedly with existing conditions.[17] For many Americans, the dissonance between material conditions and the promise of improved housing and better living only increased throughout the interwar period.

This effort to rationalize housing and transform home building into a modern industry extended beyond the house type to encompass quantity production and site planning. Environmental reformers conceived the new housing as a basic module for self-contained, satellite communities. Lewis Mumford, a prolific and outspoken proponent of modern community planning, drew explicit links between an individual dwelling and the community. "A good house can not exist in a city by itself; it can only come as part of a community plan, and until we learn to design our communities and our houses cooperatively, treating each separate unit as part of the whole, we shall not succeed much better than the jerry-builder does today."[18]

When planners, housing advocates, and reformers spoke of creating "complete communities" they were referring to neighborhood-scale developments with dwellings, schools, commercial centers, recreation facilities, religious structures, and civic institutions all sited in close proximity to employment. To describe these projects, the members of Southern California Telesis, a multidisciplinary group of environmental and social reformers, coined a purposefully broad and inclusive phrase: "commu-

nities for balanced living." For these design professionals, the physical plant of housing, public facilities, and business and industry required its social complement of families, play groups, and a community of elders to become a "place for living, work, and play."[19]

Regulating the Subdivision of Land

There was general agreement that these complex, interconnected physical and social objectives could be achieved most efficiently through large-scale operations; that is, asserting increased control over the planning and development of new projects from initial land use to the design of an individual dwelling. Comprehensive planning was mandatory to achieve this level of coordination. In "The Planned Community," the editors of *Architectural Forum* argued: "The modern dwelling is a unit in a neighborhood community. . . . To build such a community effectively and cheaply, one must do it in a single operation, from the purchase of the raw land to the final plan and construction of shops, schools, playgrounds and other communal facilities."[20] Community builders worked to secure greater control over land development through their advocacy of local and statewide zoning controls. At the local level, developers and property owners exerted control over formal design and social monitoring by requiring and enforcing deed restrictions and restrictive covenants. And like the lot and home buyers at Leimert Park, residents formed neighborhood associations to monitor these internal controls.[21]

While these proposals may appear prosaic and the objectives self-evident, a consideration of contemporary assessments concerning issues ranging from premature and excessive subdivisions to the lack of planning standards and regulations and the changing nature of urban neighborhoods allows us to evaluate them situationally. Writing in the *Nation* (1932), Clarence Stein drew his readers' attention to one of the acknowledged shortcomings afflicting subdivision practice, namely, profligate speculation and needless infrastructure. Stein grounded his polemic through a discussion of residual streets and lots, a first pattern that set the mold for future development and ended up as costly "municipal equipment" serving no one. Vast segments of American cities were, he noted, "fixed by street layouts and subdivisions that are in great part already obsolete. Under our present procedure the pattern can be changed, the mold broken, only at vast expense by repurchasing individual lots" (fig. 1.4).[22]

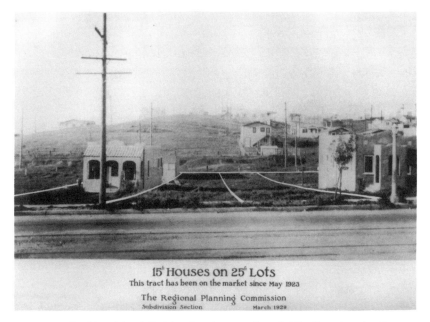

FIGURE 1.4 Residential subdivision in advance of need. The Los Angeles Regional Planning Commission included this image in its 1929 *Annual Report* to illustrate "poor" planning and development practices, in this case a reference to the six years these lots had been on the market, as well as the lot width.

In *Housing for the Machine Age* (1939) Clarence Perry elaborated on Stein's observation.

> A drive through the outskirts of most cities would bring to view large areas, crisscrossed by streets, curbstones, or sidewalks, yet exhibiting no dwellings. . . . Residents in the adjacent district might disclose the fact that the tract had been opened years ago, at the time of a real estate boom. Further investigation would often reveal that hundreds of people had invested hard-earned savings in those lots and then lost them; and that the man who had cut up the tract, the subdivider, to whom they had reverted, was no longer able to pay the taxes on them.[23]

In decrying the physical blight and social costs of premature and excess subdividing, Perry and Stein were speaking for good-government advocates, realtors, builders, and taxpayers, all of whom saw "land butchering" as a "cancer" affecting the urban landscape. Critics argued that munici-

palities funding infrastructure in advance of need were underwriting de-
velopers and jeopardizing public funds through their investment in grad-
ing, paving, and the installation of underutilized or unutilized services.
Once in place, premature infrastructure drove property values up, increas-
ing land costs and encouraging higher-density development to recoup
investors' initial outlay. Left undeveloped, these "forlorn" and "unproduc-
tive" properties became a visual blight, a certain damper for development
on surrounding property.

Other studies documented the prevalence and extent of excess subdivi-
sion, examining its social and fiduciary costs, especially that of taxes antici-
pated but never collected. In "Exploiting the Land," a 1927 report on
premature subdivision in Chicago, Henry Wright claimed that "newly
plotted suburban land has been opened up sufficient to house 80,000,000
people."[24] Realtors and subdividers were concerned as well about the
"over-production of residential allotments." Writing in the *Pasadena Star
News*, Stephen Barnson, commissioner of the California State Real Estate
Department, claimed in 1930 that land developers who did not look be-
yond the mere marketing of lots were self-seekers who threatened the
orderly growth of the city. He blamed these opportunists for higher taxes
and the abnormally high cost of civic services. While he expressed cer-
tainty that subdividers could regulate their own, he threatened that, de-
prived of significant change, "the people should demand that all public
utilities and street improvements be installed at the subdivision owners'
expense."[25]

Articles in professional publications targeting developers and property
owners expressed similar concerns and argued for control of new lot sales
to stabilize real estate values. *California Real Estate Magazine* went as far as
to ask the state to appoint a "real estate czar to prevent the next million lots
from being offered before the present surplus supply is consumed."[26] In
New York, the State Planning Council found evidence indicating prema-
ture subdivision in metropolitan regions "more extensive than the total
areas actually in use for urban purposes." Reporting on the crisis in 1934,
the *New Republic* singled out modern community planning as a possible
solution, since it assured the "end of the premature opening up of vacant
territories on the edge of cities, so that they may be broken up by the
individual land speculator. It means the end of water systems and transit
lines and other municipal utilities in advance of actual use."[27]

But even ostensibly successful developments raised the ire of these
critics. Typically, land subdivision and home building were small scale.

Reformers criticized these operations as haphazard because subdividers rarely considered external conditions such as the mandatory coordination with existing streets, sewers, and other systems. And often they failed to account for public services such as schools, requiring children to travel long distances to the nearest facility. "Respectable" realtors, stakeholders in the long-term accretion of property values, denounced these practices and agitated for subdivision regulation and controls. They chastised "curbstoners" and "fly-by-nighters," "con men" motivated by self-interest who speculated in vacant land and suckered the unwitting into gambling their savings. They believed that instituting standards for lot sizes, street widths, drainage, and utilities would lower construction costs, close the affordability gap, and, over time, improve civic welfare, especially environment and health.[28]

The National Association of Real Estate Boards and state real estate associations engineered the drive toward greater subdivision control with the cooperation of local planning officials. After noting that "every city is made up of a series of subdivisions," the Los Angeles Regional Planning Commission proposed a set of uniform countywide guidelines. The commission's 1929 *Regional Plan of Highways* stated that whereas proper land subdivision benefits everyone, "done badly, the damage is great and frequently irreparable. The subdivider, the purchaser, the utility corporations, the banks and financing companies and the public are all better safeguarded . . . by a set of fair and workable regulations which govern land subdivision in a manner conducive to the community's best interest."[29]

To be effective, development regulation had to address planning issues within an individual project as well as external connections. Internally, design standards were a primary concern. Developers of large parcels could control site planning, stipulate and maintain guidelines, designate a house type and often the range for construction costs and value, and coordinate amenities. Subdividers such as Walter Leimert, who initiated or supported these measures, realized that they furthered their interest in setting and maintaining property values.[30] Externally, the first priority was to implement zoning controls to designate land use and direct the nature and quality of surrounding development. Once land use and transportation plans were in place, new development could proceed with the assurance that internal systems such as streets, drainage, and waste would dovetail into existing networks.

A 1933 planning pamphlet for public administrators stressed the need for central control and a comprehensive plan that could inform individual

developers. The authors found that the failure to align streets, for example, was the result not of subdividers' unwillingness but rather of their ignorance of future requirements. "The city plan becomes the subdivider's guide in relating his property to future thoroughfares, parks, and other public works. The planning commission provides a medium whereby the subdivider may adjust his scheme to the city plan and the layout of abutting plats."[31]

The Neighborhood Unit

These calls for enhanced physical planning to create coherent, coordinate subdivisions and, by extension, cities complemented the social reformers' stated agenda. Their focus on the neighborhood as a unit of analysis, a point of intervention, and the appropriate scale at which to undertake improvements was a legacy of the Progressive Era, particularly the settlement house movement. In response to the perceived anomie and dislocation of the industrial city, social reformers seized on the comprehensive and comprehensible neighborhood as a framework for community. They understood the neighborhood as a fundamental social unit, the scale at which face-to-face relations could be encouraged and maintained. As such, it constituted the proper sphere for socialization, especially of children, who were understood to be the most dependent on family, play group, and a community of elders. Sociologist Robert Park viewed the neighborhood as a community's natural area, defined by group experiences and a sense of territorial parochialism.[32] From this analysis of the neighborhood as a definable, workable, and progressive social unit and a belief in positive environmental intervention, it was a short step for reformers to adopt the neighborhood as a primary unit for physical planning.

Social reformers also championed formal principles associated with modern community planning such as a consistent formal character that, they believed, could promote social unity and "neighborhood consciousness." For the members of Southern California Telesis, "the desirable neighborhood is one developed as a community in which the concept of home extends beyond the individual house and lot to the neighborhood; where an opportunity to participate in the life of the group leads to the development of a sense of social responsibility for the whole."[33] For Catherine Bauer, the neighborhood was simply "the minimum unit," the basic module for "planned developments equipped from the beginning with adequate facilities and services."[34]

Planner Tracy Auger made the connection between the social group and physical planning explicit in a 1936 presentation to the Joint National Housing Conference.

> What does a wholesome community structure look like, and how does one lay out a housing site to approximate it? Two notable contributors . . . Sir Ebenezer Howard and Clarence Perry give us the first lead. Before [undertaking] site design we must begin with a unit of urban life that is capable of maintaining itself. . . . Howard set up the Garden City as a type of metropolitan unit that could survive as a well-rounded healthy community uninfluenced by the ups and downs of urban life around it. Perry carried the same idea into the internal structure of cities in his neighborhood unit, a residential cell capable of building up a community life . . . capable of resisting tendencies to depreciation and disintegration.[35]

Howard formulated his garden city proposal in response to London's congestion. He first outlined an alternative configuration in a 1898 publication *To-Morrow: A Peaceful Path to Reform*. In it he included a diagram for new settlements disengaged from the current spread of urban centers and set in open country. These self-sufficient towns would house thirty-two thousand residents. Each satellite of a thousand acres would have another five thousand acres of agricultural land surrounding it as a permanent greenbelt. Howard's scheme included public land ownership, which, he believed, would encourage low-density development, since in his view speculation was a root cause for agglomeration. Letchworth, the first community organized according to these tenets, was begun in 1902 eighty miles from London. Letchworth and the later Welwyn did not conform precisely to Howard's criteria, but the formal idiom introduced there, particularly in terms of streetscape design and unit siting, and the pronouncements of designers Raymond Unwin and Barry Parker were influential for modern community planning.[36]

A distinctly American translation of these principles was formulated in the 1920s by members of the Regional Planning Association of America (RPAA), particularly Clarence Stein, Henry Wright, and Lewis Mumford. Clarence Perry sketched the most succinct and influential exposition in his 1920s design for a "neighborhood unit" (fig. 1.5). Perry traced his development of the concept to two sources, his work for the Russell Sage Foundation on schools and their appropriateness as community centers and his personal experience as a resident of Forest Hills Gardens, Queens (1910),

the model garden housing estate that Grovesnor Atterbury and Frederick Law Olmsted Jr. designed for the Sage Foundation on a 164-acre site within New York's city limits.[37]

The foundation intended Forest Hills to be a workers' estate for moderate-income tenants. Following Unwin and Parker's lead the designers inserted a picturesque street pattern within the regular urban grid. Here, according to Olmsted, New York's "monotony of endless, straight, windswept thoroughfares . . . will give place to short, quiet, self-contained and garden-like neighborhoods." At Forest Hills each specialized street was carefully keyed to an internal and external hierarchy. Comprehensive site planning included a central common surrounded by civic buildings and generous garden courts between blocks.[38]

In developing his neighborhood unit Perry drew formal attributes from Forest Hills and the English garden suburbs, principally the superblock street configuration, which he favored because it discouraged through

FIGURE 1.5
Clarence Perry's diagram of neighborhood unit principles.

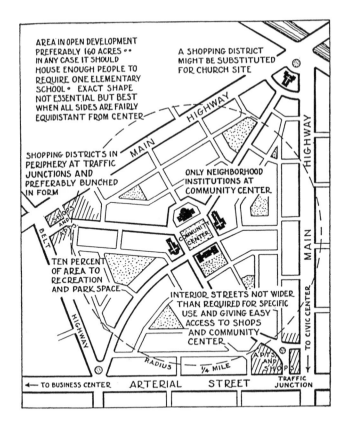

traffic. Major arterials, designed to encourage and accommodate through traffic, would bound each neighborhood. Internal service streets were intended for residential access only. Longer blocks and fewer intersections reduced the area devoted to circulation, land that could be dedicated to recreation. Ideally, this pattern would reduce automobile intrusion into the neighborhood and, if properly planned and managed, might return primacy to pedestrians. In Perry's diagrams, retail shops were placed at select intersections; the implication, in plan, was that contiguous, interlocking units would form a commercial district.

Socially, the neighborhood unit reflected Perry's commitment to the settlement house movement. Each community-scaled project would house a sufficient number of families to fully enroll a primary school; each child would live within a quarter mile from the facility. As diagrammed, adjacent and ancillary playgrounds would occupy one-tenth of the total site area. Perry envisioned residents forming voluntary associations to promote social cohesion, administer public land, enforce restrictions, and staff neighborhood services such as recreation and child care. In his schematic plan, community institutions cluster around a central green or common; a network of small parks, planned to meet local needs, are sprinkled throughout the site. Physical and social planning intertwined in an emphasis on neighborhood consciousness and belonging.

The neighborhood unit was an ideal. It was a tightly planned, perfectly integrated, and replicable module that could replace blighted inner-city areas, form the nucleus for new developments, and become a building block for improving cities through contiguous projects. Perry and other supporters intended the concept to be applicable throughout the country. It was the epitome of rational design, efficient and economical, the product of applied research.

Dissemination of the neighborhood unit concept began with its publication in the *Regional Plan of New York and Its Environs* (1929).[39] Members of the thirty-one committees organized for the 1931 President's Conference on Home Building and Home Ownership endorsed the concept enthusiastically. Herbert Hoover called the meeting to "pool the wisdom" of professionals engaged in housing production and real estate, design, and planning in order to "inspire better organization . . . and the spread of home ownership [in] both town and country."[40] As a measure of acceptance, the neighborhood unit concept appeared twenty-five times in the published conference proceedings. Committees on subdivision layout, city planning and

zoning, types of dwellings, housing and the community, blighted areas and slums, standards and objectives, legislation and administration, and research singled it out for consideration and eventual implementation.[41]

The committee on city planning and zoning, for example, linked the neighborhood and dispersion in their final report. After stating that the "neighborhood unit type of community development will assist in preventing the straggling building of residences," the committee expressed its belief that Perry's scheme could assure "re-establishment in a complete community instead of depositing [people] as isolated family units[.]"[42] Dispersion, they argued, "should apply to both industry and population, and it should be encouraged to take place in forms that will create conditions suitable for well-organized community life." As part of regional or city plans, a series of neighborhood units could encourage "re-grouping or re-centralization; that is, the establishment of new community centers rather than scattered and unplanned decentralization. . . . The aim should be a desirable degree of concentration for industry, residence, and business."[43]

Beginning in 1936, the Federal Housing Administration (FHA) spread the neighborhood unit formula through its technical bulletin series. These brief, inexpensive pamphlets, directed at land developers and speculative builders, guaranteed that awareness of these principles would be diffused beyond the professional boundaries of planning, design, and social reform. Multiple titles pitched modern community planning as sound business practice, encouraging entrepreneurs to consider the economic advantages of good planning in the creation and maintenance of real estate values. Arguing that "environment is the final source of value," the FHA intended to extend physical planning practices common in "exclusive neighborhoods and subdivisions of high-priced homes" to large-scale projects of low-cost dwellings. Illustrations labeled "good" and "bad" with narrative captions assured that readers unschooled in planning and design practice would get the point.[44]

"Planning Neighborhoods for Small Houses," first published in July 1936, outlined modern community planning for the agency's readership. Under "General Principles," the FHA counseled residential developers to integrate their large-scale projects with the city master plan and stressed the importance of accessibility to schools, employment, and commercial centers. In part 3, "Neighborhood Design," readers found a resumé of the neighborhood unit concept detailing proper street patterns, planning for parks, playgrounds, and commercial areas, and recommending a buffer zone of multifamily dwellings and commercial buildings between major

arterials and minor interior streets. The frontispiece and caption, a "complete community development," illustrated the agency's debt to the garden suburb tradition and the RPAA. The accompanying text catalogued a "carefully planned shopping center," the "provision for parks," the "minor residential streets feed[ing] into broad traffic boulevard," and a section "set aside for a park and playground."[45]

While its technical bulletin series endorsed up-to-date planning and community design, the FHA publications were intended primarily as promotions for home ownership, the administration's preferred form of tenancy. This signals an evolution in the dissemination and popularization of the neighborhood unit concept. Early proponents did not equate it explicitly with home ownership. Perry, for example, advocated the concept for both single-family and multifamily units, renters and owners.

In a retrospective assessment of Perry's contribution Lewis Mumford explicitly linked three factors central to modern community planning: the neighborhood as a social unit, the neighborhood unit as a planned equivalent, and the positive role this social and physical ideal could play in reshaping the urban region.

> What Perry did was to take the fact of the neighborhood and show how, through deliberate design, it could be transformed into what he called a neighborhood unit, the modern equivalent of the medieval quarter or parish: a unit that would now exist not merely on a spontaneous or instinctual basis, but through the deliberate decentralization of institutions that had, in their over-centralization, ceased to serve efficiently the city as a whole.[46]

Overlooked by Mumford in this account was the role the neighborhood unit played as a reference point for community builders and its status in the important debates over development and building practices.[47]

Precedents for Implementation: The World War I
Housing Programs

Although the neighborhood unit and, more broadly, modern community planning presented a highly coordinated landscape, theorists and design professionals remained silent concerning implementation. In their polemic *New Homes for a New Deal* (1934), Mumford, Henry Wright, and Harold Mayer articulated the need for economies of scale in planning and production, including comprehensive plot and building design, centralized mate-

rial purchasing, and rationalized site operations, the latter predicated on a high level of labor organization and the use of time-saving machinery. Implementation, however, required an unintended convergence of government policy with the objectives of community builders. Both drew upon the design, organizational strategies, and development practices the regionalists had endorsed.[48]

To ground these discussions, environmental reformers inevitably cited the United States Shipping Board's Emergency Fleet Corporation (EFC) and the United States Housing Corporation (USHC) as precedents. During World War I these agencies oversaw a housing program for workers migrating to defense industries in manufacturing centers such as Hampton Roads, Virginia, Camden, New Jersey, Portsmouth, New Hampshire, and Vallejo, California. While newcomers and long-term residents endured shortages and hardship, defense contractors and a military dependent on the timely production of matériel knew that poor housing and the lack of community services increased the already high level of employee turnover. When housing shortages reached a critical point the federal government reluctantly intervened with a limited experiment in community building. The exigencies of the armament effort afforded a brief window of opportunity for a collaboration of prominent housing reformers, architects, and planners, buttressed by federal authority and government funding. In just fourteen months these two agencies completed fifty-five projects with 15,500 family units and dormitory lodgings for 14,200 individual workers. In the view of contemporary observers, these communities demonstrated benefits that might be derived through comprehensive planning and industrialized building methods.[49]

Professionals employed by the EFC and USHC modeled the U.S. wartime housing experiment on European, particularly British, projects. In 1917 Charles Whitaker, editor of the *Journal of the American Institute of Architects*, sent architect Frederick Ackerman to study recent developments in European housing. Ackerman reported enthusiastically on the importance British authorities assigned to housing. These officials recognized that improved living conditions and worker satisfaction were essential for increasing and maintaining wartime production. Most striking for Whitaker was the British approach to town planning. He found the English "did not treat the house as an isolated factor"; rather, they conceived of it as the core of an entire community. The scope and scale of these operations impressed Ackerman as well. The British communities contained "dining-halls, recreation buildings, clubs, institutes, schools, playgrounds,

churches, hospitals, stores, markets [and] excellent roads with curbs, side-walks, fences, hedges; in many cases, trees have already been planted."[50]

In the United States, design professionals translated the British prece-dent into community-scale developments on open sites close to industry and independent of adjacent cities. Architects prepared standard house plans with uniform minimum requirements. Windowless rooms were elim-inated, and each unit had gas kitchens, interior bathrooms, and sepa-rate bedroom closets. Development codes set standard lot dimensions, including a twenty-foot separation between detached dwellings. Across the ninety-one proposed communities the median project size was 135 dwell-ings, but over half exceeded 500 units.[51]

In their retrospective assessments, planners and designers stressed the program's benefits for residents and pointed to lessons that could be drawn from these experiments. Sylvester Baxter argued that improved housing in planned communities would exert a positive moral influence and "coun-teract the slovenly and vicious tendencies of the usual tenement environ-ment lead[ing residents] along the first steps toward the higher grades of American working-life." Carol Aronovici focused on the crafting of new standards for single-family housing and a positive shift in the housing reform agenda away from its historic focus on pathologies and improper living conditions. John Nolen found the outlines for new housing policy in the World War I communities, programs capable of providing adequate shelter for those in need.[52]

There was also considerable speculation that developers and builders might cull from these war villages a government-sanctioned standard for wage earners' housing. These expectations informed Andrew Crawford's account in "The Future and Influence of American War Housing De-velopments," where he suggested that through a federal appropriation of $150 million for housing, the "government has accepted a responsibility for setting the standard for living conditions for the working people of the United States. Whatever it does, whether good, indifferent, or bad, will be accepted as good enough by the real estate operators and by the mass of the people."[53]

The wartime industrial mobilization provided a catalyst for experi-ments in community-scale developments and modern community plan-ning that focused attention on the instrumental role housing played in na-tional welfare and industrial efficiency. When, almost two decades later, the Urbanism Committee of the National Resources Committee conducted its survey of 144 planned communities, its members selected seven of the

World War I war housing projects for inclusion. Five of these received detailed analysis in their supplemental report, "Planned Communities."

> The permanent war housing developments had two considerations in mind after a shortage of housing in any one vicinity had been determined: first, to provide homes for war workers . . . on adequate sites, favorably located with reference to industry . . . and [second,] to take into consideration the adaptability of the development after the war. . . . The measure of success in both directions is manifested by their functioning during the war, by the influence which they have had in promoting better subsequent development, and by their [excellent] current status.[54]

By way of explanation the committee pointed favorably to the high degree of home ownership, low turnover, and the retention of "identity." In these communities researchers found a "desirable relationship between residence and industry, as they are conveniently located without being dominated by contiguous industrial development."

The enabling legislation funding these projects mandated their postwar sale "as soon after the conclusion of the war as it can be advantageously done."[55] Progressive housers decried the fee-simple sale of these communities. The stated objective was a recovery of the government's financial investment, but critics viewed this as a placatory decision intended specifically for private sector realtors and developers. Tenant purchase was possible, however, because defense workers found continuing employment in the plants to which the war housing was initially linked.[56] The individual sale of these units was consistent with dominant ideologies concerning home ownership and contemporary concerns regarding the national rate, which, according to the decadal census findings, had been declining for fifty years. Over the previous thirty years there had been a 2 percent decrease in the number of American homeowners.[57] Any decline was perceived as a threat to social stability. Opening the 1931 conference, then president Hoover stated: "There can be no fear for a democracy of self-government or for liberty or freedom from home owners no matter how humble they may be."[58] Hoover equated home ownership with citizenship, good citizenship with a stable workforce, and both with an improved social order.[59]

Own Your Own Home

As secretary of commerce, Hoover served as titular chairman of the Better Homes in America movement, which was at the forefront of efforts to

redress the decline in home ownership.[60] Marie Meloney, an editor at the *Delineator*, a service-oriented magazine for women, launched this campaign to educate housewives as "trained experts, discriminating consumers, and moral arbitrators within a defined architectural setting"; it was a program designed to meld thrift and self-reliance with new household technologies.[61] Political endorsements soon followed. In a letter to Hoover, President Coolidge offered a simple rationale for his support: "[The] American home is the foundation of our national and individual well-being."[62] Hoover concurred. In the first two years following its inception volunteers and staff affiliated with Better Homes sponsored demonstrations in more than five hundred communities. After securing financial backing from the Rockefeller Foundation the campaign moved to Washington, where it was restructured and effectively absorbed within the Department of Commerce.

An eleven-point bulletin stated the Better Homes objectives; home ownership was central. Item 3 made this point explicit: "To encourage thrift for home ownership, and to spread knowledge of methods of financing the purchase or building of a home." Hoover enlisted the Department of Agriculture's Extension Service, state Supervisors of Home Economics, and local chambers of commerce to assist in meeting this goal. Supporters formed local Better Homes committees nationwide.[63] These groups, which numbered 760 in 1924 and 7,279 by 1930, spread the home ownership message through demonstration houses, lectures, competitions, and publications devoted to informing the "general public regarding the practical details of house architecture, construction, and equipment, and each of the processes involved in purchase, financing and management."

The Department of Commerce enticed renters to become home owners with pamphlets such as *How to Own Your Home: A Handbook for Prospective Home Owners* (1923). "An owned home with its many satisfactions is an ideal that most families wish to secure for themselves. . . . The home owner is master of his dwelling. . . . He can make alterations as he sees fit, and money spent for improvements adds to the value of his own property. His family feels a sense of security, and finds a stimulant in earning and saving to pay for the home and in making it attractive."[64]

Three years later Culver City, California, the "City of Better Homes," sponsored two demonstration houses during National Better Homes week, April 25 to May 1, 1926. The city joined forty-nine other California municipalities that unveiled demonstration houses and offered lectures and events. Developer Harry H. Culver created this incorporated community

west of Baldwin Hills in 1914. Twelve years later Culver City was a center for the movie industry, second only to Hollywood in the concentration of companies and annual production. Six studios including Metro-Goldwyn-Mayer, the Cecil B. DeMille Studio, and United Artists provided employment and supported a population approaching fifteen thousand. A local executive committee assisted by the Board of Trade organized the construction of two demonstration dwellings and a week of lectures. Siegfried Goetze designed the units, described in an accompanying brochure as the epitome of economy, featuring "unusual and charming features seldom found in small home buildings; [a] great aid to families of modest means [who want] to own homes which are comfortable and attractive." Sharethrift Community Homes and Pacific Building and Loan supplied the skilled labor and financing, respectively. Goetze and other officers of American Home Betterment, a Los Angeles–based nonprofit housing corporation, presented talks ranging from "Locating and Financing the Home" to "Duty to the Child in the Home" and "Making Plants Grow."[65]

Private initiatives complimented the Better Homes campaign. For example, during the 1930s, the Building Contractors' Association of Southern California organized a cooperative program with the regional FHA office to "bring home ownership within the reach of industrial and commercial workers."[66] The FHA's participation was critical. When legislators drafted and approved the 1934 Housing Act the administration's mission was to release the federal government from the Home Owners' Loan Corporation's (HOLC) direct lending practices. Eventually, FHA programs acted as a stimulus for home building, and Congress supported this as a means of reviving construction and reinvigorating investment, employment, and consumption.[67]

In an unintended policy outcome, the administration's mortgage guarantee program revolutionized the conditions for purchasing and owning a dwelling. Federal insurance encouraged lenders to fund home loans for a larger percentage of the face value of the mortgage, originally 80 percent but later as much as 90 percent of the loan amount. Using FHA loan insurance allowed buyers to finance a greater percentage of the total purchase amount, thereby reducing their down payment. Lenders, backed by FHA guarantees, jettisoned their customary three- and five-year repayment periods and adopted first fifteen-year and later unprecedented twenty- and twenty-five-year plans. With FHA-guaranteed mortgages, monthly payments applied to principal as well as to debt servicing. The FHA also standardized loan procedures, eliminated second mortgages, and lowered

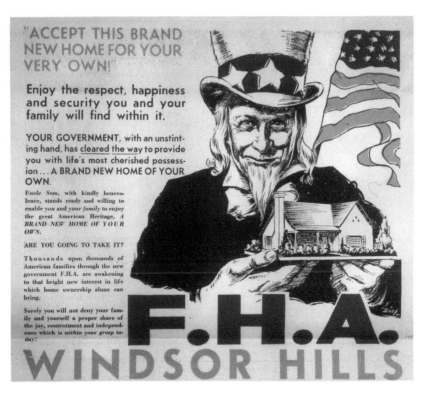

FIGURE 1.6 Marlow–Burns and Company 1938 newspaper advertisement for Windsor Hills promoting FHA mortgages as a means for home ownership.

interest rates. All these features were in marked contrast to the prevailing system for financing a house purchase. Over time the administration made home ownership an attractive option for a new demographic and income stratum.[68]

Beginning in February 1940 the FHA launched a "concerted campaign" to promote home ownership among the "mass of modest-income families" with twenty-five hundred dollars in annual earnings, sufficient to own a dwelling on a budget of twenty-five dollars a month. The administration worked closely with mortgage institutions, real-estate firms, building materials dealers, home products manufacturers, and home builders to expand its new housing market (fig. 1.6). The FHA promoted the "possibilities of home ownership" with posters, booklets, and newspaper and radio advertisements proclaiming, "Now You Can Own a Modern Home—comfortable to live in, attractive to look at, convenient to pay for."[69]

Industry, Home Building, and the Regional City

Home building for modest-income wage earners was taking place in a particular domain. These small, single-family dwellings did not form a working-class equivalent of socially exclusive, functionally segregated, up- per- and middle-class residential enclaves. Industrialists, land developers, and wage earners recognized the advantages offered by a close spatial link between the workplace, residences, and civic institutions. Developer Harry Culver, whose Culver City served as a Better Homes locale, implemented this strategy when he lured movie studios, one of the region's largest employers, to his incorporated community. Contemporaries praised Cul- ver for coupling jobs with housing; popular accounts featured the de- veloper who "bought a barley field and built a city."[70]

In a housing market analysis of the Los Angeles area, the FHA under- scored the importance of industry for home building and ownership. The authors identified seven advantages local manufacturers enjoyed, rang- ing from a large and growing urban market, relatively cheap fuel and energy sources, and harbor improvements to a desirable regional labor pool housed in "attractive residential conditions." While the FHA surveyors were conducting this study, enumerators employed by the WPA were engaged in an exhaustive survey of county residents, structures, and land uses. Coded data cards reported tenancy, occupation, place of work, jour- ney to work, and mode of transit for each household. Their findings docu- mented the diversity of manufacturing and its spatial reach. In a joint executive summary the Regional Planning Commission and the WPA highlighted this geographic dispersion. "In almost every municipal and geographic division of Los Angeles, as well as in outlying satellite centers, small industrial districts occur. . . . Hundreds of manufacturing establish- ments of diverse kinds are widely scattered over the metropolitan district. Even such noteworthy residential suburbs as Hollywood, Beverly Hills, Santa Monica, Pasadena, and Long Beach have their industrial tracts."[71]

The joint RPC-WPA survey confirmed a dispersed pattern of satellite development that Southland industrialists, planners, home builders, and boosters actively promoted and encouraged as an antidote for the per- ceived detriments of congestion and overcrowding they attributed to New York, Chicago, and other East Coast and Midwest cities. In 1922 the Los Angeles County Board of Supervisors sponsored four conferences on re- gional planning devoted to subdivision regulation, transportation, and water and sewage, issues whose effects and domain elided tidy jurisdic-

tional boundaries. The proceedings from the first meeting, held in Pasadena, included an illustration depicting Los Angeles as an urban region consisting of a "center city surrounded by many satellite sub-center cities and communities" (fig. 1.7). George Damon, an engineer and subsequent RPC board member, wrote the accompanying text. "The whole District is crystallizing about natural centers and subcenters. The nucleus is the business center of Los Angeles. Beyond the five- or six-mile circle we find sub-centers developing, each with its own individual character and identity." The diagram, abstracted from the regional system of automobile laterals, portrayed a set of four major and minor satellites. Culver City, along with Glendale, Montebello, and Palms, appeared as a minor subcenter in this metropolitan constellation. Representatives attending the conference drafted a Declaration of Inter-dependence, a pioneering regional planning document that catalogued their empirical findings regarding specialization and units in an urban system.[72]

Three years later, Gordon G. Whitnall, then director of the Los Angeles City Planning Commission, addressed the League of California Municipalities. His topic, ostensibly, was the relation between downtown commercial districts and outlying business centers. Whitnall used the forum to rehearse a favorite theme, that the "eastern type of metropolis is unnatural—even wasteful," whereas, in light of "certain new factors, the Los

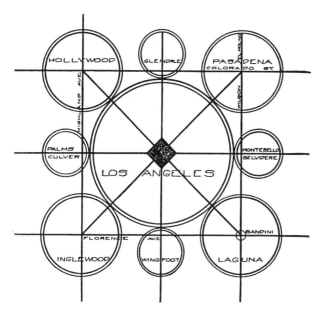

FIGURE 1.7
Diagram produced for the first Regional Planning Conference of Los Angeles County (1922) showing a comprehensible metropolitan region.

Angeles (or Western) type of development is normal, economically sound, socially correct and consequently unusually stable." In describing this pattern, Whitnall offered an astrometric analogy locating Hollywood, Glendale, and Pasadena on the inner orbit of a metropolitan solar system while Long Beach, Santa Monica, and Whittier constituted an outer ring. This system was "mechanically efficient, economically sound, and socially ideal." Most critically, according to Whitnall, it represented the application of universal rules "prized by industry, commerce, and society" to the process of city development, namely, specialization and the unit system.[73]

Clarence Dykstra, an engineer and efficiency expert for the Department of Water and Power, blended boosterism with progressive planning in "Congestion De Luxe, Do We Want It?" arguing against the "centralization complex" typical of eastern cities and for a new kind of city "full of opportunities for work and play [with] industry to provide for the needs of all." Contrary to the received wisdom regarding urban dispersion and functional segregation in Southern California, Damon, Whitnall, and Dykstra envisioned growth and development clustered around specialized units within the metropolitan region. And, most critically, they based their projections on an analysis of existing patterns.[74]

This new way of thinking about cities was not limited to Southern California. In 1924 sociologist William Bailey alerted readers of the *American City* that twentieth-century cities would be dispersed. In the past, planners and "interests of all sorts have been looking to the 'center' but [they] must soon begin to regard the 'circumference.'" The National County Roads Planning Commission's 1932 manual made a similar point when it stressed that residential dispersion alone "will not solve the problem of congestion if it is unaccompanied by the wider dispersal of industry. . . . The spreading of industry and population in well-balanced proportions is necessary to arrest the evils of congestion."[75]

Although commentators from varied perspectives agreed that a decanting of population and jobs was already under way and that past patterns were becoming obsolete, there was no unanimity regarding the timing and nature of change. Contemporary discussion and debate centered around means and ends, particularly the relative merits and probability of controlling and directing dispersion. Assessments and projections tended to fall within or between two narratives; in retrospect, proponents can be situated in relation to these discourses as either pragmatists or decentrists. Pragmatists analyzed industrial location and changing population gradients in terms of "natural forces." From their perspective any intervention de-

signed to inform these processes would be confined to management. Generally speaking, pragmatists favored minimal physical planning interventions, limited to incremental adjustments that responded to existing and evolving urban structures. Decentrists were more proactive. Where pragmatists intended only to guide ongoing processes, decentrists preferred preemptive strategies. They planned to capitalize on changes already in progress and fashion an alternative to the industrial city.

Decentrists

Catherine Bauer coined the term *decentrist* to refer to "urban theorists who believe in thinning out the dense cities and dispersing businesses and people to smaller places." Bauer identified a loose federation of theorists, architects, planners, progressive housers, and critics who shared a common objective, harnessing the ongoing dispersion and redistributing people, institutions, industry, and housing into new towns. Within these regional cities each autonomous satellite would provide for residents' local needs while serving as a center for at least one shared function such as a university or medical center. Bauer considered Henry Wright, Frederick Ackerman, and Robert Kohn, architects who figured prominently in the World War I housing experiments, Stuart Chase, an economist and advocate for resource and economic planning, conservationist Benton MacKaye, and Lewis Mumford as decentrists. These individuals are best known, perhaps, as members of the RPAA.[76]

The decentrists' regional prospect and inclusion of dedicated greenswards in their plans underscores the reach of Howard's garden city. Mumford, a preeminent spokesperson for these principles, argued against urbanization that "fill[s] up the land with an undifferentiated mass." Along with his colleagues he favored "weed[ing] out . . . part of the population of the congested metropolises of today" by "transplanting [people] to more favorably situated centers." In a pointed rebuttal of the pragmatists, he condemned planning that began from an assumption that cities were "bound to grow continuously on the lines they have followed in the past"— an admission, Mumford felt, that "planning is impotent except to facilitate results which would take place anyway."[77]

Mumford and other decentrists accepted as a given an increased rate of technological change and subsequent reconfiguration of cities. Decentrists rehearsed industry's freedom from site-specific power, the widespread adoption of telephones and other communication systems, and increased

auto ownership as causal factors. Frank Lloyd Wright distilled this particular line of reasoning to its essence when describing Broadacre City. "In the days of electrical transmission, the automobile, and the telephone, [urban concentration] becomes needless congestion, it is a curse." In place of the dread industrial city, Wright offered a uniformly decentralized landscape with "no core and no periphery." Following implementation, central cities would wither away of their own accord. More-tempered assessments assigned existing urban centers a reduced role as one node among equals, "ruralizing the stony wastes of our cities," as Mumford romantically intoned.[78]

Decentrists formulated or reformulated concepts, methods, and objectives that eventually became central tenets of modern community planning. The first was an insistence on comprehensive planning. Redistribution would begin with a survey of existing conditions—physical, social, and economic. From this quantitative data, experts could develop a rational plan with zones for business and manufacturing in a balanced relation to residential areas. Development would include greenbelts for recreation, relaxation, and rejuvenation. Crafting the necessary balance between concentration, mandatory for civic life, and open space, required for health and hygiene, would be one metric for success.[79] Mumford understood the region as a "natural base and social fact." Planning, he argued, should begin "not with the city as a unit in itself [but] with the region as a whole." The goal was a balanced system, an "environment including work, housing, recreation, and the customs and habits of the people who make up a region."[80]

Efficiency was a secondary benefit decentrists ascribed to comprehensive planning, especially when viewed in light of the waste inherent in haphazard or piecemeal planning. Henry Wright, Clarence Stein, and Clarence Perry, for example, published numerous studies of street systems. Text and graphics denounce the regular, nondifferentiated grid as an evil, a contributing factor responsible for the needless depletion of land and other resources. They championed the superblock, a rational, efficient, and hierarchical diagram of use. In a critique of New Deal housing programs written with Albert Mayer and Henry Wright, Mumford attributed yet another benefit, which he defined as "economies of planning." The reference was to economies of scale of industrial production and the perceived benefits of large-scale operations, integration, and enlightened management. A related legacy was also based on efficiency and economies of scale. Advocates for neighborhood or community-scale projects recognized these

could be carried out effectively and economically only through land packaging (by eminent domain if necessary), quantity purchasing, and coordinating the construction process to assure that workers, equipment, and material moved through the site in an orderly, productive manner.[81]

Like Howard, decentrists conceived of cities as organisms with minimum and maximum optimal populations. Howard had drawn his formulation from Patrick Geddes. When American design professionals such as Stein and Wright programmed for the collective with neighborhood centers and elementary schools, they reinvested Geddes' organic community as a foundation for modern community planning. The decentrists resurrected Geddes because his theory transgressed tidy numerical and areal boundaries to articulate a humanist conception of community as a collective civic character or spirit.[82]

These principles were endorsed by the Committee on City Planning and Zoning in its report for the 1931 President's Conference.

> The need may be expressed thus: first, the diffusion of groups by creating new sub-centers of industry with the object of lessening the density of congested centers; second, the grouping of homes into reasonably compact residential neighborhoods, with adequate spaciousness for health and recreation throughout the whole urban region, integrated with the industrial sections so as to reduce distances between homes and places of work; and third, minor centers of business within these new sub-centers, so arranged as to promote the maximum of convenience to residents.[83]

Here, the authors, who included planners Thomas Adams, Harland Bartholomew, Alfred Bettman, Charles W. Eliot, James Ford, and John Ihlder, produced a concise brief for modern community planning.

Pragmatists

Unlike the decentrists, who questioned the viability of the center-dominated metropolis, pragmatists accepted the existing urban system, with its discrepancies among competing centers. Theory and practice were directed toward managing development and dispersal within this framework. Pragmatists believed they could engineer an economical and efficient balance between industry and population, for example, through adjustment and fine-tuning. This perspective was quite different from the redistribution the decentrists favored. Seward H. Mott, FHA director of land plan-

ning, captured the pragmatic perspective in a discussion of "fringe" locations. "Decentralization is taking place. It is not a policy, it is a reality—and it is as impossible for us to change this trend as it is to change the desire of birds to migrate to a more suitable location."[84] Naturalizing dispersion did not render it less complex. The location theorist Edgar M. Hoover spoke to this point when he reminded his audience that "industrial decentralization" had to be understood as a multifaceted process encompassing a "real growth of the large cities [and] . . . a redistribution of activities within them."[85]

Hoover's focus on manufacturing was indicative. Pragmatists considered industrial dispersion a principal factor in decentralization. They found manufacturers choosing peripheral locations to meet a variety of needs such as modern management and mass production. Expansion in chemicals, metalworking, and other industrial sectors favored larger plants with specialized single-story buildings. Manufacturers engaged in these increasingly land-intensive operations preferred sites with property for future expansion, which generally meant locations at a distance from older industrial districts. Hoover was also referring to changes in employment, especially a dramatic reduction in the number of workers directly involved in manufacturing and a rise in the numbers in service occupations. Over time, this transformation in work and the workforce encouraged an increasing separation of administration and clerical operations from production. Administrative needs preempted downtown locations, while production decanted to the periphery.

The Committee on Industrial Decentralization and Housing at the President's Conference examined housing associated with decentralized manufacturing. Unlike the majority of conference committees, staffed primarily by professional planners, progressive housers, and other reformers, this committee was composed entirely of representatives from business and banking.[86] In their foreword the committee noted that poor sanitation, overcrowding, and visual blight affected millions of wage-earning Americans in both cities and industrial villages.[87] In response, the committee considered the importance of industrial siting in terms of population and "various types of intensive housing" as well as the locational opportunities afforded in less densely occupied areas. In their analysis, committee members emphasized the economic costs of poor housing and contrasted this with the potential benefits decentralization afforded. These included better housing and home ownership, economic self-reliance, and improved

morale and health. Their report included case studies of Radburn, New Jersey, Longview, Washington, Kohler Village, Wisconsin, and Marie-mont, Ohio, which they extolled as models for managed industrial disper-sion and associated residential development. Where the Committee on Large-Scale Operations argued for government action to encourage the creation of entire communities through tax incentives, publicly funded infrastructure, and eminent domain, the Committee on Industrial Decen-tralization and Housing charged their peers, American manufacturers, with providing these improvements.

Although decentrists and pragmatists both recognized the increasing speed and scale of industrial and population dispersion, their responses to these phenomena were dissimilar. Decentrists' planned to harness decon-centration and create a new urban pattern. Pragmatists, on the other hand, understood industrial location, jobs, and housing within the orbit of a dominant city center. They promoted the dispersal of individual manufac-turing concerns or the development of clustered industrial plants with their associated residential community, as isolated entities within an urban orbit. Given this, they strove to uncover structural factors and, following scientific analysis, organize people, production, and space in a rational manner. Enlightened industrialists could then provide employees with minimum housing, neighborhood centers, playgrounds, and parks.

A Third Way

Organizing these actors, their theories, and their strategies as oppositional pairs is an artifice, a rhetorical device. Modern community planning evolved through an exchange among these alternative assessments and visions. An example can illustrate the convergence. As author of the neigh-borhood unit, architect for Sunnyside and Radburn, and RPAA insider, Clarence Stein helped define and further a decentrist agenda. But he displayed a quintessentially pragmatic response to the question of indus-trial location and the construction of attendant housing and community facilities during World War II. As the war progressed, new materials, security concerns, and the need to reduce transit time and costs encour-aged the War Production Board and the Plant Site Board to develop satel-lite facilities. Stein argued that the threat of air strikes demanded a national policy for dispersing industry and residences beyond existing population and manufacturing centers.

> Limited size communities are a necessity of wartime security as well as
> peacetime economy of government and living. Residential neighbor-
> hoods should be large enough to support the essential equipment of
> modern communities for education, community gatherings, entertain-
> ment, fire and police protection, and sanitation. They should be no
> larger. Nothing is gained in peacetime or wartime by increasing beyond
> the limited size set by these requirements. Moderate sized communities
> are better places to live in than are larger cities. Modern industry can be
> run more effectively and more economically in less congested centers.
> The cost of building new communities is less than that of rebuilding old
> and obsolete cities. The total cost of carrying on industry and business in
> the United States would be greatly decreased by a more scientific dis-
> tribution . . . of goods and people.[88]

In effect, Stein viewed the defense emergency and associated federal
policy initiatives as a means of implementing balanced regional develop-
ment. As head of the Office of Production Management's supply section,
community builder J. C. Nichols also argued for planned deconcentration.
In an address to the 1941 National Conference on Planning, Nichols asked
for assistance designing "whole new communities of fifty to seventy-five
thousand population near defense plants" and wondered rhetorically
whether their location could "fit into the pattern of future growth."[89] Here
Stein and Nichols combined the central principles of the RPAA vision
with the pragmatists' instrumentalism.

The middle ground did not appeal to Mumford and other progressive
housers who feared that large-scale development organized entirely by
builders would not only fill up the land with an "undifferentiated mass"
but might also further social isolation, stigmatization, and ghettoization on
the basis of race, income, and religion. Rexford Tugwell provided a literate
account of this perspective in a damning review of Norman Bel Geddes'
Magic Motorways. An economist, theorist, and decentrist who admin-
istered new town and resettlement communities for the New Deal Reset-
tlement Administration, Tugwell drew from that experience firsthand
knowledge of resistance to national planning. This led him to challenge the
"presumptive naturalism" in Bel Geddes' large-scale, comprehensive vi-
sion. According to Tugwell, the new landscape order Bel Geddes pre-
sented in *Magic Motorways* was in sharp contrast to American cities, where
"the jewels there are of design are set in dumps of an obsolescent hideous-
ness." This juxtaposition represented the "failure of our generation,"

whose renewed embrace of "laissez faire, of individualism, [and] of competition" canceled the "collectivism, planning, [and] overhead direction" integral to the fulfillment of *Magic Motorways*' promise. "Because it is conceived as one design, one operating whole, it must be, shall we say, coordinate. Everywhere its functions must be fitted to the thousandth of an inch. There must be no projection to catch the wind, no friction to slow the flow. And how is that to be achieved in a society which admits no general design and, above all, no overhead control?"[90]

Tugwell played on the irony of Alfred Sloan's vociferous speeches for individualism, competition, and free enterprise, while General Motors awaited the coming of magic motorways via federal highway programs. In his critique Tugwell revealed the yawning chasm between a vision of communities linked by parkways and the national and regional planning required for implementation. This was a complex polemic. In pillaging Bel Geddes, Tugwell elided the frustration that he and other New Dealers endured in their struggle to implement proposals as "faltering in conception[s] of wholeness, of fitting, of dependence, and of a smooth running order" as Bel Geddes' magic motorways.[91]

Agency and implementation were missing from the decentrist's equation. The regional city was a landscape coordinated to a high degree. Mumford pondered this challenge in an article written for the *Nation* following the Armistice. "The housing problem, the industries problem, the transportation problem, and the land problem cannot be solved one at a time by isolated experts, thinking and acting in a civic vacuum. They are mutually interacting elements, and they can be effectively dealt with only by bearing constantly in mind the general situation from which they have been abstracted."[92]

At the crux of debates concerning the industrial city, living conditions, and wage earners was an investigation of the workplace, the neighborhood, and the dwelling. These three domains triangulate and form the spatial logic of everyday life; the search, during the interwar years, was for an efficient and efficacious arrangement. This formulation provides a useful framework for comparing the regional city and the metropolitan region. The decentrists advocated maximum integration of employment, the community, and family life. They argued for a balanced equation, with close spatial proximity, and overlapping domains. Lewis Mumford and Pare Lorentz scripted a paean to the regional city for the documentary film "The City," contrasting the social ills of the industrial city with the social harmony, orderliness, and functional segregation of the New Deal green-

belt communities. Here, the narrator intoned, "science serves the worker and you can't tell where the playing ends and the work begins."[93] Pragmatists, on the other hand, argued for a more diffuse landscape with functional segregation and exclusive zoning defining a core and periphery with service-sector employment, cultural institutions, and administration firmly ensconced in the center city.

The neighborhood served as a middle, common ground. Decentrists and pragmatists conceived it as an integrated whole, tightly segregated within the overall city or region, with its own internal hierarchy from public to private, from the workplace to the individual dwelling. This can be seen most clearly in the street system. The bounding thoroughfare was designed for maximum traffic flow, a major artery providing fast, efficient metropolitan and regional connections. This grid intersected with the neighborhood at the juncture of a thoroughfare and an internally focused collector street where a commercial area acted as contact point and buffer between a particular community and the city. The interiority of the residential quarter was maintained by the restricted access street or cul-de-sac, a street pattern contrary to the high-volume arteries that surround individual neighborhoods. Frank Lloyd Wright and Norman Bel Geddes cast this template on a grand scale in Broadacre City and Magic Motorways.

Cities and regions were less diagrammatic and coherent. Although the regularity and internal coherence of the neighborhood and industrial landscape increased over time, the connective armature and, more critically, the greenbelt buffers were never realized. Well-planned neighborhoods became islands of rational planning in a pragmatists' sea.

What, precisely, the nature of urban expansion in the postwar era might be provoked considerable uncertainty. During the war, workers and their families demonstrated an unexpected mobility as they sought employment in production centers. With the impending release of over 10 million military personnel, pundits and government forecasters predicted a mobile populace of up to 30 million seeking jobs and housing. Homer Hoyt, a location theorist and FHA consultant, predicted a vast, floating, postwar population:

> At the close of the war nine to thirteen million men in the armed forces
> and twenty million workers in war factories will form a great mobile
> population that will be ready to move to any city promising jobs. A great
> number of industries will, of course, remain tied to old locations and will
> resume their pre-war types of manufactures. However, many new, well-

located war factories suitable for conversion into peacetime production will draw industries away from obsolete plants. A vast reshuffling of plant locations will in turn cause great shifts in the sites to be selected for new housing.[94]

Hoyt, the author of sectoral theory, went on to ponder whether postwar development would follow old patterns or if a new structure might usher in a new type of city. "Assuming then that homes will be provided in cities where expanding peacetime employment activities warrant their construction: Where will they be placed in the city pattern? Will the old sector-theory pattern be resumed?" Hoyt envisioned industry gravitating to "new war plants on the periphery, [where] workers' homes will be built in areas where there is room for gardens and play space."[95]

What we find in the decentrists' model of a regional city and the pragmatists' attempt to organize and direct industrial deconcentration, in the turn toward modern community planning and the neighborhood unit, and in the emphasis on the social benefits to be accrued through home ownership was a broad-based effort to mediate the impending revolution in urban space with the traditional ideals of community. Reformers, design professionals, and critics found themselves caught between the seemingly intractable problems of the city core—overcrowding, congestion, and an "undesirable" mixing of classes—and the prospect of unchecked, unmitigated development in the unincorporated urban fringe. We can understand the Chicago School's concentric zone theory as a diagram of orderly urban extension drafted while new forces appeared to be wrenching cities apart. The sociologists offered stability and surety and kept the locus of growth and control planted in the city center.

Modern community planning was another response to this apparent dissolution. As builders finessed the concept from ideality to practice they drew from the writings and drawings of decentrists such as Lewis Mumford and Clarence Stein as well as the dictates of the pragmatists. In contrast to theory, paper projects, and experimental models, projects such as Leimert Park were not predetermined either by area or population, nor were these projects surrounded by greenbelts. And while these satellite developments had important similarities with the decentrists' regional city, they were tied to unregulated industrial dispersion and speculative property markets. In theory, modern community planning was intended to promote an orderly deconcentration of existing urban centers, to increase home ownership, and to improve living conditions through technol-

ogy and planning. In practice, it was an unlikely, tenuous coupling of a progressive public project and long-range, comprehensive regional planning for population, industry, and institutions with the individualistic and privatized campaign to "own your own home."

Democracity, the focal exhibit at the 1939 New York World's Fair, presented a scale version of these principles.

> A perfectly integrated garden city of tomorrow, not a dream city but a practical suggestion of how we should be living today, a city of light and air and green spaces. . . . The population of 1 million does not live in the city proper, the cultural arts, business administration, higher schools of learning and the amusement and sports centers are here. Stretching out in all directions are fine roads crossing broad greenbelt areas and connecting residential and industrial towns to this center. Each satellite town is a complete unit of factory, homes, schools . . . relying on the central city only for general administration and other things smaller towns cannot economically have.[96]

The designers and planners who conjured Democracity and were instrumental in the fair's overall physical and ideological planning were descendants in the garden city genealogy. Lewis Mumford, Henry Wright, Robert Kohn, and Albert Mayer played important roles in setting the broad outline of the fair. Mumford argued that the overarching theme should emphasize the story of "this planned environment, this planned industry, this planned civilization. If we can inject that notion as a basic notion of the Fair, if we can point toward the future, toward something that is progressing and growing in every department of life and throughout civilization . . . we may lay the foundation for a pattern of life which would have an enormous impact in times to come."[97]

By the end of the 1930s a vision of an alternative urban future was in place. Ironically, despite the theoretical and popular attention lavished on Democracity, a basic module necessary for activating this transformation was tucked away in a far corner of the fairgrounds. Billed by the sponsors as "real life housing," two FHA-approved low-cost dwellings constructed by a Long Island builder were sited in the Town of Tomorrow alongside the more exotic "houses of the future." At the groundbreaking, FHA administrator Stewart McDonald described these homes as representative of the attractive, well-built units the agency proposed for that "large group of American citizens whose incomes are limited." Builder Paul Roche pointed out that these "livable, attractive, and efficient units" provided him

a "fair margin of profit" and the financing institution a "desirable and safe investment."[98]

To understand the evolution in home-building practice that led to the FHA exhibit housing, we must turn our attention to another set of actors who were attempting to isolate, codify, and manufacture a standard minimum dwelling. Technicians examined room layouts, household activities, and health and safety, while productionists labored to refine new building methods, institute industrial management, and streamline housing production. Their efforts are detailed in the following chapter.

THE MINIMUM HOUSE

There are laws of human well-being, scientific laws, and we know better than
ever that in the long run it pays to follow them. In this respect, housing is not
peculiar. There are standards in food, in clothing, in ships, in munitions, in fac-
tory buildings, in motor vehicles, in airplanes, and in all the vast material of
the modern world. JOHN NOLEN

The point . . . is that we should bend our energies to producing the desirable
individual house types as efficiently as possible. We should not be balked by
customs and preconceived ideas. We should consider the modern house as an
invention, and perfect it exactly as the automobile or telephone has been per-
fected and brought into common use, not withstanding that these devices
went counter to many a time-honored convention.
 JOHN TAYLOR BOYD JR.

The obstacles to change [in housing] are great and involve many established
interests such as the enormous number of individual architects and small con-
tractors, the practices in real estate and land subdivision, present housing
regulations . . . [and] the lack of large housing corporations. [This represents]
an ideal instance of a great social problem which could be solved easily by the
methods science has so successfully used in its struggle with nature. The prob-
lem is definite. The facts are known. The automobile industry has shown an
example. The conclusions are inescapable. What America needs most is a
Henry Ford for the home. GERALD WENDT

Scientism and Housing

In volume 3 of his encyclopedic survey, *The Evolving House* (1936), Albert
Farwell Bemis appealed to readers for a "new conception of modern
houses . . . better adapted not only to the social conditions of our day, but

also to modern means of production: factories, machinery, technology, and research."[1] When Bemis, a successful manufacturer, surveyed the housing problem, he trained his attention on production and product; when considering solutions, he fixed on cost reduction, which he termed "bringing housing in line with other factors." As a first step toward lower cost Bemis advocated setting aside outdated, "preindustrial" structures for alternatives engineered to current standards in materials, mechanics, and mass production. The means he endorsed, research informed by the scientific method and conducted according to industrial tenets, would, Bemis believed, rationalize the entire domain of housing and secure his penultimate objective, improving individual and collective well-being.

Bemis's wide-ranging project encapsulates the aggressive interwar campaigns to isolate, codify, and manufacture a standard, low-cost, minimum house that the majority of American wage earners could afford. Three correlative aspects warrant investigation. The first was simplifying the product and lowering its price. Generally this was a reductionist exercise, as evidenced in the number of house plans presented as the smallest, most efficient dwelling, a fact achieved through the elimination of infrequently used or "wasted" space. A second aspect, streamlining the construction process, would address that same objective through the introduction of time- and labor-saving equipment, materials, and techniques. Modern industrial management was the touchstone for a third approach, based on economies of scale and the ordered, sequential production of components, whether in a shop or in the field.

Of course Bemis and his contemporaries were not the first to consider small-house planning, production techniques, and questions of use, value, and markets. Wage earners often built their own houses; and for at least three decades prior to Bemis's tome, catalogue and mail-order companies had been providing customers with manufactured dwellings. Along with national merchandisers such as Sears, Roebuck and Company, regional firms like Pacific Ready-Cut in Los Angeles offered a range of plan types sold as kits-of-parts. The latter's Pacific System offered buyers a predictable product and quality assurance at reduced costs by passing along savings the firm achieved through quantity production and the use of standard parts. At the house site, builders or buyers with basic skills could readily assemble these precut dwellings. Pacific Ready-Cut's 1925 catalogue included a 715-square-foot, four-room-plus-bath dwelling with a roughly square floorplan (fig. 2.1). Over the next decade government agencies, researchers allied with the public and private sector, and home build-

ers would adopt variants of this basic house type as an ideal minimum house.[2]

Two factors, urgency and ethos, set Bemis and other principals engaged in these investigations apart from suppliers of manufactured housing. While they were interested in personal profit, many were motivated as well by a social agenda and set out to provide housing for those in need and to increase the number of home owners. In terms of method, they were, generally speaking, searching for a universal solution, the one best way to provide a unit plan, structural system, and construction technique appropriate to new living patterns. This is not to suggest that theirs was a highly coordinated project with intrinsic purpose and clearly identified goals. On the contrary, despite common objectives and a shared belief in the value of a scientific method, optimization, and large-scale operations, it was a disparate set of technicians and productionists who participated in this enterprise.

Technicians studied households in either a controlled setting or in situ to determine the minimum space required for specific activities, health, and safety. From this data they developed "scientific" house plans for low-cost dwellings, redefined and revised health and sanitation codes, determined performance standards for regulating these norms, and pressed for their adoption in policy and codes. The John B. Pierce Foundation's space-and-motion studies are representative. The foundation also conducted community-scale experiments. At Pierce Heights in Highbridge, New Jersey, technicians planned and constructed a twenty-unit cluster designed for a longitudinal study of housing and family needs.[3]

Productionists, on the other hand, were convinced that only an extensive restructuring in housing provision, from the manufacture of basic materials, parts, and components to land development and construction to marketing and sales, would assure mass housing and increase home ownership. Productionists understood the housing problem as an engineering problem, one whose solution could be attained through industrial and production design. They championed the minimum house and rational planning for its efficiency and ease of production and distribution and believed that standardizing parts and product, adopting large-scale operations, and capitalizing on machine power would reduce unit and final costs.

From their perspective, modernizing production required a rationalizing of the business of building through industrial management and of building practice through improved technique. Critics chastised the

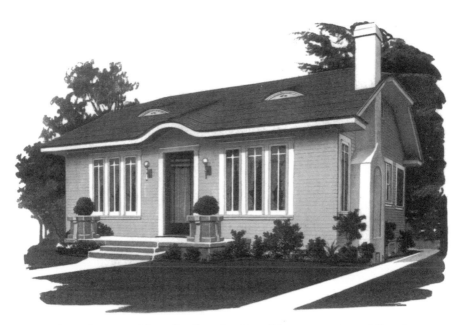

Style 263 ∾ *Pacific Ready-Cut Home* ∾ Specifications

The following specifications briefly cover the materials furnished. See Price List. Cost of constructing this home on your lot ready for occupancy, including all carpenter labor, painting labor, cement work, plastering, plumbing, etc., quoted on request.

Foundation—Floor 1'-10" above ground. Wood steps for rear door. 2" x 6" redwood mudsills; 2" x 4" underpins on outside walls; 4" x 4" girders; 4" x 4" underpins on piers.

Frame—Douglas fir. 2" x 6" floor joists 16" o.c. 2" x 3" studding 16" o.c.; 2" x 4" rafters 24" o.c.; 2" x 4" ceiling joists 16" o.c. Double headers for all openings.

Floor—Sub-floor 1" fir boards covered with ⅜" x 1½" oak flooring in all rooms except kitchen, breakfast nook, screen porch and bath room, which are 1" x 4" tongued and grooved vertical grain fir flooring.

Walls and Partitions—Framed for lath and plaster. Ceiling height 8'-2¼". Outside of building covered with insulating felt and ⅝" x 4" rabbetted and beveled redwood surfaced siding.

Roof—1" x 3" or 1" x 4" surfaced fir sheathing covered with No. 1 "A" cedar shingles laid 4½", to the weather, every fifth course doubled. 18" projection finished with boxed cornice as shown.

Terrace—With segment roof over door as shown. Masonry not included.

Doors—Front door 3'-0" x 6'-8" 1¾" thick special. All other doors No. 210 except No. 303 from kitchen to screen porch.

Windows—Casement and double hung as shown.

Screens—14-mesh galvanized wire. Full hinged screens for all casement sash, half sliding screens for double hung windows. No. 551 screen for rear door.

Interior Finish—Baseboard No. 1; casings No. 1; picture moulding No. 1; continuous head casing in kitchen, breakfast nook and bathroom.

Built-in Features—Mantel shelf No. 913; linen closet No. 501; cooler No. 402; kitchen cupboard No. 202; drainboard prepared for tile or composition; sink cabinets No. 305 and No. 306; breakfast nook No. 702; medicine cabinet No. 602.

Hardware—Solid brass door knobs, escutcheons, drawer pulls, cupboard turns, etc. Nickel finish in kitchen, breakfast nook and bathroom. Dull brass for all other rooms. Cylinder lock for front door. Door butts, hinges, sash locks, etc., plated steel.

Paint—Exterior and screen porch two coats of paint, either white or color. Roof to receive one coat of shingle stain. Interior—Floors, oak floors to receive paste filler, one coat of shellac and wax. Screen porch floor and rear steps to receive two coats of floor paint. Interior—Three coats throughout, two of flat and one of enamel.

Refer to pages 135 to 155 for illustrations of trim, doors and built-in features.

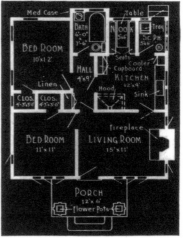

Style 263—Size 26' x 27'6" and Porch

FIGURE 2.1 A catalogue minimum house, Pacific Ready-Cut (1925)

"building industry," an oxymoron to most, as inefficient, narrowly focused, and arrogant regarding product cost. In response, manufacturers, private sector foundations, and the federal government sponsored research and development into on- and off-site production and component standardization. For example, the Bureau of Standards promoted simplified practice and year-round construction as an antidote to the prevailing seasonality of output and employment. Government analysts, economists, and reformers argued that industrial organization and the transfer of principles perfected in the factory would lower costs. They admonished land developers, material processors and handlers, builders, and the real estate sector to lift the industry out of the "age of handwork" and into the "age of labor, time, and money saving machinery."[4]

Technicians and productionists shared an abiding faith in a technological fix they believed would address issues as diverse as job creation and retention, cycles in production and consumption, and shelter provision commensurate with an American way of life. While the development and implementation of universal spatial standards and the drive to reorganize the business and practice of building occurred simultaneously, they are examined separately in this chapter.

Surveys to Standards

During the interwar years technicians employed by industry, philanthropic institutions, and multiple branches of the federal government worked individually and jointly to establish spatial standards for a minimum dwelling. Their research and development process can be situated within three domains: surveys, performance testing, and ratings or certifications.[5] An assessment of existing housing informed these strategies. When analyzing house plans, technicians noted that room layouts and the space assigned for daily activities was based on tradition, which they regarded as mere fashion. Second, their evaluation of existing codes and regulations revealed that spatial requirements typically reflected unexamined or outmoded standards rather than current knowledge concerning health and safety or the possibilities offered by new materials. From these analyses they argued for jettisoning the traditional and replacing "outdated" house types with scientific designs drawn from a rational assessment of how people actually used space, designs that would incorporate up-to-date equipment and technologies. Technicians viewed surveys as a first step toward determining functional requirements as well as the preferences and needs of se-

lected families.[6] Once collected, this data would allow researchers to construct a baseline on which minimum requirements could then be fixed.

John B. Pierce, a vice president at American Radiator Company, established a foundation in 1924 to support survey research and publications in the fields of heating, ventilation, and sanitation. Over the next five years the foundation systematically broadened its purview to focus on the dwelling and, more broadly, housing rather than on specific technologies. In 1931, Pierce appointed Robert L. Davison director of the housing division. Before assuming this post Davison had served as a housing analyst for the Bureau of Labor Statistics. After heading the division for almost a decade, he went on to work for manufacturers of sectional housing. At the Pierce Foundation, Davison oversaw a staff of designers and sociologists engaged in qualitative and quantitative research. John Hancock Callender, a foundation architect, argued that empirical fieldwork in housing was long overdue. According to Callender, advanced building methods were replacing handicraft production, but "design has remained traditional and unscientific. . . . It seems peculiarly inappropriate to employ the most advanced methods of industrialized production on a product which is itself so inefficient and antiquated."[7]

In his *Introduction to Studies of Family Living*, Callender reviewed the literature and outlined three research areas: postoccupancy studies of housing developments, prescriptive literature such as home economics material on the scientific kitchen, and reports addressing the psychological aspects of design. His text singled out Swedish sociologist Svend Riemer, who applied multiple research methods including guided interviews, annotated activity logs, and scale models and drawings that residents could manipulate for studies of residents in Stockholm's cooperative apartments.[8] Callender endorsed both Riemer's methodology and his assessment that with these techniques researchers could ascertain their subjects' explicit and implicit housing preferences. He noted, however, that even the most innovative and rigorous work fell short of the foundation's objectives. Riemer's studies, for example, lacked a transformative dimension, the application of fieldwork toward design alternatives. Two projects, Alexander Klein's investigation of circulation and natural lighting and Eugene Klaber's analysis of unit plans and furnishings, were closer to what the foundation hoped to accomplish. But neither Riemer, Klein, nor Klaber directed their research efforts toward low-cost housing.[9]

As a first step the foundation, in cooperation with the American Public Health Association's Sub-Committee on Occupancy Standards, con-

ducted a study of 131 families in the New York area using Riemer's methodology as a template. Interviewers and respondents completed a twenty-five-page form, families kept chronological records of selected activities, and researchers documented each dwelling, measuring and recording room sizes and storage space and cataloguing possessions. The guiding assumption was that a "detailed list [of] scientifically verified" data could serve as a baseline specification for unit design.[10] In addition to conducting focused interviews and undertaking quantitative assessments of artifacts and space, researchers probed householders concerning preferences and desires, using what survey designers termed "projective techniques." These included open-ended questioning and the arrangement of scaled furnishings on floor plans in order to elicit "valuable clues about the basic guiding trends and values determining specific attitudes and actions," including home ownership.[11]

Laboratories for Living

For technicians, the interpretation of quantitative data and user preferences could only serve in constructing a benchmark, a metric of existing conditions. This may have been adequate for modifying existing housing, but they were interested in creating something new, a minimum house which, they reasoned, required basic research, an investigation of people in space. Investigators employed by the Pierce Foundation recognized that a static analysis might reveal what people did in a house and when, derived from daily logs and interviews, but could not offer insight into the space required for any given activity. To this end, they made a deliberate effort to begin programming and design with an agreed-upon set of activities, such as eating, sleeping, dressing, and washing, rather than with a set of predetermined spaces, such as dining room, bedroom, and bath. To determine minimum functional requirements, they developed space-and-motion studies. These began with the "human being . . . wrapping around them space, equipment, and environment," an approach they contrasted with the "usual one of beginning with four walls and a roof and then subdividing this shell into rooms, which are later 'furnished.' " In a laboratory setting, researchers used still photography to record everyday activities, mounting a series of cameras to capture subjects in motion and the volume of space their actions consumed.[12]

There are significant methodological parallels between the foundation's space-and-motion investigations and Frederick W. Taylor's better-known

time-and-motion studies. And even though twenty years separated these experiments, Taylor's "one best way" informed the functional home studies. However, there were considerable differences between these two projects. Where corporate managers capitalized on Taylor's studies of workers performing routine tasks to subdivide labor processes into their component motions, increase task fragmentation, and exert control over the workplace and production, technicians used the data gleaned from space-and-motion studies to construct an alternative to the fixed coupling of tasks and space. They proposed a flexible arrangement of multipurpose zones. In the minimum house, tasks would be performed in loosely defined "activity areas." This diversity is in sharp contrast to scientific management and labor specialization.[13]

Pierce Foundation researchers also constructed experimental housing to conduct performance tests, refine standards, and elicit users' evaluations before scheduling a unit for production. Pierce Heights functioned as a laboratory for construction technology, building maintenance, and the spatial requirements of family living. Here, technicians refined a twenty-four-by-twenty-eight-foot four-room-plus-bath unit, a house type that became a community building standard.[14]

Performance testing was not confined to private sector initiatives. Engineers employed by the U.S. Housing Authority's (USHA) Technical Division constructed a full-scale, four-room study house with exterior and interior walls mounted on movable tracks. After placing essential equipment and furniture in each room, researchers adjusted the walls' position to determine spatial minimums for fixtures and families. When evaluating kitchen design, technicians cranked in the walls incrementally as demonstration homemakers baked, cooked, and cleaned. A panel of USHA technical staff, domestic economists, and builders assessed the test results. "Here," according to the USHA, "the advocates of eating in the kitchen battle with the defenders of combination living and dining rooms, each faction supporting its belief by concrete demonstration."[15] Nathan Straus, the USHA administrator who authorized the study house, had a predilection for minimum standards. In an article in the *Washington Evening Star* he cited over a dozen material economies the administration had achieved through "degadgeting," including the combination of cooking and dining spaces, elimination of basements, and the use of concrete as a finished floor.[16]

Some commentators challenged this approach. Housing reformer Edith Elmer Wood criticized the USHA minimums, which, she felt, had reached

the level of "reductio ad absurdum." Wood feared that if generally adopted, "USHA room size standards would produce a nation of neurasthenics."[17] The National Association of Housing Officials' Committee on Physical Standards and Construction cautioned against the adoption of universal standards per se. Chairman Coleman Woodbury argued for guidelines that lay between the "poles of specifications and vagueness," such as "adequate light," that could be "left for local bodies and agencies to develop for their own projects."[18] Other writers feared the drive to produce less-expensive dwellings was leading inadvertently toward a substandard unit, one with smaller rooms and fewer amenities, rather than a low-cost minimum house.[19]

Other reform-minded groups avoided universal standards, choosing instead to amend existing practices. Private industry, their support institutions, and government-business alliances advocated rating systems for certifying and labeling housing. The U.S. Chamber of Commerce and the Bureau of Standards floated a plan, backed by real estate developers and consumer advocates, to monitor construction based on a U.S. Government Master Specification. Following inspection, completed dwellings would be classified A, B, or C depending on building materials used and quality of construction. The builder could then advertise these ratings to encourage sales. George Burgess, director of the Bureau of Standards, noted that periodicals had recently begun operating in-house proving plants and testing institutes where technicians analyzed the performance characteristics of materials to gauge consumer interest and acceptance.[20]

Participants in the 1931 President's Conference evaluated those ratings systems that were already in place. The Committee on Design endorsed a scheme similar to the Bureau of Standards' for assessing "quality small houses in relation to their cost." The committee designated its proposal, drawn from a table first published in *The Small Home* (1931), as a standard measure for the "wide variation in quality and completeness of houses in the same or different cities."[21] In "A Score Card for Appraising a House," they drafted a "standard measuring rod" that would "indicate various basic elements and establish accurate relative values for each." This system, it should be noted, established a more inclusive domain than the one the Bureau of Standards pressed. In addition to evaluating the construction and character of an individual house relative to current practice, surveyors using the scorecard would assess infrastructure and facilities and appraise the unit in relation to its site. Committee members endorsed these objec-

tives, arguing that official standards would "automatically eliminate substandard products."[22]

Weeding out "substandard products" and minimizing financial risk was precisely the FHA's rationale for its subsequent institutionalization of ratings procedures. The agency's underwriters' code recognized four factors: property, location, the borrower, and a general mortgage pattern. FHA guidelines discouraged the "construction of poorly planned, poorly specified houses, the development of unsuitable neighborhoods, the assumption of home ownership by unqualified families, and the writing of weakly secured mortgages." Director of Land Planning Seward H. Mott outlined the appraisal process in a presentation for the National Association of Real Estate Boards. According to Mott, FHA underwriters followed a "uniform, almost mathematical procedure" when assessing the "pattern of relationships between the four elements" rather than simply grading a prospective property and applicant according to minimum standards. The FHA justified its comprehensive surveys as a means of improving existing residences, assuring new neighborhoods of good address, and maintaining property values.[23]

A third set of ratings considered health and safety. The American Public Health Association (APHA) established a Committee on the Hygiene of Housing in 1937 to "establish fundamental objectives that should govern the design of the dwelling." The committee set performance standards for "health, safety, and satisfaction in the dwelling and its environment." The chair of the APHA's Subcommittee on Occupancy Standards, C.-E. A. Winslow, chose a structural analogy to dramatize the significance of spatial standards, comparing the frustration and stress a congested household induced to those of an overloaded column.[24]

An APHA study, *Basic Principles of Healthful Housing* (1939), outlined general design standards. Under fundamental psychological needs, the committee mandated four hundred cubic feet per occupant as a minimum necessary for the performance of household functions without fatigue, as well as privacy and a healthy community life. This standard area was an aggregate, a sum of subunits—for example, the fifty-square-foot-per-occupant minimum floor area in each bedroom mandatory for protecting against the dangers of contact infection. The committee devised its guidelines as advisory objectives in a technical rating system. The APHA Subcommittee on the Appraisal of Residential Areas published a monograph series detailing its metric for housing quality, its objective a concise and

quantitative analysis of current housing conditions, "a graded measure of housing assets and liabilities."[25]

Better Living in Fewer Rooms

Among the liabilities that technicians and housing reformers identified were single-purpose rooms with limited use, such as the dining room, and unnecessary zones within the dwelling, such as the basement and attic. Henry Wright captured the reformers' frustration with the housing status quo and what they understood as needless expense.

> Housing has been confined to the realm of 'assembled' ideas [consonant] with that era of the motor car industry (1905–1910) when cranks and tanks, magnetos and things were strapped on promiscuously, while the body still retained reminiscences of its former prototype. Thus even improved houses have carried over from the horse-and-buggy age such things as fore and rear doors and wasteful basements with coal bins, heating plants, and other crudities.[26]

Reformers had been crafting their critique of the basement in home improvement literature throughout the 1920s. In turgid prose, critics such as W. H. Ham of the Bridgeport Housing Association argued that "we are building four times too much cellar for our houses. . . . I should recommend a cellar under 25 percent of the house and [none] under the remainder." Robert T. Jones, technical director of the Architects' Small House Service Bureau, asked, in an article detailing fifty ways to lower home building costs, if basements were necessary at all. "Most of our homes have full basements . . . [which] involve deeper foundations and more excavating. A full basement is not an absolute necessity. The saving involved in omitting it may amount to $600 or $700—often more." In the journal *Small Home,* Jones called the "millions of dollars invested in cellars under American homes" a buried treasure. He noted that recent practices, such as placing a central heater on the ground floor, offered considerable savings and quoted leading architects who found that basements represented 15 percent of the total cost in small dwellings. The Dwelling Construction Committee of the President's Conference reported that builders and design professionals interested in eliminating needless parts of the house should focus on the basement and the attic, for which the "original needs no longer exist or are rapidly disappearing."[27]

The FHA technical staff instrumentalized this campaign through the financial leverage of mortgage commitments. By 1936, the "Desirable Characteristics" section in its publication *Property Standards* included the following: "A basement under the entire house is rarely essential and results in waste[.] . . . The part basement . . . may be reduced to the space required for the heating plant. In small dwellings the tendency is to eliminate the basement entirely and provide space on the first floor for heating plant and laundry."[28]

For advocates of the minimum house, the dining room was anachronistic as well. The authors of *How to Own Your Home: A Handbook for Prospective Home Owners* informed their readers the dining room was no longer a functional necessity. "Where it is used but three times a day, it is the most expensive room in the house."[29] The Department of Commerce, the FHA, and progressive home builders promoted these changes as a small price to pay for home ownership. One catalogue house company enticed potential buyers with the slogan "better a house too small for a day than too large for a year."[30]

As we have seen, technicians conducting surveys and performance testing questioned the a priori dedication of space. The Pierce Foundation experiments dovetailed precisely with concomitant investigations into a smaller, more efficiently planned house with rooms designed as flexible zones to accommodate multiple daily activities. While a decision to include a dining room or to substitute an alcove or eating nook might be made solely for economic reasons, the move away from a discrete room assigned a single activity was also understood as one aspect of an emergent ethos of informality. Speaking before the NAREB Homebuilders and Subdividers Division in 1929, James S. Taylor alerted his audience to the frequent and increasing use of the phrase, "We eat anywhere in the house."[31] FHA technical bulletins devoted to small-house planning also questioned the relative advantage of a separate room for dining and encouraged readers to consider eating as a complimentary activity suitable to the living room or kitchen.[32]

The FHA played a key role in disseminating these principles and guiding the adoption of an efficient, four-room-plus-bath minimum house.[33] Illustrations and text in the agency's technical bulletin series presented functional design to home builders and buyers. "The small house is not a large house compressed and trimmed down. It may not be created by determining what can be left out of a large house, but only by analyzing the

essential functional requirements." FHA strategy and guidelines were consistent with those sponsored by the Pierce Foundation, the AHPA, and design professionals.[34]

The FHA's minimum-house prototype was a 624-square-foot dwelling, which it presented simply as the "minimum house" or "basic plan" (fig. 2.2). The accompanying text informs readers that "in the design of small, low-priced houses, the principles of efficiency, economic use of materials, and proper equipment, which are important in any class of dwellings, become paramount."[35] To satisfy functional and spatial requirements, FHA design staff organized the house in a side-by-side arrangement. A small hall served as the pivot for this plan type. The private spaces, two bedrooms and a bath, opened off the hall. Opposite this was a public zone with living room and kitchen. These contained a major and minor entry respectively. FHA publications showcased alternative sitings for this roughly

FIGURE 2.2
The FHA's basic minimum
house, plan and elevation.

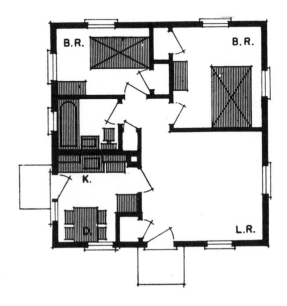

square floor plan, setting the public zone parallel to the street or rotating it so that the living room faced the front of the lot and the kitchen opened to a rear yard. The kitchens were small, planned for efficiency, and stocked with up-to-date appliances. A utility room with an integrated mechanical system replaced the basement heating plant and coal storage. A wet wall separated the kitchen from the bath, a configuration that permitted reductions in the material, time, and labor required to plumb each unit.

The FHA encouraged and supported this form of pre-engineering. In "Principles of Planning Small Houses" the agency implored designers and builders to eliminate "every square foot of space, every odd corner, every length of pipe, every pipe connection, every foot of lumber" that could be saved. At the same time, the authors underscore the technicians' creed that these economies and efficiencies "may not be obtained at the sacrifice of substantial construction or of minimum standards for convenience and comfort." This bulletin concludes with a recognition that planning the small house requires skill and care; it "becomes a special art, rigidly limited by the necessity for low cost, yet none the less exacting in its requirement for functional arrangement and aesthetic satisfaction."[36]

Technicians and the FHA were not alone in their efforts to reduce first costs through the provision of multifunctional space, planning efficiency, and new mechanical components. Whether guided by financial considerations or social concern, prominent design professionals devoted considerable time and resources toward developing minimum-house prototypes and built projects that furthered these investigations. This was, in part, an international trade that linked the European modernists' housing estates with tradespeople and developers raising bungalows and other popular house types.

Within this milieu, the FHA's prominence was due to its financial incentives rather than to its standard plans. The agency's *Annual Reports* attest to the leverage their mortgage guarantees wielded and to the speed at which the preferred, rational house type spread. In tables and charts FHA statisticians graphed annual declines in the number of rooms contained in those dwellings the agency approved for mortgage insurance. In 1936 (the first year these figures were collected) the national average for new housing was 5.8 rooms. By 1940 the average room count had fallen to 5.1. During the same period, the percentage of four-room dwellings in the FHA's portfolio rose from less than one in ten to one in four. A comparison between existing units and new housing the FHA qualified reveals the magnitude of this change. In 1940, when new dwellings receiving FHA

mortgage insurance had 5.1 rooms on average, existing houses averaged 5.9 rooms, and the highest percentage (35.2) of existing units were those with 6.0 rooms. These figures reflect how home builders, informed by FHA bulletins and the agency's review process, had begun focusing their operations toward smaller units with five rooms or less.[37]

At the metropolitan level, FHA data from 1940 reveal that one in five new houses had no more than four rooms; five-room units accounted for half of the national total. In Los Angeles, the figures were nearly consistent: 16 percent of the dwellings the FHA qualified that year had four rooms, 48 percent had five. In San Diego, the percentages were higher, 23 and 58 percent respectively.[38] Statistically the California data is significant. For the decade 1930–40, the FHA insured just over 3 percent of all new homes in metropolitan regions. In the Pacific Division this jumped to 7 percent. But in Los Angeles, the FHA provided mortgage insurance for almost 20 percent of the new housing constructed. After the war, the absolute number and percentage increases accelerated. The median number of rooms in FHA-insured houses fell from 5.6 in 1940 to 4.9 in 1950. That year, 56 percent of new homes had four rooms and a bath.[39] Tracking room counts in the FHA's annual reports reveals a prophecy fulfilled.[40]

Data compiled by the Bureau of Labor Statistics in conjunction with the Works Progress Administration were consistent with the FHA's findings. Their study of wage earners and family expenditures reported on living quarters by occupation and income. Survey results, tabulated by city and region, included the number of rooms per dwelling. In California and the West, 1,642 households with annual incomes from $250 to $2,499 resided in units with 5.1 rooms on average.[41]

It is instructive to compare the FHA data, restricted to dwellings the agency insured, and the Bureau of Labor Statistics' findings, limited to wage earners, against households nationally. Census enumerations are the likely source, but the first census of housing in 1940 reported aggregate figures only. These show 65 percent of Americans living in units with five or fewer rooms. Housing summaries in the 1950 housing census distinguished between owner- and renter-occupied dwellings. Within each category, units were classified by their year of construction: 1939 or earlier, 1940–44, and 1945 or later. This breakdown provides certain statistical evidence of the increasing number of four-room dwellings and a trend toward smaller houses overall. Dwellings built before 1939 were predominantly six-room, while the greatest number of those constructed after 1945 had no more than four rooms.[42]

Housing and household surveys recorded an ongoing and widespread adoption of the small, four-room house type during the interwar and immediate postwar years. The statistical sources can not disclose the physical planning and formal attributes of these small houses. However, variants of the FHA basic plan and the Pierce Foundation prototype appear with increasing frequency in the prescriptive literature and as full-scale exhibit housing. Home builders, material and product manufacturers, and groups such as Better Homes in America mounted or sponsored demonstrations that provided the requisite person-to-product contact. The FHA did its part, featuring approved plans in the quarterly *Insured Mortgage Portfolio,* underwriting or endorsing traveling displays, and sponsoring model housing at regional and national events such as San Diego's California Pacific International Exposition and the New York World's Fair. Demonstration housing gave the curious a glimpse of recent technical progress and the FHA a venue for disseminating information regarding its financial innovations. When *Life* magazine approached prominent Bay Area residential architect William W. Wurster concerning his interest in its small-house program, they assured him the housing problem was "neither one of need nor opportunity, but of public knowledge."[43]

Manufacturing the Minimum House

Whether opportunity or need was the central issue, the design and adoption of a minimum-house type was an evolutionary process. Local conditions informed both the timing and degree of change. Acknowledging discrepancies among regions and across cities within a given region does not reduce a discussion of the minimum house to mere particularism. On the contrary, this process should be viewed and interpreted within a broader national context of modern community planning and a technologic response to housing need. While technicians conducted surveys and tests and strove to craft an efficient house type, productionists were engaged in a complimentary endeavor, formulating a standard house design amenable to high-volume, quantity output. They targeted their efforts at revolutionizing building practice and the industrial organization of residential construction. This effort to rationalize housing and transform home building into a modern industry extended beyond unit design to encompass quantity production and large-scale operations.

Productionists chided "shoe-string" builders or "curbstoners" and derided their operations as "archaic," "disorganized," and "diffuse," still

mired in a "time-worn approach" reminiscent of "scattered handicraft industries." In a call for modern community planning, Lewis Mumford singled out the "jerry-builder," a small operative who undertook and completed a few speculative or contract units each year, as an obstacle to and a reminder of the need for change. Land developers and real estate entrepreneurs mounted a similar critique and posited community builders such as J. C. Nichols and Hugh Potter as the progressive alternative. Robert Lasch authored *Breaking the Building Blockade,* a jeremiad with sections titled "When an Industry Is Not an Industry" and "Breaking through the Barriers." The former began simply: "Housebuilding is a small-scale business, a local business, an unspecialized business, an inefficient business."[44] Mumford and Lasch voiced a common criticism. Contractors or tradespeople with an "office under their hat," who set up and then closed shop according to short-term opportunity, could never produce or contribute effectively to the creation of neighborhood-scale developments, since these projects required a systematic and comprehensive approach.

Increasing the scale of operations would allow builders to introduce production planning and exert tighter control over product supply. In "Merchandising Residential Properties," Richard R. Mead argued that the current system of construction did not bring housing onto the market in an orderly or intelligent fashion. As a result there were "recurring periods of over- and under-supplies." Federal agencies and private sector groups had documented seasonal and longer-term home-building cycles. Mead faulted the builders for both the fluctuations and what he interpreted as their inadequate and inappropriate response. On one hand, Mead lambasted them for overbuilding, which, he argued, led to forced sales, individual losses, and reduced property values. Then as the housing inventory thinned over time, prices would rise and competition increase, triggering a new boom and the conditions for the next downcycle.[45]

A. C. Shire, an engineer and technical editor of *Architectural Forum,* gave these arguments against the home-building status quo their full rhetorical voice in "The Industrial Organization of Housing."

> In an age of large-scale financing, power, and mass production, we have the anachronism that the oldest and one of the largest of our industries, concerned with the production of one of the three essentials of life, is highly resistant to progress, follows practices developed in the days of handwork, operates as a large number of picayune businesses, is overloaded with a whole series of overheads and profits, is bogged down by

waste and inefficiency, is unable to benefit by advancing productive techniques in other fields, and is tied down to an obsolete and costly system of land utilization.[46]

In Shire's estimation, correcting these shortcomings would free up the available expertise and technique necessary for the quantity production of quality, low-cost housing.

Productionists championed regional or national firms practicing twelve-month construction and building for less-specialized markets. Most home-building concerns were not structured or capitalized for this level of internal management and external coordination. Increasing output while reducing production time demanded an operation tooled to the principles and strategies of the modern business enterprise. These included close oversight throughout the production process, from estimating and cost accounting to the sequencing of trades on a job site and the marketing and sales of multiple units.[47] Implementing these management practices, productionists believed, would reform home building and allow a steady expansion in the construction of inexpensive, up-to-date dwellings, an important step toward creating a nation of home owners. Government analysts and policy makers agreed. The FHA identified four "fronts" in an "attack" on the high cost of housing production: first, factory fabrication of components and the design and engineering of multipurpose building parts to reduce on-site assembly; second, the development and use of materials better suited to factory fabrication; third, purchasing materials and equipment in larger quantities from fewer sources; fourth, improved labor and hiring practices, specifically a promise of continuous employment in exchange for hourly wage reductions.[48]

The FHA's interest in factory fabrication underscores the degree to which pundits, the press, and the public had linked housing progress with mass production. During the interwar years technicians, design professionals, and builders shared an abiding fascination with factory-assembled dwellings and panelized housing, which they imagined would propel building into the modern era. Manufactured housing appeared in numerous editorials and articles in the home-building, architectural, and popular press. It is sufficient to mention the attention the print media lavished on Buckminster Fuller's Dymaxion House. And popular-science writers, whose works had prefigured kit housing that could be quickly erected and "plugged in" to utilities, championed Fuller's vision of a self-contained dwelling machine.[49]

Popular-science utopians were not alone in extolling the glories of pre-fabrication. Contemporary observers from many fields believed homes built like Fords could eliminate waste and inefficiency, reduce final costs, and raise housing conditions for society's less fortunate. These commentators in truth were enamored of mass production, exemplified in Ford's vertically and horizontally linked corporation, which encompassed belt-line manufacturing but also marketing and merchandising, through a network of licensed dealers, and maintenance.[50]

For many observers, prefabrication offered the single solution that would jump-start the building industry. *Fortune* alerted its readership to manufactured housing as a promising new industry, "perhaps the greatest single commercial opportunity of the age." The editors began a six-part series on American housing by examining production. Chapter headings such as "How Much House for a Dollar: Being the history of a $20,000 house that costs $40,000, a $5,000 car that sells for $2,000, and an industry the Industrial Revolution has passed by," set the tone for a derisive assessment of contemporary practice. When it came to assessing the future, *Fortune* endorsed "industry's answer." Analysts based their projection on the experiments corporate, government, and individual research teams had conducted and their reading of industrialists' plans.

> It is now past argument that the low-cost house of the future will be manufactured in whole, or in its parts, in central factories, and assembled at the site. In other words, it will be produced in something the same way as the automobile[.] . . . Design will dictate the form of thousands of units instead of the form of one. And the designer will necessarily consider not only the appearance, convenience, and efficiency of the completed product, but the feasibility of its production in mechanized plants and its distribution by modern transportation.[51]

However, some questioned whether the automobile analogy was an oversimplification or even inappropriate. Housing reformer Catherine Bauer articulated this concern in an unpublished review of *Fortune*'s compendium, *Housing America*. Here she challenged the commonly held assumption that factory-based prefabrication could meet the current crisis in housing inventory and affordability. Bauer uses the editors' bias toward a new "big industry" to make her point: "The very reason the dwelling business has been so backward is the fact that mechanization has so little to do with it. Shelter is inseparable from problems of land, government,

and income distribution." In her view, *Fortune*'s editors understood housing solely as an inefficiently produced good. Their solution, a factory-fabricated dwelling set up on individual lots by individual entrepreneurs and sold through the same "indefensible Own Your Own Home propaganda," succeeded simply in shifting production from contractors to the "more nauseous cunning of high-pressured national [firms engaged in] cosmetic advertising."[52]

Bauer feared stories detailing housing "built in a day" would lull the public into a false complacency regarding the depth of need and the breadth of the response necessary for solutions. In its place, she preached the gospel of quantity production, reducing costs through large-scale operations and rationalized building practices. Bauer advocated design and planning that anticipated savings through a judicious siting of units and systems, component standardization and preassembly, and the on-site application of jigs and other techniques adopted from belt-line processes.

As this abstract of an extended, vitriolic exchange suggests, *prefabrication* was a catchphrase for an array of processes that might be applied or adapted to home building. Contemporary usage was imprecise; pundits and critics used the term for practices as diverse as factory-based continuous-flow principles modified for the construction site, the off-site production of wall, floor, and roof panels, or the factory production of an entire house with furnishings and appliances, ready for shipment to a finished lot. Robert L. Davison, director of the Pierce Foundation's housing division, offered a concise, inclusive definition: "Prefabrication is the assembly . . . of parts or subassemblies into sections [that are then] assembled into a structure, as distinguished from the assembly of parts during the erection of the building."[53]

Here Davison articulates an essential distinction between manufactured units assembled in the field and the on-site manufacture of a dwelling. Howard T. Fisher, an architect, entrepreneur, and founder of General Houses, Inc., made this distinction more concrete when he wrote: "If you shove and snap a product into place in the field, that is prefabrication. If you mix, cut, spread, fit, and patch, that is not prefabrication. If the field operation is essentially assembly rather than manufacture, you have prefabrication." Fisher offered a further refinement with the example of a brick and plaster wall, which, he noted, employed manufactured elements but is produced in the field. As a rule of thumb he suggests paying attention to the amount of waste and scrap that had to be removed from the site,

a rough index of the degree to which prefabrication had been employed, since "waste results principally from a manufacturing process and not an assembly process."[54]

A final distinction concerned locale, whether assembly takes place away from or at the building site. Using this criteria, prefabrication can be defined typologically as either factory assembled, ready-to-assemble, or assembled on-site. Factory-assembled housing would roll off the line like Ford's Model T, the entire dwelling manufactured in a central facility and then transported to the site either in sections or complete. Once at the lot, all workers had to do was set each dwelling on its foundation and connect the utilities. A number of firms, including Acorn and General Panel, produced factory-assembled units during the 1930s. The second type, ready-to-assemble, also relied on off-site fabrication, but in this case subassemblies such as floor and wall panels, storage and cabinet units, and mechanical systems were delivered to the site for final assembly. On-site prefabrication, or horizontal building, required a reorganization of the project area. Work crews would move through the site sequentially, completing carefully orchestrated, precisely timed, and repetitive tasks. Often a temporary staging area served as a shop, a centralized, occasionally enclosed facility for the multiple sizing and shaping of parts such as rafters and the quantity assembly of components such as wall panels, which could then be distributed across the job site.

Although horizontal building shares many techniques and practices with traditional building, there are critical distinctions. Theorists and practitioners modeled horizontal or serial production on the belt-line factory. Treating the building site as a continuous process meant that each unit would be assembled uniformly, from sitework to finish, and all units would be produced sequentially. For individual workers, horizontal building accelerated the advent of dedicated operatives whose labor increasingly was augmented by portable power tools. Skilled and semiskilled labor replaced the craftsperson who had performed a variety of tasks within an assigned field. Serial production workers performed tasks repetitively as construction proceeded through the site. Although task organization was similar to a belt-line factory, at the building site operatives moved from station to station, whereas at the factory an assembly line brought each unit to the worker.

Each of these methods focused primarily on the building shell, but productionists intended to extend prefabrication to components and home

equipment. For example, the American Standards Association, the American Institute of Architects, the Producers' Council, and the National Association of Home Builders worked together to develop and implement a "modular measure," a four-cubic-inch module that, when adopted, would become the metric for materials and all building components. A universal measurement system for appliances, cabinets and furnishings and, more important, entire plug-in units such as kitchens and baths promised both increased efficiency and reduced initial costs. Furthermore, a modular standard promised tradespeople and home owners an enhanced option to improve or update the house according to changing equipment, style, or means.[55]

Interchangeability is a useful way to view these correlative objectives; it was indispensable for a minimum house and modern community planning. Building practice offers a demonstration. For example, an individual prefabricated panel was a module, a unit in a space-forming system. A vertical panel might be used interchangeably for an exterior or interior wall, a horizontal one for a floor or ceiling. Within a wall, each panel could be placed in a variety of positions: modified with a door or window, it could become an entry or a segment in a fenestrated wall. Each panel served as a replicable module in an intricate, interlocking system. At the same time, interchangeability was an important conceptual construct. We have already seen its importance for researchers analyzing existing unit plans and proposing alternatives. Interchangeability was perhaps no less literal for promoters of industrial management who advocated the deskilling of craft labor. In this case, the objective was to develop a production system where laborers, for example, could carry out discrete operations or phases following a minimum of training.

Unlike a Taylorite factory, housing production had long been the province of a loosely allied cluster of materials manufacturers, wholesalers and retailers, contractors, and tradespeople. Material and production costs were highly localized, based on the volume of building and the degree of influence area dealers and tradespeople exerted on prices.[56] Within this system, the builder, or a subcontractor supplying materials for a few homes, was at a disadvantage, unable to purchase in lots and situated at the end of a long chain of transactions, beginning with a material manufacturer and extending down through various wholesalers and jobbers to the retail level. The markup on each of the estimated twenty thousand to forty thousand items that went into an average house multiplied into a considerable sum.

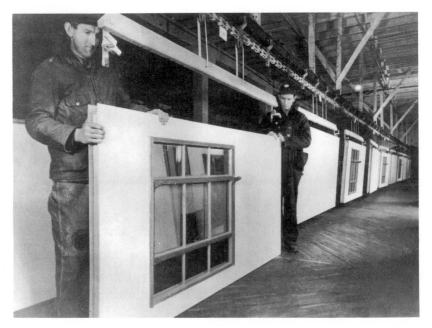

FIGURE 2.3 The productionists' ideal. Beltline operations at the Gunnison Corporation's New Albany, Indiana, plant.

Writing for *Consumer Reports*, Virgil Tobin rehearsed a familiar commentary when he noted: "Building today means scores of separate parts, a swarm of men to assemble them, and numerous markups in route."[57]

Once materials and parts were in place, the builder or general contractor had to organize a team of craftspeople and coordinate independent subcontractors, each of whom wanted to complete a designated segment of the project in the shortest time allowable within a critical path. Tobin captured the dissimilarities between this method and the iconic auto assembly line. "When you buy an automobile, you don't hire a mechanic to shop around for an engine, wheels, transmission, [and] body, and then assemble those thousands of various parts into a finished car. Yet in this age of assembly lines and mass production, that is exactly what takes place when you buy a house." The author lamented the fact that there was no "integrated responsibility for materials, design, quality, or price of the product through the stages of manufacture until it is finally delivered to the consumer."[58]

Tobin's corrective was a belt-line with subassemblies progressing along a track. In figure 2.3 a series of wall panels are proceeding along a conveyor in Gunnison's New Albany, Indiana, plant. The Gunnison prototype led

many to believe that factory prefabrication would set home building on the desired track. However, residential construction was not amenable to this production type. Instead, quantity or large-batch production and the use of jigs and templates revolutionized home building.

Industrial Management, Simplified Practice, and Standardization

The Forest Products Laboratory (FPL) and the Pierce Foundation had been experimenting with quantity production since the 1920s. Through research and testing, technicians perfected a range of manufacturing innovations that builders subsequently adapted for residential construction. Forest Products Laboratory, a Department of Agriculture division established to promote timber utilization, began studying woods and glues for plywood in 1921. Following the aircraft industry's World War I advances, particularly in adhesive technology, engineers at the lab eventually shifted their focus from furniture to plywood's structural applications. Over time, FPL engineers fixed on a stressed-skin panel, a composite of waterproof plywood sheets bonded to lightweight framing. Manufacturing this structural box required the introduction of phenolic resin glues under carefully monitored conditions. Finished floor and roof panels maximized plywood's sheet form for a two-way membrane with high compressive and tensional strength. Preassembled wall units were slipped into slotted, four-by-four-inch verticals set at eight-foot centers. The FPL premiered its first stressed-skin unit in 1935, the most widely known experimental house from this period.

Initially, the Pierce Foundation directed its research efforts toward monolithic wall materials infilling structural steel frames. The first prototype, produced in 1932, featured Microporite, manufactured from cellular glass and a cementitous fiber. In 1935 the foundation redirected its research program to plywood. In plywood, this system resulted in a single or double wall infill panel set between four-inch-square posts at twelve-foot centers. By 1941 the foundation had released its system to twelve licensees. Commercial prefabricators such as Gunnison, Plywood Structures (Los Angeles), and Bates Prefabricated Structures (Oakland, California), as well as federal agencies such as the Farm Security Administration, adopted the stressed-skin panel. During the defense emergency the Pierce house, modified by the addition of a Celotex asbestos-surfaced insulating board, saw extensive service.[59]

The Pierce Foundation's experiments with materials, production processes, and standard construction systems was similar to those conducted by a number of private and public sector organizations interested in developing optimal methods for quantity production. Moreover, the foundation's research trajectory, from an interest in composite materials outside the realm of traditional home building to reengineering construction practices and techniques using wood, was symptomatic of other research units. Although manufacturers and builders continued to experiment with factory and other off-site house-building systems, these methods found limited applications. However, over time progressive builders' alternative site fabrication techniques and the use of plywood as a thin and lightweight sheet material applied to a scaled-down wooden frame, the basis for either factory fabrication or on-site construction, became standard practice.

Builders adopting horizontal operations had to enhance and restructure their advanced planning. Engineering high-volume production required precise coordination between the supply and delivery of material inputs and the sequence of work on the site. Implementing these changes proved a challenge. During the 1920s the Department of Commerce and the Federated Engineering Societies issued reports that assigned more than one-half of total construction costs to inefficiency, specifically poor management. While the agencies disagreed on the proportion of that waste attributable to management (34 percent and 65 percent respectively), in each case the bottom line was significant. The Department of Commerce survey attributed poor management to a "lack of simplification, inefficient methods, and obsolete machinery" and pegged the resultant costs at two billion dollars annually. Both agencies reported greater losses in the construction of small buildings than in large projects.[60]

The federal government, through the Department of Commerce, encouraged the adoption of industrial engineering principles in its effort to improve efficiency and reduce waste. The Commerce Department facilitated a network of realtors, building materials producers, contractors, architects, engineers, and planners who shared information and findings.[61] Secretary of Commerce Herbert Hoover was instrumental in organizing the Division of Building and Housing and the Division of Simplified Practice, voluntary associations for industry, trade groups, professional societies, and government representatives striving to forward these objectives.[62] Hoover envisioned the Division of Building and Housing (DBH) as a clearinghouse for developing and implementing universal building codes and coordinating this program with other federal agencies. In addition

to standardizing codes, the division encouraged the introduction of new building materials and the diffusion of up-to-date design standards developed by other government agencies, private industry, or joint public-private initiatives.[63]

Individual and corporate members within this associational network viewed standardization and efficient production as a foundation for low-cost, small-house construction, advocating, with federal assistance, organizational change and the adoption of scientific management principles. For example, to improve accuracy in bidding, they encouraged home builders to use standard forms for estimating, cost accounting, and job scheduling. They supported uniform building codes and petitioned for conformity in the presentation of code requirements to promote both the observance of existing regulations and the elimination of outmoded requirements. And they agitated for the standardization of building materials through grade marking and trade marking. Manufacturers' standard labeling, they argued, would eliminate misrepresentation and assure quality construction; it carried an added benefit for sales and promotion through the advertisement of prestigious, nationally recognized components and equipment. Finally, they encouraged home builders to adopt a uniform system of specifications, a development reformers believed would benefit both the builder and home buyers through performance-based designations of materials and construction technologies.[64]

Consistent with Hoover's interest in better housing and home ownership, the Division of Building and Housing began addressing key home-building issues such as standardizing materials and housing components, industrial production and efficiency, and financing. The division's primary mandate was to develop a working coalition among business, technical, and professional groups and, with their cooperation, to stimulate residential construction. The DBH chose to focus their efforts on stabilizing production. This project had two functions: securing a more even distribution of building throughout the year and reducing or eliminating seasonal fluctuations in residential construction.

Housing analysts considered building cycles wasteful and inefficient. *Seasonal Operation in the Construction Industries*, a 1924 report authored for the President's Conference on Unemployment, concludes that fluctuations in housing starts resulted from "custom rather than climate." Supported by a rising volume of data, economists and statisticians at the Bureau of Labor Statistics began generating monthly indexes of construction activity. Seasonally adjusted charts of residential contracts and

permits revealed a steep ascent from the January low to an April peak, followed by an even descent through the remainder of the year.[65]

While conceding that weather was an important factor in a production process that occurred to a great extent out-of-doors, critics such as Robert Lasch condemned the industry for letting contracts primarily in the spring and the subsequent shutdown of operations come fall. Lasch ascribed this to builders' reactionary embrace of conventional methods and rejection of modern practice, such as off-site subassembly, which could take place under cover. Analysts pointed optimistically to alternative procedures such as an early installation of mechanical heaters, which would allow for interior work during inclement weather, new materials including concrete additives, and the educational program under way by national trade associations. Productionists believed twelve-month construction would reduce labor costs on a by-project basis, since tradespeople and laborers would agree to reduced hourly wages in return for a guarantee of uninterrupted employment. However, while all these changes might reduce seasonal variances, home buying remained subject to longer-term cycles driven by financing, debt costs, and consumer mobility.[66]

Another avenue productionists pursued when engineering cost reductions centered on material standardization and simplified practice. For productionists, standardization meant fixing the basic mechanical and physical properties of materials, their process of fabrication, or their applicability and usage. After identifying fundamental qualities and use, standardization could focus on establishing ratings governed by law, consent, or general use. Advocates for simplified practice focused on means for rendering industrial practices, in this case home building, less complex through an absolute reduction to the fewest possible variables. Efficiency experts at the Department of Commerce viewed simplified practice as a first step toward standardization. Proponents concentrated on eliminating "excess dimensions, types, and qualities of a specific article of commerce by mutual agreement between producers, distributors, and consumers."[67]

Large-scale builders recognized the advantages simplified practice offered and quickly formed institutional linkages. The National Association of Builders' Exchanges appointed a committee as a liaison to the National Bureau of Standards; its charge was to promote "adherence to simplified practice recommendations in the building and construction industries and to develop new opportunities for simplification as a method of eliminating avoidable waste."[68] In the home-building field, simplified practice was credited with significant reductions in the number and variety of basic

materials, equipment, and construction tools. Edwin W. Ely cited common brick, which went from forty-four sizes to one, and the elimination of twenty-nine of forty rebar cross sections as representative.[69]

Simplified practice accelerated a process that was already under way. The FHA acknowledged its benefits for high-volume construction: "The standardization of the parts of a house offer economies in construction without a loss in flexibility in planning. Based upon a common unit of measurement, parts can be made interchangeable. This form of standardization simplifies manufacturing and production and ease of erection. Cutting of materials on the job is reduced and waste eliminated."[70]

However, simplified practice and standard materials would not, by themselves, reduce housing costs. Doors and windows or cabinets and appliances, whether uniformly sized or not, still required considerable labor time during installation, and each component accrued additional costs through constant rehandling and shipping. Productionists argued that practicality dictated fabrication of entire sections, adaptable to any type of construction and a variety of designs.[71] This classificatory logic was consistent with efforts in other fields, which together can be understood as an attempt to inaugurate a national comprehensive system of planning and coordination. For example, Hoover viewed the American Engineering Council's *Waste in Industry* survey as an "attempt to visualize the nation as a single industrial organism and to examine its efficiency towards its only real objective—maximum production."[72] Hoover's vision clarifies the productionists' obsession with volume and prices. Production planning was the key aspect of their relentless push to increase scale, capture economies of material and time, and reduce costs.

Robert Lasch identified the degree of coordination necessary for a revolution in building practice.

> This enterprise demands a special type of producer organization bringing together a variety of specialized skills. There must be a real estate expert to handle land acquisition and related problems; a land planner and staff to lay out the general scheme of the subdivision; an architectural staff to design the houses; a construction engineer to organize production; [and] financial experts to manage the loans. The size of the organization, and the degree of specialization which can be called upon, depends upon the scope of operations.[73]

Compare this ideal to the small-scale building of a single house or a handful of units, a system A. C. Shire captures in this passage.

If we examine an ordinary house in the process of construction we find delivered to the site . . . twenty to forty thousand parts or pieces of material to be handled, assorted, rehandled, fitted, and fastened together. We find over a thousand kinds of materials to be ordered, received, checked, invoiced, and paid for; there may be a hundred men working directly on the design and construction of the house; that these hundred men represent twenty different kinds of skills and specialized work; that as many as one hundred different firms studied the plans and prepared estimates of the cost of certain parts of the work; and that about fifteen different contracts were drawn up with the fifteen successful bidders.[74]

The FHA Technical Division produced a similar assessment in 1941. In "An Analysis of the Distribution of Critical Materials Used in a Typical Housing Development," FHA staff spell out the one hundred different firms Shire alluded to. A typical housing project required the services of 13 subcontractors, 5 utility organizations, 15 material supply dealers, 8 material and equipment jobbers, 1 retail dealer, and 108 manufacturers.[75] If operative builders would only change their operations, the argument continued, they could begin developing comprehensively planned communities. However, regardless of the extent to which productionists reengineered home building for volume production, their efforts would eventually reach a ceiling in terms of cost reduction. Fabrication and construction of an individual housing unit's shell accounted for just over one-third of the total cost. After a point, further improvements in production would garner diminishing returns.

Although this discussion of management, standardization, and innovation has focused on housing production, there was an equally vigorous debate concerning marketing and consumption. Quantity output required volume sales. The means for achieving this objective and opening up the market for low-cost dwellings was not self-evident.

In 1932, General Houses, a Chicago corporation, advanced one strategy that had direct implications for modern community planning. Howard T. Fisher organized the firm to market a panelized steel house of his design. In its choice of material and product the company was not exceptional. What was innovative about Fisher's organization was his marketing strategy. By establishing a network of licensed dealers and service units associated with local builders, Fisher intended to replicate the auto manufacturers' sales system and "Fordize" the building industry. In other words, Fisher and General Houses would act primarily as merchandisers. Paral-

leling the auto industry's strategy, Fisher planned to operate General Houses as an assembler of parts, not a prime producer. As suppliers he enlisted a Who's Who of American manufacturing, including Thomas A. Edison, Inc., General Electric, Pittsburgh Plate Glass, American Radiator, and the Pullman Car and Manufacturing Corporation.[76]

In their introduction to the report on large-scale housing for the 1931 President's Conference, John M. Gries and John Ford noted that regardless of one's approach to the housing problem, you find the "source of evils to be disorganization, and the cure to be organized cooperation between the varied forces whose combined efforts produce modern housing."[77] Technicians and productionists, along with decentrists and pragmatists, cooperated in the formulation of modern housing and, by extension, modern community planning. Technicians and productionists engaged in identifying the minimum ideal, restructuring building practice, and instituting management innovations participated in the creation of a new kind of city. They contributed to the efficient, high-volume production of standard, low-cost housing, an ideal that intersected with the spatial, formal, and social concerns of the neighborhood and region outlined by the decentrists and pragmatists. The origins of and rationale for a minimum house have remained obscure. The case studies in the following chapters examine the ways in which this standard was implemented and how it was modified in the process.

CHAPTER THREE

MODEL COMMUNITIES FOR MIGRANT WORKERS

A keen observer who has never visited a farm workers community . . . will see that each frame building is for a purpose [and] the community layout is the result of much planning. . . . Off to one side the school buildings are located. In the Garden Homes and apartments the keen mind will find meticulous care in the planning and setting out of flowers, lawns, and vegetable gardens. [In] the cleanliness of the streets and lawns . . . there is evidence of the residents' efforts to make their individual shelters comfortable. . . . The visible cleanliness and orderliness [are] signs of our invisible community pattern. M. P. BRUICK

I do not know whether you are familiar with the fact that we are now building something which is almost new under the sun; camps for migratory labor. . . . To our fraternity, engineers, architects, and construction men, migratory labor presents a public health problem, and the camps to shelter them, a public health [benefit]. We have had no precedent as to basic design policy. . . . Thus we have gone into a rather new application of site planning; something which may be called housing, [but includes] a central building for public assembly and education, a clinic for inspection, a common bath house and laundry. In these designs there are some things old and some new. In construction methods there are, I believe, some interesting features. BAIRD SNYDER

The design of a community is seldom the work of an individual: success depends on the skill of the collaborating designers and technicians and the ability of the architect and engineer who coordinate this group effort. ELIZABETH MOCK

The FSA Camp Program

Beginning in 1936 the Farm Security Administration (FSA) and its predecessor, the Resettlement Administration, planned, built, and managed thirteen communities for California's seasonal agricultural workers

(fig. 3.1).[1] Central to this program was the integration of physical planning and social reform. To provide migrant field hands and their families improved living conditions, FSA staff drew on the social policy formulated by housing reformers such as Edith Elmer Wood and Catherine Bauer, the formal design principles enunciated by practitioners and theorists including Clarence Perry, Henry Wright, and Clarence Stein, and technicians' innovations in building practice. The California camp program had important links with, and over time informed and advanced, the environmental reform movement, modern community planning, and modernization in building practice presented in the preceding chapters.

Scholars have rightly interpreted the FSA's social program, an experiment in "guided democracy," as a failure.[2] The California camps, by extension, have been judged similarly. During five years of design research, however, professionals at the Region IX Engineering Office (headquar-

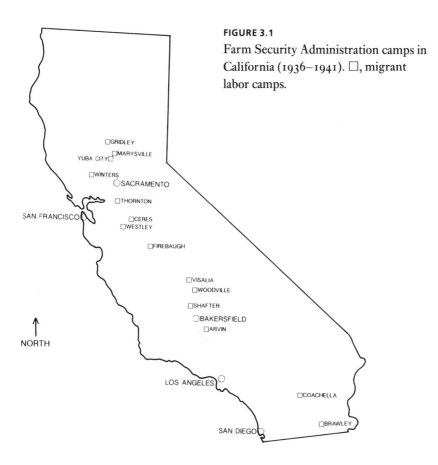

FIGURE 3.1
Farm Security Administration camps in California (1936–1941). ☐, migrant labor camps.

tered in San Francisco) developed a sophisticated prototype for new communities that could be constructed quickly and efficiently at minimum cost. The FSA utilized its innovative plans and the construction techniques that staff had perfected throughout the western states, from Washington and Idaho to Colorado, Arizona, and Texas.

It is instructive to view the FSA camp program as a rural counterpart of the Progressives' better-known response to the industrial city. Similar to Progressive Era settlement workers and the community center movement, the FSA addressed the needs of a disadvantaged and dispossessed labor force; agricultural workers were perceived as casualties of unregulated corporatism and unrestrained capitalism.[3] The Region IX administration, design staff, and field personnel shared their predecessors' conviction that decent shelter, adequate sanitation, and access to neighborhood amenities would recast social relations. They centered their program on minimum housing, standardized site plans, and the completion of model camps. Each of these components had direct ties to a Progressive Era precedent, the California Commission of Immigration and Housing (CCIH), which Governor Hiram Johnson empowered in 1915 to establish codes and enforce standards. In fact, the FSA program advanced a number of CCIH objectives, and key personnel in program and building design as well as field administration shared the environmental reformers' conviction that reconfiguring spatial relations would lead to improved social relations.

Rationalized building practices and the formal repertoire of community planning figured prominently in the later stages of the California experiment. The Region IX design staff sponsored and endorsed innovation. Engineers tested a variety of building materials and structural components, and contractors who bid for these projects were encouraged to realize the labor and material savings associated with site prefabrication. Low-cost, quantity production of permanent housing, schools, and clinics set the physical landscape for migrant communities such as Yuba City and Woodville, the Region IX showcase. These projects were promoted as model rural new towns where agricultural workers might divide their time between wage labor and family farming.

Planning and constructing new communities and experiments with construction technologies were consistent with the Resettlement Administration's national mandate. Through its Division of Subsistence Homesteads, this agency pioneered federal intervention into rural living conditions and the direct provision of improved housing. Design professionals

intended the administration's better-known greenbelt program, and the three new town projects undertaken in Maryland (Greenbelt), Wisconsin (Greendale), and Ohio (Greenhills), as demonstrations of new principles and techniques of land use and town planning.[4]

Within this context, two factors made the California program unique. Congress empowered the Resettlement Administration to assist low-income farm families; but in California, relief workers confronted a different problem. Here the rural poor were not marginal farmers but the lowest strata in a mechanized and productive system of industrial agriculture. Over time and through considerable activism, reformers and labor advocates extended the Resettlement Administration's mandate to include these itinerant farm laborers. The FSA communities marked the first time the federal government acknowledged the housing needs of this previously invisible workforce. Second, community building for rural relief in California had to address the needs of a mobile and fluctuating population. The seasonal rise and fall in absolute numbers and the continual turnover of residents presented the Region IX staff with a planning and design problem different from that of either the homestead or greenbelt initiatives.[5]

To meet these programmatic requirements, FSA designers adopted a standard pattern for the camps, a permanent, centralized institutional core surrounded by impermanent dwellings. The challenge they faced in the early camps was integrating these two elements. At first, the diagram itself served as the site plan. But FSA planners continually reworked the site plan, in accordance with the national directorate's incremental modifications and their increasing technical expertise. By 1941, at Woodville, we can readily discern the formal repertoire of modern community planning.

In other words, the FSA planners fused the environmental reformers' objectives with the community building principles advocated by productionists. Although the shaping of a communitarian social order eluded the FSA planners, tracing the evolution of its physical counterpart, a community plan, can illustrate the means through which theory and practice informed subsequent developments. And even though the World War II defense emergency cut short this experiment in rural new town design, the FSA's innovations were extended, and in some cases accelerated, after the agency and many of its key personnel were drafted to meet the increasing demand for industrial war-worker communities in California.

California Agriculture and the "Migrant Problem"

In March 1935, Paul Taylor, field director for the California Division of Rural Rehabilitation, submitted an application to the State Emergency Relief Administration requesting one hundred thousand dollars to erect forty camps for the "forgotten men, women, and children of California." Taylor formulated his request following fieldwork that included surveys of squalid, unhealthful roadside camps and "Hoovervilles," a term whose popularity attests to the association of economic hardship and depravation with the Hoover administration. Photographer Dorothea Lange accompanied Taylor and poignantly rendered these living conditions (fig. 3.2). Taylor's proposal outlined an across-the-board aid package that would improve shelter conditions for a vast number of destitute families regardless of country or state of origin, length of residency in California, or future potential for rehabilitation to the consuming class. Taylor knew these camps could not be self-liquidating; he proposed labor in lieu of rent and argued that where people's need was greatest—due either to an extreme seasonality of crops or severity of climate—was precisely where the state should extend the largest amount of aid.[6]

In response to Taylor's request, the Emergency Relief Administration

FIGURE 3.2
Orange pickers'
camp, Farmersville,
Tulare County,
California (November 1938).

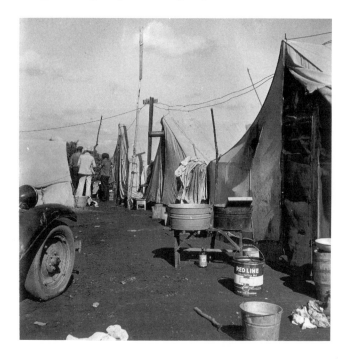

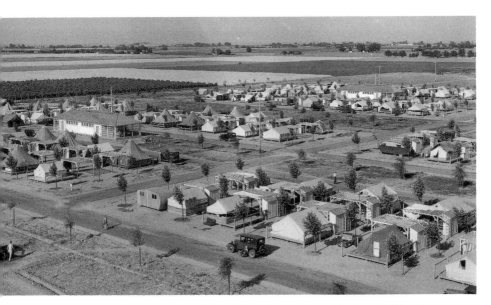

FIGURE 3.3 Farm Security Administration migrant camp, Shafter, California (1937).

(ERA) began constructing migrant camps at Arvin and Marysville in September 1935. Both settlements opened later that year, and each housed one hundred families. The plan was extremely simple, consisting of little more than tent sites on grade with tie rails and three "sanitary units" or "utility" buildings, all organized around a central community facility and anchored by an orthogonal street system. The sanitary units contained services including washrooms and showers, laundry facilities, and flush toilets; one unit for every forty tents was standard. Entry was by a single gate adjacent to the camp office. From this vantage FSA staff could monitor residents and visitors alike. The following year, California turned over Marysville and Arvin to the New Deal Resettlement Administration. The agency's final budget of March 30, 1936, specified raised tent platforms and shade arbors, additional sanitary units, an assembly room and nursery, recreational facilities, and landscaping.[7]

Immediately after assuming the state's demonstration camps, the Resettlement Administration began four additional projects at Shafter, Winters, Coachella, and Brawley. An oblique aerial view of Shafter highlights the physical improvements (fig. 3.3). Despite their benefit for migrants residing here, a platform with storage unit, arbor, and tie rods and an elaborated community building did not alter the fact that these initial camps remained

inexpensive and expedient way stations. Because they housed the largest number of migrants possible at a cost low enough to permit construction throughout the state, these settlements adhered to the democratic vision Taylor and other activists first advanced.[8]

In many respects the site planning and physical plant of these early Resettlement Administration camps followed the codes and standards the CCIH enacted and enforced through the State Labor Camp Act (1915). The camps provided sanitary, impermanent housing that satisfied a rotating population's short-term shelter needs. Each unit was a repetitive module laid out in neat rows, a straightforward diagram of programmatic requirements. Camp personnel occupied the only year-round dwelling, located at the entry to allow for monitoring and control. In other words, the state, and later the federal government, responded to the Dust Bowl migration by instituting a relief program that, at least initially, was overlaid onto an existing program of labor reform.

Understanding this evolution requires some knowledge of California agriculture and the "migrant problem." Contrary to widely held contemporary assessments, drought-state "refugees" did not precipitate California's migrant problem (the term *migrant problem* was used inclusively for the seasonal workforce, their living conditions, and their impact on the state's "permanent" residents). From the inception of bonanza wheat farming in the nineteenth century, agricultural production in California was different from that in the northeast and midwest, where families, with cyclical assistance from hired hands, managed comparatively smaller farms. Although there were family farmsteads in California, the legacy of Spanish landholdings favored large-scale operations, as Hubert Howe Bancroft notes in his *History of California* (1890). "For size of farms California exceeds every other state, and it is a peculiarity favored by her speculative spirit, which delights in operations on a large scale."[9]

By attributing the formation and success of large-scale farming to a universalized "speculative spirit," Bancroft excised an entire class of workers who made these operations possible. He was not alone. Agricultural migrants, a product of California's "peculiar" pattern of commercialized and industrialized farming, remained largely invisible until the Wheatland riot riveted public awareness to this particular workforce.[10] In August 1913, twenty-eight hundred wage seekers arrived at the Durst brothers' hops ranch outside Wheatland in the upper Sacramento Valley. The Dursts were one of the largest employers of farm labor in California. This particular harvest required approximately fifteen hundred workers, but labor

agents had advertised throughout the state and as far away as Oregon and Nevada. Angered by the discrepancy between people and positions, squalid living conditions, and inhumane working conditions, farm laborers, assisted by members of the Industrial Workers of the World (the IWW, or Wobblies), assembled to draft a petition demanding improvements. The Dursts responded with a show of force. On August 3, four persons died and a crackdown on the IWW commenced.[11]

Governor Hiram Johnson directed the newly enacted California Commission of Immigration and Housing (CCIH) to investigate the "riot" and determine its root causes. The commission, a statewide coalition whose membership included prominent progressives such as director Simon Lubin, assigned the study to Carleton Parker. Parker attributed the labor unrest to inadequate housing and unsanitary living conditions. The commission concurred and endorsed Parker's recommendations for stricter regulations and standards and systematic camp inspections.[12]

The CCIH intended to focus public outrage and concern following the Wheatland incident and compel employers to implement minimum improvements, which, they argued, were in the growers' best interest. Better housing might ease the strained relations between employers and labor and encourage productivity. Under the auspices of the State Board of Health, the commission sponsored a Labor Camp Act and, following its passage, began to monitor the employment, hygiene, and housing of seasonal workers throughout the state.[13]

To improve living conditions at migrant camps the commission established regulatory standards and introduced an educational program for California growers. The reforms codified under the Labor Camp Act focused on sanitation and scientific camp management. "Sleeping places," defined as cabins, bunkhouses, or tents, would be located on dry, well-drained ground, maintained in good structural condition, and "arranged in rows so that the area can be kept clean." These units had to meet minimum requirements, and the standards specified the number and placement of windows and the amount of unobstructed space between beds. The state code separated food preparation and storage from living areas and restricted the former to adequately screened structures. Additional statutes called for "convenient and suitable" bathing and privy facilities, placed at a reasonable distance from the sleeping units and far enough removed from the water supply to prevent contamination.[14]

The CCIH designed its education program for the purposes of publishing advisory pamphlets, disseminating standard camp and shelter plans,

and developing model "villages" for workers. Some of California's large growers endorsed and implemented these physical planning standards. In 1920–21, G. B. Hodgkin, a member of the Fruit Growers' Exchange Department of Industrial Research, published a series of articles in the *California Citrograph,* addressing the role of improved housing for meeting the "one big cost item to be reckoned with . . . labor." To make his point Hodgkin quoted J. D. Culbertson of the Limoneira Ranch: "The more completely we study this problem the more thorough will be our conviction that adequate and respectable homes for agricultural workers in close proximity to their work is the most promising permanent solution of our labor problem."[15]

Hodgkin went on to analyze the housing the San Dimas and La Verne associations provided their "Mexican" workers. Based on observation and interviews he recommended freestanding units, sited on "good sized, fenced-in yards with room for gardening." Each house should be equipped with running water and electric lights; showers could be communal. Hodgkin concluded with an assessment of five construction systems: adobe, wood frame, hollow tile, poured concrete, and ready-cut or "portable" construction. In a follow-up article the author reported in detail on housing the Azusa Foot Hill Citrus Company had constructed. These were "modern" four-room, concrete units complete with sanitary facilities, bathrooms, and running water in the kitchen. Of particular interest was the inclusion of a twenty-two-by-fifty-foot "club house," including chairs and writing desks, tables and shelves stacked with reading material furnished by the county library, and a pool and billiard table. Nine years later, Howard F. Pressey, manager of Rancho Sespe, reported on their "Mexican village" in the same journal. Pressey walked the reader along streets fronting forty-to-fifty-foot-wide lots with three-room, 440-square-foot dwellings of "California design," a reference to bungalows and bungalow construction.[16]

Consistent with the CCIH's emphasis on educating private growers, the Resettlement Administration justified their initial projects to a hostile electorate as models that large-scale producers could emulate. The agency publicized the Frick ranch, photographed in November 1936 by Dorothea Lange, as evidence of the positive influence the government-sponsored alternative had on private camps. What made the Resettlement Administration and later the Farm Security Administration settlements different, however, was not their tidy rows of tents or gravel walks and streets but their social planning. This community focus was evident in the permanent,

centralized communal facilities that served to stabilize camp life, organize the floating pool of workers for potential employment or state relief, and introduce the migrants to modern standards of health and hygiene.[17]

Two factors explain the FSA's attention to social planning and the inclusion of permanent community facilities. The first was an ongoing demographic change. Although the Dust Bowl migration did not begin in earnest until 1933—and only reached its peak during the years 1935 to 1938—it was apparent during the 1920s that the workers who made up California's seasonal agricultural labor force were changing. According to Carey McWilliams, the roots of this change can be traced to the rapid expansion of cotton acreage in the San Joaquin Valley immediately following World War I. Inspectors from the CCIH first recorded a shift in the composition of the workforce in 1925, when the supervisor of camp inspection filed a report stating, "The labor supply for cotton this season consists of a majority of Mexicans, the balance being American and Negro cotton pickers from Oklahoma and other southern states who are coming into the Valley in answer to advertisements placed in southern papers."[18] The rising number of native-born white families working in California's seasonal economy altered the state and federal governments' response to the plight of agricultural migrants. Then in 1929, the first deportation drives and forced repatriation of Mexican "nationals" accelerated this transition.[19]

Second, unlike the reportedly peripatetic "foreigners" whom they replaced, "Americans" came to California with every intention of remaining beyond the planting and harvest seasons. Farmworking families began occupying private facilities such as roadside auto camps for prolonged periods, and migrants from the southwestern states were found battened down for the winter.[20]

A 1935 *San Francisco News* editorial identified in-migrating families as the agents of change.

> It took a riot in which a district attorney, a sheriff, and two strikers were killed to arouse California to the need of cleaning up conditions for migratory laborers in 1913 [at Wheatland] when the picking was done almost entirely by single men. Growers provided camps for them, and the State Immigration and Housing Commission [CCIH] enforce[d] standards. Today a different problem exists. The harvesting is done by whole families instead of by single men, and individual growers can no longer provide adequate camps. So the families squat by the side of the road or in vacant fields.[21]

The California State Relief Administration (CSRA) conducted a housing survey of relief clients in Tulare County during the spring of 1939. Tulare is at the center of the San Joaquin Valley, in the south-central cotton-belt McWilliams identified. Southwest migrants' familiarity with the crop made Tulare a destination of choice. Okies were a majority of the thirty-seven thousand individuals (35 percent of the county's residents) receiving assistance. In a Farmersville camp a family of thirteen shared two tents pitched together. The surveyor's report records these conditions: "Three rickety beds with straw mattresses lined the rear and one side; in front stood a wood stove with box shelves nearby. A plank served as a table. A two-foot aisle ran down the middle; here two boys slept. There was only a dirt floor, no electricity, and water was hauled from a pump nearby. Two outhouses served the entire camp of twelve families."[22]

As head of the California Division of Immigration and Housing (DIH), Carey McWilliams knew firsthand the squalid living conditions of roadside camps and Hoovervilles throughout the state. And because the DIH was charged with inspection and code enforcement of private camps, he was aware of their frequently oppressive conditions. In testimony to the La Follette Committee he stressed the coercion employers could exercise over captive fieldworkers through foremen, contractors, and ranch managers. Many growers' camps included company stores, and laborers were paid in scrip, an added infringement.[23] In fact, it was the boast of the Herman Baker Camp, in Madera County, that no one who worked there left with their earnings. However, the DIH hesitated to enforce the law and condemn employer housing, fearing it would force migrants into illegal and even more unhealthful squatter settlements.[24]

The Dust Bowl influx overlaid additional factors onto an existing problem, which then conditioned the direction of housing and community building for rural workers. While reports by the CSRA and the DIH—and the scare tactics favored by groups like the Associated Farmers—fostered broad-based recognition of the hardship endured by those on the bottom rung of the agricultural ladder, there was no consensus in terms of a remedy.

According to the best statistical data the FSA could generate, in the late 1930s California agriculture required between 170,000 and 200,000 seasonal workers. At this time, the number of families following the crops reached upwards of 125,000. Border inspectors from the state Department of Agriculture recorded over 90 percent of the in-migrants as "caucasians," more than 75 percent of whom came from four states: Oklahoma, Texas,

Arkansas, and Missouri. Family groups entering FSA camps had, on average, just over four members. Three-quarters of the men were between the ages of twenty and forty-four; children under ten years of age, over 50 percent of camp residents, predominated. Family incomes ranged from $400 to $450 a year.[25]

These young family groups required expanded community services, and FSA camp managers responded by instituting a variety of programs. They encouraged the formation of a democratically elected camp council and urged residents to participate in civic affairs and attend council meetings. The FSA sponsored reading groups, sewing clubs, and community newspapers. Residents initiated other programs and staffed committees, such as "good neighbors" to acculturate newcomers, child welfare to impress the importance of personal health and hygiene, and recreation to promote athletics and sponsor competitive events. In 1940 the average length of stay in an FSA settlement reached one year.

Planning for Community and Low-Cost Construction

The architectural embodiment of this cooperative system, and visual focus of the camp layout, was the community center. Here the camp council held meetings, agricultural extension personnel and home management specialists offered classes, and social events such as plays and Saturday night dances occurred. At first the assembly site was nothing more than an enlarged shelter, a platform covered when needed. As the importance of the centers for community life became apparent, the FSA design staff secured approval for permanent structures. At this point the community buildings achieved a heightened symbolic significance through their contrasting construction, but they remained a large flexible space that residents could adapt readily for a variety of functions.[26]

In response to the migrants' extended stay, the FSA design staff first appended permanent housing, called "labor" or "garden homes," to Casa Grande and Chandler in Arizona (fig. 3.4). Works Progress Administration employees constructed both projects. Subsidized labor and a desire to keep relief workers employed as long as possible suggested adobe construction. On the one hand, adobe was a judicious choice; the material required, mud and straw, is inexpensive, while the production of blocks from these ingredients is labor intensive. On the other hand, the artisanal nature of adobe construction, and the degree of craftwork the FSA designers specified, which included elaborate columns, sculptural panels,

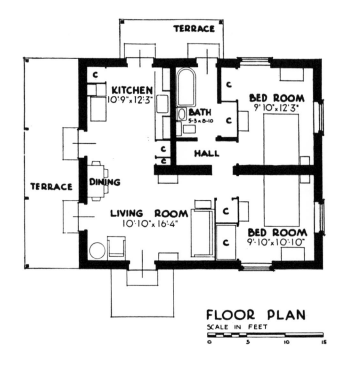

FIGURE 3.4
Floor plan for the
FSA adobe garden
home. These two-
bedroom, detached
dwellings had five-
hundred seventy
square feet of floor
area.

and reliefs depicting the migrants' plight and the cooperative promise,
eventually pushed these projects beyond budget.

When the Resettlement Administration elevated Region IX Director
Walter Packard to the national directorate, he summoned Vernon DeMars,
a California staff architect, to Washington to develop more cost-efficient
plans. DeMars devised an efficient two-story, multifamily housing block,
the prototype for all subsequent row housing built in FSA communities.[27]

Immediately following completion of the Arizona camps, the FSA
elected to retrofit existing California projects with small, single-family
cabins. A carryover from Chandler and Casa Grande is evident in the
choice of adobe for the modified garden homes at Arvin (fig. 3.5). Their
240-square-foot plan contained a kitchen, a bath with shower, a dining
area, and a sleeping cot. Two additional beds were in a sleeping porch,
which could be closed off for winter occupancy. These units rented for
$8.20 a month furnished, including utilities. The total construction figure,
$550, fixed the rent. Because hard costs such as services and grading
accounted for a high percentage of the final cost, the FSA staff decided to
use the larger Arizona plan for subsequent projects.[28]

Although both permanent house types, the two-story apartment and

the single-family garden home, were introduced in adobe, budget con-
straints, instituted following the agency's transfer to the Department of
Agriculture, left the FSA staff few options other than experimenting with
low-cost construction. The Department of Agriculture enacted strict cost-
cutting measures. In his 1938 annual report, FSA administrator Will Alex-
ander noted that Agriculture officials mandated construction costs be cut
to an "absolute minimum." As a guideline, the department set finished,
per-unit maximums for multifamily and single-family units.[29]

It was at Westley, which opened in November 1938, that the Region IX
staff took the first steps toward construction efficiencies, standardization,
and economies of scale. The metal shelters were one product of that effort
(fig. 3.6). These units were designed as a more durable substitute for
cotton tents and to improve residents' protection from inclement weather.
Manufacturers delivered the shelters in five panels. At the site, a crew of six
could assembly a finished structure in ten minutes. Each unit included a
covered porch and a storage area with built-in shelves. In addition, the
FSA provisioned each family with two iron beds, two iron benches, and a
kerosene stove. Tennessee Coal and Iron Company manufactured and
delivered these efficient, ready-to-assemble units at a cost of $150. They

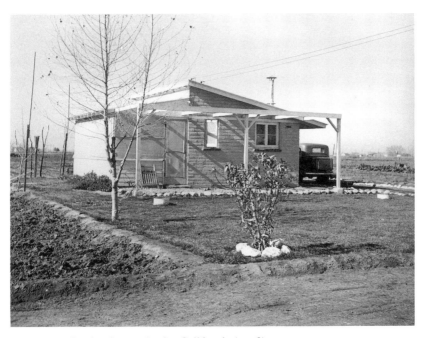

FIGURE 3.5 Garden home, Arvin, California (1938)

FIGURE 3.6 Metal shelter, Visalia, California (1940)

were affordable, long-lasting, and easy to erect.[30] However, while the metal shelters provided a much needed improvement over makeshift canvas tents, they were, as one resident described them, "little more than an experiment."[31]

But the evolution from labor-intensive construction systems to design based on labor and material savings proved to be far more significant. There were two components for this change, pre-engineering and sub-assembly. Pre-engineering refers to those aspects of design and planning that anticipate and incorporate cost-saving procedures at the preconstruction phase. The FSA applied pre-engineering principles to achieve material reductions, but these practices generated time and labor economies as well. To minimize initial capital outlays for building products and reduce waste, the FSA staff worked from manufacturers' standards as they engineered the structural system and designed unit plans. A sixteen-foot module, based on the four-by-eight-foot sheet size of composition framing units such as plywood, set the plan configuration for the multifamily apartments.[32] Designers applied this approach when they determined the building envelope and its volume. For example, the eight-foot length of sheet insulation and finish plywood determined finish floor-to-floor as well as floor-to-ceiling dimensions. Specifying presized materials reduced on-site labor, since tradespeople did not have to modify products after they arrived on the job.

Just as important as the material savings FSA designers pre-engineered into their floor plans was the ease with which these units could be erected from components assembled at the site. For example, to construct the modular wall and floor panels for a multifamily apartment, workmen placed precut studs and joists into temporary frames or "jigs" for rapid assembly. Jigging also connotes the use of mechanical devices and guides to speed the sizing of studs and rafters or other repetitive on-site fabrication. The FSA encouraged contractors to set up portable mills and manufacture doors, windows, and shutters on site. Field reports attributed increased precision and time savings of 80 percent to the widespread use of jigs. The FSA determined that "precutting and prefabrication are practical whenever the number of structures built at any one time permits the purchase of main dimension stocks in carload lots, and when the operations are confined within an economical trucking radius."[33]

Pre-engineering principles dictated the vertical alignment of plumbing in the two-story six-plexes. In each apartment the bathroom, located on the upper level adjacent to the bedrooms, sits over the kitchen below. By inverting identical plans, the designers clustered baths and kitchens in adjoining units. Vertical stacking and functional adjacencies permitted common supply and waste lines. Plumbers responded as expected by shop-producing multiple subassemblies in temporary facilities set up at the building site.

As the labor camp program evolved and the staff's experience and expertise increased, the FSA refined its planning for and production of permanent housing. Improving efficiency and reducing costs led FSA engineers to develop flexible building and unit designs that could be constructed from a kit-of-parts, and workmen created on-site shops for the production of multiple subassemblies, which were then distributed to individual building lots. From programming through site analysis to interior finishes, the later camps were the product of pre-engineering and horizontal building, directed and coordinated by FSA staff, who adopted and refined the methods of sequential, large-scale operations that reformers, critics, and government personnel had been advocating for the preceding two decades. Garrett Eckbo, a landscape designer and FSA engineer, emphasized this in an article on site-planning practice. "The great lesson which [these] problems have to teach us is the need for replac[ing] the standard segregated compartmental design system [with] an integrated assembly line technique, in which operations at the end work out correctly because they were considered at the beginning."[34]

Eckbo's assessment was consistent with the fundamentals production-
ists espoused. However, he extended their homage to Ford and the assem-
bly line to the design process. His prescription, a product of economic and
social conditions particular to the Depression, prefigured the practices and
strategies of private, speculative community builders. Through their at-
tention to site planning, low-cost building and construction systems, labor
processes, and, most important, the overlap and interplay between these
phases of community building, the Region IX office crafted a series of proj-
ects that brought considerable attention to progressive construction prac-
tices. In fact, the office's multidisciplinarity foreshadowed that of specula-
tive building concerns such as Kaiser Community Homes.

At the regional office all technical staff, regardless of their training,
assumed the title "engineer." Site planners, civil and structural engineers,
and landscape and building designers adhered to a team concept and cross-
disciplinary problem solving.[35] Eckbo spoke to this point when he argued
that, unlike their professional counterparts, FSA engineers considered the
"total site space as one operation." This approach

> points out clearly and unmistakably the futility and obsolescence of the
> present carefully established and maintained professional boundaries. . . .
> No single kind of professional designer can do a completely good job of
> site planning all by himself. It requires collaboration between architects,
> engineers, and landscape architects on smaller jobs, with the addition of
> professional town planners on larger ones.[36]

This innovation was atypical. Most New Deal agencies were highly
centralized.[37] Although the national office in Washington allocated proj-
ects and monitored regional budgets, all the FSA planning, engineering,
and design was local. According to Vernon DeMars, the nominal head of a
self-consciously non-hierarchial staff, the San Francisco office was able to
build "without approval from Washington."[38]

The resulting projects garnered considerable recognition. Internally,
the FSA assigned the Region IX staff responsibility for design and con-
struction supervision in Texas and Florida. A memo outlined their ra-
tionale. Baird Snyder, the agency's chief engineer, authorized the work
order while visiting San Francisco because "[District Engineer Herbert P.]
Hallsteen's crowd have their hands in this thing, and it will be far less
expensive to do it this way than to expand the organization in Dallas." He
suggested to FSA administrator C. B. Baldwin that it would be "wise to do
the same for Florida" because "they are good [designers] with camp expe-

rience. They are getting out several experimental designs for shelters and these will be built on site near San Francisco to determine if they are any good."[39]

After field personnel representing four of the eleven FSA regions completed a three-week tour in California, they advised the Washington office to consider extending the program from a "regional to a national plane."

> Camps and labor homes, patterned after California models, are operating or soon will go into operation in Arizona, Washington, Idaho, Oregon, Texas, and Florida. Further large expansions are being planned in all these states. The program . . . demands the same sort of policy integration and procedural coordination as the other national programs of the FSA such as rural rehabilitation, tenant purchase, and resettlement.[40]

In their report they recommended that the labor homes be substituted for emergency housing as rapidly as funds permit and local conditions warrant. "In this way stabilization of large numbers of the migrants may be effected, as well as their integration into the larger pattern of the surrounding community."[41]

In a 1943 study, *The History of Prefabrication,* Alfred Bruce and Harold Sandbank singled out the FSA projects as essential laboratories for quantity production. "The FSA, during the period prefabrication was growing to maturity, sponsored the development of whole communities of low-cost homes using varied types of construction in what might be called an actual field laboratory of prefab housing. It has placed an emphasis on both low-cost and mass-scale production, attempting to develop complete plans for communities based on mass-scale operations." The authors concluded that the FSA, along with the Tennessee Valley Authority, had been the "stimulation for the actual use of prefabrication in direct efforts to provide and erect low-cost homes."[42]

Others found the FSA housing a model for low-cost dwellings in radically different settings. Rex Thomson, the superintendent of charities in Los Angeles, petitioned Supervisor John Anson Ford to consider building one hundred units based on the Arvin garden homes for residents of the Olive View Sanatorium. Thomson included a photo of the Arvin housing with his request and suggested that similar dwellings would be received sympathetically by a public otherwise indignant when they learn that the cost for charitable housing exceeds the housing costs of "tens of thousands of tax-payers."[43]

In addition to pre-engineering and the on-site production of subassem-

blies, the FSA investigated off-site or factory assembly and analyzed its potential cost savings. Proposals to lease property for the planting or harvesting season prompted experiments into portable and demountable sectional housing that could be moved from site to site. After reviewing available systems, the FSA staff decided on a modified version of the Forest Products Laboratory's stressed-skin panel. At the site, these factory-formed plywood components were set into a precut spline.[44]

During the war the FSA used this system for "duration dormitories" and single-family "cabins" in San Diego as well as row housing at Carquinez Heights in Vallejo, California. For the design staff these floor and wall panels became a kit-of-parts; a variety of dwellings could be easily erected from identical four-by-eight modules. Over time the same panels could be modified or reused. In fact, plans called for disassembling the housing and reassembling the panels after the war. According to the "Products and Practices" editor at *California Arts and Architecture,* "So precise has been the planning of these temporary housing [units] that the panels can be re-erected into tenant dwellings or housing developments for farm laborers."[45]

The FSA's research and development in standardization, site fabrication, and modular planning was not limited to wood framing or wood-based sheet materials such as plywood. In concert with other branches of government and private groups like Gunnison and the Pierce Foundation, Region IX engineers experimented with a variety of materials. Stanley P. Stewart, principal FSA architect in Washington, reported on the range of structural systems and building products under consideration for the migratory camp program. Stewart visited San Francisco in December 1939. Among the topics he discussed with Burton Cairns was the use of firesafe materials and the relative advantages of a concrete column and beam system with Tilecrete panels for the floors and roofs. The latter was subjected to a comparative analysis with a steel frame and infill wall systems such as a rigid insulation faced with cement asbestos, a Thermax panel with stucco on the exterior face and plaster on the interior, and corrugated asbestos board.[46] Although FSA engineers were not the first to experiment with these products (for example, the Pierce Foundation's Cemesto house used essentially the same wall panel system that Stewart found under consideration in San Francisco), they were in the forefront of field testing and application.

Despite the array of materials and systems under analysis, district engineers concluded that a reorganization of on-site operations best met their

objective of flexible-unit plans within stringent budgets. Jigging, subassemblies, and serial production reconfigured the construction process without replacing wood as a building material. Their findings aligned with those of other researchers such as Gunnison, the Pierce Foundation, Forest Products Laboratory, and Plywood Structures who determined that the most efficient and cost-effective approach to housing production could be found in pre-engineering the dwelling and its fabrication, not through the application of alternative materials.

In July 1938 the Douglas Fir Plywood Association sent the FSA administrator a letter of interest regarding their product. The association questioned the use of noninsulated metal shelters in California's inland valleys and suggested substituting plywood. Two years later, Plywood Structures of Los Angeles contacted the district office requesting the rights to manufacture, market, and distribute the plywood panel system developed for the multiunit labor homes and dormitories.[47] These two inquiries attest to the expertise the FSA designers and research staff had achieved.

In "Low-Cost Construction," a sub-section of his 1938 annual report, Alexander offered this assessment of the program's importance.

> The first step in reducing construction costs was to work out scientific plans and specifications which would give maximum space and utility for the smallest possible expenditure. . . . In the course of three years experience, engineers of the FSA have devised low-cost methods of rural homebuilding that set new standards in that field. Already the project program has developed certain building methods that may prove of major significance to American industry.[48]

The FSA communities presented one of the only viable and visible demonstrations of innovative construction practices, and the agency actively promoted its experiments and experience. For example, in 1939, Baird Snyder wrote Vincent Smith, editor of *Construction Methods and Equipment*, asking if he was "familiar with the fact that we are now building something which is almost new under the sun." He suggested Smith visit some camps and research an article. Based on his own observations, Snyder argued that contractors were "going about to the limit of the law of diminishing returns on prefabrication." He stressed the advantages of constructing plumbing trees, wall panels, and roof trusses on site, or "anything that lent itself to preassembly."[49]

Pre-engineering and rationalized building operations not only lowered costs and improved efficiency; these practices also encouraged a reworking

of the camp plan. The four Resettlement Administration camps at Shafter, Winters, Coachella, and Brawley followed CCIH standards. After their completion, FSA staff reevaluated the site plan to address budgetary constraints and changing functional requirements. In a follow-up letter, Snyder directed Smith's attention to the basic design of the camps themselves, which, he argued, was without precedent. "We have gone into a rather new application of site planning. . . . [The] designs are more practical than novel . . . [but] I think they might be interesting to the trade."[50]

At Westley, the orthogonal grid that ordered the first camps was replaced by a new geometry, a double-loaded hexagon.[51] FSA designers offered a functional explanation for their selection; this configuration allowed a more efficient layout for service lines and other infrastructure and reduced the total land area given over to surfaced streets. Since the shelters followed the pattern of access roads, they could be laid out more economically and planners could dedicate a higher percentage of the site for pedestrian circulation, recreation, and shared open space.

While the benefits that accrued from this plan were significant, the most efficient plan, and the one favored by the FSA staff, was a circular scheme. The circle is an ideal type with deep historical roots that invokes centripetal forces both as a diagram and when plotted on the ground.[52] Visual prominence and the authority centrality secured were precisely what camp managers desired. The majority viewed their role as stewards empowered to instill residents with the virtues and values of proper citizenship. Although publicly they professed equality with other residents, camp managers exercised a final say over camp affairs, a status reflected in the uncontestable veto they held over the democratically elected camp council. Their preemptive power began at the camp entry, the location of the manager's office. This authoritative siting was modified only at Woodville, where the office was placed beyond the cooperative store at the intersection between the public sphere and the impermanent shelters and tent sites.

The hexagon plan, concentric and similar to a circle in effect, also provided a prominent and convenient locale for community services. Camp council meetings, home economics and other classes, the library, and a stage and assembly hall were set in this all-purpose facility. Formally, a hexagon articulates rank and importance through relative distance from the center. It is significant that shelters were zoned by type for the first time at Westley. Metal shelters lined an inner ring within the double-loaded hexagon, and tent platforms were sited along the outer edge. In this

plan longer-term residents, who occupied a location closer to the community center, would maintain a stable core as the camp population fluctuated according to agricultural cycles.

While a new generation of camps was under construction, the FSA began adding permanent housing to the earlier settlements. The first California garden homes were completed at Arvin. Jonathan Garst informed Rexford Tugwell:

> Each small but substantial adobe house shall be [sited on] three-quarter acres with electricity and running water. In the dwelling, storage for food will be provided [along with] a kitchen stove, table, chairs, and two iron bedsteads and springs. A roadway is to provide access to these units. Shade trees are to line the roadway and be placed around the dwellings. . . . It is felt that since the government will continue to own the property that no charge of any sort should be made for the land or the improvements which are of a public nature.[53]

Following completion of the Arvin cottages the FSA engineered a series of cooperative projects with single-family units such as Mineral King. At this time the FSA also introduced multifamily apartments.

Yuba City (completed in February 1940) was the first project planned with permanent housing from its inception. Here, FSA planners sited the multifamily units to take advantage of the shade offered by an existing cypress grove. They arranged twelve six-plexes in an orderly east-west orientation to maximize the cooling from prevailing breezes.[54] However, an aerial photograph reveals that even though they programmed Yuba City for permanent housing, there were two independent spatial orders (fig. 3.7). To the north, metal shelters and tent sites were organized in the familiar hexagonal configuration around a community center and shared facilities. The permanent housing was planned around the grove and climatic concerns.

The alternative foci had parallels with changing policy. Initially, the FSA administered relief to the largest number of migrants possible. The introduction of permanent housing signaled a revised objective. At this point the directorate began to focus its attention on transforming agricultural laborers and their families from a seasonal, migrant workforce to a fixed population that supplemented wage work in growers' fields with domestic production, with a view toward self-sufficiency. The multifamily units and garden homes were critical for that effort. In a memo to

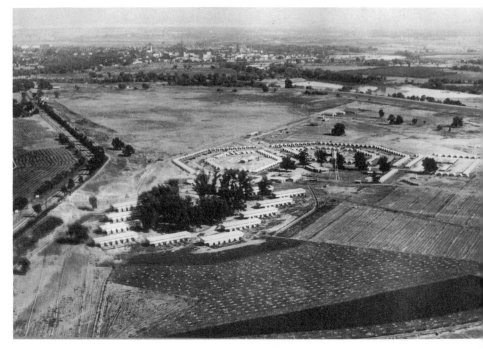

FIGURE 3.7　Yuba City, California, view to the north

C. B. Baldwin, Gregory Silvermaster, chief of the Labor Division, recommended putting "greater emphasis" on the labor homes.

> In part, this is due to the fact that the areas to which standard camps are appropriate appear to be fairly well taken care of, and in part to the belief that the FSA is now in a position to direct its efforts toward improving the living conditions of resident agricultural workers. . . . More specifically, I believe we should orient our program with the view to 1) assist in stabilizing resident agricultural workers in areas where such stabilization is feasible, socially desirable, and economically justifiable; and 2) arrest or check the incipient migratory trends where farm displacement or shifting crops have stranded [workers].[55]

In short, it was a transitional moment. In California, the FSA redirected its priorities from standard camps sheltering an itinerant workforce to permanent housing and the resettlement of workers on small homesteads or cooperatives. At Westley, Yuba City, and other camps from this period, the two objectives were overlaid.[56]

Woodville, a Satellite "New Town"

Only after the Region IX staff turned their attention to the design of permanent satellite communities did an integrated, comprehensive master plan result. This was the planners' stated objective at Woodville, a rural new town intended as a model for the program's next phase. In his article on the planning evolution, FSA designer Vernon DeMars suggested that here could be seen the "general pattern [that] agricultural workers' housing will take in the future." Moreover, Woodville demonstrated the "important task of testing new patterns, unencumbered by the millstone of property values or restrictions imposed by existing land patterns."[57]

According to DeMars, Woodville was conceived as the "nucleus for a new small town." No longer primarily a way-station, the FSA camps now had to function immediately as a self-contained settlement and, at the same time, possess the infrastructure and facilities for a future complete community.[58] At Woodville, FSA designers adhered closely to the principles of modern community planning. The site layout reveals these attributes and illustrates how the Region IX planners integrated the need for temporary housing and services with the new directives of a permanent settlement.[59]

As constructed, the project occupied 80 acres of a 160-acre parcel (fig. 3.8). The site is in Tulare County, seven miles east of Porterville and ten miles west of State Highway 99. It is the northwest quadrant formed by the intersection of county highway J27, a north-south artery, with Avenue 160, an east-west feeder. The FSA planners anticipated J27 would become a major thoroughfare. Given this, they placed the major entry off this route but implemented two strategies to mitigate the detrimental effects of traffic. First, they designated a permanent greenbelt along this entire stretch to "discourage the establishment of stores [and businesses] opposite the entry." Second, they set a major axis perpendicular to the road to "point the direction of future growth."[60]

Within this transit armature the Region IX staff located 313 housing units. However, the housing at Woodville, unlike that at Tulare and Yuba City, was zoned by type within an integrated and hierarchically organized master plan. Temporary housing—tent platforms and metal shelters—was located in the northwest quadrant, furthest from the entry. Contrary to the strict orthogonal planning of the early camps or the absolute geometry at Westley, here the tent platforms, and particularly the shelters, were arrayed with greater variety. The regular, gridded tent sites were parceled out

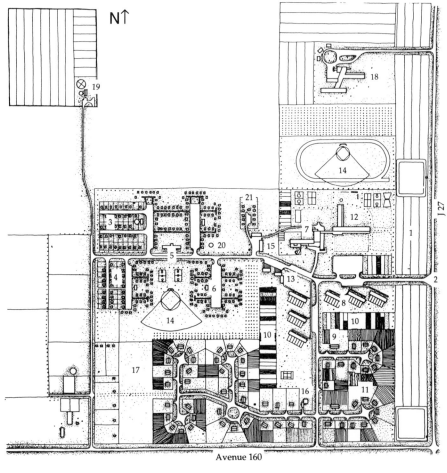

N↑

1. Greenbelt
2. Entry
3. Tent Slabs
4. Metal Shelters
5. Central Utility
6. Comfort Station
7. Community Center
8. Six-Family Row Houses
9. Duplexes
10. Allotment Gardens
11. Garden Homes
12. School
13. Store
14. Baseball Diamond
15. Gatehouse
16. Manager's House
17. Future Homes
18. Future Hospital
19. Sewage Disposal
20. Water Tower
21. Isolation Unit

Avenue 160

FIGURE 3.8 Site plan, Woodville, California

along pedestrian paths that led into a cul-de-sac. The metal shelters shared this studied informality, enhanced by a series of minor pedestrian spurs. Rather than addressing the street, each shelter opened out to a shared court. Vehicles were restricted to the cul-de-sacs. A central utility building fronted the feeder street and served as the visual focus for this cluster. Although the FSA stated its intention to "retire" the impermanent units

and replace them with permanent housing, their overall planning displayed a considerable degree of care and integration with the permanent units and the community center.

Thirty-six apartments and thirty-seven labor homes formed the community's southeast quadrant. The principles of modern community planning are more transparent when analyzing the permanent housing. FSA planners sited the multifamily units at the contact point between Woodville and the surrounding landscape. This particular strategy can be traced through the work of Perry back to Atterbury and Olmsted's plan for Forest Hills Gardens. At Woodville, the FSA design staff retained a heliotropic orientation for the apartments. The siting, thirty degrees south of the east-west axis, obscured residents' backyards from public view and provided convenient access to individual allotment gardens.

The garden homes were arranged along cul-de-sacs on eighth-of-an-acre plots. In an interview, DeMars acknowledged their debt to Radburn. The relatively large lots were consistent with those in the national subsistence homestead program as well as the California cooperatives such as Mineral King. Farm Security Administration staff projected that the individual family gardens would provide both sustenance and a supplemental income. As drawn, the plan anticipated additional units to the southwest.

The different house types clustered around a community center, a school, and a cooperative store, a grouping the FSA referred to simply as "the center," a term that underscores the link to neighborhood unit planning. The social program did, as well. This complex housed adult education, home economics classes, and a library. Adults and children could participate in and attend performances at the community stage or larger assembly hall. The center also housed a nursery school, a clinic, and the camp offices. A lineage for each of these functions can be traced to the Progressive Era community center movement. Playing fields, including a baseball diamond, were sited directly adjacent to the elementary school; recreation was considered essential for a balanced community.[61]

Woodville exemplified rational and comprehensive community planning, and it is instructive to analyze its physical and social programs in light of the environmental reformers' terms and conditions (fig. 3.9). At the community scale, Woodville was bounded by an arterial street (Avenue 160) and a county highway (J27), which provided ease of access. With the inclusion of a landscaped buffer, the community's edges were clearly articulated. Internally, the FSA designers adopted formal strategies to reinforce a sense of belonging and promote residents' identification with their

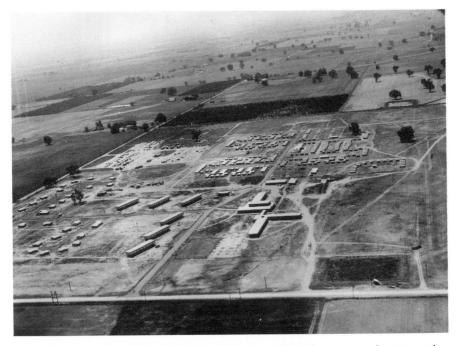

FIGURE 3.9 Woodville, California. Oblique aerial looking west, main entry and community center in the foreground. Compare with previous figure.

neighborhood. They achieved comprehensibility at multiple scales. At the master plan level, functional segregation and clearly defined land uses—distinctive house types, a commercial core, community facilities, and recreation—encouraged legibility. While these distinct uses were clearly articulated, they were also well integrated within a coherent, overall scheme.

One principle the planners applied was a specialized and hierarchical circulation system. Pedestrian foot spurs led residents from the cul-de-sacs and minor streets into a common green. A main collector, lined with the cooperative store, the school, the community center, and medium–density housing, channeled residents out to the highway. Infrastructure, services, and housing supported this network. The planners sited them skillfully and structured the entire program to focus attention and activity on the community center and school.

Farm Security Administration planners lauded Woodville as a model satellite community. DeMars considered it "endowed not only with the necessities but many of the amenities of living." Woodville lacked one important element that both pragmatists and decentrists considered essen-

tial for a balanced development, however, proximity to diverse sources of steady employment. DeMars and others remained optimistic. "Perhaps the decentralization of industry will really come, and a balance may be achieved between work in the factory and work in the field. Perhaps with the availability of cheap electric power [from the Colorado River project], raw materials could be processed at their source into finished products."[62]

Although Woodville's constitutive elements, the impermanent tents and metal shelters, the lightly-constructed apartments, and the five-hundred-square-foot garden homes, could be dismissed as inconsequential, taken as a whole the project was significant. Through this model rural community project the FSA planners interpreted and reconfigured the formal vocabulary of modern community planning, and in turn inserted themselves into the ongoing discourse. At Woodville the ideals and standards propagated by a broad cross section of social and environmental reformers, government agencies, and business leaders, all of whom turned their attention to housing the wage earner and refining the spatial order of the dwelling and workplace during the economic crises of the 1920s and 1930s, were articulated on the ground.

The FSA's experiments in community planning and the design and construction of low-cost housing caught the attention of reformers and other federal personnel engaged in similar research. Nathan Straus, the head of the United States Housing Authority, who presided over the use of experimental mock-up dwellings to test minimum spatial standards, wrote to Will Alexander in 1939 regarding the FSA program. "Several times I have heard of the excellent plan developed by your organization for migratory camps. Will you be good enough to let me know when it would be convenient for me to inspect models or plans? From what I have been told, there is much which the USHA could learn."[63]

Baird Snyder, an ardent publicist, responded by sending Straus a portfolio containing illustrations of garden homes and multiunit row housing. Snyder enclosed a detailed accounting of construction costs with the visual documentation. At that time (November 1939), the FSA had completed six hundred garden homes in the western regions; cost per unit was $1,459 plus $600 for land. "That is to say, for approximately $2,100 on average we built a town of these houses starting with virgin agricultural land." Snyder continued:

I am happy to send you this material because there has been so much discussion in housing circles ever since I [entered] government three years

ago about the possibility of building a fully modernized home with all the appurtenances of a modern town at $2,500 a unit or less. . . . If you will permit me to venture an opinion, I am going to say that the quality of shelter provided by these single homes is good enough for any low-income worker, whether he wears overalls or a white collar, and, furthermore, it does not appear that he has to have been previously sheltered in a tent to consider these quarters by comparison first-class in every respect.[64]

In interviews and in the letters and poems they sent to the camp papers, those living in the camps supported Snyder's contention. Residents were, on the whole, appreciative of the government alternative to private camps and ditch-bank housing provided at Woodville and the earlier FSA camps. It would be hard to overemphasize the basics; the camps provided migratory workers treated drinking water, sanitary facilities, and disease-free accommodations—a significant achievement. A comparison between the relative luxury afforded by a labor home complete with appliances, or the community wash and laundry room, and the degradation of a ditch-bank is instructive. In describing what the government camps meant to her family, one camp resident stressed that while they came in from the field just as dirty, "in a few minutes we can be scrubbed from head to foot and in clean clothes, and have a clean bed to sleep in. We can dump our work clothes in a machine, wash them, and hang them out. The camp is a salvation to us." In a 1940 survey, Gridley camp manager Charles Kirkpatrick queried residents regarding their work and status before migrating, their separation from people and places, and future plans in California. Many hoped to acquire a place of their own. One resident's response summed it up: "I'm figuring on anchoring just as quick as I can."[65]

Housing for the Home Front

Despite the FSA's optimistic projections and the favorable criticism garnered by the California program, Woodville never served as a model for new town development. Two weeks after the first families settled at Woodville, fifteen hundred single men moved into nineteen FSA designed two-story dormitories for Vallejo defense workers.[66] Soon, many agricultural laborers joined the next wave of in-migrants to California, this time bound for high-paying jobs in industrial urban centers.[67] Eventually this influx dwarfed that of the 1930s. An October 1941 *Oakland Tribune* headline

claimed, "Migration to California at New Peak: Job Seekers Coming for Defense Work Greatest Influx Yet." According to the author, a "new migration of job seekers, greater even than the mad rush of gold hunters in 1849 and of farm migrants in 1937, is in full swing as a result of California's leading role in the national defense program, and it has officials worried."[68] Speaking one year later as vice president of the California Housing and Planning Association on the radio program "Town Meeting of the Air," Catherine Bauer informed her audience that California's 12 percent population increase, which translated into eight hundred thousand newcomers, "makes the once famous *Grapes of Wrath* problem look like a picnic, and hundreds of thousands more are still needed."[69]

California's defense migrants encountered severe housing shortages, and in scenes reminiscent of Dust Bowl shantytowns and Depression Era Hoovervilles they crafted alternative arrangements in converted storefronts, trailers, tin and cardboard shacks, garages, chicken coops, and automobiles. In response to this crisis, particularly acute in California's critical aircraft and shipbuilding centers of Los Angeles, San Diego, and the San Francisco Bay Area, Congress passed the Lanham Act, which empowered the Federal Works Agency (FWA) to "provide housing for persons engaged in national defense activities, and their families, in areas where the President shall find that a shortage of housing impedes defense activities . . . and such housing would not be provided by private capital."[70]

According to DeMars, "Critics of the defense housing effort implied that the ultimate state of confusion was reached when even a federal farm agency was at work on the problem." In fact, the FSA made an important contribution to the war effort. Using the Bay Area as an example, from the passage of the Lanham Act in October 1940 to the reorganization of the principal federal housing agencies in February 1942, the Region IX office produced over 30 percent of the defense housing total. In his 1941 annual report C. B. Baldwin described how the FSA drew on its experience "providing shelter and sanitary facilities for migrant agricultural workers. Because of this the defense housing coordinator recommended that the FSA be responsible for a stopgap program."[71]

Other wartime community projects had direct and indirect links to the FSA camp program. Many workers at Bechtel's Marinship yard in Sausalito resided at Marin City, where the panelized construction of row housing, single-family cottages, and public buildings followed the FSA prototype, as did the community plan. And the architect of the "active community life" visitors found in Marin's second largest city was Milen

Dempster, a former FSA camp manager. In short, beginning in 1941, the production technologies and community planning principles the FSA had put into practice during the 1930s to create rural new towns for seasonal agricultural workers and their families were redirected toward the housing of defense workers.[72]

All of the innovations in building practice and community planning that the FSA marshaled for the design and construction of Woodville had been identified and developed in the preceding two decades. In fact, experiments with both construction technology and modern community planning were key components in Resettlement Administration projects throughout the country. For example, in the South, the agency experimented with houses made of cotton and rammed-earth as low-cost alternatives. In the better known greenbelt communities, it sponsored three exemplary demonstrations of community planning. But at Woodville we can see how these innovations were brought together to produce a novel, though much-heralded, configuration, one that informed subsequent large-scale community projects.[73]

Although the Region IX experiments were grafted onto a broader and, in many respects, antithetical national program, and although the communities constructed could never house more than ten thousand of the approximately 150,000 farmworkers in the state, the California projects did have an impact. These rural settlements served, much as their promoters and sponsors had argued, as an unparalleled opportunity to test and refine the hypotheses and proposals of planners, reformers, and productionists. Their models might have remained just that. But the exigencies of the Depression, and the particular configuration of the federal government's response to this crisis, created an opportunity to apply these principles. Once the California projects were complete, they offered a visible representation of low-cost community building. Moreover, federal sponsorship of these experiments legitimized modern community planning and industrialized housing.

By 1942, however, the Region IX community building project had been jettisoned. The programmatic demands and time constraints associated with defense projects, and the FSA's lowly position within the FWA, curtailed its experiment in planning and production first organized for the labor camp program. In the next chapter, we shift our attention away from an enervated FSA to examine the role of speculative builders who responded to the demand for housing in proximity to defense industries.

CHAPTER FOUR
THE AIRPLANE AND THE GARDEN CITY

There is going to be a Detroit of the aircraft industry. Why not here in Los
Angeles? E. J. CLAPP

Land surrounding airport sites is destined . . . for extensive development, not
only for housing and retail . . . but for industry as well. . . . Factories will em-
ploy thousands, just as plants which turn out locomotives and railroad cars do
today. Since the families of workers must live nearby, new communities will
arise. FRANCIS KEALLY

In May 1929 the Los Angeles Chamber of Commerce presented readers of
Southern California Business a surprising projection of regional develop-
ment. "In the past an airport has been just a tract of land, usually difficult
to get to and at some distance from the roar of the city. [In the future] we
will probably see considerable development around these [fields]. Each will
produce a community of no small importance . . . solid settlements of in-
dustry, commerce, and private residences."[1] At that time, there were fifty-
three landing fields within a thirty-mile radius of City Hall; not one, how-
ever, was municipally owned. Chamber members knew their colleagues in
"large cities and small . . . [are] providing themselves airports . . . that will
yield a return." Contrary to the received wisdom regarding urban disper-
sion and functional segregation in Southern California, these boosters
envisioned airports as growth poles, vibrant centers for industrial and
population expansion, attracting a mix of land uses characterized by a tight
and desirable link between a residence and place of work. The Los Ange-
les Chamber of Commerce, E. J. Clapp, Francis Keally, and other "air-
minded" enthusiasts did not have to wait long to see the general outline of
their vision fulfilled. What they could not have predicted, however, was
that airfields and their associated industry would become factors for in-

creased working-class home ownership and large-scale builders' experiments in modern community planning.

The World War II home-front mobilization recast urban patterns and the social order in American cities. Three factors, migration, industrial location, and modern community planning, are central for understanding these transformations. During the war, short-term federal policy designed to jump-start and sustain production converged and coalesced with the long-held objectives of environmental and social reformers. The War Production Board (WPB) encouraged defense contractors to decentralize, planners pressed for a rational dispersion of manufacturing and housing, and real estate interests capitalized on these initiatives. While these interrelated processes accelerated satellite development throughout the nation, western cities prefigured future trends. With hindsight, wartime Los Angeles and the southern California region more generally can be seen as portents for contemporary metropolitan landscapes.

Defense Contracts, Employment, and Interstate Migration

Defense-related employment and economic opportunity were not distributed evenly across the country. The Southwest, a section of the country we now refer to as the Sunbelt, received a disproportionate share of jobs and job seekers. The President's Committee on Congested Production Areas (CCPA) tracked population growth in fifteen designated centers throughout the war; Pacific Coast cities set the pace. In fact, California industries alone secured over 10 percent of the production contract total. Here, wartime manufacturing centered on aircraft and shipbuilding firms located in metropolitan areas.[2]

Constructing, equipping, and operating an "Arsenal for Democracy" required a mobilization of workers to production plants. In April 1941, the House Select Committee to Investigate the Interstate Migration of Destitute Citizens (better known as the Tolan Committee), estimated that direct "reemployment" from defense expansion would create 6 million additional jobs that year. Although at this date underemployment and unemployment remained high—estimates ranged from 7 million to 10 million individuals—officials from the Office of Production Management (OPM) were already expressing concern over a spatial imbalance between production jobs and "idle labor." The Tolan Committee, renamed the Select Committee Investigating the National Defense Migration to reflect changing circumstances, recognized that defense production was altering the character

and scale of migration. Their final report, filed in January 1943, predicted an eventual twenty-five million workers in war-related industry, half the nation's "gainfully employed."[3]

Of course interstate migration, particularly to California and the West, was not a new phenomenon. When the Census Bureau reported in 1920 that half the nation's citizens resided in cities, it provided statistical evidence of a dramatic rural-to-urban migration with deep historical roots. This population flow reversed direction during the 1930s, when Americans responded to Depression hardships by returning to small farms or taking to the road in search of economic opportunity. Ironically, John Steinbeck's fictional account of Dust Bowl refugees toiling in California's Central Valley was published precisely as itinerant agricultural workers were deserting low-paying, seasonal employment for high-paying jobs as "Aviation Arkies" and shipbuilders in Los Angeles, San Diego, and the San Francisco Bay Area.[4]

Federal expenditures guided this migratory stream. To save time and money, the Defense Council channeled prime contracts to firms with existing plant and the capacity to expand. From June 1940 to June 1941, military orders exceeded fifteen billion dollars; the council awarded 45 percent of these contracts to manufacturers and suppliers in eight metropolitan areas: New York, Philadelphia, Boston, Norfolk, Virginia, Los Angeles, Detroit, Seattle-Tacoma, and the San Francisco Bay Area.[5]

Although most everyone rejoiced to see lines forming at factory gates rather than soup kitchens, city administrators faced challenging boomtown conditions as newcomers overwhelmed existing infrastructure and services.[6] In March 1941, *PM Magazine* reported, "No Housing in California for New Defense Migrants." An October 29, 1941, *New York Daily News* headline proclaimed, "Defense Housing Crisis 'Desperate,' " and on December 1, "Thousands Wait on Housing Fund" (fig. 4.1).[7] In Bay Area communities such as Vallejo and Richmond, where population increased 200 and 250 percent respectively between 1940 and 1943, the sheer number of incoming war workers stretched housing and services beyond their carrying capacity, creating an urban equivalent of the Depression Era roadside encampments documented by Dorothea Lange and other FSA-OWI photographs. The USO–Travelers Aid Service found Richmond defense workers and their families living in converted storefronts, theaters, trailers, garages, automobiles, and chicken coops.[8]

On December 18, 1941, the *New York Daily News* reported, "Housing Lack Called Arms Output Obstacle." That same month, the Federal

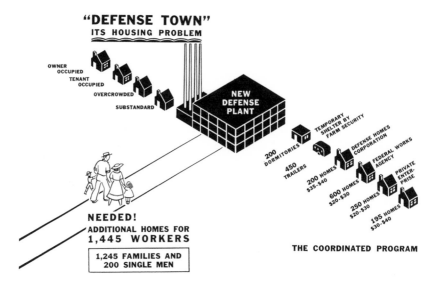

"DEFENSE TOWN"
ITS HOUSING PROBLEM

OWNER
OCCUPIED
TENANT
OCCUPIED
OVERCROWDED
SUBSTANDARD

NEW
DEFENSE
PLANT

TEMPORARY
SHELTER BY
FARM SECURITY

200
DORMITORIES

DEFENSE HOMES
CORPORATION

450
TRAILERS

FEDERAL WORKS
AGENCY

200 HOMES
$35-$40

PRIVATE
ENTER-
PRISE

600 HOMES
$20-$30

250 HOMES
$20-$30

195 HOMES
$30-$40

NEEDED!
ADDITIONAL HOMES FOR
1,445 WORKERS

1,245 FAMILIES AND
200 SINGLE MEN

THE COORDINATED PROGRAM

FIGURE 4.1 Projections for addressing the defense housing "problem"

Works Agency devoted an entire issue of *Public Housing* to their critical role in the defense effort. "Rent Takes Half of Wages in Boom Town" outlined in detail how employee turnover aggravated labor shortages while defense manufacturers strove desperately to stabilize their workforce. Testifying before the Senate Military Affairs Subcommittee on Manpower, Marshall Beaman, industrial relations director for North American Aviation, stated, "An alarming number of job terminations may be attributed to housing dissatisfaction."[9]

Speaking before the Tolan Committee, the sociologist Louis Wirth argued, "The problem of interstate migration did not loom large in American history as long as we had an open frontier." The problem, he continued, was no longer a search for land; rather, "it is a problem of the search for jobs" and the economic "inequalities between localities and regions." Defense workers responded to these regional inequities, but during the war years their continued mobility threatened the efficient and timely completion of contracts.[10]

The Aircraft Industry, Home Building, and Home Ownership

To address this emergency, Congress approved the Lanham Act in October 1940. The legislation, with amendments, appropriated $1.3 billion for

war worker housing in areas where acute shortages impeded the defense effort, provided private builders could not leverage the necessary capital and construction materials. That ambiguous proviso triggered a pitched and divisive battle between public sector housing advocates and speculative home builders. During the war years, federal personnel interpreted the act in favor of the latter, who finessed concessions in regions where they could generate and exercise political support. In addition to granting a uniform liberality in FHA loan terms to extend home ownership to wage earners, the federal government granted home builders priority assistance in obtaining scarce or restricted construction materials.

Contrary to popular perceptions, home building during World War II was not restricted to barracks and temporary shelter. In fact, the attention paid to duration dormitories and impermanent housing obscures a critical home-front development. During the war years private builders, subsidized by FHA guarantees, undertook 80 percent of the nonfarm housing starts recorded nationally, and home ownership rates climbed significantly.[11] In other words, the defense housing program was designed to fix a production problem—labor mobility and the need for expanded industrial output—as well as a social need—decent housing and the provision of basic services—by fixing people in place.

Local conditions informed the nature and timing of defense housing, which varied within and across regions. In the Bay Area, for example, the Federal Works Agency oversaw a program of temporary housing, trailers, and demountable dormitory units. In March 1941, a local civil defense official noted, "Whole new towns are springing up, a thousand houses at a clip, where yesterday were empty fields, and where today there are no provisions for sewers, playgrounds, fire and police protection, hospital facilities, and all other local services."[12] This statement highlighted the lack of services available to early residents in Bay Area defense housing developments while underscoring a need for large-scale community projects planned and constructed with schools, recreation, health facilities, and adequate infrastructure.

One month later, during April 1941, Mr. and Mrs. Darrell Ratzlaff moved into their two-bedroom house at 8406 Vicksburg Avenue in the Westchester district, ten miles southwest of Los Angeles City Hall (fig. 4.2). The Ratzlaffs were among the first of ten thousand new residents who moved to this area adjacent to Mines Field (later Los Angeles Municipal Airport and then Los Angeles International). Darrell Ratzlaff was a buyer for AiResearch Manufacturing Company. Prior to their house purchase the

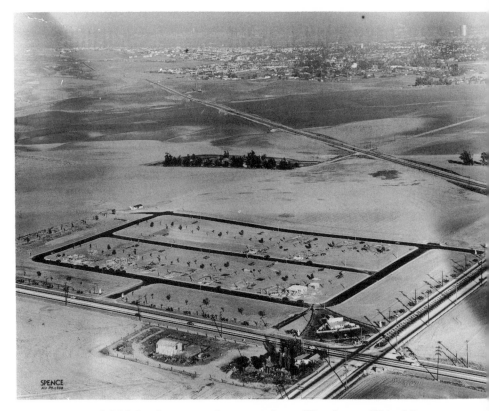

FIGURE 4.2 Initial development and construction at Westchester. This oblique aerial was taken from the southwest looking towards City Hall. In the foreground is the intersection of Sepulveda Boulevard and Manchester Avenue. Vicksburg Avenue is the middle street of the three Silas Nowell had completed. Note the hog farm on the northwest corner.

Ratzlaffs rented on South Normandie at Santa Barbara Avenue (now Martin Luther King Boulevard). Darrell commuted to his job in Glendale, next to Grand Central Air Terminal; Gertrude worked in the legal department at the Southern California Automobile Club. According to Mrs. Ratzlaff:

> In 1940, Darrell and I were looking for a place to build. . . . As we drove La Tijera often, we noticed when a sign was posted stating "400 Homes to be Built—FHA 10% Down." The address was in Bell, [w]e immediately checked into it and found a beautiful tract of homes built by Silas Nowell. . . . Si took our name and . . . soon called us; we picked out our lot on a map and started to build in January, 1941.

At the time the area was known for a hog farm and the surrounding bean fields. The FHA assured the Ratzlaffs the "hogs would be gone before anyone moved in."[13]

AiResearch, Darrell's employer, supplied heat transfer equipment, cabin pressure control valves, and air coolers to airframe prime contractors including North American and Douglas. In January 1941, *Southern California Business* reported the firm's acquisition of a twenty-acre site at Sepulveda and Century Boulevards, a location equidistant from the Ratzlaff's lot and North American and Douglas's plants at Aviation and Imperial Highway. AiResearch had an eighty-thousand-square-foot facility under construction when the Ratzlaffs occupied their dwelling, and the company moved in at the beginning of March.[14]

North American had chosen its site following a nationwide search. J. H. "Dutch" Kindelberger, a former vice president at Douglas, had accepted an offer in 1934 to become president and general manager of General Aviation, North American's predecessor firm located in Baltimore. After securing a contract for an Army Air Corps basic trainer, the NA-16, Kindelberger leased a twenty-acre site in Inglewood at the southeast corner of Mines Field. In November 1935, 75 employees relocated into temporary quarters adjacent to the new facility. In January 1936, 250 workers entered the new 158,678-square-foot assembly plant. The first production NA-16 came off the line one month later. Between September 1939 and December 1941, the company increased monthly output from 70 to 325 units, added fourteen thousand employees to its workforce, and expanded floorspace to more than 1 million square feet (fig. 4.3). In addition, by 1940 North American had more than a thousand firms under subcontract and had begun construction of its branch plants in Dallas and Kansas City.[15]

Contrary to the accounts of industry leaders and an earlier generation of business historians who cited topography and California's temperate climate as the critical factors, airframe production concentrated in Los Angeles because of technical advances developed by innovators such as Donald Douglas, the presence of a skilled, nonunion labor force, and the proximity to research institutions, especially the California Institute of Technology. During the 1930s aeronautical engineers and industrial entrepreneurs, supported by civic boosters and key military personnel, created a regional production network with major research and manufacturing centers in Santa Monica, Inglewood–El Segundo, and Glendale-Burbank.[16]

Collectively, the locational decision making of airframe prime contractors such as North American and ancillary manufacturers such as

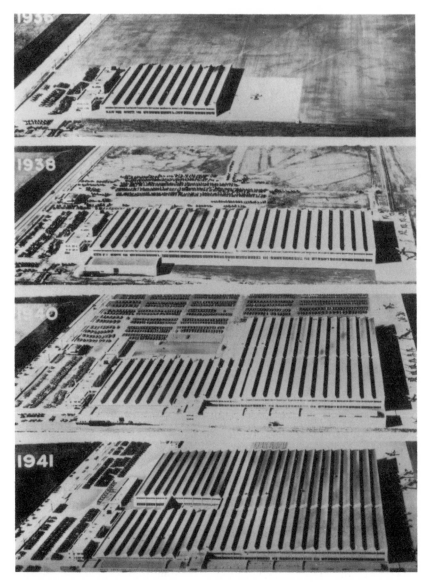

FIGURE 4.3 North American plant expansion (1936–1941)

AiResearch, as well as those made by thousands of individuals and families including the Ratzlaffs, led to the creation of new satellite communities around Los Angeles and Southern California. Home builders anticipated an influx of defense workers drawn by these employment centers and selected sites in close proximity to new production facilities for the plot-

ting and construction of new communities. In their location, design, and construction they adhered to the dictates of modern community planning. Westchester is one of the premier examples of this trend.

At the time, Los Angeles, like many cities, had an extensive inventory of platted land. In a 1934 review of the county assessor's records, Charles D. Clark, subdivision engineer for the Regional Planning Commission, found that only 57 percent of the lots in the metropolitan area that had been surveyed were occupied (fig. 4.4). In outlying areas, only 8 percent of the parcels that had been subdivided were in use. In the zone eight to ten miles from downtown, only one-quarter of the "usable," subdivided land had been developed. As late as 1940, when the county was in the midst of a residential and commercial building boom that rivaled that of the early 1920s, 35 percent of the subdivided property in Los Angeles County remained vacant, and ninety thousand parcels were tax delinquent.[17] Clearly the location question would not be decided simply by the supply of subdivided or subdividable land or the availability of property zoned for residential or industrial uses; community building did not take place on every open tract or on every available parcel in the region.

Analyzing the Ratzlaffs' decisions and actions as well as those of thousands of their cohorts suggests that the spatial logic of community building was tied to that of industry. In Los Angeles, San Francisco, San Diego, and other metropolitan regions throughout the country, private home builders sited their new neighborhoods in close proximity to employment,

FIGURE 4.4 Sunset Hills tract, Alsace Avenue and Exposition Boulevard (1939)

aggressively marketed their projects' location as a primary inducement for sales, and targeted wage earners employed in defense industries as their principal buyers.[18] Federal policy conditioned this spatial order. The National Housing Agency (NHA) monitored the labor requirements of essential industries in defense-critical areas and coordinated the supply of dwellings. Along with the War Manpower Commission (WMC) and War Production Board (WPB), the NHA managed housing production (both public and private) through a system of restrictions and quotas. Together these programs directed builders toward areas of greatest need.[19]

The federal government enacted housing policy and amended existing programs in response to the unprecedented influx of defense workers into production centers. In severe cases these in-migrants trebled population and placed extraordinary demands on the existing housing stock; their numbers outpaced the construction of new dwellings. National policy also informed the type of units builders provided. For example, wartime amendments to FHA statutes encouraged a reorientation toward low-cost, single-family housing, a product type home builders had previously identified as a primary market objective. War Production Board and NHA programs reinforced FHA policy. The private sector bias of all three agencies allowed speculative home builders to capitalize on the housing shortage. While the Ratzlaff's purchase of a single-family house during the war may strike many as the exception, it was actually close to the norm. Private builders produced over 1 million housing units during the war. In their 1946 report, "Effect of Wartime Housing Shortages on Home Ownership," the Bureau of Labor Statistics documented a 15 percent increase between April 1940 and October 1945. The authors compared this gain with similar intervals and found the wartime increase outpaced any comparable time span on record.[20] In other words, the defense emergency advanced a particular configuration in community building, the minimum-house type, large-scale operations, and modern community planning, one that reformers and productionists had defined in the preceding decades.

Industrial Location: The Big Six Airframe Contractors

In 1934, the Regional Planning Commission (RPC) authorized an inventory and mapping of "existing land cover and uses" in Los Angeles. Works Progress Administration surveyors (assisted by the RPC) conducted an exhaustive enumeration. The five hundred nine-color maps they produced identify land use and locate every manufacturing plant, shop, and resi-

dence over an area of 450 square miles.[21] The planners' tabulation revealed
only 5 percent of county land was devoted to industry; more important,
these sites were widely dispersed. In their final report the authors note
that "small industrial districts occur [in] almost every municipal and geo-
graphic division of Los Angeles, as well as in outlying satellite centers. . . .
Hundreds of manufacturing establishments of diverse kinds are widely
scattered over the metropolitan district. . . . Airplane manufacturing is
rapidly giving a new industrial importance to the Inglewood–Santa Mon-
ica district."[22] In effect, the WPA and RPC researchers found that firms in
some sectors, such as aircraft and parts production, had created what Fred
W. Viehe described as "suburban industrial clusters." Viehe uncovered this
pattern in his examination of the extractive industry, oil and oil refining, in
Los Angeles.[23] Tracing the emergence of industrial clusters in aviation can
reveal conditions during the 1930s and enhance our understanding of an
industrial sector that is critical for analyzing urban expansion in Southern
California. The origins of McDonnell-Douglas, Northrop, and Lockheed
can be traced to small, undercapitalized companies renting space for office
and plant in warehouses and loft buildings. Glenn L. Martin founded the
first Los Angeles firm in 1912. Previously, a crew of mechanics under his
direction had been assembling biplanes in a Methodist church and later a
cannery in Santa Ana. The company relocated its plant into a brick loft
building, formerly a bedding and upholstery shop, with a first-floor store-
front at 943 South Los Angeles Street, in a mixed warehouse and produc-
tion zone adjacent to the central commercial district.[24]

Donald Douglas, an engineer and Martin vice president, opened his
own firm with investor David R. Davis in June 1920. The Davis-Douglas
Airplane Company rented the back room of a barber shop at 8817 Pico
Boulevard, eight miles west of city hall. Five former Martin employees
crafted one-off components for a transcontinental plane in the second-
floor loft space at Koll Planning Mill, a woodworking shop ten miles away
at 421 Colyton, just east of Alameda and Fourth Streets (fig. 4.5). Finished
parts were lowered down an elevator shaft and trucked for final assembly at
the Goodyear Blimp hanger in southwest Los Angeles.

After losing his investment partner and securing a contract for three
experimental torpedo planes, Douglas, with financial support from Harry
Chandler, the *Los Angeles Times* publisher and real estate entrepreneur who
used his position to promote industrial development, incorporated as the
Douglas Company in July 1921. The following year forty-two employees
relocated to a movie studio at 1924 Wilshire Boulevard in Santa Monica.

The site was chosen for its adjacent field, which proved inadequate for test flights; completed aircraft were towed to Clover Field, a private airfield established in 1923. Between 1922 and 1928 Douglas produced 375 units, 314 for army and navy contracts. In the latter year, the company moved its entire operations to Clover Field, which the city of Santa Monica had purchased two years before. Municipal ownership assured continuity of operation, the requisite zoning, and eminent domain for expansion.[25]

In 1928 the firm opened a subsidiary adjacent to Mines Field, an airstrip the city of Los Angeles had recently leased for a municipal airport. By the time the city purchased the property in 1937, the district had become a nucleus for prime airframe contractors, subassemblers, and parts and component manufacturers. Local governance and control also enticed North American to select a site in the airport's southeast quadrant.

Collectively, these decisions on location contributed to an ongoing interregional restructuring. Initially, the majority of airframe, engine, and propeller firms concentrated in the manufacturing belt, with principal agglomerations in New York and Ohio. Then, during the 1930s, airframe contractors relocated or set up shop in Southern California, and the West Coast's share of national output increased from 14 to 40 percent. The

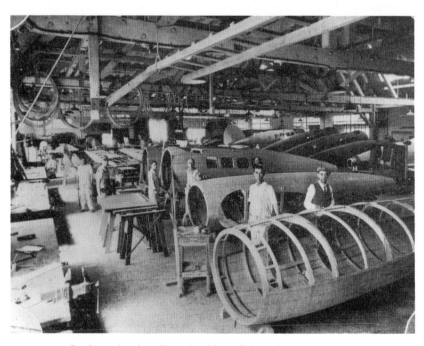

FIGURE 4.5 Craft production, Douglas Aircraft (1920)

Department of Commerce's 1939 *Census of Manufactures* recorded the aircraft industry's interregional shift as the most extensive among the key 139 industrial sectors.

In California this expansion spurred regional employment. The Commerce Department's 1939 *Census* reported a 50 percent increase in the number of wage earners employed in aircraft and parts production in 1937. After modest growth in 1938, the ranks of nonsalaried workers grew 122 percent in 1939, 80 percent in 1940, and 110 percent in 1941. By 1940, 60 percent of airframe employment was concentrated in the western district. At the beginning of the year, 48,000 workers were employed in California alone. Two years later, that number exceeded 150,000, or 48 percent of the national total. The wartime peak occurred in California during 1943. At that time, prime contractors employed 280,000, 40 percent of the manufacturing workforce. Between 1940 and 1943, civilians employed in manufacturing increased 271 percent statewide.[26]

Initially, the increased labor demand was met locally through sectoral employment shifts, the reemployment of workers previously underemployed or unemployed, and new wage earners entering the workforce. Eventually the in-migration of additional workers became mandatory. In February 1936, *Newsweek* noted that Los Angeles's "aeronautical factories" faced a "labor shortage" and that "factory heads find the region's supply of skilled airplane craftsmen already depleted." Three years later, Security–First National Bank reported that aircraft industry expansion provided thousands of new jobs for local residents while attracting "skilled laborers . . . in significant numbers from other industrial centers." In 1941, thirteen thousand new workers were joining Los Angeles's industrial payroll each month. By 1944, one-quarter of the county's residents had arrived during the preceding four years.[27]

According to the state Department of Industrial Relations, two out of every three persons "recruited to the ranks of the civilian employed augmented the personnel of manufacturing firms." The aircraft and shipbuilding industries led this unprecedented growth, "absorb[ing] one-half of the entire 1940–1942 increase in the total number of civilian employees in California."[28] Whereas in 1939 prime contractors employed 15,000 aircraft assembly workers in Los Angeles, by 1943 their number had grown to 190,700, 40 percent of the regional workforce.[29]

As early as February 1941 the *Los Angeles Times* had begun reporting the dramatic effects the defense program exerted on Southland communities. "Burbank Has Become a Hive of Aerial Industry" outlined Lockheed's

"meteoric growth." In a single year the company had grown from 7,400 employees working, in 668,000 square feet of shop space on a backlog of $13.9 million in orders, to 18,569 employees, 1,259,387 square feet of plant, and $277.3 million in orders. At this point the company employed another 5,000 workers in satellite facilities. The *Times* presented Lockheed as a "colossal" enterprise where planes begin as "raw pieces of metal at one end [of the facility] and come out the other painted with their names and insignia." The author noted as well "sideline industries" such as Aero Tool Company, manufacturers of machine-tooled aircraft parts, rivets, and drivers, and Acme Tool and Machine Company, which turned out cameras for Army aircraft. It was these ancillary industries producing parts and sub-assemblies that allowed Lockheed, Vega, and other prime contractors to meet their deliveries, not a belt-line factory, as the *Times* had reported.[30] Still, by 1943 Lockheed and Vega formed the nucleus of an impressive industrial zone in the San Fernando Valley's southeast quadrant. In his monthly NHA "Area Requirements," regional director Joseph Weston portrayed Lockheed and Vega as "industrial concerns of the largest magnitude," employing over 72,000 of the valley's 87,500 war industry workers.[31]

Security–First National Bank tracked the defense build-up and the benefits for Los Angeles business in its *Monthly Summary of Business Conditions.* In July 1941 the bank noted:

> The defense program is now one year old. The effect on Southern California business to date has been favorable in practically every line. Industry has expanded at a rate never before approached in the history of the area, the growth being fully as impressive as that in Detroit when expansion of the automobile industry was underway. Industrial employment has increased by more than fifty percent. . . . Construction activity is at its highest in fifteen years.[32]

Increased production in the 1935–41 period has been attributed primarily to additional work shifts and improved production efficiency. However, greater floor space, achieved either by physical expansion or leasing, was essential.[33] Fixed plant in Los Angeles increased explosively. In January 1939 the county's airframe manufacturers controlled 2 million square feet of floor space. One year later, they had expanded this area to 3.270 million, two-thirds of the national total. By August, floor area was up to 3.836 million square feet, and the Big Six firms (Douglas, Lockheed, North American, Northrop, Vega, and Vultee) projected an additional 2 million. By December the total stood at 5.844 million square feet, or an

increase of 292 percent in two years.[34] In lieu of contracting for additional space, each of these firms established a system of feeder plants. North American, for example, moved their entire subassembly department into leased buildings in Pasadena. Later they converted the Hollywood Park racetrack into a warehouse and purchasing department.[35]

The workforce was changing qualitatively as well. Prior to 1935, aircraft manufacturing and assembly was essentially craft based. Skilled technicians worked at fixed stations in small, multistoried loft buildings. Vultee introduced the first powered conveyor assembly in 1942. In the interim, a production system structured on point assembly had been rapidly transformed into an integrated line-assembly system.[36] Production engineers reconfigured the specialized tasks into routinized procedures that semiskilled and unskilled operatives could accomplish following a minimum of training. In just four years (1940 to 1943), wage earners employed in aircraft and parts production classified either as operatives and kindred workers or as laborers rose from slightly less than one-third to over two-thirds of the labor force.[37]

Until 1940, contracts called for one to three planes on average. Management routinely scheduled concurrent production on ten different models, and various aircraft crowded the assembly floor. Military orders for multiple units of a single aircraft supported the adoption of continuous flow principles, which reduced production time dramatically and cut costs almost in half. To meet production deadlines, prime contractors such as North American and Douglas relied on feeder plants and ancillary industry. These included shops manufacturing metal castings and forgings, wood patterns, coil springs, electrical supplies, radio and communication equipment, and safety instruments. Between 1939 and 1941 the Los Angeles Chamber of Commerce reported on over fifty firms that either began initial business operations, moved to the Los Angeles region, or expanded to new production facilities within the county.[38]

Harvill Aircraft Die Casting Corporation was representative. Henry L. Harvill, a mechanic and backyard machinist, developed an innovative technique for casting aluminum parts under high pressure in dies milled from solid tool steel. Harvill capitalized on military contracts and within a few years was supplying cable pulleys, pedestal mountings, hydraulic landing gear and deicing parts, bushings, bearings, and cowlings to Douglas, North American, Northrop, Vega, Vultee, Ryan, and Boeing. After enlarging his original plant at 2344 East 38th Street in 1939, Harvill purchased a ten-acre Century Boulevard site adjacent to Los Angeles Municipal Airport in

July 1940 and constructed a sixty-thousand-square-foot facility for 350 mechanics and 50 office staff.[39] In February 1941, the Chamber of Commerce reported that Hughes Aircraft had purchased 380 acres on Jefferson Boulevard north of Loyola Marymount University. The firm's total investment for land, construction, and outfitting four buildings was $1.5 million. In June, *Southern California Business* cited Hughes again, this time for constructing the "world's largest experimental aircraft works." Previously Hughes had operated in leased space at Union Air Terminal in Burbank.[40]

Rapid industrial expansion and the escalating demand for workers exerted enormous pressure on the region's housing supply. The National Housing Agency's "Locality Reports" and testimony offered to the House Subcommittee on Naval Affairs, the Tolan Committee, and the Senate Military Affairs Subcommittee on Manpower attest to the level of need. John C. Lee, a representative from the War Production Council (an advocacy group for the aircraft industry), singled out housing as the manufacturers' greatest concern. Lee filed detailed statements supporting the council's findings that labor turnover, then in the range of twenty-two thousand workers a month, was the "single most important phase of the manpower problem." The Census Bureau found over sixty-four thousand persons occupying "rooms or suites in hotels and dormitories" and identified another sixty-eight hundred as lodginghouse residents. No doubt those surveyed considered themselves fortunate. Others lived in whatever accommodations they could manage. A cartoon from the House Committee for Congested Production Area's *Final Report* illustrates "hot-bedding," a common practice.[41]

The FHA's Role in Defense Housing

Housing need had two aspects. The first concerned absolute numbers. Even though the vacancy rate in Los Angeles hovered just over 6 percent at the beginning of the defense buildup, the influx of workers soon eclipsed the supply of available housing. By May 1942 the number of vacant units dropped over 40 percent, and the War Production Council requested authorization for twenty-one thousand dwelling units for their workers alone.[42] Although housing availability was a critical concern, over time the location of dwellings became far more pressing. As we have seen, established regional airframe manufacturers such as Douglas and Lockheed selected outlying sites adjacent to stable airstrips for their production

facilities. When these firms expanded, their locational criteria led them to similar sites within the metropolitan region. For example, when Douglas needed production space in addition to its Clover Field and El Segundo facilities, management chose a site adjacent to Long Beach airport.[43]

Home builders anticipated an influx of defense workers drawn by these employment centers and selected property in close proximity to new production facilities for the plotting and construction of new communities. In May 1938, analysts at Security–First National Bank called building "the brightest spot in the current industrial picture." They noted the concentration on small homes and inexpensive lots, "reflecting the new FHA program." Throughout this period the bank placed housing reports, rather than the aircraft industry's takeoff, on the front pages of its *Monthly Summary*. As an index to the strength of this recovery, it is important to note that from 1936, when FHA *Annual Reports* first published data on mortgages insured by states, to 1941, California averaged 19 percent of the national total.[44]

As Security Bank's reports suggest, FHA policy amendments provided the supply-side stimuli for increased housing starts. In February 1938, the FHA initiated a new class of mortgage insurance targeted precisely toward small homes. Title I, Class 3 loans were restricted to purchases with principal under twenty-five hundred dollars. The FHA designed this program to entice builders toward the burgeoning market of factory workers such as those entering the aircraft industry. A second inducement, Section 203, increased the percentage of the home mortgage available from 80 percent of appraised value to 90 percent and extended the repayment period to a maximum of twenty-five years on owner-occupied homes valued under fifty-four hundred dollars.[45]

Following the extension of FHA guarantees, private sector residential construction in the Los Angeles metropolitan region attained levels surpassed only during the boom of 1923.[46] More important, the Southern California FHA office received 1,793 Class 3 applications, one-fifth of the national total.[47] This home-building wave crested in the spring and summer of 1941, when authorizations for family units averaged 4,550 a month. Between April 1, 1940, and May 1, 1942, Los Angeles builders constructed ninety-five thousand family units countywide.[48]

The FHA *Annual Report* for 1939 included the most extensive data on housing and home buyers released during the 1935–50 era. That year, just over 30 percent of the new, single-family dwellings approved for mortgage

insurance in Los Angeles were valued below four thousand dollars. By contrast, of the largest twenty metropolitan areas in the country, only in St. Louis did greater than 10 percent of FHA-insured dwellings fall within that price range.[49] In short, Los Angeles and Southern California were in the forefront of a national recovery and, specifically, the provision of low-cost homes for wage earners previously locked out of home ownership.

At this moment, a set of discrete but mutually reinforcing factors allowed a particular set of Los Angeles real estate developers and subdividers to incorporate home and community building into their operations. More critically, these operative builders extended the home-buying market by focusing on low-cost dwellings for wage earners. Security Bank noted this when the *Monthly Summary* carried a brief statement: "Large-scale housing projects, the subject of much interest in recent years, are at present becoming reality in the Los Angeles metropolitan area." The author pointed to FHA-insured projects such as Wyvernwood (at eleven hundred units the largest housing project in Southern California) and Thousand Gardens (later renamed Baldwin Hills) as representative. Then in July 1940, the bank reported: "There continues to be considerable activity in private mass construction of relatively inexpensive homes selling, for the most part, from $2,500 to $3,000. A large majority of these houses are being built . . . within close proximity to industrial plants, principally aircraft factories."[50]

Westside Village, a 788-unit community development Fritz B. Burns and his business partner Fred W. Marlow began in 1939, can illustrate the trend Security–First National reported. Burns came to Los Angeles a real estate salesman and capitalized on the 1920s boom. Following the downturn, he recapitalized through oil and gas holdings to return in the vanguard of real estate and land development. Marlow studied engineering before moving to Los Angeles where he began his real estate career as a "roper," riding public transit and rounding up potential clients for speculators. Within a year he made the transition to subdivider–lot seller, plotting a tract at Owensmouth (now Canoga Park) in the San Fernando Valley.[51]

Despite Marlow's professed opposition to the New Deal and any participation by government in housing, California senator William Gibbs McAdoo appointed him the first FHA district director for Southern California and Arizona. The developer embraced the program's entrepreneurial aspects and became a vocal advocate for low-cost dwellings, volume building, and modern community planning. In an address to the California

Real Estate Association (CREA), he challenged his colleagues to produce houses selling for less than thirty-five hundred dollars.

> Right there is the biggest market. . . . Just as the auto industry met the same mass market, deluged it with fine low-priced cars and put the whole nation on wheels, so the housing industry must build good houses for the masses at prices they can afford. The real estate fraternity can sell this market by offering an acceptable product at the right price. This does not mean the building industry must content itself with lower profits. Rather, it may find it better business to narrow the profit margin on unit sales and build more units.[52]

Marlow knew from experience that realtors' and home builders' primary motivation was economic. To date, self-interest had focused their attention on middle- and upper-income buyers. The FHA strove to expand this market, and Marlow made his pitch in terms of mass sales, a language and calculus his developer colleagues could divine easily.

Marlow drew on knowledge gained during his tenure and capitalized on a network that included key personnel in government and finance for later projects. Burns possessed considerable institutional capital as well. He chaired the Los Angeles Realty Board's Subdividers Division in 1930 and later served as president of the National Association of Home Builders. Burns played a key role in organizing the Home Builders' Institute of America, an NAREB affiliate chartered in 1941 to lobby local, state, and federal officials regarding subdividers', land developers', and home builders' interests.[53]

In 1938 the two land and lot sellers formed Marlow-Burns and Company, Realtors, Owners, and Developers, to improve a tract on the east slope of Baldwin Hills, just south and west of Leimert Park. Northridge Drive and Slauson Avenue formed the property's northern and southern boundaries, Keniston Avenue and Overhill Drive defined the tract on the east and west. Marlow-Burns marketed Windsor Hills to first-time purchasers. Printed advertisements touted the "new 90% FHA financing" and encouraged potential clients to avoid the "rent wringer" (see fig. 1.6). The developers laid out a curvilinear street system fronting 572 "spacious building lots" averaging 60-by-140 feet. The $1,450 to $1,850 purchase price included "paved streets, electroliers, sidewalks, curbing, gas, water, electricity, and parkway planting." Print ads also extolled the virtues of ready access to county-maintained Ladera Park.[54]

As they had in the past, the developers sold these lots to investors, fami-

lies interested in constructing or contracting their dwelling, and builders completing units for speculation. What makes this project of interest, however, is that Burns and Marlow built houses for the first time at Windsor Hills. William Hannon, their sales manager, explained this transition in strictly economic terms. When developers such as Marlow-Burns improved a tract, they assumed a series of carrying costs. The first was for the property. Additional indebtedness accrued from improvements. Typically, 70 to 80 percent of the lots would be sold to home builders. To encourage sales, developers offered builders concessions, which often took the form of a low down payment and a release from installments for two to six months. At Windsor Hills, Burns and Marlow required 25 percent of the lot price down and the first payment in six months. As a result, while the builders' financial commitment was limited, the developer incurred an increasing level of obligation and a stagnant cash flow. In effect, they were subsidizing the builders who stood to profit when the dwellings were completed and sold.[55]

Recognizing the extent of nonproductive capital they had invested in the preliminary stages of development and lured by the promise of increased profit, Burns and Marlow decided to integrate home building into their operation. There was an important caveat; they made this decision confident that FHA approval of their house plans would assure them financing and, after the units were complete, FHA mortgage insurance would eliminate the risk of foreclosure.

Marlow-Burns offered buyers a "Windsor-Built System Home" in eighteen plan types ranging from the "Two-Bedroom Standard" to the "Special." Except for the "DuBois," named after the architect, Wardell Engineering and Construction provided the unit design. These were middle-class dwellings targeted for salaried managers or professionals. Even the relatively modest two-bedroom model included a separate dining room in twelve hundred square feet and cost $5,150.

Although Marlow-Burns constructed individual dwellings at Windsor Hills, they acted primarily as developers converting raw land into lots for sale. Except for a few parcels dedicated to commercial development, the tract consisted solely of house sites; there were no schools, libraries, or churches, nor was there a park or playground within the tract. Finally, despite the repeated references to Henry Ford and mass production, Marlow and Burns adopted a strategy closer to the full-line approach perfected by General Motors. The eighteen Windsor Hills unit plans were graded to attract a range of customers, and annual models added to this variety.

Westside Village

It was at Westside Village that this particular group of real estate entrepreneurs made the transition from land developers and lot speculators to community builders. For this project, Burns selected a site approximately two miles from Clover Field, Douglas Aircraft's parent facility in Santa Monica (fig. 4.6). Burns owned the title to the property, hired J. Paul Campbell as his builder, and financed the construction. Print ads highlighted the workplace-residence link (fig. 4.7). In an aerial perspective, the Douglas plant is prominent while the distance between the new housing and potential employment has been artfully reduced.[56]

Westside Village showcased formal principles central for modern community planning. The site planning demonstrated the lineage and utility of the neighborhood unit as drawn from FHA technical bulletins. Major and minor streets were clearly defined and sized for their intended use within a system designed to facilitate internal access and discourage through traffic. Burns and his associates proportioned the lots in the order of 1:2 and 1:3 (width:depth) and placed two-bedroom, 885-square-foot dwellings on these 5,400- to 6,000-square-foot parcels. FHA guidelines required builders to pull the unit back from the property line and encouraged them to orient dwellings so that their ridge lines paralleled the street. Burns used a single floor plan throughout, alternating the garage location and roof massing and adding covered porches and trellises to enliven an otherwise homogeneous tract.[57]

The unit plan reflected the spatial standards technicians had identified and codified and the FHA had endorsed. The efficient, four-room-plus-bath house incorporated simplicity of design, flexibility of spatial arrangements, and the preferred reorientation of living spaces (fig. 4.8). Burns adopted the scientific kitchen and included up-to-date appliances. This allowed him to eliminate the pantry. In its place was a utility room with an integrated mechanical system that replaced the basement heating plant and coal storage. Burns and Campbell pre-engineered the service core; supply and waste lines for the kitchen and bath were located back-to-back, reducing material costs and the time and labor required to plumb each unit. Finally, note the orientation of the kitchen in relation to the site. It is facing the rear yard, the focus of private family life.[58]

Setting aside some minor modifications, the Burns plan replicates the FHA's minimum unit illustrated in "Principles of Planning Small Houses" (see fig. 2.2). Burns added a small bay in the living room, which provided a

discrete alcove, a compromise between a dining room and kitchen eating nook. The builder also turned the utility room into an entry porch by shifting it to an exterior corner. Except for these minor refinements, the plan presents a distillation of twenty years of reform and innovation. The basic house type Marlow-Burns introduced at Westside Village became a standard for subsequent projects and was the precursor for Kaiser Community Homes' postwar developments.[59]

Within the project, Burns sited individual homes irregularly to create what he described as "architectural sequencing." This attention to the formal attributes of the street and the project distinguished community builders from small-scale builders whose focus was an individual dwelling.[60] David D. Bohannon, president of a San Francisco firm that included the term *community builders* in its title, expressed this concern for the streetscape in these terms:

> Most important in creating an attractive development of standard small homes is land planning and subdivision pattern. The project must be planned as a whole, and houses placed on each lot so as to have good orientation and elevation detail giving the feeling of variety within the range of vision. At least sixteen distinctive elevations should be used—

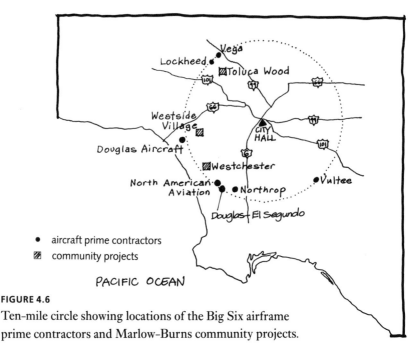

FIGURE 4.6
Ten-mile circle showing locations of the Big Six airframe prime contractors and Marlow-Burns community projects.

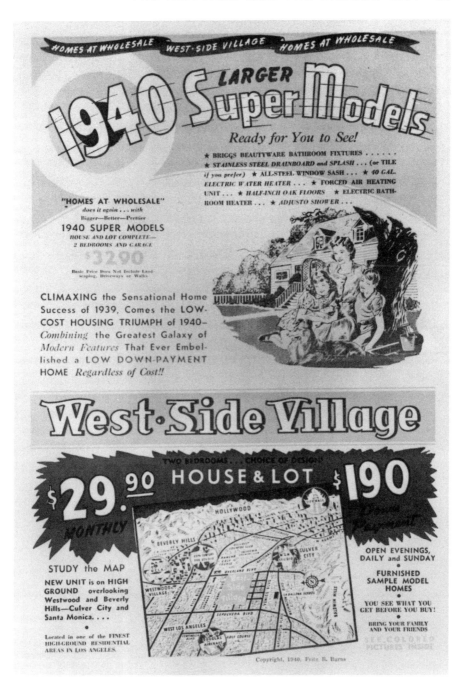

FIGURE 4.7 Marlow–Burns advertisement

twenty or twenty-four can be created from one floor plan. Color and ex-
terior materials deserve expert handling. . . . To avoid monotony . . .
there must be a number of roof elevations. Landscape will do the rest.[61]

Bohannon and other builders recognized the importance of siting, mass-
ing, building finishes, and landscaping—in other words, comprehen-
sive planning—if community-scaled projects composed of multiple small
dwellings were to be attractive and profitable.

Westside Village home owners were encouraged to enhance this formal
variety. Burns offered residents building material for fences and landscape
material at volume prices. Their labor helped assure that the "efficiencies
and economies of [volume] building have not sacrificed individuality."[62]

At Windsor Hills, Marlow-Burns and other home builders constructed
individual dwellings following standard construction practices. At West-
side Village, by contrast, Marlow-Burns first applied the principles of mass
building (fig. 4.9). They organized a staging area along National Boulevard
where suppliers delivered materials that workers precut and preassembled
for eventual trucking throughout the construction site.[63] The site itself be-
came a continuous production process. Specialized teams of laborers and
craftsmen moved sequentially through the project, grading and grubbing,
preparing and pouring foundations, framing and sheathing the building
envelope, and applying finish materials. A full decade before Levittown, we
find the application of manufacturing practices developed for production
in the factory adapted to the on-site assembly of housing. This trans-
formation in home building was the product of a twenty-year debate con-
cerning the standardization of unit design, industrial organization, and

FIGURE 4.8
Two-bedroom house plan,
Westside Village.

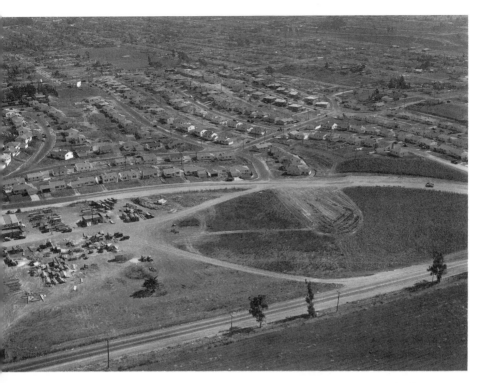

FIGURE 4.9 Westside Village under construction. Note the staging area in the foreground.

rationalized production. Horizontal building operations, and the added degree of management and coordination it required, were essential for mass housing and the low-cost manufacture of multiple units.

In 1939, units in Westside Village sold for $2,990 complete. Buyers needed $150.00 down, and monthly payments were $29.90. Burns kept final costs low by leaving sitework, such as driveway paving, and finish work, including exterior painting, to the home buyer. Burns was, in essence, selling an entire project rather than a single house. Westside Village is notable because it offered working-class families a community package.[64] As the developers of a 788-unit project, Marlow-Burns was almost without peer. Fewer than one-tenth of one percent of Los Angeles builders completed one hundred or more units that year.[65]

Similar factors informed development at Toluca Wood, a four-hundred-unit project built on open acreage straddling the North Hollywood–Burbank line. Marlow-Burns began construction in May 1941; the de-

velopment was substantially complete a year later. Here, Burns sold the identical two-bedroom units for $3,690, including lot, house, garage, and improvements. According to the sales brochure, "standardized floor plans and large-scale operations made possible many luxury features usually associated with residences costing many hundreds of dollars more." The brochure also touted the homes' location—"Within a three mile circle are the great Vega and Lockheed Aircraft plants and scores of allied industries"—while claiming that home buyers were "representative of scores of diversified industries throughout the great San Fernando Valley."[66]

An aerial photograph of the Lockheed facility published in *Los Angeles: Preface to a Master Plan* (1941) illustrates North Hollywood's low-density land use pattern. The caption notes the number of automobiles, indicative of the "need for convenient housing facilities; the space available for such housing is clearly evident." In 1940, census enumerators reported that three-quarters of the homes in this sparsely settled tract were built after 1930. Then, between 1940 and 1946, twenty-nine thousand new residents (a population increase of 75 percent) moved to this section of the metropolitan region.[67]

Westchester, "A Model Community"

Congress passed Title VI of the Housing Act in March 1941. This legislation provided home builders additional incentives for concentrating on the small-house market. Title VI was restricted to 146 industrial areas where the defense housing coordinator forecasted critical shortages. The stated objective was to stimulate private construction proximate to defense manufacturing. Under Title VI, home builders in critical housing areas could apply for direct guaranteed loans up to 90 percent of a project's appraised value. These loans reduced developers' up-front costs and assigned risk to the federal government. Only defense workers employed in certified industries and earning less than three thousand dollars a year were eligible for these units, which had to be purchased or rented for under fifty dollars a month. During the first year, California accounted for over one-quarter of the Title VI loans guaranteed nationwide.[68]

A contraction in home construction began in August 1941. The business community assigned the drop-off to material shortages associated with the defense buildup. The Priorities Division of the Office of Production Management initiated restrictions on critical building materials for defense housing on September 22, 1941. In April 1942, the War Produc-

tion Board banned nonessential construction. These material allocations benefited builders like Fritz Burns by directing construction toward authorized work, which, in addition to war production plants, included "small homes for war workers." In effect, the building materials priority system sustained the volume of low-cost private residential construction in defense-housing critical areas. In Los Angeles, the programs enhanced and further solidified a particular configuration in home building that had begun crystallizing in the late 1930s.[69]

Marlow-Burns participated in the premier example of wartime nodal development—Westchester, in southeast Los Angeles. The tract, in what was known popularly as the city's "West Coast section," had been held in syndication for forty years by the Los Angeles and Inglewood Extension Companies. For years, grazing sheep and wildcatting for oil were the primary activities. When the property went into receivership, Security–First National Bank took over acreage in use as beanfields and a hog farm, the latter sited prominently on the northwest corner of Sepulveda and Manchester.[70]

In just four years (1941–44) developers converted a five-square-mile parcel into a complete community for ten thousand residents housed in 3,230 units.[71] The bank's development plan centered on a commercial district along Sepulveda Boulevard from Manchester Avenue south to Ninety-sixth Street. Security–First National sold three thousand acres to four sets of community builders, with restrictions against commercial development in lieu of a percentage holding in their business center. In addition to the Silas Nowell Building Company, developers of Westport Heights, the participants included Bert Farrar (Farrar Manor) and Frank H. Ayres and Sons (Kentwood). Marlow-Burns marketed their tract as "Homes at Wholesale" and built over one thousand units (fig. 4.10). Two-bedroom houses sold for $3,650 to $3,990 (figs. 4.11 and 4.12). Title VI restricted sales to workers in designated defense industries.[72] The NHA reinforced this advantageous market position in July 1942 when they restricted residential construction in Los Angeles County to the area south of Manchester and Firestone Boulevards.[73]

An oblique aerial from the southwest illustrates the pattern of development (fig. 4.13). "Homes at Wholesale" is the quadrant southeast of the Manchester-Sepulveda crossing. Ground was broken for the business district in August 1942. In this photograph taken three years later, the commercial core, though only partially realized, is readily apparent. A primary school, on property deeded to the Board of Education by Marlow-Burns,

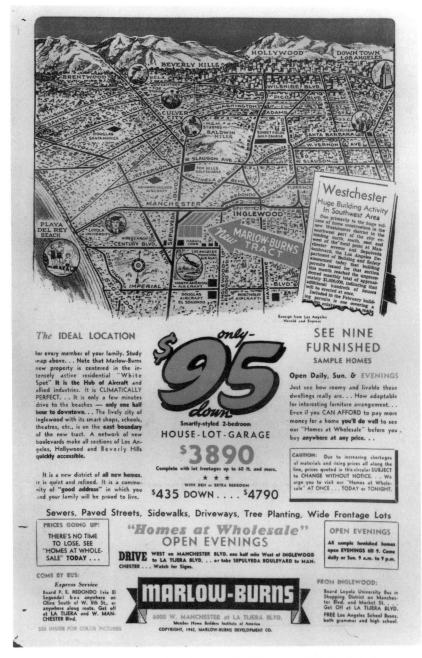

FIGURE 4.10 Marlow-Burns advertisement for "Homes at Wholesale" showing proximity to "Aircraft and allied industry."

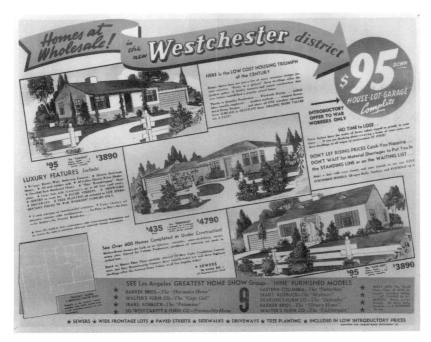

FIGURE 4.11 Three variations on the minimum house

is visible just south of Interceptor Street.[74] A view from the south looking across the airfield shows airframe plants in the foreground and a cluster of ancillary industry extending along Century Boulevard at the northern boundary of the airfield (fig. 4.14). Real estate advertisements highlighted the proximity to "substantial business enterprises employing many thousands of workers." A map in the *Los Angeles Examiner* identified twelve "important plants and allied projects."[75]

The *Los Angeles Daily News* touted Westchester as "the model residential community of the decade" in May 1942, citing unidentified city planners "from all over the country" who visited this "expertly planned community." In August the *Los Angeles Downtown Shopping News* extolled the development, placing it squarely in the lineage of modern community planning.

> You have only to visit Westchester to see the advantage of modern community planning over old-fashioned guesswork methods. In most old communities a hodge-podge of single-family, duplexes, apartments, and business properties are all mixed together. At Westchester you are at once impressed with the residential streets . . . and the business area . . .

located in the center of the community for maximum convenience to all. The entire Westchester district is served by a network of boulevards with intersections leading into residential areas carefully designed to provide the greatest safety. . . . The impression the visitor has is that here at last is a well-planned community for moderately priced homes.[76]

Westside Village, Toluca Wood, and Westchester were not intended as suburbs, if the term is used to invoke economically inert bedroom communities populated predominantly by middle- and upper-income families. The social homogeneity of these "good residential neighborhoods" was mirrored in a low-density and functionally exclusive land use pattern zoned to prohibit incompatible or noxious uses that might diminish property values.[77] Nor were Lakewood Village, Lynnwood Park, Murray Woodlands, and other wartime developments in Los Angeles and elsewhere the less expensive spin-offs of upper- and middle-class neighborhoods of good address.[78]

A number of factors set Westchester apart from the residential suburb. Although it shared a curvilinear street pattern fronting rows of single-family dwellings occupied by home-owning families, Westchester and other developments were not planned as sleepy, provincial commuter sheds

FIGURE 4.12 The Marlow-Burns "Defender"

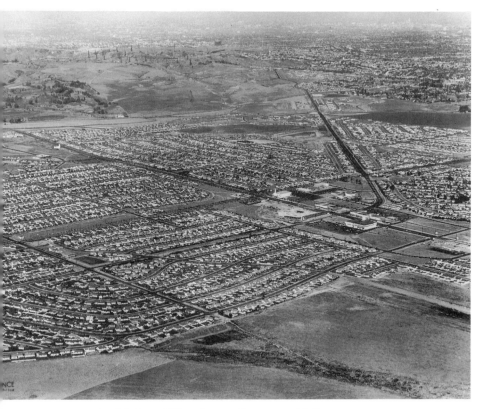

FIGURE 4.13 Aerial view of Westchester. Compare with figure 4.2

of workers destined for the urban core. And even though their developers sited "modern" homes on lots ample enough for side and rear yards, the land use density was greater than in the traditional suburb.[79]

Homogeneity by income and occupation, a central factor for the traditional suburb, did not hold here, either. Data on class of workers from the 1940 and 1950 censuses reveals a high degree of heterogeneity in Westchester. Semiskilled and skilled workers predominated, but there was a statistically significant number of laborers, managers, and professionals. The census classified approximately one-quarter of the residents employed outside the dwelling as operatives and laborers, another quarter as professionals, one-fifth as craftsmen, and just under one-fifth as proprietors and managers. These percentages remained consistent into 1950, despite an increase of over 3,900 percent in the number employed.[80] Community builders presented this diversity as a selling point. Ads for Lakewood Village, a

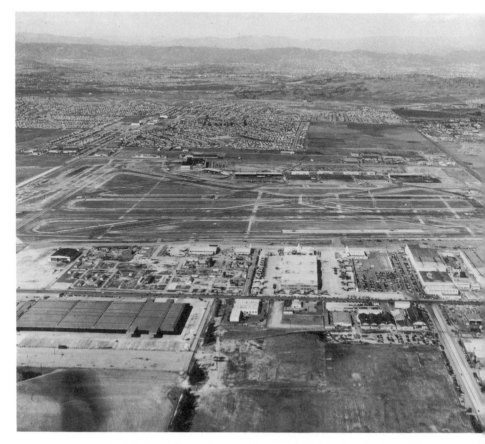

FIGURE 4.14 Aerial view of Westchester taken south of Los Angeles Municipal Airport (now LAX) showing aircraft prime contractors and ancillary industries in the foreground and Westchester beyond.

twenty-five-hundred-unit project constructed adjacent to Douglas's new facility at Long Beach Airport, promoted it as a "fifteen-million dollar community of individualized homes for defense workers and executives."[81]

Finally, these communities subverted the principal raison d'être of the residential suburb, middle- and upper-class flight from the industrial city. Examining specific case studies and exploring the causal role of defense industries reveals a tight and desirable link between employment and home building. These wartime developments were planned as complete communities for balanced living, affordable for workers and families. Home builders recognized the significance of new manufacturing and capitalized on the employment opportunities these plants offered. Following the princi-

ples of modern community planning, they integrated the residence, civic and commercial facilities, and the workplace and offered this package to wage earners, thereby tapping a vast, previously neglected market. The workplace-residence link was essential to the whole enterprise of satellite development. The aircraft industry provided the economic foundation, the manufacturing base, and the people that necessitated and sustained community building, which in turn accelerated an emerging pattern of regional metropolitan growth.

Postwar Projections

War workers migrating to defense production sites and housing policy enacted to meet their shelter needs provided developers and home builders the incentive and means to experiment with and adapt many of the construction techniques and innovations in management and industrial organization productionists had promoted during the preceding two decades. In 1945 the Bureau of Labor Statistics estimated the probable volume of postwar construction. The bureau spoke directly to the war's impact on home building and the evolution in construction practice.

> [During the war] off-site processing increased and site work [now] consists less of fabrication and more of installation. Site fabrication has been segregated to an increasing degree; cutting and processing are carried out at temporary shops followed by installation by another group of workmen. Greater attention has been given to scheduling materials and material flow, to timing of operations, and to the organization of the work between specialized gangs to reduce waste motion and lost time. . . . All of these developments may be expected to continue.[82]

The report noted that "numerous firms have pursued programs of design and development and have made concrete plans for postwar operation." The specific reference was to off-site fabrication of "floors, walls and other elements [a practice which,] although known for many years, was quite limited in extent prior to the war." The bureau predicted this "division of the construction industry will expand tremendously."[83]

In addition, the bureau determined that builders who had completed "projects of several hundred units" during the war had advanced large-scale operations and "manufacturing economies"

> marked by more thorough planning of operations, more careful timing and control of materials, and greater use of power-operated tools than

were general in prewar promotional building. Numerous contractors accustomed to management procedures [undertook] residential work, and residential builders learned the possibilities present in large-scale operations. On some projects, materials were bought directly from manufacturers. In these respects and others, the housebuilding industry matured substantially.

After reviewing these factors, the bureau concluded that the war housing program anticipated postwar projects of larger average size. While small builders would retain a place in the industry, "an increasing part of total volume will be in projects of 25 to 50 units, and to some degree in projects up to 100 units."[84]

Community builders such as Burns and Marlow were planning aggressively to realize the bureau's predictions. Burns established a research division in 1943 to "field-test products, processes, and the durability of materials." To test "public acceptance," Burns turned to an established builders' practice, the housing exhibit. His "Postwar House" opened in 1946 on the corner of Wilshire Boulevard and Highland Avenue. Over two hundred manufacturers and suppliers donated materials and products. Burns hired the architects Wurdeman and Becket to design a backdrop for these components that would appeal to a cross section of potential home buyers.[85] This strategy was all the more effective because the target audience had been anticipating this moment for the past twenty years. The building interregnum exacerbated demand, and home builders' associations, public utility companies, federal housing agencies, and manufacturers conjured a profusion of "homes of the future," which predisposed the "legion of the home hungry" to "miracle homes" or, at the very least, a "vague expectation of new materials and new designs resulting in houses of fundamentally different character from those of the past."[86]

At the same time, some factors of the community-building process remained constant. Land was one of these, and Burns had positioned himself favorably for the expected postwar expansion. He had considerable holdings in the Los Angeles region, controlling approximately three thousand acres of developable property. And in association with Fred Marlow, Burns had organized and successfully completed some of the largest projects in Southern California and the nation.[87] Burns and Marlow had recognized the new market that federal housing policy and industrial expansion generated and acted upon these favorable conditions. In the process they had

finessed a critical transition, coupling volume production of a rational, low-cost house, the expanding market of wage-earning families desirous of home ownership, and the functional and formal dictates of modern community planning. This configuration became the foundation for postwar community building and the basic module for postwar urban expansion.

Cities and Flight

With the end of armed conflict in sight, Lewis Mumford published "An American Introduction to Sir Ebenezer Howard's 'Garden Cities of To-Morrow.'" Here the éminence grise of regionalism proclaimed: "At the beginning of the twentieth-century two great inventions took form before our eyes: the airplane and the Garden City; both harbingers of a new age. The first gave man wings and the second promised him a better dwelling place when he came down to earth."[88] Mumford believed this new transportation technology would transform urban regions into garden cities.

Mumford was not alone in divining the airplane's importance for urban patterns. By 1945, aircraft, airfields, and the urban region had been the subject of a vigorous twenty-year debate that centered principally around land planning. After noting that "railroads changed the United States from a group of isolated states into a union [and] the automobile . . . obliterated state lines," United Air Lines president P. G. Johnson promised "there is reason to believe the airplane will work a similar transformation in this generation."[89] The debate over the proper location of airfields and terminals engaged representatives from the aeronautics branch of the Department of Commerce, regional planning agencies, and local boosters. The Commerce Department organized a Cooperative Committee on Airport Zoning in 1930, the Los Angeles Chamber of Commerce tracked the "amazing gains" in air travel and aircraft ownership, and in a prescient 1929 editorial, *Southern California Business* had speculated that airport development would attract related manufacturing, which would lead eventually to the creation of "community centers around the fields where airplanes land and take off." When Mumford made his pronouncement, municipalities and developers were confronting this issue head-on.[90]

Although Mumford captured poignantly the importance and magnitude of these two "inventions," he envisioned them linked inextricably: "If the [airplane] is to become as much a part of our daily lives as the motor car now is, it will be so only after the Garden City, with its wide belt of open

land, has become the dominant urban form." Contrary to Mumford's assessment, a coupling of the airplane and the garden city was already in place, albeit not in a form Mumford could endorse.[91]

In 1945, government agencies, local officials, business elites, community builders, and planners found exceptional promise in the programs and experiments of the war years. For many, these innovations suggested that postwar home building might offer consumers greater variety and opportunity at reduced prices. Although at that time Burns could not have known where his recently established association with Henry J. Kaiser—and the capital and technical resources of Kaiser Industries—would lead, the following chapter, a case study of Kaiser Community Homes, reveals that some wartime experiments could not compete with systems already in place, and other innovations—for example, true factory fabrication—were never adopted.

By addressing a market the federal government supported, operative builders seized the conditions the defense emergency presented to advance the practices and consolidate the gains they had achieved in the late 1930s. To do this, they adopted the small, rational, four-room-plus-bath house type identified and codified by technicians—and actively promoted by the FHA—and coupled it with the community planning principles advocated by reformers.

KAISER COMMUNITY HOMES

The American home that we are fighting for is not just a well-built building, not even a building equipped with gleaming bathtubs and refrigerators. It is a dwelling place composed of house, neighborhood, and community rolled into one. TRACY AUGER

The needs of war housing brought problems of greater magnitude, involving whole communities of hundreds and even thousands of houses. These projects had to have shops and stores, schools, community centers, and other facilities. . . . After the war, many urban communities will be ripe for extensive building. . . . [N]ow is the time for every architect not needed in the war to be preparing for practice in a world where his invisible client, the community, is going to be more demanding than ever. Now is the time to learn to understand the neighborhood, the town, the city, the region, and all their inter-relationships which have significant bearing upon every individual building project within them. KENNETH REID

The secret of fast production is plenty of materials, plenty of space. KAISER COMPANY

A Postwar Prospect

At the end of the war, operative builders surveyed a landscape of unparalleled opportunity. Active-duty personnel had been promised housing consistent with the American dream as their rightful compensation for service (fig. 5.1). The staggering backlog of substandard dwellings enumerated in the immediate prewar Census of Housing had never been addressed, due to the all-out war effort. Doubling up, another result of the building interregnum of the 1930s, increased from 1941 to 1945, when defense in-migrants and many established residents shared accommoda-

tions. And contrary to the downturn in family formation during the Depression, young men and women increasingly chose to begin new families in the war years. Taken together, these factors aggravated short-term shelter needs and heightened the urgency for long-term solutions.[1]

In July 1944 the California Reconstruction and Reemployment Commission published a report on the state's war-driven population growth. The commission determined that more than 1.5 million additional residents had entered California since the last official census in April 1940, an increase surpassing that in any other state. Newcomers numbered 1.32 million; children born during the preceding four years accounted for the rest. From 1940 to 1946, Los Angeles alone gained 301,410 new residents, a 20 percent increase and the equivalent of the influx during the entire preceding decade. In a single year, 1943, six hundred thousand newcomers arrived in California, at that time the highest annual growth rate ever recorded in the United States. When *Women's Wear Daily* surveyed Los Angeles defense workers, 90 percent of respondents planned on staying; three out of four intended to build housing.[2]

The commission explicitly linked population and housing in its 1946 study, "California's Housing Crisis."

> The housing shortage, now acute throughout the United States, actually was a prewar problem in California. As a matter of fact, the steady increase in population in this state in the period 1930 to 1940 resulted in a definite lack of adequate facilities. As the nation approached war, homebuilding was not keeping pace with the natural increase in families and the continuous flow of new families into this state.[3]

However, as most housing pundits were quick to point out, immediate and long-range need did not, in itself, constitute the ground on which large numbers of units would be built. Need had to be translated into effective demand and, as it had in the 1930s, the federal government provided a medium for exchange. Defense jobs offered established workers an improved wage structure, others their entrée into industrial employment. For many families, higher relative incomes combined with wartime shortages and restrictions encouraged savings beyond customary levels. This pattern continued until 1945, at which time Americans had generated unprecedented reserves. After the war, wage earners, with an assist from FHA-backed mortgages, became prospective home owners. And following the passage of the Servicemen's Readjustment Act (or the GI Bill of Rights) in 1944, eligible personnel could couple FHA insurance with

their Veterans Administration loans to qualify for a purchase with no downpayment.[4]

In terms of production, the forecast was equally sanguine. The Bureau of Labor Statistics' assessment of postwar home building concluded that

> in almost every respect the United States is better prepared for sound expansion than after the previous war and in the 1920s. The construction industry is more mature. The home mortgage system is incomparably more satisfactory from the standpoint of both borrowers and lenders, and has provided useful minimum standards of construction and environment. Promotional builders following accepted business-management practices are much more prominent in the field than twenty-five years ago, and are likely to increase in prominence.[5]

Here, then, are the well-rehearsed causal factors that drove the home-building boom and postwar suburbanization. A chart of annual housing starts depicts the magnitude and extent of this cycle (fig. 5.2). Although residential construction never eradicated housing need, the speed of recovery and the number of units begun and completed each successive year outpaced most forecasts of what home builders could produce. During the war, private builders had followed FHA guidelines to secure insured mortgages and construction financing. They produced over 1 million units, 80 percent of the total built, and home ownership climbed significantly. In their 1946 report on the effect of wartime housing shortages on home ownership, the Bureau of Labor Statistics documented a 15 percent increase between April 1940 and October 1945. The authors compared this gain with similar intervals and found the wartime increase outpaced any comparable time span on record. Beginning in 1947, the majority of dwellings were owner occupied, for the first time since the census began tracking tenure in 1890. Single-family housing predominated. In 1946, one-family dwellings accounted for 88 percent of all housing starts. That figure dipped slightly to 83 percent by 1950, but the inescapable fact is that single-family, owner-occupied housing dominated the postwar home-building cycle.[6]

The nature and trajectory of this cycle is obvious, as is the continuing spatial dispersion; however, neither were inevitable. Granted, federal policy and programs favored the construction of single-family housing for ownership, surveys designed to elicit buyers' preference revealed this house type had gained widespread acceptance, and builders elected to focus their attention on this segment of the market. These factors, indi-

FIGURE 5.1
The postwar promised
land.

"After total war
can come total living"

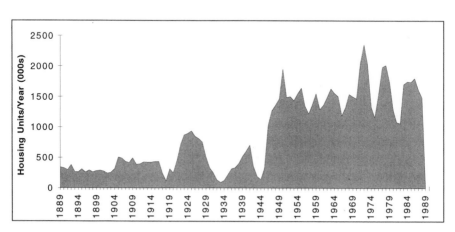

FIGURE 5.2 National nonfarm housing starts (1889–1989)

vidually or collectively, can not explain America's postwar metropolitan landscapes.

Stripping the gloss of statistics, hyperbole, and triumphalism away from the received history of postwar suburbanization reveals four basic tenets. First, the suburbanization that occurred after the war is cast as something new, unprecedented, and possibly revolutionary. Second, the entire process has been presented exclusively in terms of residential construction and home neighborhoods. Third, postwar suburbanization is perceived as predominantly middle class. And fourth, it is interpreted as discrete, something outside or even in opposition to the broader social and spatial concerns of city building.[7]

A case study of Kaiser Community Homes (KCH) challenges the received wisdom. Corporate officers hoped that Kaiser Homes, a fifty-fifty partnership of Fritz Burns and Henry J. Kaiser, would capitalize on the Burns organization's expertise in land development and home building and Kaiser's corporate assets.[8] In addition to the three thousand acres of developable property he held in Los Angeles, Burns brought to the association his recent experience as a community builder. Kaiser offered access to capital, the control, production, and handling of raw materials, expertise in fabrication and quantity production, and research facilities for testing new materials and product development. Kaiser's promotional literature and corporate records set out an ambitious agenda; the creation of a "national homebuilding enterprise [producing] not only dwellings [but] communities . . . which provide beauty and variety as well as . . . hospitals, recreation facilities, theatres, child welfare centers and all the conveniences and necessities of modern family living."[9]

Participation in public works projects and wartime practice at their Richmond shipyards and Fontana steel plant alerted officers with the Kaiser companies to community-scale housing and the advantageous coupling of home building and community services. Starting in 1943, when analysts began projecting the cessation of armed hostilities, technicians employed by a newly established Housing Division, a subsidiary of the Henry J. Kaiser Company, began considering postwar housing while simultaneously conducting research and development in a variety of construction technologies and household products. Kaiser executives anticipated a postwar expansion in housing and aggressively pursued expertise in quantity production, distribution, and marketing. Kaiser was one firm among many developing strategies to capitalize on the projected windfall from postwar consumer spending. The company planned for the national sales

of individual components and modules such as "Kaisercraft Coordinated Kitchens," the "Kaisercraft Unit Bath," and a "Kaisercraft Laundry Assembly," as well as a complete housing package (fig. 5.3). To achieve this, corporate officers drew up plans for a network of licensed franchises in every region except the Pacific, where KCH would operate directly. While this comprehensive agenda eventually eluded them, KCH did complete a number of community projects in California, principally in Los Angeles. An examination of these operations can unveil the complexities and unevenness of housing production and community building in the immediate postwar years.

Kaiser Community Homes' evolution in industrial organization, management, production, and marketing challenges every tenet of the boom thesis. First, KCH's production innovations were far more evolutionary

FIGURE 5.3
Publicity photograph for an aluminum "motorless" Kaiser dishwasher.

than revolutionary. After the war, community builders, in this case Burns and Kaiser, purchased land, planned sites, obtained financing, installed infrastructure and improvements, constructed dwellings, and marketed these units to buyers in a manner consistent with developments traced in preceding chapters. This is not to say there were no changes in industrial organization and building technique or to negate the significance of the war and the considerable advances it engendered. It is simply restating a central argument; wartime practices had their roots in interwar experiments and programs, and many purported innovations had been field-tested prior to 1941 by the FSA and speculative builders.

Second, contrary to popular assessments, proximity to employment remained a central development tenet. Postwar dispersion was not an inchoate sprawl. Developers knew all raw land was not prima facie subdividable, and community builders could not and did not exploit each and every citrus grove or potato field. Modern community planning remained a highly valued objective, one that planners, builders, and their clients, the home buyers, pursued aggressively. In other words, the postwar spatial organization represented a planned deconcentration of jobs, housing, and services to the urban periphery.[10]

Third, the occupational and economic diversity noted at Westchester, Lakewood Village, and other satellite settlements for defense workers was seen in postwar projects. This was not happenstance. Burns and Kaiser, for example, intentionally programmed heterogeneity into their community developments. Writing as the Southern California chair for the state Reconstruction and Reemployment Commission's report on postwar housing, Burns lobbied for "modern neighborhoods" in "satellite cities" offering a range of units priced to attract a "varied community." Although stridently opposed to mixed-race neighborhoods, Burns and other developers chose to build housing that families from different occupational, income, and social strata could afford. Burns believed his projects would counter a stratification that he viewed as "un-American."[11]

Fourth, and most important for this study, are the linkages between these elements—comprehensive community planning, construction methods and standards, working-class home ownership, and the workplace-residence link—and their urban implications. Postwar home building was neither an isolated development nor one that affected cities simply by siphoning away people and resources. Kaiser Homes' community projects, such as Panorama City in Los Angeles's San Fernando Valley, were one facet in a wide-ranging process of metropolitan development. Although

the received narrative presents postwar city building as an outright rejection of urbanism and the city, community builders and practicing planners envisioned it differently. They recognized the intrinsic relationship between developments downtown and on the edge.

This is not to suggest that postwar city building matched the predictions Homer Hoyt and other urban theorists made; nor did it align precisely with the master plans the Los Angeles City Planning Commission drew, to cite just two sources from the multitude who envisioned an orderly, efficient, and socially uplifting postwar city.[12] At the same time, community builders hoping to roll out an unending supply of housing, situated in modern neighborhoods, in close proximity to employment, and interconnected by parkways, found conditions different from their expectations.

It required far more than ambition and capital to finesse the transition from home builder to community builder. Few could negotiate the organizational changes and coordinate or sustain the degree of project management large-scale projects required, particularly when firms began operating in multiple locales or markets. New entrants to the field, unfamiliar with the intricacies of land acquisition, housing production, marketing, and sales and without the wherewithal to coordinate these discrete phases of the development process, had an equal tendency to fail. Changing land values, materials shortages, market saturation, or inappropriate timing could easily derail even the relatively small number of established operative builders. All faced short-term but critical material shortages and sharply escalating costs in the first years after the war.

Consumer uncertainty compounded these difficulties. Here, builders faced a Scylla and Charybdis largely of their own making. They perceived themselves caught between home buyers' heightened expectations, which they purposefully stimulated during the 1930s and the war years through the continual publication and exhibition of "miracle houses," and the limitations imposed by product scarcity and cost. Builders responded by back-pedaling and adopting a more conservative approach. Home buyers waited in vain for a widely available, low-cost dwelling complete with up-to-date appliances and loaded with work-saving gadgets. A Bureau of Labor Statistics bulletin called consumers' "picture" of postwar housing "unrealistic" and found two common misconceptions: first, a vague anticipation of new materials and design resulting in houses of different character from those in the past, and second, concrete expectations of "luxury-grade mechanical equipment in inexpensive mass-market houses." The bureau sponsored

advertisements to "correct these impressions" but counted on the postwar houses themselves, which would demonstrate that these "irresponsible promises cannot be met."[13] Finally, even though the federal government's restructuring of financing and mortgage guarantees fueled the postwar home-building cycle, state and local policy could just as often restrict development as encourage it. Each of these factors, and the multifarious ways in which they intersected and inflected, must be examined for any region.

Kaiserism, Product Development, and Applied Research

Kaiser obtained his education in housing principally through business associations and philanthropy. He drew on his tenure as a board member with the National Committee on Housing, an advisory panel stocked with industrialists with close ties to the Producers Council, for his postwar program. Correspondence and his active participation suggest Kaiser felt at home in this milieu. On the other hand, Senator Robert Wagner's entreaties soliciting support for the 1947 Housing Act and urban redevelopment, and the National Association of Housing Officials' offer of a forum in the journal *Housing,* did not earn responses.[14] While the chair of the National Committee on Housing, Dorothy I. Rosenman, forecast a need for 1 million new housing units annually at the end of the war, an estimate numerous agencies and individuals endorsed, Kaiser envisioned 2 million units annually and confidently predicted that Kaiser Industries would produce ten thousand and oversee the completion of another ninety thousand through a nationwide system of franchised builders (fig. 5.4).[15]

KAISER TO BUILD 10,000 HOMES

FIGURE 5.4
Cartoon from *Permanente News,* an in-house Kaiser publication.

Fundamentally, Kaiser viewed housing and community building as a means of addressing three concerns. First, he was acutely aware of the imminent defense industry shutdown and the potential for dislocation. He foresaw the consequences for business and worked to avert the manufacturing downturn and inflation that had followed the World War I Armistice. For Kaiser, housing was a prime source of employment, and he vowed to create job opportunities for returning veterans and defense workers through construction and ancillary production and services.[16]

Second, Kaiser believed home ownership afforded wage earners a stake in the American dream, an initial toehold on the ladder of upward mobility. In a letter to Walter McCornack, chairman of the American Institute of Architects' Postwar Committee, Kaiser divulged this concern. "You must know that [we] share your interest in the problem of providing proper living conditions for the 75 percent of our population who have never had the American standard of living. . . . This is the primary motive that has led [us] into the field of home and community building." Kaiser targeted families whose annual income was in the fourteen-hundred-dollar range.[17] The industrialist believed working-class home ownership was beneficial for management, as well. In a presentation to the National Committee on Housing he pressed his case, arguing that "agricultural and industrial employers alike have come to realize that housing is an absolute essential in sound labor relations." According to Kaiser executives,

> the broad and humanitarian objectives of [our] program are to provide individual small homes to the great masses of American people who otherwise would be forced to live in the crowded tenement districts or in wartime "cracker boxes" . . . that is, [to] supply a small, well constructed, fully equipped modern home at a price which the low-income worker can afford. This is a field of housing which has not been touched by any private builder.[18]

In interviews and radio broadcasts Kaiser proposed building communities of five hundred to ten thousand fully-equipped houses priced between four thousand and five thousand dollars, including the lot. He predicted owners would pay "about $150 down and the rest in installments." Kaiser often asked rhetorically, "Do you know that in the United States we have only 18 million homeowners? That's because the opportunity to buy a house has never been given them so easily as the purchase of an auto."[19]

Third, and least altruistically, Kaiser sought to position his corporate enterprises and profit from any such advance. Kaiser Community Homes

was only one component in Henry J. Kaiser's visionary plan to reorient the corporation and the domain of consumer durables when the war concluded. For Kaiser, the individual house was one part of an entire package, and research and development personnel were preparing plans and production schedules for a Kaiser-Frazer auto, a Hiller-Copter, and a hybrid personal aircraft, the Y-2, an automobile of the air.[20] Kaiser Homes would consolidate land purchasing and subdivision, home building, sales, and maintenance into a single operation.[21] Within this organization Kaiser intended to integrate operations vertically and horizontally. The former required controlling raw materials for production, marketing and selling each unit, and providing upkeep and home owners' insurance. The latter would be achieved by incorporating products manufactured by companies Kaiser Industries either owned or controlled.[22]

Corporate planners engaged in postwar housing consciously adopted auto industry strategies, which Howard Fisher had first employed for his short-lived General Houses. Kaiser rehearsed the auto analogy at every opportunity. "Just as the auto industry was the spark-plug of our economy after the last war, housing can set the wheels of industry turning in the coming post-war epoch." Kaiser went further, suggesting a wholesale appropriation of one industry's method for the other.

> The auto manufacturer designs the car, purchases some of the components, manufactures a few himself, and puts them all together in a car. KCH will likewise design those parts of the home that can and should be standardized—the mechanical and working components, and the various combinations of structural materials. It will make these components and materials available in large quantities. And it will build them into communities. There is no patent on this idea. When it has been proven in action, it should become the method of the whole home-building industry.[23]

To meet this objective, Kaiser would organize a nationwide network of dealers and franchised builders. Control and administrative centralization would be key for this project. In an internal memo, "Kaiser Community Homes: Basic Development Plans," Vice President Howard V. Lindbergh spelled out six scenarios ranging from outright land purchase with no associates and complete development by KCH to lease options, joint ventures, and the sale of products with contracted services.[24] Under "General Comments" Lindbergh added, "The following functions will always be reserved exclusively for KCH: land planning; architecture (including the placement of houses on lots); purchasing and procurement; sales methods;

advertising; management of the project including the business center; servicing loans; and maintenance and repairs. The above functions, as you will note, are the *control functions*."[25]

In terms of administration, Lindbergh advised assigning a manager "trained in our operation" for each project to "maintain the proper coordination between the various divisions of the home office and [local] personnel."[26] Procurement and material control were essential if KCH was to benefit from economies of scale for unit prices and final return on investment and ensure consumers a quality product. Lindbergh proposed a central purchasing office responsible for accurate and timely disbursement. A national home-building program based on local combinations required a high degree of design standardization; such standards would have to be transmitted to builders throughout the country in the form of clear, precise, and consistent construction documents and specifications. Kaiser engineers were entrusted with formulating transferable unit designs and land-planning guidelines easily adapted to local conditions.[27]

Continuous volume production would demand a highly coordinated distribution system. Theoretically, each output scheduled to come off the line should be accounted for in a system stretching back to an individual retail sale and forward to its shipment and eventual installation in a specific house on a particular lot. Kaiser proposed controlling each step in this process. The broad objective was to transform not only the way homes were constructed but also the means of stimulating demand and how that demand would be channeled. In a *Harvard Business Review* article on prefabricated housing and marketing, William K. Wittausch suggested only ten firms "aspire to national prominence."[28] Kaiser Community Homes was one of these.

Name recognition is critical for national merchandising. According to Lindbergh, "After six years of study our technicians have worked out the perfect model home—the Kaisercraft Home."[29] An April 1945 report announced that KCH would "construct, market, and service a standard, accepted product" and recommended timing the corporation's entry carefully because the "public expects big things of Mr. Kaiser and [we need] to build consumer acceptance [and] interest and facilitate the establishment of franchise agents."[30]

Kaiser Housing executives planned to manage the design, distribution, and merchandising of this brand-name product. Kaiser staff worked assiduously to link the corporation's name intimately with quality, mass-produced goods.[31] Henry Kaiser's addresses and radio broadcasts, the press

releases, reports, and memorandum of KCH officers, and articles and cartoons in company publications reiterated the quantity and quality housing that would be completed each year, month, and day (see, e.g., fig. 5.4).[32]

Wartime Precedents

The Kaiser organization had hands-on experience in low-cost housing. At remote, large-scale projects Kaiser had participated in joint ventures in housing, utilities, sanitation, and medical facilities with federal assistance. This practice continued at the Richmond shipyards and at the Kaiser steel plant in Fontana.[33] At Fontana, the company planned an eight-hundred-unit community to house a quarter of its workforce (fig. 5.5). Seventy percent of these workers took home less than thirty-six dollars a week. Housing was in short supply, and turnover at the plant reached 17 percent in 1944.[34] On a 280-acre tract, Kaiser proposed to build one-, two-, and three-bedroom houses with prices ranging from $2,427 for a 500-square-foot one-bedroom model to $3,894 for a three-bedroom, 976-square-foot

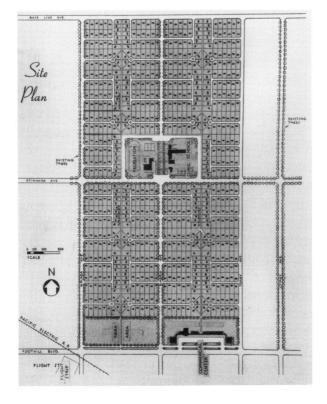

FIGURE 5.5
Community plan for employees at the Kaiser Company's Fontana steel plant.

home with carport. The price included land costs and improvements. These dwellings would have been less expensive than comparable FHA homes in the area, and the Kaiser proposal offered medical services and community facilities as well.[35]

The community plan placed the homes around a common with recreation center, school, and Kaiser Permanente clinic. A commercial center with an eight-thousand-square-foot market, thirteen hundred square feet of shops, and a four-hundred-person theater fronted Foothill Boulevard. An east-west arterial and north-south collector divided the site into four quadrants. Internal pedestrian paths linked the resultant superblocks. A network of alternating courts and cul-de-sacs limited interior auto access for privacy and safety. Except for the compromised siting of a neighborhood park adjacent to the commercial center, Kaiser site planners limned FHA formal standards and Clarence Perry's neighborhood unit.[36]

At Richmond, noted Bay Area community builder David D. Bohannon constructed a Title VI project, Rollingwood, for Kaiser shipyard workers. This project must have been instructive for Kaiser engineers conducting research into low-cost housing and analyzing the postwar market. Using horizontal building methods, Bohannon engineered a "construction record," completing seven hundred housing units in 693 hours. According to the builder, "Four weeks after ground was broken, a completed three-bedroom home was ready for occupancy every thirty minutes of the working day."[37]

Bohannon presented Rollingwood and the benefits of site prefabrication at a national conference on postwar housing in 1944. Kaiser offered the keynote address, "Building the Future." Carl Boester (Purdue Research Foundation), D. C. Slipher (Research Associates), and Robert Davison (Pierce Foundation) were among the housing researchers in attendance whose expertise in building materials, construction methods, management, and subdivision practice informed Kaiser's formulation of community building and modern community planning.

More concretely, it was through this network that Kaiser and Burns first met. On his way to consult with Kaiser in Oakland concerning building materials and production methods, Carl Boester stopped in Los Angeles to confer with Burns. Joseph Schulte, director of Burns' Housing Research Division, accompanied Boester north. There is no record of their meeting, but Kaiser must have been favorably impressed, since he accompanied them on their return to visit Toluca Wood, Burns' prewar project in North Hollywood.[38]

Planning for Postwar Production

Kaiser Housing Division, under Howard Lindbergh's direction, began operating in spring 1944. At an Emeryville complex, engineers pursued product development and applied research into "model communities, prefabrication, and other phases of the housing problem."[39] One aspect of this program resulted in an exhaustive series of cost estimates comparing a two-bedroom, nine-hundred-square-foot house priced for six different structural systems and analyzed for corresponding variations in load-bearing and nonbearing materials. Kaiser researchers considered the Toluca Wood units an "ideal starting point for postwar living," and they calculated their construction take-offs from Burns' 1939 plans.[40]

Once estimators calculated the costs for individual units they turned their attention to assessing mass production and economies of scale. Kaiser analysts applied National Housing Agency average cost shares for production costs, which set raw materials and purchased items (45.7 percent), labor (29.5 percent), overhead and profit (12.3 percent), and land (12.5 percent) and considered one hundred units the base for a five-thousand-dollar house. They then factored cost reductions for identical units at multiples of 200, 400, 800, 1,600, and 3,200 units. Their calculations projected 50 percent savings per unit at multiples of 3,200 dwellings, based on a 40 percent reduction in materials, 55 percent in overhead and profit, and 70 percent for labor.[41] Although Kaiser staff used NHA data for this analysis, an accompanying chart compared the NHA's estimates with their projections, which held labor savings constant but raised savings on materials to 48 percent and on land to 13 percent while reducing overhead and profit to 9 percent.[42]

In an August 1944 "Digest of Housing Notes," Lindbergh assessed the division's research on the building shell. After stating that material, equipment, and labor had increased approximately 50 percent in the "low-cost range" since Toluca Wood's completion in 1939, he reported that, at present, no large additional savings would be possible within the scope of conventional construction. Lindbergh cited outdated building codes and traditional construction techniques as the principal limitations. However, in section 3, "Full Factory Fabrication vs. Conventional Construction," Lindbergh argued that if a "standard acceptable home were constructed in a central factory and hauled in two or three pieces to the site (say, in a 200-mile radius), it would be possible to increase labor efficiency, use the best shop techniques, program the work, obtain speed in output, and still have

variety in the finished homes." Under these conditions, he estimated a 15 percent saving over conventional practice if annual production ran between five thousand and ten thousand units and suggested Los Angeles, Chicago, and Trenton as likely sites for a housing factory.[43]

From this assessment Lindbergh devised three approaches for Kaiser Industries to enter the housing market. First, Kaiser could contract and deliver large export orders to China, Russia, England, or South America; "to do this we might wish to set up shop in the shipyards." Second, they might continue their research until a "super-house is developed." Third, the Kaiser companies could advance site prefabrication by turning Kaiser materials into "super-prefabricated" products such as oxychloride cement for packaged floors and magnesium for door knobs, which could then be offered to dealers like Sears, Roebuck. Lindbergh advised that Kaiser should limit its immediate role to producing basic materials for housing while establishing a limited association with a large-scale builder "such as Fritz Burns" so their researchers could obtain a better overall picture and collect data on actual costs.[44]

In September, Lindbergh expanded on factory production, offering the auto analogy to support his hypothesis. "There is no question in my mind but that someday the gap will be bridged from large-scale operators in individual cities . . . to the mass production of complete houses in central factories." Just as mass production reduced costs in auto manufacturing and parts by 50 percent, "mass production of houses can cut costs by a similar amount, which would more than pay for transportation across the country. . . . The future of housing is tied up in a few organizations that . . . will have an adequate house dealer organization and servicing department to handle the final assembly and other items at the site." Lindbergh then addressed monotony, a recurrent concern, suggesting that again the auto manufacturers had provided a solution, achieving "1,500 variations in their cars through different makes, models, colors, and trim." This was how the "home producer can relieve the monotony of machine methods."[45]

In one case Kaiser planned to put these principles into practice in a literal transfer of plant and process. A Housing Division rendering for the Richmond Shipyard reconfigured the site from the quantity production of Liberty ships into a factory for Kaisercraft Homes. Building materials entered on railcars, and production engineers programmed the plant layout so that wallboard, for example, would enter the fabrication building at the north end and finished panels would exit at the south, where they would be stored on the shipways for external transport by water or rail.

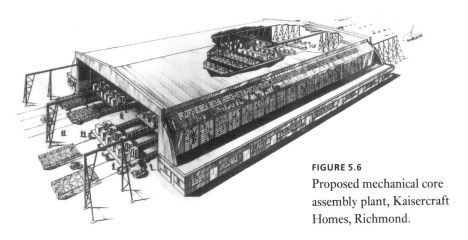

FIGURE 5.6
Proposed mechanical core
assembly plant, Kaisercraft
Homes, Richmond.

The Housing Division did not limit its research and product development to the building shell, however. The corporation's strategy included "packaged items": manufactured components such as appliances, cabinets, water heaters, furnaces, windows and doors, and storage units. To control manufacture and supply, the division pursued an aggressive program of patent purchases, licensing agreements, and joint ventures in addition to basic research and development. The "mechanical heart" was the linchpin of this effort.[46]

Initially, technicians conceived the mechanical heart as a complete, preassembled service unit with kitchen, bath, and utility room. Kaiser design staff planned this service core as a monolithic unit: floor and wall panels, cabinets, countertops, and lavatory, prewired and plumbed equipment, the entire package trimmed, finished, and painted ready for shipping and site installation. A "Kaisercraft Coordinated Kitchen" featured a stove, sink, cabinets, refrigerator, dishwasher, and garbage disposal, all to be designed, patented, and manufactured under Kaiser's control.[47]

In the Richmond conversion proposal, plant engineers sited the fabrication and assembly of mechanical cores in a separate facility. A cutaway axonometric of this plant in operation shows workers unloading and organizing "core parts" fabricated in an adjacent structure (fig. 5.6). At a series of fixed stations, crews assemble wall subassemblies into their final configuration awaiting equipment installation. At the output end, completed units are stacked onto a waiting flatbed.

Kaiser Community Homes never realized centralized factory production of the type diagrammed in the Richmond "Plant Layout and Flow

Sheet." The contributing factors are complex and cut through every aspect of the firm's project. Time certainly was a pressing constraint. One difficulty faced early on with the mechanical core was simply the quantity and variety of household equipment and products. It was ambitious to expect that engineers and designers could develop an entire line of new appliances. In December 1944, for example, Lindbergh sent Kaiser a memo informing him they had installed dishwasher and garbage disposal prototypes in a test kitchen. Those were the only Kaiser components included. In response, the Housing Division pursued alternative strategies. One was to study existing products and, after identifying significant refinements, apply for a patent to produce. A second approach involved purchasing a controlling interest in proven companies. In May 1945 when a representative from Southern California Gas Company notified Tom Price, a Kaiser executive, that the stove they promised to produce and sell under the Kaiser name was behind schedule, Price suggested Kaiser "continue to get on the inside of the Graham Company [manufacturers of Wedgewood Stoves] to take advantage of their consumer recognition and local production."[48]

The Housing Division's association with Southern California Gas indicates a third strategy. In this case the gas company was an intermediary between KCH and Western Stove Company in Culver City. Western Stove was principal designer of a four-burner appliance that Kaiser engineers hoped to install in the mechanical heart. When this arrangement fell through, Schulte introduced Kaiser officials to Jacob Teller, an inventor who held seventy-seven patents on stove construction under which "ninety percent of manufacturers of gas and electric stoves [are] licensed." Teller offered to work with Kaiser on a stove line, either selling a set of dies from one of the seven factories he ran in the Midwest or assisting in the development of an entirely new line. Teller, for instance, held patented drawings for an aluminum stove, a unit with obvious appeal for Kaiser's operation.[49]

By September 1945, a general summary of the mechanical heart project included a list with the unit prices of purchased components, all of which were obtained from conventional suppliers such as General Electric, Kohler, Sloan, and Briggs. At this time, Kaiser was slated to manufacture only the dishwasher. This decision reflected both mounting pressure to get the building program under way and concern over materials restrictions and limited supplies. The report paid close attention to availability; in the chart, lots and production figures accompanied each item.[50]

Each delay in finalizing components pushed back the start-up date for

KCH housing production. In a letter to Henry Kaiser, Burns spelled out his concerns. "Considerable delay was encountered in freezing the final plans for Kaiser Homes principally because . . . we had to make several compromises from a practical standpoint pertaining to the physical parts of the house. . . . The bathroom has given us the most trouble. The problem is illustrative of several other[s]. The point is that we cannot talk in terms of 'additional housing' for the lowest income families and at the same time include 'turret-type shower stalls' even though such fixtures were included in the original picture book." Burns reiterated his commitment to producing an adequate house at the lowest possible cost and promised that the bathrooms would surpass those in other low-cost houses. "But I must confess it will not look like those seen on movie sets. It is very easy to let plans get out of hand costwise and then have to scrap them when it comes time to make the cost estimate." Burns concluded optimistically, underscoring the point that their house plan was flexible enough for standard equipment in the event that "priorities in quantity become available prior to the time the mechanical core was complete." His reference was to material and products restrictions, the result of government policy and market uncertainties.[51]

Design questions, product availability, and material shortages forced KCH officials to evaluate the relative advantages of beginning production with housing units containing "materials, equipment, and structural characteristics of pre-war homes" or waiting until they could deliver the "ultimate" Kaiser Community Home. An undated report reveals the dilemma: "If it is possible to produce and have ready for delivery in quantity, Kaiser-built Coordinated Kitchens and Mechanical Core Bathrooms within six or seven months, the consensus is that it would be advisable to wait until that time before launching a building program of any large volume." On the other hand, if this meant a delay beyond six or seven months, the "disadvantage in loss of time would be greater than the disadvantage of presenting a product that does not represent the ultimate."[52]

Pressure to meet a production schedule Henry Kaiser had advanced cavalierly trickled down the embryonic organizational hierarchy at KCH. In particular, it exacerbated the mounting concerns anxious Kaiser executives in Oakland were expressing about field operations in Los Angeles. In January 1946, Henry Kaiser Jr. wrote to KCH vice president Eugene Trefethen that he was "sincerely and deeply disturbed by the affairs in Los Angeles." After assuring Trefethen that Fritz and "his boys" were sincere in their efforts, he asserted they lacked any "conception of the problems

ahead of them, the size of the job, the unprecedented volume as well as all the complexities it will present. Their lack of progress is amazing and their naivety is unbelievable. At times I think ignorance is almost a blessing, otherwise they would be in a cold sweat. . . . They are used to building a few houses and most of that is done on the back of an envelope." Henry Jr. went on to suggest the implications for Kaiser's reputation: "If we intend to come anywhere near the program Dad gave over the radio, either a complete turn about of affairs will have to occur in KCH with jet propulsion added or Edgar [Kaiser] had better get his [housing] program under way at Portland in order that the prediction Dad made on coast to coast radio will come true."[53]

Despite their setbacks in developing a preassembled mechanical core and their inability to manufacture a complete line of components and appliances, the Kaiser Company did proceed with production of an aluminum "motorless" dishwasher. The unit featured an aluminum drum, driven around a sealed ball-bearing shaft by seven jets emitting hot water at forty pounds pressure. Following the wash cycle, flatware and cutlery airdried by convection. Advertisements in journals such as the *American Home* promoted the ease of installation (only two connections), the appliance's "silent" operation (no motor), and its speed (only five minutes compared with the "average" of twenty to forty minutes). Highlighted as well was the unit's low-cost, $139 for the basic model, $189 ("just fiftycents a day") for the deluxe, which featured a hydraulic lift.[54]

Product development and production engineering for the Kaiser dishwasher reveals the considerable challenge a coordinated and integrated housing package presented. Design and development was a disjointed process that belied Henry Kaiser's bold and optimistic predictions. At the same time, analyzing this process derails the determinism that drives narratives of postwar consumer durables and modern housing.

The Kaiser Company purchased design rights for the unit from Raymond W. Wilson of Glendale, California, who received his patent for a motorless dishwasher in April 1943. Research and design engineers in Emeryville subjected prototypes to a battery of tests before product development experts drew up production schedules, bills of material, and labor and unit cost estimates. Only then was the unit considered for production. However, unlike the compact and comprehensive plant rendered in the plans for Richmond, production engineers assigned the dishwasher to Kaiser-Fleetwings (later Kaiser Metal Products), a Bristol, Pennsylvania, aircraft subassembly facility in which Kaiser held a controlling inter-

est. When orders from prime contractors for tail surfaces, wings, and rudders tapered off, Kaiser invested $12 million to convert the facility for appliance manufacturing, the majority targeted for a heavy power plant and porcelain enamel capabilities.[55]

After the dishwasher went into production, Kaiser Community Homes failed to generate the demand product planners had anticipated. For the overage, market analysts tried developing an independent outlet in competition with other manufacturers. When this effort failed, Kaiser officials sought alternative strategies. In September 1948 Sears, Roebuck bought a substantial interest in Kaiser Metal Products, and the retailer assumed the marketing and distribution of stock not targeted for KCH. With the consumer base that Sears provided, Fleetwings began a line of enameled aluminum kitchen cabinets, sinks, and bathtubs for general distribution.[56]

The aluminum components Fleetwings manufactured represented one attempt to integrate Kaiser raw materials and building material fabrication with finished products. Six Kaiser-managed companies extracted, refined, or manufactured home-building materials. The Permanente Cement Company also produced ash and lime. The Henry J. Kaiser Company mined sand and gravel and manufactured refractory brick. Kaiser Industries was the West Coast's major supplier of gypsum and gypsum wallboard. Kaiser Steel turned out three-quarters of a million tons a year. And Kaiser Aluminum and Chemical provided aluminum, phosphates, and other chemicals.[57] From this abundant source list company engineers proposed manufacturing essential equipment ranging from heating units, steel windows, and screens to electrical and plumbing fixtures and consumer household items such as door chimes, metal ironing boards, clothes hampers, and milk containers.[58]

A majority of these components and products never reached the prototype phase. Some aluminum products did, and a few, such as garage doors and siding, eventually made it into production. That did not, however, guarantee their immediate acceptance. In a memo to Burns, Schulte vetoed Kaiser's aluminum garage doors in favor of their wooden model for three reasons. First, he questioned the aluminum models' initial cost and suggested that more efficient production of the wooden door offered a better opportunity for reducing the final price of a dwelling. His second point concerned longevity and maintenance, arguing for the wooden doors proven performance. Both points could be challenged or dismissed as parochial and self-serving. But interestingly, the thrust of his argument turned on aesthetics. For Schulte, "even if the cost was the same," the

aluminum door's appearance would offset the expense and effort they had expended to "destroy the prefabricated look of our housing. . . . Wood may be difficult to obtain but it will be well worth our while cost-wise to concentrate on its procurement for garage doors."[59]

Aluminum siding fared better, although its introduction and final acceptance was an extremely slow process. The Kaiser Housing Division conducted tests on aluminum as an exterior cladding as part of a larger program for an all-aluminum house. By late 1946, D. C. Slipher was surveying fabricators in Los Angeles to identify those whose equipment could form aluminum sheet into siding and roofing. He reported to Trefethen that the "Architectural Division [of KCH] is deciding which patterns are best, taking into account available equipment, dies, etc. Just as soon as these conclusions are reached we will forward the information to you as it may be that the equipment at Richmond would fit right into the program."[60] Despite the housing experts predictions and survey findings that the general home-buying public shared an enthusiasm for new products and new materials, it was not until two years later that KCH completed an "experimental" house in Panorama City featuring aluminum siding.[61]

A 1945 illustration in *Tomorrow's Town* conveyed consumers' uncertainty and frustration (fig. 5.7). A dejected parent, one of the "Legion of the Home Hungry," stares distractedly while his son completes a model of "Industrialized Housing" with intense concentration, oblivious to his fa-

FIGURE 5.7
"Legion of the Home Hungry"

WE'RE WAITING

ther's concern. A clipping in Henry Kaiser's scrapbooks from a Cleveland, Ohio, paper locates a source for this anxiety.

> Kaiser certainly started the ball rolling when he injected the word pre-fabrication into our modern language. It has extended down the line to every finished product and even the latest form of doodling or constructing your dream house in miniature while waiting for materials. This is done with heavy cardboard walls and wooden joists that may be assembled to taste, knocked down, and reassembled until the house plan is workable and foolproof.[62]

When Kaiser spoke of transferring the auto industry's methods to home building he imagined factory fabrication, rationalized, large-batch, line-flow production. A press release timed to announce the first KCH project in northern California states:

> Kaiser Community Homes introduces to home construction proven basic principles of modern quantity production successfully employed by the automobile crafts and many other high production industries. Standard component parts of Kaiser engineered homes are factory-produced by the thousands so that precision fitting and uniform quality are assured. Materials are purchased in carload lots and the homes are constructed on an efficient, scientific, waste-abolishing basis which includes one complete over-all operation from virgin acreage to the completed community.[63]

For KCH, off-site housing fabrication was beset by a host of difficulties that paralleled those encountered in appliances, and the record for factory production of the building shell was similarly checkered.

The KCH Housing Factory

Early in 1946, KCH constructed a housing "factory" for "production homes" in Westchester at 5555 West Manchester Boulevard (fig. 5.8). The sixteen-and-one-half-acre site, owned by Burns, was immediately east of his wartime development, Homes at Wholesale. Manchester Boulevard was the property's southern boundary, a rail-line and dirt spur (later Isis Avenue) was on the east, the future Eighty-third Street formed the northern edge, and Osage Avenue set the western boundary. The plant was divided into three zones. A 104,000-square-foot central production facility (the

saw-toothed-roofed structure adjacent to Osage in the left-center of figure 5.10) housed interior, exterior, and floor- and ceiling-panel assembly lines.

A photograph taken midway down the shop floor shows the floor and ceiling lines (fig. 5.9). In the foreground, two workers are applying plywood back battens onto five-sixteenths-inch plywood, a sheet of which we see the next team of workmen about to apply to a preassembled frame. At the third station, tackers attach the plywood. Next, the completed floor panel is hoisted by an overhead conveyor and carried to exterior storage racks to await shipment. A similar operation produced the ceiling, exterior, and interior panels. The latter received a finish treatment after being lined up for storage.[64] The remaining 50,000-square-feet in the main shed housed a cabinet department for the fabrication of kitchen cabinets, bathroom lavatories, and the "Kaiser Storage Wall" or "storage partition."

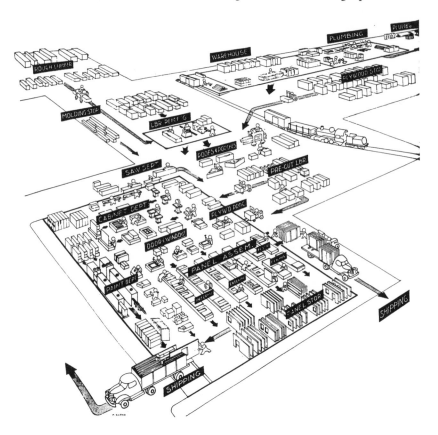

FIGURE 5.8 Diagram specifying the sequence of operations at Kaiser Community Homes' housing "factory" in Westchester.

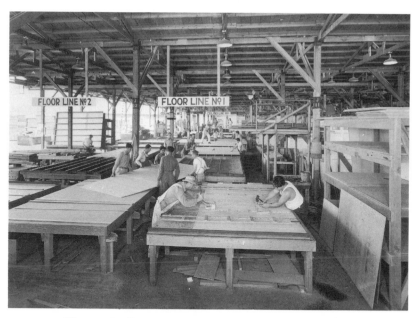

FIGURE 5.9 Floor and ceiling subassembly

Workers assembled these components from precut lumber that, in some cases, arrived from a Kaiser mill rabbeted, bored, and numbered. Following assembly, the cabinets and storage walls entered a series of paint booths for finishing.

East of the rail spur was a long, shallow structure, the warehouse, plumbing, and plumbing supply area. Here, finished lumber was stored in carloads, and skilled workers preassembled multiple plumbing trees. In the middle ground, two-sided and four-sided planers "remanufactured" rough lumber. Sized material went directly to the saw department or to the roofs and porches department for preassembly.

In an aerial photograph (fig. 5.10), a truck carrying roof sections is turning off Manchester, north on Osage to Homes at Wholesale #2, visible one mile to the northwest. Flatbeds trucked panels, storage walls, and cabinets to sites throughout Los Angeles, including Ontario and North Hollywood. An aerial from the opposite direction shows the Homes at Wholesale site and open acreage beyond (fig. 5.11). At this point in the development and production process, lots and units at each phase of completion can be seen, from engineering, grading, and perimeter foundations in the upper right (northeast) and foundations with pier beams and floor panels in place in the lower left (southwest) to completed chassis (with and

without roofs) and finished homes in the middle ground. Stakebeds loaded
with panels have been deposited among the house sites. Work crews fol-
lowed an efficient path down one street and then another, a pattern evident
in the illustration.

In September 1946, Clyde C. Henley, a veteran and father of two, pur-
chased the first unit completed at Homes at Wholesale #2. Before turning
over the key at the dedication ceremony, Kaiser addressed reporters con-
cerning his "100-mile plant-to-site housing assembly line." The indus-
trialist claimed, "I am using the same methods that I used in building
ships. The same methods that made America great—the assembly line, the
brainchild of private competitive force urged by the profit motive."[65]

Closer inspection reveals that Kaiser's production method was, in es-
sence, closer to the process developed by the aircraft industry than that of
shipbuilders. The Manchester factory was a feeder plant, and the building
lot in a Kaiser community the "prime contract" site where teams of work-

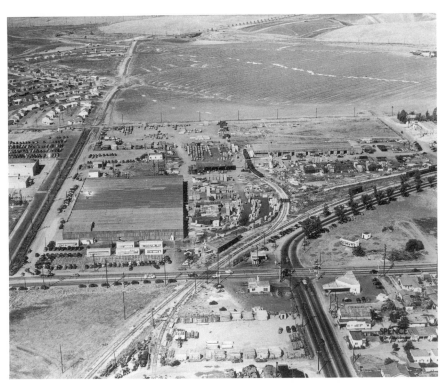

FIGURE 5.10 View of Kaiser Community Homes production facility, Homes at
Wholesale #2 visible in the left background.

ers organized in sequenced operations put individual homes together out of a kit of interchangeable parts. Once components reached the site, assembly and finishing were conventional, craft-based operations. As Burns put it, Kaiser homes were "built with precision-manufactured parts skillfully adapted to perfect assembly on the site under the highly-engineered and mechanized techniques [we] have developed."[66]

The Manchester plant had a discernible Kaiser imprint. Kaiser officers and engineers believed in modern business enterprise, an ethos that prized production planning and the centralized plant. The factory permitted efficient and rational management and accounting, the bedrock of corporate method. Theoretically, one benefit of panelization and sectional construction was the ability to estimate in advance "every single cost factor . . . the labor and material to make [a panel or section], the cost of loading and transporting it, the cost of placing it in the house, and the cost of finishing it," a process John C. Taylor, president of American Homes, labeled "positivizing costs."[67] Kaiser officers and engineers coveted this level of precision, and they strove to convert the technological and organizational infrastructure developed in the earlier public works projects and wartime shipbuilding to home building.

Two overarching concerns fueled this approach. The first had to do with material priorities and procurement, the second with Kaiser's efforts to tap into a guaranteed market. Both required close cooperation with the federal government, a relationship that had been, after all, a trademark of Kaiser's industrial development.

As previously noted, Kaiser was actively engaged in postwar planning, and both he and his staff tracked the development of federal policy and programs.[68] Gerard Piel, Kaiser's personal assistant, came to the company from government and kept Kaiser abreast of policies and decisions concerning the Veterans Emergency Housing Program. In a February 1, 1946, memo, Piel outlined the objectives and policy proposals the president would announce the following week. Of particular interest for KCH were the total number of units targeted for "private enterprise," one million in 1946, and one-and-a-half million the following year, and the fact that 60 percent of these would be restricted to two- and three-bedroom units under one thousand square feet, constructed with " 'prefabricated' materials [and carrying] a price of $5,000 to $6,000." In addition, the program would call for "prefabricating" 25 percent of the total units slated for 1946 and 40 percent of those produced in 1947.[69] Piel elaborated on this memo the following day, offering a "gross calculation of the dollar and materials

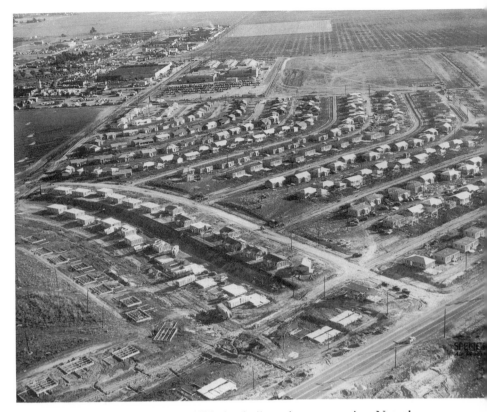

FIGURE 5.11 View of Homes at Wholesale #2 under construction. Note the sequence of construction. KCH "factory" is in the mid-range center of this photograph.

volume represented in the housing program." In this second memo, he projected 150,000 Kaiser Homes, one-quarter of the 600,000 small, low-cost units Housing Expediter Wilson Wyatt anticipated for that year.[70]

Wyatt proposed expanding production through premium payments to materials manufacturers and by offering prefabricators guaranteed markets, material priorities and allocations, and wage and price adjustments. A new FHA housing priority system reinforced this program. In April 1946, the agency established housing "goals" for each of its districts. At that time, Los Angeles was allotted 15,301 units per quarter. Seventy-five percent of these were designated for individual purchase. Of these, one-half (or 37.5 percent of the total) had to sell for less than seven thousand dollars. Burns kept track of the FHA program through his contacts in the district office.[71]

For Kaiser, prefabrication's most powerful lure may have been indications from the federal government that a program of guaranteed purchase contracts was imminent. Then, in October, Wyatt announced that three prefabricators had secured guarantees. Slipher wrote Burns:

> There is strong indication that holders of these contracts may receive preferential treatment on Reconstruction Finance Corporation facility and working capital loans and to some extent from the Civilian Production Administration, the National Housing Agency, and the Federal Housing Administration. We should also anticipate preferential allocation of critically short materials under circumstances where the guaranteed purchase contract producers claim to be held up because of an inability to secure a material.[72]

In addition, Kaiser officials were paying close attention to what Slipher referred to as "public evidence of increasing downward pressure from Wyatt's office on aircraft producers calling for their participation in the [housing] program through prefabrication." Slipher alerted Burns that "major companies and/or industrial combines are stepping into housing, using the Wyatt program as an umbrella over start-up problems." And the National Housing Agency was reportedly negotiating with Douglas, McDonnell, Ryan, and Consolidated concerning production of aluminum-panel housing. Trefethen monitored unofficial reports claiming the NHA was urging Douglas alone to consider an annual production schedule of two hundred thousand units. In this particular case, Kaiser's interests might have been served regardless of the outcome. If these manufacturers entered the home-building industry, they would be in direct competition with KCH. However, if their product featured aluminum panels, Kaiser Aluminum would stand to benefit.[73] Either way, it appeared certain the federal government would extend support principally to prefabricators producing low-cost single-family units, and the Kaiser Companies, true to form, planned to garner a share.[74]

A centralized production facility met another Kaiser objective. Corporate executives assigned to KCH voiced continuing concern over the shortcomings they perceived in Burns' operation. In a confidential assessment following his January 1946 visit to Los Angeles, Henry Kaiser Jr. described how the "conditions of affairs" left him "sincerely and deeply disturbed." He doubted Burns had structured his organization effectively for a program scaled as his father had promised. "When you can plainly see how little he realizes the bigness of the task in front of him, it cannot help

but worry one." Kaiser presented the problem explicitly in management terms. "At present it is a one man organization with everyone trying to get answers from Fritz and only about one-quarter of the people even able to see him because he is so swamped in detail."[75] To instill some rigor in accounting, he inserted Kaiser executives into the Los Angeles office. M. R. Ekrid was responsible for educating Burns' head purchasing agent, and Don Browne for organizing accounting. As a first task, both men instituted standardized and regular project accounting through production scheduling and flow charts.[76]

As soon as they implemented these procedures it became apparent that operations in the plant were outpacing those in the field.[77] One reason for this discrepancy, they discovered, was land processing. In March 1946, Tom Price, vice president of Kaiser Engineers, wrote to Burns concerning his analysis of the surveying and site planning completed to date. After reminding Fritz of KCH's target of ten thousand houses and translating this into ten thousand lots, or 2,350 acres, he alerted him to the fact that to date the field operation had provided title to only 175 acres.

> In order to complete the program outlined it will be necessary for us to deliver you all the engineered lots by November 1st which would allow you two months to complete construction. In order for us to [engineer] these lots by that time it will be necessary for you to supply us the required property by August 1, 1946. [Therefore] in the remaining five months it will be necessary for you to deliver us 2,000 acres at a uniform rate of 400 acres per month.[78]

At root, the dissonance in this exchange can be traced to a tension between a corporatist Kaiser enterprise and a set of financially successful entrepreneurs who were, nonetheless, unschooled in business management.[79] Neither party was right in any measurable sense. The program Kaiser outlined required coordination beyond the reach of a single developer such as Burns. At the same time, community building was not comparable to the building of Liberty ships or dams. Land is a prime example. Leaving aside for the moment the myriad ways in which the two organizations' operational styles differed, it would have been a tall order for any land-purchasing agent to meet the dictates spelled out by Kaiser Engineers. As any developer will attest, land is a manifestly different commodity from sheet steel and rivets.

Burns reluctantly endorsed centralized, off-site subassembly, most likely as a means of assuring a relatively consistent flow of materials. How-

ever, he also created a parallel operation. While workers at the plant continued to produce panels, Burns had crews and subcontractors employing on-site fabrication. As a result, most KCH projects were hybrids with a mix of production houses and site-built units. By 1948, KCH began phasing out the Manchester facility. That year, a development in Monterey Park was the first to be completed without factory panels. In retrospect, Burns cast the entire episode as an experiment. The conclusion he drew was that panelization and on-site fabrication were simply a matter of choice: in terms of efficiency and costs they were interchangeable.[80]

Burns' interpretation can be read another way. The off-site procedures KCH developed at the Manchester plant were, in effect, a transfer of on-site subassembly methods—precutting, jigging, and the construction of standard components—to a central location. Although its centrality and permanence distinguished it from a temporary site shop, the "factory" was in many respects simply a large staging area. At this facility KCH refined the industrialization of home building; it did not, contrary to Kaiser's proclamations and the expectations of housing pundits, constitute a highly mechanized, capital-intensive, mass-production operation.

The marketing program never attained the scope or prominence Kaiser executives envisioned, either. Marketing, like much of production, wound up with Burns, and his sales organization met the challenge increased scale presented by inflating their standard rhetoric and orchestrating more extravagant sales events modeled on familiar strategies refined in the 1930s. One technique Burns favored was the staged move-in. In February 1947, print reporters were invited for the simultaneous arrival of forty families and forty moving vans on Reading Avenue in Westchester. Like all such affairs, this was highly choreographed. Events were closely timed to provide photographers compositions with families fronting their homes and moving-vans in the drive (fig. 5.12).[81] And like many builders, Burns adopted the yearly model, a technique perfected by auto manufacturers. To keep sales moving, print ads for Kaiser Homes stressed the benefits associated with the latest, up-to-date line.[82]

Henry Kaiser promised far-reaching benefits for mass-produced housing. His public assertions activated an overwhelming response that outstripped the progress his engineers had achieved and, more than likely, what was attainable through any program he could have enacted. Once the discrepancy became apparent, Kaiser backpedaled from his earlier statements, and company officials worked aggressively to deflect criticism and deflate expectations while still asserting that production would eventually

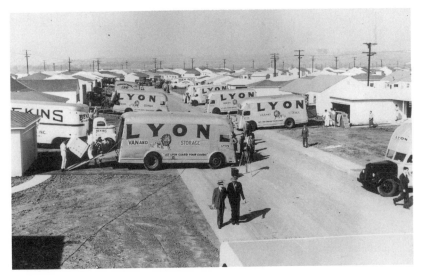

FIGURE 5.12 Associated Press photograph of forty veterans and their families moving into Homes at Wholesale #2, Westchester.

match prior claims. Gerard Piel fielded public relations and responded to a stream of requests for more information about KCH. His statement to the Chamber of Commerce in Albany, New York, was typical: "Because it becomes increasingly apparent that we have undertaken a major social responsibility in entering the field of low-cost housing, we have determined not to promote our advertisement of this undertaking in any way until such time as we have major results to exhibit and demonstrate to the public. We must therefore decline your invitation to begin operations in the Albany area."[83]

Piel's reworking of Kaiser's ambitious program signaled a denoument for the industrialist's vision of houses rolling off an assembly line, stocked with Kaiser brand components and equipment and trucked to tidy communities of working-class home owners. The difficulties KCH encountered in the immediate postwar years also called into question Kaiser's dream of a vertically integrated, standard-setting, national enterprise controlling everything from land to health care and capable of delivering a complete community package anywhere in the country. But production from the Manchester factory, mixed with some on-site fabrication, did provide the housing for a series of infill projects in Los Angeles, including Westside Terrace, North Hollywood, and Monterey Park and a small community development in Ontario targeted for "veterans" of the Kaiser Fon-

tana steel mill, as well as completion of the Westchester district. By 1948, as production at the central plant tapered off, KCH had worked out some of the discrepancies between management styles, settled on a building method, and reoriented sales to local markets. At this point, the company's focus shifted, and Burns directed land-purchasing agents who focused their efforts on identifying and securing parcels large enough for the planning and construction of a complete community.[84] The concluding chapter, using Panorama City as a case study, examines precisely what KCH was able to accomplish, and, most critically, situates this particular project, and similar community-scale developments in other parts of the nation, in the context of the metropolitan region.

CHAPTER SIX
"BUILDING A CITY WHERE A CITY BELONGS"

[The] San Fernando Valley eagerly awaits the development which is its natural right. . . . With His protecting arms, the mountains, God preserved this 100,000-acre domain from the premature encroachment of man until the latter evolved more modern methods of city planning. CHARLES L. WOOD

Burbank will never revert to its pre-war status as a 100 percent residential city. When the war ends, [it] will continue to be a balanced community. While it is true that our war industries will no longer produce war goods, they will be just as busy producing peacetime products. If the rumored Lockheed automobile becomes a reality, Burbank could be a second Dearborn, Pontiac, or Detroit. FRITZ B. BURNS

In contrast to questionable methods of subdividing, a strong tendency is being shown, in recent subdivisions, for the development of complete communities. . . . This type of subdivision will continue in popularity and will increase as building materials are made ready.
 REGIONAL PLANNING COMMISSION

It has been said that the quality of tomorrow's city depends on the quality of today's subdivisions. If this is true, our housing and city planning theorists can cheer up a bit and revise their gloomy predictions of urban decay and chaos.
 SEWARD H. MOTT

The spread-out character of Los Angeles . . . has resulted in a natural, and from some points of view a highly desirable, dispersion of population. Industries are widely scattered. . . . For the most part the wartime growth has taken place round the edges . . . rather than at the center. Therefore Los Angeles has become the first modern, widely decentralized industrial city in America.
 CAREY MCWILLIAMS

Having solved a "People Are Funny" radio riddle, Mrs. Ward George and her family left their home in Lebanon, Oregon, to start a new life in Panorama City, California. Their prize dwelling was the first unit in a planned community designed and constructed by Kaiser Community Homes. Located in the San Fernando Valley, fifteen miles from downtown Los Angeles, the house came equipped with a Kaiser hydraulic dishwasher, Kaiser garbage disposal, and a two-car garage for their 1948 Kaiser-Frazer sedan (fig. 6.1). The sponsors also offered the winning contestant a "responsible job" in Southern California. Past success coupling community building with the aircraft industry must have guided Fritz Burns' choice; Mrs. George would join the personnel department at Lockheed's Burbank facility. When, in a carefully choreographed pageant, Burns and Art Linkletter presented this couple the key to home ownership, the Georges completed a transition promised to all American wage earners in the postwar period (fig. 6.2).[1]

At the time of the 1940 census, Lebanon had twenty-seven hundred inhabitants. Residents depended on Corvallis (population eighty-four hundred), a regional center forty miles away, for governance, civic institutions, and health care. Census enumerators recorded 863 dwellings in Lebanon; one-third of these lacked private baths, and an equivalent number, they determined, required major repair. The Georges' house, built to local standards, lacked running water. Mortgage financing for its purchase, if available, was most likely short-term, with large payments at both ends.[2]

Eight years later, when the Georges took up residence in Panorama City, they joined other newcomers in the initial phase of a projected three-thousand-unit "City in Itself." Corporate officers from Kaiser's Housing Division had "scientifically planned" this "City in the Making" as a "total" community, a place for "living, work, and play." Here they integrated "modern" housing with schools, recreation, health care facilities, churches, and a commercial center. Just as important for the Kaiser land agents who surveyed this property was the site's proximity to regional industries such as General Motors, Anhauser-Busch, Lockheed, and Rocketdyne (fig. 6.3). A vignetted map highlighting the "great $10 million GM plant" became KCH's graphic signature for newspaper advertisements and circulars. Copy touted the "more than one hundred new industries within a fifteen minute drive." At Panorama City, wage earners "with slim pocketbooks" could capitalize on the sophisticated system of insurance and loan guarantees the Federal Housing Administration and

Veterans Administration offered home buyers purchasing minimum housing in a community setting.[3]

When Kaiser Homes had completed Panorama City it quickly became one of the most cited postwar communities in the nation.[4] Although contemporaries viewed it as an exception, it is best understood today as one of a type. For this line of inquiry, continuity and commonalities are the essential considerations. Panorama City is noteworthy both for the continuity of personnel, principles, and practices that link it with Leimert Park and community-scale projects from the 1930s and for the common objectives and strategies KCH shared with developers in Southern California and other regions. But most critical was the degree to which these community builders' interests and vision intersected with those of industrialists, planners, and home buyers and how these agents collectively shaped the postwar metropolitan landscape.

Master Planning for the San Fernando Valley

The Los Angeles Regional Planning Commission (RPC) had been tracking and then encouraging community-scale projects during the war. In its 1944 *Annual Report,* the commission noted an increase in the number of preliminary plans submitted for "marketing new subdivisions and building new communities." In a prescient anticipation of postwar development patterns, the commission assigned staff to draw up community design plans for the Lakewood area, north Long Beach, the Baldwin Hills district, and southeast Arcadia. These comprehensive plans considered highway frontage, drainage, lot design and building setbacks, and planting strips at a level of detail adequate for recording a plat. Collectively, they signaled the commission's belief that "house-and-lot selling programs" were a thing of the past. Regional planners in Southern California were convinced the "widespread interest in developing community plans of the complete neighborhood type," projects that "exclude traffic from residential areas [and] provide combined park and school sites and independent shopping centers as focal points of the plan," indicated future trends.[5]

For its 1945 report the commission again considered "community design," but this time in light of regional industry and wartime expansion, specifically a "trend toward [the] decentralization of specialized and service industries"; members concluded that the "integration of plans for modern industrial districts with other community development . . . must be given early attention." Planning staff had studied adjustments in land

FIGURE 6.1 Mr. and Mrs. Ward George photographed with their prizes, a Kaiser-Frazer sedan and model KCH dwelling.

FIGURE 6.2
Mrs. Ward George with Art Linkletter and Fritz B. Burns.

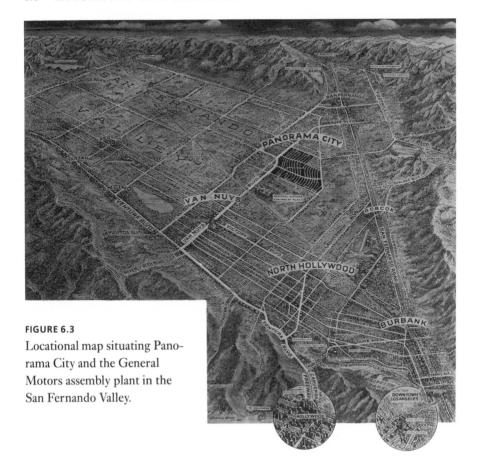

FIGURE 6.3
Locational map situating Pano-
rama City and the General
Motors assembly plant in the
San Fernando Valley.

use, zoning, and ordinances to protect existing and potential industrial districts from "spurious town lot development." The commission determined a need for detailed study and for crafting "coordinated plans for complete community development" to preserve order, provide for adequate urban expansion, and meet the projected housing shortage.[6]

Following the war, the RPC reported the greatest countywide population increase and building activity in a concentric zone approximately fifteen miles from City Hall. In its July 1946 "Statistical Area Report," the commission mapped the distribution of proposed dwelling units. This revealed a "striking increase in outlying sections of the northerly portion of the metropolitan area," particularly the San Fernando Valley and Tujunga; both showed increases "well above the four-percent of last quarter."[7]

In the early 1940s, as defense-related industry and in-migrant workers

and their families recast the spatial and social order in Los Angeles, the City Planning Commission undertook comprehensive, long-range studies to determine prevailing land use patterns in the San Fernando Valley. Members of the city commission expressed concern that postwar expansion, left unchecked, would envelope the Valley in its entirety. When considering past population growth and probable future trends, planning director Charles B. Bennett found that the Valley's areal expanse, equal to that of Chicago, "indicates the need for realistic avoidance of the fallacy of assuming it to be potentially one large densely-populated urban community."[8]

From his vantage point, in fact, home-front production had altered the Valley's land use and population patterns inexorably. In the late 1930s, Lockheed's continued expansion and Vega's site selection had triggered the formation of a dynamic industrial-residential district. At its peak, Lockheed employed ninety thousand war workers. Ancillary industries such as Adel Precision Products, Bendix Aviation, and Trumbull Electrical clustered around these prime contractors. Home builders capitalized on this industrial development, undertaking both residential and community projects. Burns and Marlow, for example, constructed Toluca Wood to capture potential home buyers working for Lockheed, Vega, and allied industries. During the war years Valley population grew 64 percent, from 112,000 to 176,000 residents. In the next five years newcomers almost doubled this figure as the annual growth rate reached 14.5 percent. In 1950 census takers reported 311,000 Valley residents.[9]

As a first step toward drafting a plan for future development, city staff surveyed and mapped current land uses. Large landholdings predominated; 179 square miles were held in parcels of one-half acre or more. Agriculture, farming, and ranching were the dominant land uses, occupying 66 percent of the Valley land and 81 percent of the area planners classified as usable. In 1943, dairying, husbandry, and food crops such as citrus, nuts, grapes, and olives amounted to a $20 million industry. Of the remaining acreage, surveyors found 33 of the Valley's 212 square miles had been platted into "town lots" of no more than twenty thousand square feet, and they identified only 15 percent of the total land area as urban.

Following fieldwork, planners began crafting a master plan document that would reinforce the existing land use pattern. Three principles guided the process. First, they considered the Valley a self-contained unit, "that is, industry and commerce should be introduced to supplement the agricultural economy and supply, insofar as possible, employment for present and

future residents." A second objective was protecting the profitable agricultural economy from the encroachment of town lot subdivision. Third, they believed future urbanization "should be guided by a rational land use plan," limiting further development to definite areas.[10] The empirical data gathered in the field led Bennett to an assessment similar to the one planners had formulated two decades earlier, when they first analyzed the region's urban pattern. In concert with Gordon G. Whitnall, George Damon, and other participants in the 1922 conferences, Bennett found a definite "trend toward concentration in small communities." There were continuities in personnel and approach as well: Whitnall advised the commission on the San Fernando Valley plan.[11]

Simultaneous with the preparation of the Valley land use plan, city staff were updating Los Angeles's zoning ordinance. The governing document, dating from the 1920s, was a patchwork pieced together from a series of ad hoc and interim controls. The uniform ordinance that replaced it effective June 1, 1946, designated sixteen land use districts. Three of the four zones on the San Fernando Valley plan, suburban (RA), agriculture A2 (two acres), and agriculture A1 (five acres), were designed in recognition of its unique development history and current conditions. The agricultural districts are self-explanatory. Land use planners devised the RA designation for areas with house lots exceeding twenty thousand square feet.[12] Prior to rezoning, the Valley had been under a blanket Residence District designation.

The master plan recognized eighteen "self-contained" communities as "nuclei" for urbanization (fig. 6.4). According to Bennett, the Valley's vast area and undeveloped nature made it possible to set aside "large areas for agriculture while designating others for urban uses . . . after careful analysis of present land use and ownership patterns." On the plan, a suburban zone of family truck farms surrounded each urban center or node. An agricultural buffer, a greensward of more intensive farming, encircled these urban-suburban clusters. A belt of large holdings, over five acres, devoted to field crops and animal husbandry would ring the Valley's far edge. According to Bennett and principal planner Milton Breivogel, the plan, if adopted and implemented, would permit a "gradual and orderly expansion" resulting in a community type known among planners as a "regional city . . . a number of well-planned and moderately sized communities of reasonable density, separated by agricultural areas."[13]

To promote the emergence of a regional city, planners allotted sixty-six square miles of Valley land for urban uses, double the existing thirty-three.

Within this area, just over six square miles were assigned to industry. Another three square miles would be developed strictly for flood control, leaving fifty-six square miles for residential and commercial development. Included in the document were "community designs" for enhancing and expanding existing nodes. For these schematic proposals, staff applied the principles of modern community planning to reconfigure an "illogical pattern of wildcat expansion," the product of metes and bounds surveys and incremental lot sales. In published drawings for Chatsworth, Northridge, and Reseda, superblocks are overlaid onto railroad and quadrangular grids. House lots front long residential loop streets, which shelter neighborhood parks containing schools and civic centers. Commercial areas line arterials, which intersect with thoroughfares or rail tracks, providing access to industry. The planners considered these diagrams a framework for "self-contained communities where industry and commerce will be in balance with population; where agriculture will continue as a substantial economic function; where people may live in an environment possessing all the amenities necessary for good living; and where controls for efficient and economic growth will stimulate development on an orderly basis."[14] Under the population densities permitted in the plan, the Valley would be home to nine hundred thousand residents by the year 2000.

In *Accomplishments 1945*, the planning commission highlighted a series

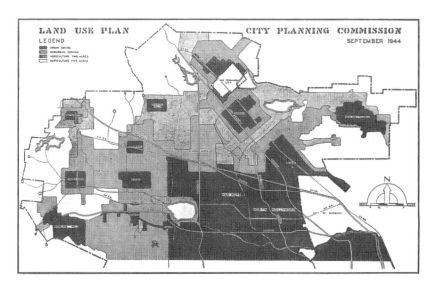

FIGURE 6.4 Los Angeles City Planning Commission master plan for the San Fernando Valley (1944).

of "Special Studies" undertaken during the year. The subdivision plan section featured "suggested developments" for a "planned community" at the Panorama Ranch, a working dairy farm managed by the Pellissier family (fig. 6.5). On this 430-acre parcel, staff planners had laid out alternate schemes, one suburban (RA), the other urban. Identical street systems, a superblock bisected by a collector with planted median, set the basic development pattern. Two arterials, Van Nuys Boulevard and Woodman Avenue, formed the west and east boundaries respectively. Major thoroughfares, Roscoe Boulevard and Osborn Street, were the southern and northern edges. Residential loops wound their way across the site, giving direct access from either arterial to a school, auditorium, and commercial center, sited on either side of a neighborhood park. The suburban development contained 433 lots and half the minor and loop streets of

FIGURE 6.5
Los Angeles
City Planning Commission
proposals for subdividing
and developing the
Pellissier Ranch.

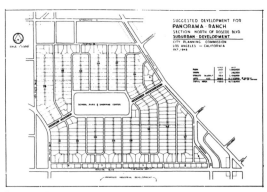

SUBURBAN

A PLANNED COMMUNITY

BETTER COMMUNITY FACILITIES
SAFER NEIGHBORHOODS
MORE AND/OR BETTER LOTS
LESS STREET AREA

URBAN

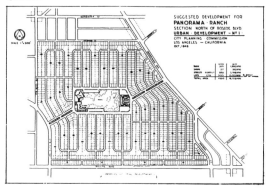

the urban alternative. The commission endorsed both plans as modern subdivisions featuring "better community facilities, safer neighborhoods, more and/or better lots, [and] less street area." Each scheme called for industrial development south of Roscoe Boulevard.[15]

Panorama City: Planning and Constructing a Postwar Package

At that time, Van Nuys Boulevard was a two-lane road, Woodman an unpaved roadbed. Roscoe Boulevard stopped at the site boundary, where it became a farm road to the Pellissier ranch (fig.6.6). While city planners prepared studies illustrating their preferred subdivision scenarios, land agents working for Kaiser Homes were considering the site for purchase. Bank of America assessed the property for KCH in April 1946 and valued it at $2,250 an acre. Bank appraisers considered four factors to be assets: the site's scale, ample for a "self-contained residential community"; proximity to employment; access to major highways; and a "suburban atmosphere." In a separate section, "Distance to Employment," the authors noted the General Motors assembly plant then under construction one-quarter mile south of Roscoe Boulevard and a Schlitz brewery immediately to the east. The report also noted the locations of Lockheed, Vega, and Adel Precision Tool, all within seven miles of the site.[16]

General Motors purchased its one-hundred-acre site in 1945 from the Panorama Ranch Company and announced it would construct facilities for its Fisher Body Division and Chevrolet with an assembly plant scaled, equipped, and staffed to produce four hundred units a day. Over the next two years the automaker built a $12 million facility; a local architectural firm, Parkinson and Parkinson, provided the design in consultation with Albert Kahn Associates (fig. 6.7). When completed in February 1948, the 1-million-square-foot, twenty-one-acre plant housed three assembly lines and the "latest in equipment." For the opening, General Motors hosted a five-day gala. Press day on Tuesday provided GM vice president and Chevrolet general manager Nicholas Dreystadt a forum for rehearsing facts and figures; fifteen hundred "local" employees would assemble one hundred thousand vehicles a year: every 1.2 minutes a car or truck would roll off the lines. Van Nuys' output would help Chevrolet meet an eighteen-month production backlog in Southern California, a delay six months longer than the national average. The new plant, GM's eleventh nationwide, was second in size only to the recently completed Oakland, California, facility.

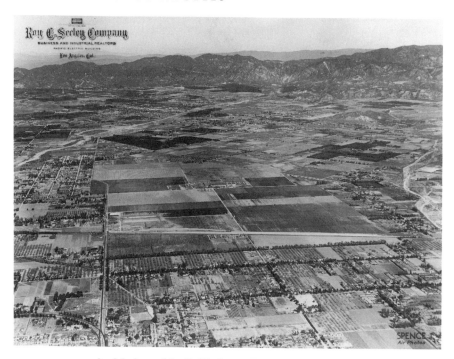

FIGURE 6.6 Aerial view of the Pellissier, or Panorama, Ranch (January 1946)

Wednesday began with a Chamber of Commerce luncheon. Lieutenant Governor Goodwin J. Knight gave the address and then joined in a two-mile parade along Van Nuys Boulevard. Well-wishers lined both sides of the street as a procession of floats and Chevy Fleetlines and Fleetmasters filed by en route to the plant. "We are glad to see industry matching population in California," Knight told employees and assembled guests. "In the last six years our population increased by more than 2.5 million." Joining Knight on the dais were local businesspeople, resident GM managers, and GM officials visiting from Detroit. After these dignitaries left for the Ambassador Hotel and dinner with Governor Earl Warren, visitors and residents enjoyed a "Hollywood style" extravaganza featuring the "most elaborate electrical display ever staged in the Valley." Thursday through Saturday GM hosted an open house with plant tours running eight hours each day.[17]

Seven months later floodlights could be seen one mile north of the General Motors site, this time trained on Kaiser's "California Ranch House." Although the first thirty-two dwellings would not be ready for occupancy until December, billboards, print advertisements, and nighttime promo-

tions that "lit up the sky" began luring the curious out to preview "1949 models" in September (fig. 6.8). Visitors could tour fifteen units, five of which had been "delightfully furnished" by Bullocks Home Stores, and place their reservations. Two "construction models" with framing, plumbing, and electrical systems "exposed for inspection" provided potential home buyers a chance to "kick the tires" and evaluate the "rugged durability combined with top quality refinements and innovations never before found in any house." A typical five-column spread showcased twenty-nine "people who know houses [and] have bought Kaiser Homes." The list of design professionals, tradespeople, construction superintendents, and suppliers included three Kaiser employees. An "All Aluminum" model house, the only one Kaiser Homes ever constructed, was open for inspection. It was then moved from Chase and Van Nuys to Osborne Street before KCH awarded it to the Georges.[18]

Before construction began, Burns had approved the land purchase for KCH, which completed the $1 million transaction on April 16, 1947, despite the fact that the Pellissiers negotiated a purchase price that exceeded the bank's appraisal. In a memo to Trefethen, Fred Pike, Burns' financial consultant, spelled out the terms for a lease option that included a percentage share in Panorama Community Homes for the former landowners. Pike suggested the bank's appraisal lagged behind the market and that the property was a "better buy than anything available at this time." He concluded with Burns' assessment that the "General Motors plant now under construction will furnish the industrial payroll necessary to support the large development which in itself will create additional value."[19]

Kaiser surveyors and engineers wasted no time developing a site plan for the property (fig. 6.9). Their proposal, published in *Accomplishments 1946*, exceeded the minimum required for approval. The planning commission chose it to illustrate the benefits of modern subdivisions and community design. The notice highlighted the project's proximity to General Motors and a Jergens plant and the inclusion of shopping areas, church and school sites, and a playground. For the commission, this plan demonstrated improvements in the "character of subdivisions submitted to the City Planning Department. Good design, as an important element of subdivision development, has been widely accepted by subdividers. The advantages in terms of dollars and cents have convinced them that city planning techniques are good business. These improvements are of great benefit to the city as a whole."[20]

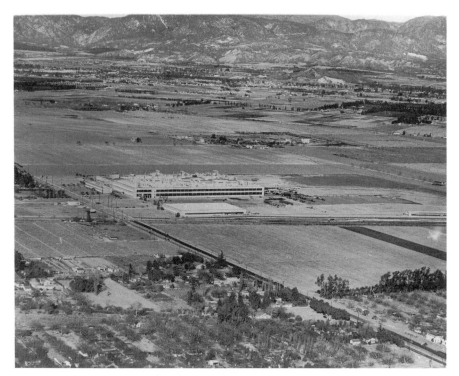

FIGURE 6.7 Aerial view of General Motors' Chevrolet assembly plant (1948)

FIGURE 6.8 Potential buyers inspecting model units, including a Kaiser Aluminum House, Panorama City (1948).

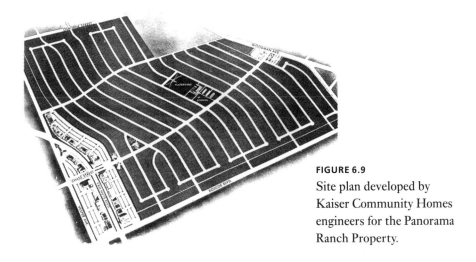

FIGURE 6.9
Site plan developed by
Kaiser Community Homes
engineers for the Panorama
Ranch Property.

Over the preceding decade, as Burns made the transition from develop-
ing raw land and selling lots to community building, he integrated modern
community planning into his operation. In "Postwar Housing," a report
written with David D. Bohannon for the state Commission on Reconver-
sion, these nationally recognized builders and developers argued for
"modern neighborhoods, unhampered by the mistakes of the past,"
providing residents with "freely accessible open space . . . schools, shops,
recreational and religious facilities, all near enough for convenient use. . . .
Transportation to business areas should be rapid and direct, and when
possible, jobs should be within walking distance, although cut off by green-
belts and concealed from the residential area."[21]

In both theory and practice the criteria and objectives Burns endorsed
for successful subdivisions had become consistent, over time, with those
regional planners and progressive real estate entrepreneurs espoused (fig.
6.10). Those principles, evident in the Panorama City site plan, set it apart
from earlier projects that had raised critics' ire. A 1933 article in *Harpers
Magazine* decried the misery and desolation speculative builders and de-
velopers had wrought on American cities. The author offered a medical
analogy, diagnosing a "slow necrosis of unsightly subdivisions, acres and
acres of jerry-built bungalows, apartments, and tenements, without dif-
ferentiation, dignity, or stability." Three years earlier a Los Angeles zoning
engineer analyzed this condition in material terms, arguing that in the past

small-scale operations and a lack of coordination had resulted in cities whose jogging, narrow, and dead-end streets, small lots, and limited services "fairly shout 'No Planning'."[22]

As former director of the FHA's land-planning division, and later director of the Urban Land Institute, Seward Mott noted, it was a reciprocal process. Although the sources for the physical planning strategies that guided Kaiser engineers can be traced to the planners' earlier proposals, the site-planning process at Panorama City reflected a community builder's interests, objectives, and vision. Kaiser Community Homes programmed the initial phase for two thousand homes on lots averaging 60 feet by 115 feet, for an average density of six units per acre. Charles D. Clark, a former Regional Planning Commission subdivision engineer and chief West Coast FHA land planner, planned the site of the Panorama Ranch property for Kaiser Homes with Charles Getchell.

The planning commission's schematic drawing showed Roscoe Boulevard as a one-hundred-foot collector. The KCH engineers disagreed, and on their initial drawings they scaled it down to a minor street. In this case, the city eventually prevailed.[23] However, contrary to the planners' diagram, where local retail defined the park's western edge, Burns and Kaiser developed a two-sided, linear commercial district on seventy-five acres along Van Nuys Boulevard and a neighborhood shopping center one mile east along Woodman Avenue at Roscoe. They sited duplexes, marketed as

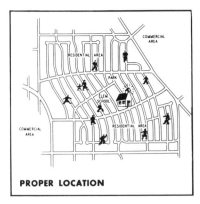
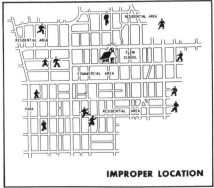

FIGURE 6.10 Los Angeles City Planning graphic showing "Proper" and "Improper" community planning for elementary schools. This 1948 study illustrated planners' continued endorsement of neighborhood planning principles. Note that in Los Angeles, planners used the Panorama City site plan to demonstrate proper school location.

"income dwellings," between the commercial zone and single-family hous-
ing as a buffer segregating each land use. The firm deeded six acres to the
city for a playground and community center and five acres for public
schools. The Presbytery of Los Angeles and the Roman Catholic arch-
bishop purchased the first church sites offered for sale.

Planners and community builders cast an agreed-upon physical frame-
work for development. Depending on the particularities of locale, scale,
and timing, either party would piece together a specific project from a
standard kit-of-parts. This dynamic process permitted variation and occa-
sional innovation.

The individual dwelling units at Panorama City reveal Burns' con-
tinued allegiance to the minimum house, a plan configuration he first
constructed at Westside Village and Toluca Wood. The Panorama City
house plans align closely with those technicians established during the
1920s and 1930s and the standard units the FHA endorsed. They are, in
fact, nearly identical to the "Basic Plan" the agency published in "Princi-
ples of Planning Small Houses." In "Postwar Housing," Burns staked out a
"middle-ground" between the "propagandists of 'miracle' homes and the
'traditionalists.'" He predicted the floor area in new housing would be less
than the prewar norm but foresaw efficient planning and functional zoning
maximizing flexibility. This "open design with fewer small rooms" would
make each unit feel more spacious. In terms of orientation on the lot,
Burns advocated placing the kitchen at the rear of the house, "toward the
backyard and privacy."[24]

Kaiser Homes marketed the Panorama City units as a collaboration
between its engineers and designers and the "well-known Los Angeles
architects" Wurdeman and Becket. A sketch of a floor plan for a three-
bedroom house on stationary from the New York Biltmore, dated and
signed by Burns and annotated "patent applied for," suggests an authorial
conflict (fig. 6.11). Except for minor variations, slipping the kitchen be-
yond the entry to create a porch, chamfering an exterior corner, and tinker-
ing with appliance and counter layout, this plan could be substituted
without notice into most contemporary developments. Burns felt other-
wise. Above his signature he wrote, "If you lose this—leave town."[25]

In 1949, a two-bedroom, eight-hundred-square-foot dwelling sold in
the $9,000–10,000 range. The price included a lot, "double garage," and a
list of shared amenities, from basic services to street trees. A buyer would
have paid approximately one thousand dollars more for the three-bed-
room, one-thousand-square-foot unit. Duplexes, which sold for $15,950,

FIGURE 6.11 Fritz Burns' sketch for a three-bedroom house plan. Note the patent application and annotation: "If you lose this—*leave town.*"

contained identical two-bedroom units with a living room and dining alcove. That year KCH completed 1,529 single-family houses at Panorama City, almost six units a day.

Successful community building hinges on many factors. To meet their criteria for success Burns and Kaiser had to be constantly mindful of speed and scale. They achieved maximum speed through standardization of parts

and product. At the project level, Burns and Kaiser used the minimum-house plan as a repetitive module, altering the roof line, massing, finishes, and siting of the garage, which KCH considered the "fundamental vari-ables," to create formal variety in an otherwise homogeneous tract. KCH ads trumpeted large-scale operations and played on Henry J. Kaiser's wartime achievements. For example, an oblique aerial framed by expanded type proclaims "22 MILES of HOMES now building"; sidebars quantify the sewers laid, sidewalks and curbs poured, and square feet of paving, as well as the number of men at work building an "entire city" (fig. 6.12).

For community builders, standardization was both a necessity and a curse. Large-scale and rapid production were in direct conflict with a marketing imperative, product diversity. In site planning and constructing a community project, builders had to strike a balance between offering the consumer an individually articulated unit and the need to create a coherent visual setting. Kaiser Community Homes and other firms achieved dif-ferentiation by alternating the massing and roof forms and combining and recombining textures and colors from a limited palette. Community build-ers seized upon the street as a means for introducing the necessary con-tinuity. The formal challenge was how to compose a varied yet unified street perspective from a standardized kit-of-parts. The inaugural KCH brochure offered this assessment of the street and streetscape: "Home sites will be arranged for maximum attractiveness within and in relationship to the community. The main streets and minor residence streets will be laid out to provide vistas which will be given variety and charm by the arrange-ment of homesites, variations in setbacks, and landscaping."[26]

In a 1957 *Mirror-News* interview for their "Your Town" series, reporter Bill Thomas asked six-year Panorama City resident Josephine Cannici how she liked living in a planned community and whether it produced a "sti-fling sense of uniformity." Cannici responded that she had watched Pan-orama City grow from a "cow pasture to a thriving community." In terms of its character, she credited Burns with carefully laying out houses "built from many plans. . . . The result is a community of graceful homes on winding streets without a trace of the mass development look."[27] Note that Cannici perceived the built landscape in Panorama City precisely as KCH intended.

From the article text we have to assume her response addressed the journalist's concern. From our perspective, we read a social issue where Cannici heard a question about physical design. Burns, for his part, was not ignorant regarding social concerns, although his values and vision were

less than exemplary. While suggesting that individual homes should display a "certain congruity" of design, Burns argued for a variety in unit prices "to provide a varied community atmosphere and to prevent un-American economic and social stratification." Occupational diversity, a distinguishing factor when comparing Westchester with the traditional residential suburb, characterized Panorama City as well. The 1950 census reveals the residents' heterogeneity. Wage earners were divided evenly between the class of operatives and laborers and that of craftsmen and kindred workers. Together these two classifications accounted for one-half of the workforce. Another one-quarter of residents in these census tracts

FIGURE 6.12
Print advertisement for
Panorama City.

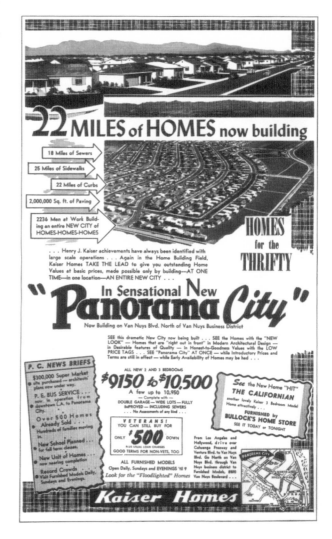

were listed as professionals and managers. However, like the majority of community builders, Burns and Kaiser placed inflexible limits on the extent of social mixing they would endorse. Kaiser restricted his dream of home ownership for all to the industrious working classes. Burns went further. He was, and remained, an adamant supporter of restrictive covenants designed and enforced to exclude people of color from purchasing housing in his developments.[28]

Within their particular vision of a complete community, Burns and Kaiser intended to construct a package tailored to anticipate and stimulate a variety of their residents' needs. Without question, self-interest and maximizing the return on investment motivated and structured their decisions and actions. Kaiser Community Homes' corporate records underscore a careful attention to finances. However, the profit motive cannot explain entirely their development strategies. Community builders did not simply purchase the least expensive parcel of available land for development, nor did they merely choose parcels with the best location structured by external factors. Burns and Kaiser created favorable locations, and they realized they could increase the likelihood of returns through skillful planning. From donating the San Fernando Valley Garden Center a site for its new association building to the eventual construction of a mid-rise office complex in 1961, every move was carefully calculated and timed to improve their odds. Burns and Kaiser encouraged home buyers to play a part. After purchasing a house in Panorama City, new residents were provided a "how-to" pamphlet, "Keeping Up with the Joneses," which offered advice on maintaining and upgrading residential property to capitalize on their investment.[29]

The approach Kaiser and Burns took in developing the commercial district, as well as their timing, illustrates how financial decisions, planning, and external factors, in this case tax policies, intersected. Kaiser Community Homes' success in constructing, promoting, and selling housing in Panorama City generated a captive consumer base. To service this clientele, Burns and Kaiser incorporated a separate operating company, the Panorama City Shopping Center, to develop a one-hundred-acre business district (fig. 6.13). Copy for a newspaper advertisement extolling the entire new city alerted readers that "with a background of 1,400 families already living here, the Business Center now begins to shape up."[30]

Panorama City Market, a $1 million, 60,000-square-foot neighborhood convenience store, which opened in May 1952, was the prime tenant (fig. 6.14). At that time a theater and "Super Service Station" were under

construction as well. Three years later N. J. Ridgeway, vice president in charge of commercial marketing, reported forty-two retailers, five restaurants, and a thirty-lane bowling alley with parking for six thousand cars behind the commercial structures. All the stores and shops were "double-fronted" with show windows and entrances at the street and parking lot. At this point the district was a typical neighborhood commercial development, designed and constructed for local residents.[31] That changed when the Broadway Valley, a 216,000-square-foot department store, opened later that year at the northeast terminus of the district. Executives at the Broadway must have recognized the demographic and retail sales trends. Their timing was fortuitous; in 1955 retail sales in the Valley outpaced those in the region's traditional, downtown commercial core for the first time. Seven years prior, total sales in the valley had been half that downtown.[32]

A 1959 sales brochure, "Panorama City Shopping Center: The Center of the San Fernando Valley," invited commercial investors to participate in the "last and final block" in the business district. The text provided readers a general overview of the project's evolution during the past decade, a booster's account of the "scientifically planned community" updated to reflect current population, which had then reached seventeen thousand. However, when discussing the commercial district the authors reworked their narrative: Panorama City was now "complete with a regional shopping center." Maps with concentric rings gave population gradients at a radius of one to six miles. At the time, twenty-four thousand people lived within a single mile of the commercial district, which registered $48 million in retail sales that year. Three major department stores, J. W. Robinson, Montgomery Ward, and Ohrbach's, had selected Panorama City for their regional centers.[33]

Initially, commercial development had been one aspect of Burns and Kaiser's integrated community-scale project. Over time, finances, specifically the prevailing tax structure, encouraged or almost compelled KCH to shift their operations from home building to regional retail and office development. In a 1952 letter to Bank of America, Fred Pike provided a detailed accounting of KCH's financing and financial performance, with particular attention to construction and mortgage loans. At this time the firm's total indebtedness to Bank of America for Panorama City was approximately $25 million. During three years of home building KCH had been realizing pretax profits of approximately a thousand dollars per dwelling. However, total profits from house sales exceeded the company's excess-profits tax exemption, and additional income was being taxed at a

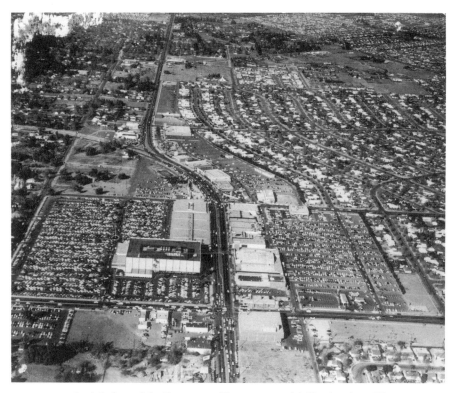

FIGURE 6.13 Aerial view of the Panorama City commercial district along Van Nuys Boulevard.

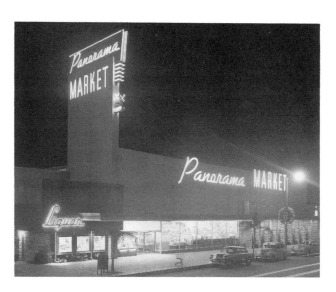

FIGURE 6.14
Panorama Market, a neighborhood convenience store developed by Burns and Kaiser.

70 percent rate. Pike penciled out a hypothetical 250 house increment to apprise the bank of this situation and build a case for their alternative. Under current conditions, completing 250 units required $1 million in working capital and returned $75,000 net, or $300 per unit after taxes. Given this, Pike continued, "we decided we would use our available working capital to build up the business district." The rationale followed. Since KCH controlled the available frontage in the business district, excepting the Panorama City Market, which they had sold to entice an anchor tenant, the company was in a "wonderful tax position . . . as we can develop a stable income based on high land values without paying any income tax on the appreciation. . . . As long as we do not sell the property, we do not have any tax to pay on the $72,000 per acre increase in value and still we get the effective benefit through the collection of rents."[34]

A Metropolitan Mosaic

Most interpreters of postwar community development analyze specific projects as discrete and isolated fragments. Their accounts provide important information but generally overlook or dismiss the complexity and comprehensiveness of the community builders' urban or regional vision. Two factors, connections and performance, account for the scope of the builders' concerns. Large-scale developers recognized the intrinsic relationship among metropolitan locales and respected these interconnections. This is not to suggest they ignored or negated competition and comparative spatial advantage. But they did realize that if specific districts or an entire region was in decline, returns would eventually diminish across locales. There was a physical correlate to these connections. The Panorama City business district, later regional shopping center, was dependent on a broad catchment area for its consumers. If KCH had followed the planning commission's proposal and sited their commercial development internally, along the park, it could not have evolved into a regional center. Instead, Burns and Kaiser chose a configuration closer to the one Perry advocated in his neighborhood unit formula, siting the commercial district along an arterial at one of the superblock corners where it could become a pivot for a set of contiguous developments. As constructed, the retail development contributed to Burns and Kaiser's ongoing project, manufacturing location.

An aerial photograph taken in 1954 captures Panorama City as a module

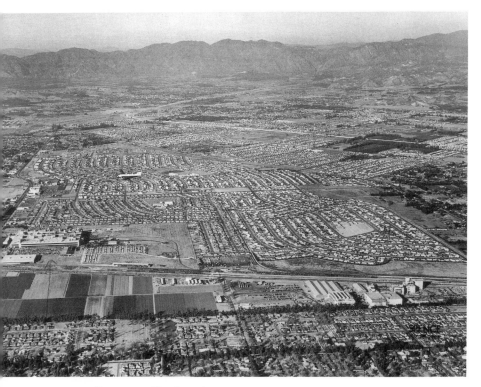

FIGURE 6.15 Panorama City (1954)

in the urban region, a "block in the metropolitan mosaic" (fig. 6.15). In
1950, KCH purchased another four hundred acres south of Roscoe Boule-
vard that had remained in agriculture for additional residential develop-
ment.[35] They marketed this second phase as Woodman Avenue Homes.
Two years later the company had completed another fifteen hundred hous-
ing units. Roscoe Boulevard bisects the site on an east-west axis linking
Woodman and Van Nuys, two of the valley's major arterials. Along Roscoe
is St. Genevieve and, to the east, the church's school site. Directly north is
the community recreation center and primary school. South and east, one
block below Roscoe, is the public high school. The commercial district,
with movie theater, bowling lanes, department stores, and convenience
centers, fronts Van Nuys Boulevard. Just south of Roscoe in the bend of
Woodman Boulevard is a vacant site where Kaiser-Permanente first com-
pleted a clinic and then a medical center in 1962. The GM plant, brewery,
and Panorama Development Center, an industrial tract west of the assem-

bly plant along the Southern Pacific rail lines, are as prominent here as they were in the advertisements and broadsides KCH circulated when attracting potential home buyers.

In many respects Panorama City was a far cry from the gridded, single-lot-sales and small-time-contractor approach to neighborhood building that characterized residential construction up to the 1930s. Just as important for understanding postwar metropolitan landscapes are the ways it can be distinguished from the exceptional neighborhood projects from that earlier period, such as Leimert Park. A comparative analysis of these developments reveals the evolution in subdivision practice over two decades. Walter Leimert incorporated aspects of modern community planning in his development, and many of these are evident in Panorama City. Both Leimert and Kaiser Community Homes based their development strategies on a belief in comprehensive planning for a mix of land uses, constructing, as contemporaries understood it, an infrastructure for community. In each case the first pattern was set with a hierarchical system of streets and roads planned for internal consistency and external connections. Both Leimert Park and Panorama City garnered national recognition. B. C. Forbes cited the former's modest homes and community planning as an exemplary demonstration of a subdivider applying lessons drawn from exclusive developments to create an "attractive, orderly, and well arranged" district for the "average home owner." In the latter case, a trade association, the National Association of Home Builders, designated Panorama City 1949's "Best Neighborhood Development" in its annual competition.[36]

At the same time, we can understand changes in the nature and timing of the city-building process if we consider the attributes and aspects that distinguish these projects. The difference in scale was critical and multifaceted. Walter Leimert began with 230 acres and platted twelve hundred lots and a neighborhood commercial district. Phases one and two at Panorama City, by contrast, contained three thousand dwelling units (90 percent single family) on an eight-hundred-acre tract with a regional shopping center. More important were distinctions in the scale and scope of the firms' operations. Leimert designed the subdivision, laid out streets, subcontracted engineering for services and installation, platted and sold lots, and managed commercial development, a considerable enterprise in 1927. Burns and Kaiser oversaw each of these operations and more. Their company built the housing, arranged financing for home buyers, and retained ownership of the commercial property. They then extended the developers

reach to include landscaping for individual units, upkeep and maintenance, and home owners' and health insurance for purchasers. The timing of these operations changed dramatically, as well. By folding construction into their domain, Kaiser Homes and other community builders accelerated the development process. This afforded prospective buyers and initial residents an opportunity to inspect or move into a dwelling whose physical context was already established. Kaiser Homes' initial brochure presented this as an asset, claiming its communities would be landscaped as a whole rather than following a piecemeal approach: "lack of symmetry, vacant lots, and unrelated residences will be things of the past."[37]

Leimert adopted a generous but functional plan with public areas for residents and visitors. He also sponsored a small-home demonstration and established procedures for architectural review to fix formal guidelines. The model dwellings, and those constructed by lot buyers and tradespeople, were set back a uniform fifteen feet from the sidewalk on narrow lots with gables facing the street and a restricted side passage to detached garages. Kaiser Homes produced two- and three-bedroom minimum houses averaging nine hundred square feet on broad lots. These units were sized, equipped, and constructed in accordance with FHA standards, which allowed wage earners to secure long-term mortgages and become home buyers.

Location was an important criteria for Leimert and Kaiser Community Homes. Position is an informative variable for a comparative assessment. Infrastructure, such as transportation, is one obvious example. In this case, we want to consider changes in the mode, or modes, of transit but also, just as critically, variation in travel patterns over time, for example, between residence and place of work. Leimert advertised his development in relation to a single regional core; it was "15 minutes from downtown" on the Pacific Electric. Although he carefully planned for the integration of a neighborhood commercial district with a mix of single-family and multiple-unit residences, Leimert did not locate his project in close proximity to employment. Burns and Kaiser, on the other hand, viewed Panorama City differently. They sought land adjacent to manufacturing and in their minds constructed "a city where a city belongs" (fig. 6.16). They intended this project as one of the self-contained urban nodes the planners recognized as components of a regional city.

The significance of Kaiser Community Homes was the way in which corporate officers, engineers, and field personnel involved in its creation thought about housing. Each individual unit would be the center for an

entire package programmed to include recreation, health care, religion, education, and consumption, all in close proximity to employment. This package had been scientifically analyzed for efficient production and management and organized to be reproduced on open tracts of land or re-platted, premature subdivisions passed over during subsequent development. Rarely achieved, this nonetheless became an ideal for postwar home building.

In other words, Panorama City epitomized the convergence of a planning ideal, the decentralized regional city, with the production emphasis and community-building expertise of a corporation such as Kaiser Homes. It was, however, like other community developments in Los Angeles and

FIGURE 6.16

Print advertisement for Panorama City.

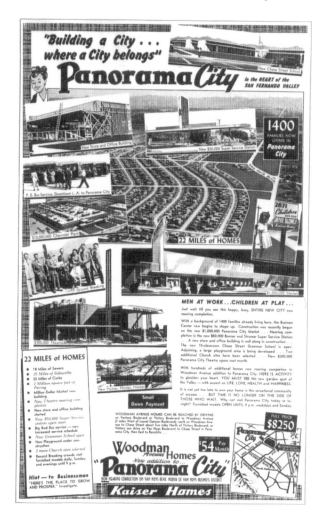

throughout the country, a compromise. More precisely, these large-scale postwar projects can best be understood as amalgams, the unanticipated blending of environmental and social reform we identify with Progressives and progressive housers, the theory and plans of decentrists and pragmatists, and the technicians' and productionists' faith in science, industrial management, and economies of scale.

As a case study, Kaiser Community Homes explicates a number of issues key to this study and to understanding our contemporary metropolitan landscapes. First, the firm adopted the minimum-house type that technicians and productionists had painstakingly developed over the preceding thirty years. Kaiser engineers strove to implement the principles of simplified practice that the Department of Commerce had encouraged during the 1920s. Through an elimination of waste and the reduction of types, they made a home-building ideal real. We can place Kaiser Homes' projects in Los Angeles, the San Francisco Bay Area, and Portland in a national context by considering them as part of the trend toward smaller houses. Federal Housing Administration data on insured dwellings showed a marked decrease between 1940 and 1950 in the median number of rooms in new housing constructed under their program, from 5.6 to 4.9 rooms per unit. In 1950 the NAHB found that 65 percent of housing starts were four-room dwellings.[38] Writing in 1958 for the Bureau of Labor Statistics, Kathryn R. Murphy stated unequivocally:

> The two-bedroom, one-bath house with less than 1,000-square-feet of floor area, which typified new houses [to] 1950, was the culmination of an earlier effort of the Federal government and the building industry jointly to focus greater attention on building for the lower-priced market in a period of rising construction costs and urgent housing shortage.[39]

Second, although they were unable to achieve all the economies of scale Henry Kaiser had predicted, community builders like KCH applied quantity production techniques, pre-engineering, preassembly, and rationalized, serialized site fabrication to construction of housing that wage earners could afford. Third, they sited these low-cost dwellings within large-scale projects designed around a predetermined cluster of amenities, a package reformers had defined as modern community planning.

And yet, even though a project like Panorama City fit within the dictates of neighborhood and community planning spelled out by reformers and adopted by city planners, it simultaneously undermined the broader objective of a regional city with a carefully planned distribution of residences,

employment, recreation, and institutions. The site plan KCH developed aligned with the functional requirements planners specified, a comprehensive master-planned community that followed superblock principles, with neighborhood and commercial facilities and good proximity to employment; but KCH engineers failed to designate or dedicate an agricultural greenbelt, either small scale (A2) or large scale (A1). Bereft of a delimiting buffer, a series of contiguous communities, regardless of how well they were planned internally, could, and eventually did, overwhelm the valley, as well as the outer zones of other American cities. This history is important because the deliberate creation of a regional metropolis in Los Angeles from the 1920s through the immediate postwar years was consistent with development in most metropolitan areas throughout the country.

This account of postwar development in Southern California is contrary to the narrative *Life* presented its readers in 1953. Four years later, *Newsweek* ran a series, "The New America," examining "one of the biggest stories in the world today . . . the story of a nation on the move," starring "people, money, cars, homes, and factories." In the first installment, "Suburbia-Exurbia-Urbia," journalists examined the changing American community. Reporters gathered the usual suspects and uncovered predictable offenses: conformity, commuting husbands, isolated wives and mothers, and no time for or interest in community life. However, on the final page someone squeezed in a telling aside, suggesting the typical suburban picture was becoming outdated because industry was now "joining the exodus to greener pastures." The example cited was Rocketdyne, a division of North American Aviation, which had opened a nine-thousand-employee rocket engine plant in the western San Fernando Valley. According to a company spokesperson, "we're like the store owners taking the shop to the customers." Rocketdyne attributed its locational strategy to available space and ready access to a skilled labor force. Their recruitment slogan, "Work Close to Home," said it all.[40] Rocketdyne, it should be noted, was a relative latecomer; the firm joined established industries and, in the postwar years, an emergent aerospace sector in the Valley. And, as we have seen, Rocketdyne's strategy was consistent with long-held principles of urban development.

Every few decades someone discovers, yet again, that urban patterns in American cities have never been as tidy as the diagrams produced by reformers, social scientists, and planners would suggest. The *Newsweek* reporter's findings are similar to current assessments such as the postsuburb, the technoburb, and the edge city.[41] In his ahistorical and uncritical exam-

ination of contemporary metropolitan landscapes, Joel Garreau reiterates the standard suburban thesis. Edge cities are not, as he states, a new urban type, in the formal sense, nor are they new in the temporal sense. In this study I have traced a genealogy back to Ebenezer Howard's garden city and the planned dispersion of the nineteenth-century industrial city. Garreau and other authors are incorrect as well when they claim that housing led and continues to lead urban expansion. Rather, as this study of Los Angeles home builders and aircraft manufacturing has shown, industry provided an economic base, jobs, and people, the foundation necessary for large-scale builders' experiments in modern community planning.

NOTES

Abbreviations

AIA	American Institute of Architects
APHA	American Public Health Association
CCIH	California Commission of Immigration and Housing
CCPA	Committee on Congested Production Areas
CREA	California Real Estate Association
CSRA	California State Relief Administration
DBH	Division of Building and Housing, Department of Commerce
DIH	California Division of Immigration and Housing
EFC	United States Shipping Board's Emergency Fleet Corporation
ERA	Emergency Relief Administration
FHA	Federal Housing Administration
FPL	Forest Products Laboratory
FSA	Farm Security Administration
FWA	Federal Works Agency
HOLC	Home Ownership Loan Corporation
IWW	Industrial Workers of the World (Wobblies)
KCH	Kaiser Community Homes
NAHO	National Association of Housing Officials
NAREB	National Association of Real Estate Boards
NAHB	National Association of Home Builders
NHA	National Housing Agency
NRA	National Recovery Administration
OPM	Office of Production Management
RPAA	Regional Planning Association of America
USHC	United States Housing Corporation
WMC	War Manpower Commission
WPB	War Production Board

Introduction: Suburbanization as Urbanization

1. ". . . And 400 New Angels Every Day" 1953, 23.
2. *American Quarterly* 46, no. 1 (Mar. 1994): 1–55.

3. Jackson 1985; Fishman 1987a and 1987b; Douglass 1925; Harris 1943.

4. Lewis 1983; Kling, Olin, and Poster 1991; Sudjic 1992; Dear 1996.

5. In his examination of the term *city*, Raymond Williams (1976) traced the distinction between urban and rural to the sixteenth century, with general currency from the Industrial Revolution. Williams studied country rather than suburb but noted the latter's changing status from an outer, inferior zone (hence the connotation provincial) to an exclusively residential area with boundaries drawn by class.

6. Blake 1964; Dobriner 1958; Mumford 1961; Whyte 1956. For interpretive accounts, see Schwartz 1976 and Palen 1995.

7. Blackford 1993; Weiss 1987.

8. Prince 1922.

9. Smutz 1930.

10. Mumford 1927b, 15. Howard 1965, 46.

11. Potter 1945, 3.

12. Jackson 1980; DeGraaf 1970.

13. "Home Ownership Drive" 1930, 149.

14. Garreau 1991, 3; Soja 1986; Davis 1990; Dear 1996.

15. Whitnall 1924, 110.

16. McWilliams 1949, 28.

17. McWilliams 1990, 134.

18. Lewis 1983.

19. Garreau 1991, back cover, 4.

Chapter One: Modern Community Planning

1. "Park Sees New Building Mark," *Los Angeles Times*, Oct. 21, 1928; "Plaza and Business Unit Dedicated, Civic Officials Speak at Leimert Park Ceremonies," *Los Angeles Times*, Nov. 18, 1928; "Business Center at Leimert Opened," *Los Angeles Evening Herald*, Nov. 20, 1928.

2. Cahalin 1929; "Our Homesite Permanently Improved in Leimert Park," *Los Angeles Times*, May 1, 1927.

3. Olmsted, Bartholomew, and Cheney 1924; "New Highway Will Open Sunday," *Los Angeles Examiner*, Aug. 3, 1928.

4. "Plan Elaborate Opening Program" 1932, 1.

5. "Development Plan Praised, National Writer Discusses Community Idea," *Los Angeles Times*, Dec. 1, 1929.

6. Robbins and Tilton 1941.

7. Smutz 1930; County of Los Angeles 1932a. Nichols 1926; City of Los Angeles 1929; Black 1933.

8. Eichler and Kaplan 1967; Longstreth 1986; Weiss 1987; Worley 1990. See also *Urban Land,* the monthly bulletin from the Urban Land Institute (ULI). Potter was ULI president in 1944, when he helped organize the Community Builders' Council.

9. *Los Angeles Times*, Apr. 16, 1927, pt. 5.

10. McMichael 1930, 11.

11. Windsor Hills material in the Fritz B. Burns Collection.

12. The Bureau of Foreign and Domestic Commerce and the Bureau of the Census produced a real property inventory in 1934. Field-workers visiting sixty-four cities inspected 2.5 million dwelling units and found that 18 percent needed major repair or should be condemned, 35 percent were without indoor toilets, and over 50 percent were without bathtubs. See National Public Housing Conference 1934. The WPA survey, conducted under the Division of Social Research from 1934 to 1936, was a comprehensive enumeration with data on type of structure and construction materials, value, tenancy, number of rooms, number of persons, equipment, race of occupants, and presence of boarders. See WPA 1938. The Bureau of Labor Statistics included data on housing in their urban surveys on wage earners and the cost of living. See Department of Labor 1939, 1941a, 1941b. For data on rural housing conditions, see Department of Agriculture 1940. These documents retain their power as indictments of unregulated speculative housing.

13. City of Los Angeles 1928; Eberle Economic Service 1932, 50.

14. On the state of the building industry in the 1920s, see Maxwell 1931; Riggleman 1933; and NRA 1934. For a contemporary assessment of the role of real estate speculation in the economic downturn, see Simpson 1933. Statistics on housing starts are from NAHB 1957, 65, table A-1, "Housing Starts." The data on residential construction and modernization of the housing stock are from Lasch 1946, 7. For examples of reform publications from this period, see Alfred (1932), who used the 1930 Bureau of Foreign and Domestic Commerce Real Property Inventory in a denunciation of poverty and its correlation to crime; and Wilhelm 1934. Later examples include Irving Brant, "The Great American Delusion" (in the Housing folio in the collections at Doe Library), an address on slum clearance and rehousing delivered to the National Public Housing Conference, Jan. 18–20, 1935; and the Home Building Program of the Committee for Economic Recovery, (ca. 1934), a report to President Roosevelt on the need for a great American home-building program (also in the Housing folio at Doe Library). See Bauer, "The Housing Movement: A Brief Political History" (C. B. Wurster Papers, carton 2) for an excellent overview of contemporary housing policy. For an interpretive study of the American economy during this period, see Potter 1974.

15. Progressive housers produced a vast literature; I consulted the manuscripts and reprints in the C. B. Wurster Papers and Wood Papers. For interpretive studies, see Lubove 1963; Fish 1979; and Keith 1979.

16. I found Rydell 1985 useful for interpreting the housing exhibits at the Chicago and New York fairs, particularly his discussion of scientific pragmatism. See also Rose and Clark 1979.

17. On advertising and modern housing, see Miller 1991.

18. Mumford 1927a, 1484.

19. Southern California Telesis ca. 1941. Planners used the terms *community* and *balanced living* without providing precise definitions.

20. "The Planned Community," in County of Los Angeles 1935.

21. Secretary of Commerce Herbert Hoover initiated an Advisory Committee on

City Planning and Zoning within the department to coordinate a joint government, business, and professional network designed to formulate a framework for local initiatives. See Hoover 1927. Weiss (1987) demonstrated the coordination among realtors, community builders, and planners.

22. *Nation*, May 11, 1932, in County of Los Angeles 1933.

23. Perry 1939, 84.

24. Wright 1927, 306.

25. *Pasadena Star News*, Aug. 16, 1930, in County of Los Angeles 1932b.

26. *California Real Estate Magazine*, Apr. 1934, in County of Los Angeles 1935.

27. Cornick 1938, 290. *New Republic*, Mar. 7, 1934, in County of Los Angeles 1935. On the problem of excessive subdivision, see also Boyd 1927–28 and Clark 1934. Critics pointed to increased property costs and development in advance of need as factors in the loss or inability to secure public open space.

28. See Clark 1934 for an account of municipal costs. Maverick (1933) and Boyd (1927–28) provide a review of the 1920s boom. For an informative and entertaining account of the "adventurous classes," "land-suckers' tickets," boosters, and "empire builders," see McWilliams 1990, especially chapter 7, "Years of the Boom."

29. County of Los Angeles 1932a.

30. For a brief outline of zoning and subdivision regulation, see Babcock 1979 and Lamont 1979. On the drive to standardize zoning, see Department of Commerce 1936. For a contemporary assessment of the restrictive covenant, see Department of Commerce 1923, 10–12.

31. Black 1933.

32. Park 1927; Park, Burgess, and McKenzie 1925.

33. Southern California Telesis ca. 1941.

34. The Bauer quote is from "Labor Housing Program" and continues, "No housing shall be done except in integrally planned community developments, equipped from the beginning with adequate utilities and services and with those external facilities without which no modern dwelling can be judged complete— schools, shops, recreation, and social centers." C. B. Wurster Papers, carton 2. See Gillette 1983 for a discussion of the Progressive roots of Perry's formulation and his social work in the community center movement. Gillette revealed the community center advocates' environmental determinism and their belief in the neighborhood as a positive attribute in the socialization process and for citizenship.

35. Auger 1936.

36. Many American design professionals who advocated planned dispersion drew their conception from European theory and models. The RPAA was initially organized as the American branch of the international garden city movement. Mumford and other members of the RPAA also shared with European adherents of garden city principles a belief in an ecologically determined set of limits to city growth. See Howe 1912; Purdom 1925; Bing 1925; Mumford 1927b; Stein 1951. Howard's garden city proposal was one of the formative paradigms for twentieth-century city building and as such has been the focus of an exhaustive secondary literature. See, for example, Fishman 1977 and Kostof 1991.

37. Atterbury 1912.

38. Perry 1929.

39. Atterbury 1912; Perry 1929. See Perry 1939, 209–21, for the influence of Forest Hills on his later thinking and Loeb 1989 and Gillette 1983 for Perry's formulation of the neighborhood unit concept. The Olmsted quote is in Kostof 1991, 79.

40. "Home-Ownership Drive" 1930, 149.

41. Wheeler 1933.

42. Gries and Ford 1932a, 20.

43. Ibid., 21.

44. FHA 1936b; FHA 1936c, especially "Part II: Desirable Characteristics."

45. FHA 1936b.

46. Mumford 1954.

47. Mumford spoke to this point in the pamphlet *New Homes for a New Deal* (Mayer, Wright, and Mumford 1934). Perhaps the tone of his statement in "The Neighborhood and the Neighborhood Unit" (Mumford 1954) reflects a distaste for postwar urban expansion. The emphasis on the social unit could be read as a critique of "sprawl" and the "growth of the suburbs."

48. Mayer, Wright, and Mumford 1934.

49. Alexander Bing, a New York developer who later organized the City Housing Corporation, a limited-dividend company that financed Sunnyside and Radburn, was secretary of the EFC's Housing Committee. Bing's assistant, Robert D. Kohn, practiced architecture with Clarence Stein, designer for both Sunnyside and Radburn and director of housing for the New Deal Public Works Administration. Frederick Ackerman directed the EFC design department. Frederick Law Olmsted Jr. headed the USHC's Town Planning Division. The Architectural Division evaluated both agencies' projects and used guidelines developed in part by reformer Lawrence Veiller. John Nolen and Henry Wright consulted on individual projects. See Colean 1940; Lubove 1960; Topalov 1990.

50. Lubove 1960. The Ackerman and Whitaker quotes are from Whitaker 1918, 30–31, 66.

51. Topalov 1990. The unit mix would have been six-room (48 percent), five-room (23 percent), and four-room units (21 percent). Floor areas ranged from 616 to 1,147 square feet. Like the British prototypes, USHC projects included shops, recreation centers, and churches.

52. Baxter 1919, 137; Aronovici 1920; Nolen 1918.

53. Crawford quoted in Taylor 1918, 723. See Boyer 1983, 144–45, for assessments by John Nolen, Charles Whitaker, Thomas Adams, and Carol Aronovici of the World War I housing program.

54. Urbanism Committee 1937, 122. The five communities selected for detailed presentation were Brooklawn, N.J.; Cradock, Va.; Hilton Village, Va.; Yorkship Village, N.J.; and Union Park Gardens, Del. The committee singled out Hilton Village in a comparative discussion of business districts because commercial uses fronted a thoroughfare.

55. Quoted in Schuman and Sclar 1996, 435.

56. Ibid. The committee also considered model satellite communities developed by industry, real estate developers, and philanthropists. See Schuman and Sclar 1996 for a discussion of home sales and the place of the World War I experiment in subsequent planning history. The quote is from United States Housing Corporation, vol. 1 of *Report of the United States Housing Corporation*, cited in Schuman and Sclar 1996, 435.

57. The comparative home ownership figures, 47.8 percent in 1890 and 45.6 percent in 1920, can be found in "Housing in Relation to Citizenship," in Ihlder Papers, box 40. Nonfarm ownership decreased slightly from 1890 (36.9 percent) to 1900 (36.5 percent) and then increased until 1920 (40.9 percent). These figures, from the 1950 census and Federal Reserve Board, were published in NAHB 1957, 80, table E-2. See also Department of Commerce 1960, "Series N 106–115: Permanent Dwelling Units Started in Nonfarm Areas, 1889–1957."

58. "President Wants Every American to Own His Home. . . . Mighty Exodus from Crowded Cities Envisioned," *Los Angeles Examiner*, Dec. 3, 1931. The following day the paper reported, "Hoover Body Urges Mass Homebuilding" (*Los Angeles Examiner*, Dec. 4, 1931), and outlined the Committee on Large-Scale Operations' proposal for a "powerful corporation with millions of dollars in resources" to meet the needs of the industrial age and to bring home ownership to "50 million industrial and clerical workers."

59. In his introduction to the *Better Homes Manual*, James Ford applied a biological analogy to the home ownership question. "The careful horticulturalist realizes that it is necessary to pay careful attention to the kind of environment in which such seeds shall be placed. . . . Children of the best heredity or of the best native endowment may be prevented from the high development which is their due by unfortunate circumstances of their upbringing—that is to say by undesirable environing conditions." Ford 1931, ix.

60. See Ford 1929 and the collection of Better Homes brochures in the Wood Papers, box 29. For an interpretive essay on the movement, see Hutchison 1986.

61. Quoted in Hutchison 1986, 168.

62. Letter dated Jan. 10, 1924, Wood Papers, box 29.

63. Roberts 1931, 1; see, in particular, chapter 1, "Home Ownership and Home Financing."

64. Department of Commerce 1923.

65. "Better Homes in America, Inc.: Culver City District," and "Second Annual Police Benefit Book, 1927," both in the Seaver Collection.

66. "Home Ownership Aid to Workers," *Los Angeles Examiner*, Dec. 12, 1938.

67. See Fish 1979 for an overview of the FHA and its position in the National Housing Act of 1934.

68. Fish 1979; Keith 1979, especially chapter 1, "Collapse and Depression, 1930–33/Rescue and Recovery, 1933–39." Tobey, Wetherell, and Brigham (1990) cite a survey of first-mortgage lenders conducted for the 1931 conference that found 65.7 percent of all mortgages in Los Angeles, San Francisco, and San Diego had repayment periods under five years, 27.5 percent had a seven-to-twelve-year schedule, and

only 6.8 percent had fifteen-year loan periods. See Gries and Ford 1932b, 56.

69. FHA 1940. Slogan from broadsides in the collection of the Institute for Government Studies. It is important to note that the FHA was never intended to house Roosevelt's "lower-third."

70. Loud 1922.

71. RPC and WPA 1941.

72. County of Los Angeles 1922, 6. See also "Evolution of RPC Attracts International Attention" 1923, 7, 25.

73. Whitnall 1928, 129, 131–32.

74. Dykstra 1926, 395.

75. Bailey 1924, 142; National County Roads Planning Commission 1932.

76. Bauer quote cited in Abrams 1971, 82. On the regional city, see Mumford 1976. For the history of the Regional Planning Association of America, see Buder 1990, chapter 11, "The Garden City Movement in America, 1900–1941"; Lubove 1963; and Sussman 1976.

77. Mumford 1976, 204. This line of reasoning parallels his well-known critique of the Regional Planning Association of New York in "Plan of New York" (Mumford 1932).

78. Wright cited in Fishman 1988, 266. Stein offered a similar assessment: "The city of our dreams . . . is lost in another city which could occur to a sane mind only in a nightmare" (1925, 134). Mumford 1925, 151–52.

79. For an example of a quantitative regional survey, see State of New York 1926. Clarence Stein was chairman of the commission, and Mumford and MacKaye, among others, conducted studies for the final report. Henry Wright produced plates illustrating existing conditions and future patterns.

80. Mumford 1927b, 37–38.

81. Mayer, Wright, and Mumford 1934. On the value of comprehensive planning, see the essays in *Survey Graphic* 7 (May 1925) reprinted in Sussman 1976; Mumford 1938; Mumford 1951. The roots of the comprehensive survey can be found in Patrick Geddes "civic survey," a study of the "geology, geography, economic life, and above all the history and institutions of the city" (cited in Kostof 1991, 86).

82. See, for example, Mumford 1932.

83. Gries and Ford 1932a, 21.

84. Mott 1939, 38.

85. Hoover 1937, 139.

86. The only exceptions were planner John Nolen and John Leukhardt from the Department of Commerce's Division of Building and Housing.

87. Gries and Ford 1934.

88. Memo, June 20, 1940, Carmody Papers, box 103, folder "FWA Defense Housing Reports, 1940–41."

89. Nichols 1941, 100–101.

90. Tugwell 1940, 3–4. See Mumford 1939 for a functionalist critique.

91. Tugwell 1940, 3–4.

92. Mumford 1919, 332.

93. On "The City," see Cusker 1988. The quote is from a film review ("The City" 1939).

94. Hoyt 1943, 478.

95. Ibid., 480.

96. "World's Fair Section," *New York Herald Tribune*, Apr. 30, 1939.

97. Cusker 1988, 4. Mumford and Wright, along with the industrial designer Walter Dorwin Teague, organized a meeting of "progressives" in the arts to advocate for the inclusion of social issues.

98. New York World's Fair Collection, box 369, folder "Groundbreaking," and box 371, folder "Paul J. Roche."

Chapter Two: The Minimum House

1. Bemis 1936, viii.

2. Pacific Ready-Cut 1925; Wright 1983; Harris 1990, 1991a, 1991b; Banta 1993.

3. Bruce and Sandbank 1943, 12.

4. Bemis 1936, 18–22; Atterbury 1912; Wright 1928; Wells 1901; Mumford 1945b; Mayer, Wright, and Mumford 1934; Lasch 1946.

5. The technicians' belief in positivist science is revealed in this statement from the Bureau of Standards:

A research program is a means of quickly achieving a wider experience than is possible in the slow process of service experience. Research is controlled, directed, and accelerated experience. So long as the quality and performance of a house must be judged by living in it for twenty-five or fifty years, the accumulation of experience is slow, and the progress in improving houses and reducing their cost is correspondingly slow. Laboratory procedures and field-test methods must be developed for objectively determining all measurable features of performance. (Dryden 1938, 1–2)

6. For an overview of this criticism, see Callender 1943; Blum and Candee 1944.

7. Callender 1944; Bruce and Sandbank 1943, 11–12.

8. Callender 1943, 5. Callender assessed these works as "isolated, and individually of little significance [but] taken as a whole they indicate a trend towards a scientific basis for housing design."

9. See Klein 1931, 1935. The FHA published Klaber's work in an "Architectural Bulletin" (1940).

10. APHA 1939. See the appendixes for the questionnaire, survey form, and activities sheets. The foundation selected two different family groups with annual incomes between two thousand and three thousand dollars. Group A consisted of families in a limited-dividend multiple-housing development. Residents of a large single-family housing project with homes valued between three thousand and forty-five hundred dollars comprised Group H. The demographic and spatial criteria limited participation to families with five or fewer related persons residing in four-

room units or families of six or fewer living in five-room dwellings. See also Callender 1944, 8–12, for a summary of this study.

11. APHA 1939, 96. Respondents desired additional space and expressed their dislike of the efficiency kitchen.

12. Callaghan and Palmer 1944. The quote is from Callender 1944, 12–13. The timing reinforced a contemporary perspective that the "science" of home building lagged far behind other fields.

13. Taylor 1911. For the application of Taylor's principles, see Chandler 1977, especially chapter 8, "Mass Production."

14. Bruce and Sandbank 1943, 12. See also the studies conducted by the APHA Committee on the Hygiene of Housing, which surveyed 562 women and determined a standard height for counters and workspaces in the kitchen (31½″), reported in APHA (1936).

15. "American Homemakers Help Design Low Rent Dwellings," in Ihlder Papers, box 101. See also Straus 1944, 102.

16. "USHA Cuts Costs by Eliminating all Frills and Gadgets," *Washington Evening Star*, May 25, 1940.

17. Letter dated Nov. 3, 1941, Wood Papers, box 2, folder I.

18. "Practical Standards for Modern Housing," Carmody Papers, box 104.

19. For a concise analysis of the lower-price versus low-cost house, see "A Housing Program for California," C. B. Wurster Papers, carton 5. In 1950 the APHA's Committee on the Hygiene of Housing attacked the "stinginess" and "excessive frugality" of the small home. "We have been retrogressing in space provision to a phenomenal extent . . . normal family life is not possible without a reasonable modicum of space" (APHA 1950, 7).

20. The Bureau of Standards account is taken from a letter Burgess sent to Julius H. Barnes, president of the U.S. Chamber of Commerce (Apr. 14, 1928), in Ihlder Papers, box 29, folder "Bureau of Standards Specifications." In "Some Notes on Quality Labels" (ibid.), Ihlder noted that sixty-eight agencies were engaged in "activities tending to bring about a change from the prevalent hit-or-miss method of specifying, manufacturing, and testing, to a logical method of formulating specifications, manufacturing in conformity therewith, and testing to insure or guarantee compliance."

21. Gries and Ford 1932d, 37–40.

22. Ibid., 49–52.

23. Mott 1938.

24. APHA 1939.

25. Ibid. The APHA's evaluation method for a dwelling and its surrounding neighborhood differed from the WPA Real Property Surveys and the 1940 Census of Housing. The APHA used the metric established in *Basic Principles* (APHA 1939) as a zero point on a graded scale, with housing conditions marked down from that point. The cumulative score of dwellings and neighborhood, "total housing," was then tallied, and a ranked letter grade assigned to urban districts.

26. Wright 1926, 175.

27. Ham 1929; Jones 1925 and 1926; Gries and Ford 1932d, 63.

28. FHA 1936a, 9.

29. Department of Commerce 1923, 15.

30. Dalzell quoted in Banta 1993, 253.

31. Taylor 1929, 7.

32. FHA 1936c; FHA 1936a, 9, paragraph (c). See also Department of Commerce 1923, 19.

33. This statistical analysis of a four-room house type is drawn from census reports, Bureau of Labor Statistics surveys, WPA property studies, and FHA annual reports—a disparate set of reports designed to enumerate dissimilar phenomena. Specific variables include spatial domain, dwelling types, tenancy, and chronology. FHA annual reports provide the most breadth and depth of coverage and focus most closely on the low-cost single-family dwelling. See, for example, Department of Commerce 1940b, 1940c, 1942; Department of Labor 1939, 1941a, 1941b; FHA 1940; WPA 1938.

34. FHA 1936c, 2. Hise 1995a.

35. FHA 1936c, 2.

36. Ibid., 2–3.

37. FHA *Annual Report* 1941. Number of rooms reported at 72–73, table 37 and chart 20. This data was first published in FHA *Annual Report* 1939, 104, table 39.

38. FHA *Annual Report* 1940, 196.

39. For 1949 data, see FHA *Annual Report* 1950, 42, table 16; for 1950, see FHA *Annual Report* 1951, 55–58, tables 23–25. See also NAHB 1957, 75–76, table D-1. The NAHB reported 65 percent of housing starts in 1950 were two-bedroom, four-room dwellings.

40. FHA 1936c, 1. The FHA qualified its enthusiasm for the small home and wage earners' home ownership. FHA publications questioned whether it was feasible for wage earners to attain these standards of accommodation and equipment "too frequently given serious consideration," suggesting these objectives were "[too] much above that now customary for the groups for whom the housing is planned." Instead, the FHA promoted a basic house providing "privacy for sleeping, ample provision for sanitary purposes, and sufficient space, and no more than sufficient, for other functions. More than this should not be expected." Ibid., 5.

41. Department of Labor 1941a. The bureau restricted its survey to nonrelief white families with two native-born parents. On average, enumerators found units in Los Angeles, San Diego, San Francisco–Oakland, Sacramento, and Seattle, Wash., were occupied by 4.2 people, which gave an average of 0.84 persons per room, a figure within accepted norms. Although the bureau's sample set was small, when analyzed with the FHA reports it sets a baseline for California and the West. Bureau of Labor Statistics researchers assembled their sample from employer records and chose a representative distribution by age, occupation category, and tenure. Between March 1, 1934, and February 28, 1935, 34 percent of the families the bureau surveyed were wage-earning homeowners. Fifty-five percent of these workers occupied

five or fewer rooms. In Los Angeles, the average annual expenditure for housing (including fuel, light, and refrigeration) was $1,525, just over 15 percent of a family's annual expenditures. Department of Labor 1939. Tenure for the Pacific region was 24.8 percent in apartments and 74.2 percent in houses. Ibid., 88, table 2. In this survey clerical workers were defined as "lower-salaried," that is, they had incomes below two thousand dollars a year. Data on the number of rooms per dwelling is in table 10, "Housing Expenditures by Income Level" (196). The WPA identified primary wage earners in the families surveyed according to four occupational categories: office workers, salesmen, and kindred workers; skilled and semiskilled workers in building and construction; skilled and semiskilled workers in manufacturing and other industries; and unskilled laborers and domestic and personal service workers (not in families). WPA classifications can be found in WPA 1935.

42. Department of Commerce 1940b, 26, table 8b, "Number of Rooms for All Dwelling Units." Census enumerators were instructed not to include bathrooms, closets, pantries, or halls in the room count and to count as only one room a "combined kitchenette and dinette." See "Instructions to Enumerators," 196. In the West, the number of urban units with five rooms or fewer was 76.7 percent. Under "Housing—General Characteristics," the Census Bureau published data by occupancy and tenure, by region, and by locale. In each case, the largest percentage of housing fell within the five-room category. National figures showed 65 percent of Americans living in units with five or fewer rooms. In the West, dwellings with five rooms or fewer stood at 78 percent. In 1950 the census enumerators found a smaller relative degree of increase in the percentage of four-room homes in the California SMAs (standard metropolitan areas) (Department of Commerce 1952). This pattern can be attributed to the relative age of the majority of the housing stock, which was comparatively newer in California than elsewhere. Nationally, 72 percent of dwellings predated 1940. In Los Angeles, only 57 percent of the owner-occupied units enumerated in 1950 were built before 1940. In other words, one-third of the owner-occupied housing in the Los Angeles metropolitan area was constructed during the period when an efficient, four-room minimum house gained widespread acceptance.

43. *Life* to William W. Wurster, 21 Sept. 1938, W. W. Wurster Papers, file 2547.

44. Mumford 1927a; Lasch 1946, 83.

45. Mead 1937, 61.

46. Shire 1937, 37–38.

47. Chandler 1977, 6–12. For a contemporary account, see Vinton 1937.

48. FHA 1936d.

49. Bemis 1936; Kelly and Hamilton 1952; Fuller 1934; Herbert 1984; Bruce and Sandbank 1943.

50. Howard T. Fisher's General Houses, Inc., is representative. Fisher, a Chicago architect, intended to "Fordize" the building industry. See "Sees Future Homes Bought like Autos," *New York Times*, May 25, 1932; and " 'Fordized' Housing Plan of New Group," *New York Times*, June 23, 1932.

51. MacLeish 1932, 111.

52. "When is a House Not a House?" C. B. Wurster Papers, carton 3. In a 1946

speech to the California Women's Club, Bauer warned against the "recurring romance of prefabrication, the idea of ordering [house] parts at the corner hardware store" and assembling them. C. B. Wurster Papers, carton 1.

53. Davison 1943, 6.

54. Fisher 1948, 220.

55. For a history of the modular measure, see NAHB 1957, 18; and Lendrum 1948.

56. Federal Home Loan Bank Board study cited in Lasch 1946, 89–91.

57. Tobin 1947, 336.

58. Ibid.

59. Bruce and Sandbank 1943, 71–76.

60. For the Department of Commerce survey, see the report of the Correlating Committee on Technological Developments, 1931 President's Conference, in Gries and Ford 1932e, 5. For the Federated Engineering Societies survey, see American Engineering Council 1921. Herbert Hoover initiated the study as president of the Societies. Lasch (1946, 85) estimated that home building was twice as wasteful in production as other durable goods.

61. Loeb 1989, 2. As Commerce secretary, Hoover encouraged industrial research for increasing production, enumeration of fundamental data, dissemination of trade information, and the establishment of standards in fields outside of weights and measures. Murray 1981, 24. This was a top-down network with experts whose recommendations traveled down to the regional and local level through a chain of voluntary associations at its apex, a structure suggested by Hoover's administrative dictum to "centralize ideas and decentralize execution." Quoted in Lloyd 1972, 109.

62. The objective of these private, self-governing organizations was to promote efficiency and ethical practice through self-policing, not regulation. For an overview, see Hawley 1974. Hoover organized the Division of Simplified Practice in response to inventory buildup. According to the division, excess inventories were the unfortunate result when producers scrambled to entice consumers with "needless variety." Writing in *Commercial Standards Monthly* (a Commerce Department publication), Ray M. Hudson cited "excessive variety" as the cause of waste and expense throughout the "whole chain of manufacture and distribution," which, in the end, "cause[s] all to suffer." Hudson 1931, 165.

63. On the Division of Building and Housing, see Department of Commerce 1932a. Personnel in the Department of City Planning and Zoning analyzed locational issues, reviewed the development process, and published their findings concerning the linkages among land values and property use, thoroughfare systems, public works, and buildings.

64. Department of Commerce 1932b, 209. An example of the application of grading and grade marking in materials was the development of the American Lumber Standards, which instituted uniform inspection and grading rules. The network's structure and preferred strategy can be detected in the Division of Building and Housing and the U.S. Chamber of Commerce's joint effort to distribute "improved" unit plans designed by the American Institute of Architects' Small House

Service Bureaus. Other examples include the DBH's support for model zoning and planning ordinances, professional societies, and a consumer education program, sponsored by realtors' and real estate associations, for demystifying housing finance.

65. Conference findings reported in Department of Commerce 1926, 5; see also Maxwell 1931.

66. Lasch 1946, 85; Taylor 1930.

67. Priest 1926. Here, the Bureau of Standards drew upon a long tradition in American manufacturing that began in the nineteenth century with the sewing machine and woodworking (the American System) and continued with Taylorism and Ford. See Hounshell 1984.

68. *Commercial Standards Monthly* 7, no. 11 (May 1931): 349.

69. See Ely 1930, 40, for an extensive listing of "excess dimensions, types, and qualities"; and McNeil 1930, 148–50.

70. FHA 1936c, 31.

71. Bemis 1936.

72. Hoover 1921, 77. Engineers argued for their privileged role based on training in and professional inclination toward precision and efficiency.

73. Lasch 1946, 156.

74. Shire 1937, 37.

75. FHA 1941.

76. General Houses' sales strategy was spelled out in "Sees Future Homes Bought like Autos," *New York Times*, May 25, 1932, and " 'Fordized' Housing Plan of New Group," *New York Times*, June 23, 1932. The production system was presented in MacLeish 1932.

77. Gries and Ford 1932d, xiv.

Chapter Three: Model Communities for Migrant Workers

1. The Farm Security Administration replaced the Resettlement Administration on September 1, 1937. Hereafter the designation FSA will refer to both the Farm Security Administration and its predecessor agency, the Resettlement Administration. For the reorganization, see Badger 1989, chapter 4, "Parity and Poverty: Agriculture"; and Baldwin 1968, chapter 4, "The Resettlement Administration."

2. For example, Stein 1970 and 1973.

3. In "How New Deal Agencies are Affecting Family Life," M. L. Wilson, the first director of the Subsistence Homestead program, wrote: "Somehow, or in some way, the attitudes and lives of the families who occupy these communities must be integrated so as to provide a new and different view of life and a new and different set of values." Cited in Conkin 1976, 102.

4. See Conkin 1976 and Ghirardo 1989 for a history of the Division of Subsistence Homesteads. My interest, unlike that of these authors, is the FSA's anomalous position as a decentralized agency in the otherwise hierarchical New Deal. The Region IX office's relative autonomy allowed for a degree of experimentation un-

matched by other New Deal housing agencies; therefore, a broad study of New Deal community programs does not explain the California camps. On the greenbelt communities, see Arnold 1971 and Stein 1951.

5. Some members of the Resettlement Administration staff viewed the marginality of the California program as an asset. In a letter to Gardner Jackson, Jonathan Garst notes: "We are however in a wonderful position. We can be legionnaires and still radical in this state. We wrap the constitution about us and wave the American flag. . . . I think that the main reason [for our support] is that you can illustrate the poverty of a migratory worker better than you can in the case of a textile worker in Massachusetts or in North Carolina." Garst to Jackson, Sept. 2, 1936, Jackson Papers, box 31.

6. "Establishment of Rural Rehabilitation Camps for Migrants in California," memo to Harry E. Drobish, Mar. 15, 1935, Prints and Photographs Division, lot 898. Drobish sent the document to Frank Y. McLaughlin, administrator of the California State Emergency Relief Administration. The assistance program advocated by Taylor was designed to provide immediate relief and promote long-term self-sufficiency. Voting restrictions based on residency requirements and the systematic exclusion of agricultural workers from New Deal labor entitlements disenfranchised seasonal workers. For Taylor, a government-funded alternative to ditch-bank housing and grower camps would offer the reprieve within which migrants could make their own decisions, develop their own institutions and, implicit in his writings, begin to organize collectively for social change.

7. In addition to a detailed analysis of project expenses—the bottom line a miserly $384 per unit—the report concludes: "Family incomes will be derived from migratory agricultural employment as at present. No provision has been made for liquidating the cost of this project." Farmers Home Administration Collection, Project Records: 1935–1940, "Region IX: California, RF-CF-25 and RF-CF-26," box 209, folder LR-89-CF-25.

8. A February 5, 1937, *San Francisco News* editorial argued that the Arvin and Marysville camps were "invaluable" and served "as demonstrations of what can and should be done. . . . That is why they have been so bitterly fought by reactionary influences intent on keeping migratory farm workers in a state approaching peonage."

9. Bancroft cited in Daniel 1981, 19. McWilliams (1939 and 1942) has interpreted California's commercialized and industrialized farming and its implications. Parker (1920), McWilliams, Taylor (1951 and 1983), and Fuller (1939) have examined social relations. Recent accounts include Daniel 1981 and Chan 1986.

10. State labor department data attests to both the extreme seasonality of employment and the number of workers mobilized. For example, the 1909 raisin grape harvest employed 15,000 to 20,000 workers from August to December. During the growing season, twenty acres of hops required the attention of only 12 workers. During the harvest, 450 to 500 laborers would be engaged on the same twenty acres. Frederick C. Mills (CCIH) recorded the state labor records; see Woirol 1991, 192. Baxter (1937) reported on hops.

11. On Wheatland and its aftermath, see Parker 1914; Daniel 1981; McWilliams 1940a and 1940b; Taylor 1983, chapter 3, "Uprisings on the Farm."

12. Governor Johnson signed the CCIH legislation on May 29, 1913; the commission was activated on Aug. 10, 1913, one week after the Wheatland strike. Although the commission was initially enacted to address the social welfare of immigrant groups, Wheatland prompted a new focus on migratory labor. As a first step, the CCIH enumerated private labor camps and surveyed their conditions and hired agents to quantify the number of migrants "adrift" in California industry. The commission determined that during the summer of 1915, approximately 150,000 migratory workers were seasonally employed, or fully 10 to 15 percent of the state's total workforce. Carleton Parker cited in Woirol 1991, 192. In 1917, a national survey of labor conditions concluded that "probably no more striking example of extremely seasonal industries exists [in the United States] than in California." Lauck and Sydenstricker cited in Woirol 1991, 192. On the CCIH, see McWilliams 1940a and 1940b; Parker 1920; Wood 1942.

13. On the CCIH and the later Division of Immigration and Housing, see the agency records in CCIH 1915 and State of California 1942. For interpretive studies, see Wood 1942 and Mitchell 1992 and 1996. On the California Labor Code and housing standards for camps, see California Labor Code, secs. 2410–25, art. 4; and State of California n.d.

14. California Labor Code, secs. 2410–25, art. 4.

15. Hodgkin 1920, 346. The passage continues: "Our experience along this line has been so consistent that as our need for help has increased we have decided to increase our housing accommodations to whatever extent satisfactory workmen can be efficiently added to our forces."

16. Hodgkin 1921. The clubhouse amenities, including the fireplace where "men lounge during their off hours and ruminate, no doubt, that this is a pretty good world after all," were restricted to the Azusa Company's "American employees." Pressey 1929. It is clear that the CCIH standards had spread to growers. The attention to CCIH standards, and the recognition that better housing was a factor in diffusing labor unrest, can be found in this statement by E. Clemmens Horst, the owner of one of the largest hops concerns in the state: "There is no doubt in our minds but that the efficiency, health, and good spirit of employees is considerably increased by the maintenance of model camps. From our experience we are convinced that it is a good investment on the part of the employer to maintain proper living conditions for laborers." CCIH *Second Annual Report* 1916, 20. However, progressive growers, such as those cited by Hodgkin, were the minority, and the construction of sanitary year-round housing with communal facilities was restricted primarily to large agricultural concerns. The majority of farmers owned or worked lesser acreage and, they argued, could not afford the expense of providing for itinerant labor. See McWilliams 1940a and 1940b.

17. In Steinbeck's fictional account of the Okie migration, the first thing the Joad women did when they arrived in the "Government Camp" was to wash up where you

"get in a little stall-like, an' you turn handles, an' water comes a-floodin' down on you—hot water or col' water, jus' like you want it" (1939, 339). Charles Todd and Richard Sonkin interviewed Mrs. Becker, from Texarkana, at Shafter in 1940; she described how she learned the hot-water and laundering systems from "overseers" and in turn helped organize a "welfare" group that brought assistance to the needy at private camps. In addition, the FSA camps served as agents of acculturation through health care clinics and by offering many residents their first chance to benefit from up-to-date appliances. Todd-Sonkin Recordings, Tape 4145–56A/B, Aug. 16, 1940.

18. Report dated Oct. 1, 1925, cited in McWilliams 1940a. In chapter 1, "Out of the Heartland," Gregory (1989) analyzed the complexities of this migration and documented California's role in the "tumbleweed circuit," a round-trip route familiar to southwest migrants prior to the drought.

19. On the repatriation, see Guerin-Gonzales 1994.

20. The California Department of Agriculture enumerated 71,047 "refugees" entering the state between June 1935 and June 1936. They estimated 75 percent of these originated from the "drought states." See Baxter 1937, 3. California growers promoted the myth that Mexican field hands were "homing pigeons" and "birds of passage" in order to pacify nativists' fears that immigrant workers would become permanent "guests." See Pressey 1929 for an example of this patronizing language and vantage.

21. Editorial, *San Francisco News*, Aug. 10, 1935, in FSA San Francisco Collection, carton 3, folder 81. In time, nativists focused intense scrutiny, suspicion, and hatred upon these in-migrants, a pattern of behavior and attitudes that paralleled earlier responses to immigrant field-workers from Mexico and Asia and led to the exclusionary acts. In other words, there had always been a mobile seasonal workforce in California; what was new during the 1930s was that the so-called Okies and Arkies represented an internal migration, and this complicated the response.

22. Johnston and Glacken 1940, 22. This was not an isolated case chosen to dramatize inadequate housing and poor living conditions. Twenty percent of the thirty-one hundred households surveyed lived in tents, chicken coops, pump houses, or trailers. Sixty-three percent of those rented. The Farmersville family paid $4.00 a month ground rent. They were fortunate: the survey mean stood at $10.50 a month, which meant an annual outlay of 35 percent of the average salary.

23. The La Follette Committee was a Senate subcommittee, chaired by Robert La Follette Jr., investigating antilabor activities. It was national, of course, but there was considerable focus on agriculture in California.

24. For McWilliams testimony, see the clippings in FSA San Francisco Collection, carton 3, folder 89, especially "LaFollette Committee Resumes Hearings Here, Studies Migrant Problem." The Baker Camp report is in "Labor Camp Schedule," ibid., carton 3, folder 77. On the DIH position, see "Completion Report: Marysville, Exhibit A: Social and Economic Justification," Farmers Home Administration Collection, box 209, folder LR-89-CF-25, Project Records 1935–40.

25. The California migration figures are drawn from "A Study of 6,655 Migrant Households Receiving Emergency Grants," FSA San Francisco Collection; Baxter

1937; State of California 1940; and Taylor 1983. Taylor (225) reported the Department of Agriculture figures in table 2, "Returning Californians and Out-of-State Migrants Entering California, by Months, June 16, 1935–March 31, 1938." For quantitative assessments of FSA camp residents, see the "Monthly Narrative Reports" in Farmers Home Administration Collection, box 21, folder PR-89–183.

26. See the camp papers (*Hub* [Visalia], *Migratory Clipper* [Arvin], *Tent City News* [Gridley], *Voice of the Agricultural Migrant* [Yuba City], and *Woodville Community News* [Woodville]) for residents' activities in the community centers. The *Hub* published a weekly schedule that included sewing classes, scout meetings, movies, and a burial fund meeting (*Hub* 2, no. 4 [Apr. 4, 1941]). The *Migratory Clipper* (Dec. 16, 1939) reported on a Christmas program with Hollywood celebrities; the *Woodville Community News* (Mar. 7, 1942) noted an evening meeting, "Adrift on the Land," to "discuss our experiences roaming the country in search of better means."

27. Vernon DeMars, interview by the author, Oct. 18, 1988, Berkeley, Calif. See also Packard 1970.

28. For rent rates, see the the the FSA's "Monthly Narrative Reports," Farmers Home Administration Collection, box 21, folder PR-89–183.

29. FSA 1938, 18. In an interview by the author (Dec. 7, 1988, Berkeley, Calif.), Vernon DeMars confirmed the urgency of these requirements.

30. Contract and Construction Docket Files, 1929–46, Farmers Home Administration Collection, box 10. The FSA Region IX office investigated and eventually practiced all three prefabrication methods: factory assemblage, ready-to-assemble, and site fabrication. Initially, the Construction Division of the Resettlement Administration (and later the FSA) undertook camp construction. Eventually in California, and then throughout the country, contracts were put out for competitive bids. See the administrator's statement in FSA 1938, 18. According to this report, initially there was difficulty finding builders interested in these projects, but once they became familiar with the standard plans and construction detailing, "competition [was] keen at all lettings."

31. Although the metal shelters proved to be a vast improvement over the unprotected makeshift arrangement typical in roadside camps, they were never more than tolerable in the field, where drifting rain "finds ready entrance at the rear of these buildings." "Metal Shelters vs. Tents" 1940, 10–11. For more on the improved standard of metal shelters over tents, see "The Joyous Thought of a Metal Shelter" 1940, 4.

32. By adopting the sixteen-foot modular and integrating dimensional standards established by manufacturers of building products, the FSA asserted the design and construction principles cosponsored by the American Standards Association, the AIA, the Producers' Council, and the NAHB. In the late 1930s, plywood was a new product. Contemporary observers viewed its use, particularly as a finish surface, as innovative. In *New Pencil Points,* the architectural critic Talbot F. Hamlin assigned a formalist rationale to the application of plywood and other sheet materials. His review is littered with references to "simple" and "honest" construction, and he extols the "fresh, clean, and beautifully clear expression" of materials. See Hamlin 1941b, 718, 720.

33. FSA 1940, 16. For a precise account of these operations and a sense of how they

differed from current practice, see the section "Low-Cost Construction" in FSA 1938, 18–19.

34. Eckbo 1942, 265.

35. See Packard 1970 for the selection and development of an office staffed with eight architects, two landscape architects, eleven civil engineers, and three construction men (a title I assume denoted construction administrators). Eckbo (1942) stated that "the ideas outlined herein have been prepared by a landscape architect who has had a great deal of integrated site-planning experience with a very well balanced architectural and engineering staff [the FSA]. The ideas are his own, but he could not have developed them without being part of a completely collaborative group" (267). There were parallel activities on the East Coast, in Europe, and in the San Francisco Bay Area; on the latter, see Eckbo (1993) for his account of Telesis. This redefinition was contrary to the professionalization project in architecture and building. On the rise of the professional architect, see Kostof 1977 and Upton 1984. Hamlin (1941a) presented the Region IX staff and their disciplines, a distinction the staff purportedly eclipsed.

36. Eckbo (1942, 263) suggested that a "truly scientific space-planning technique" required a simplification of disciplines to three interrelated clusters: planners, space designers, and object designers (264).

37. See Stein 1973; Conkin 1976; and Leuchtenburg 1963 for a general account of New Deal agencies.

38. DeMars, interview, Oct. 18, 1988. See also Hamlin (1941a, 2), who asserted that "virtually unique in government is the FSA's willingness to experiment, a reflection of the large measure of local autonomy enjoyed by the planners."

39. Baird Snyder to C. B. Baldwin, Farmers Home Administration Collection, box 4, folder RP-M-124.

40. "Recommendations of Migratory Labor Personnel Representing Regions V, VIII, IX, XI," Farmers Home Administration Collection, box 4, folder RP-M-124. The report continues: "The migratory labor program has taken gradual form without a great deal of direction from above. However, now that it has become a national program, unified national direction is imperative in shaping its further growth."

41. Following her tour, Louise Stanley, chief of the Bureau of Home Economics, Department of Agriculture, sent W. W. Alexander a report. She described the multifamily housing at Firebaugh as "most satisfactory" but expressed a decided preference for the garden homes. Memorandum to Dr. W. W. Alexander, Mar. 14, 1940, Farmers Home Administration Collection, box 18, folder RP-89–183. When the FSA's own Standing Committee on Farm Labor reviewed the camp program at a 1941 conference, they concluded that the committee's "chief value lies in pointing the way to genuinely adequate housing along the lines indicated by the development of the garden homes and the home colonies." "Report, Conclusions, and Recommendations," Farmers Home Administration Collection, box 8, folder RP-M-124.

42. Bruce and Sandbank 1943, 14.

43. Rex Thomson to John Anson Ford, Feb. 9, 1938, Ford Papers, box 65, folder 14aa.

44. See DeMars 1941a for a discussion of the FSA demountable panel system. DeMars argued that postwar conversion and the imminent housing shortage would necessitate the dismantling, shipping, and reerection of these units, most likely in rural areas. He concluded, "It is significant that for the first time on a scale other than experimental, the building industry is using the methods of production which have made the automobile and the radio almost universally accessible."

45. "Products and Practices" 1941, 36.

46. Stanley P. Stewart to John F. Donovan, Dec. 18, 1939, Farmers Home Administration Collection, box 8, folder AD-124. From San Francisco, Stewart visited Los Angeles where, in the company of Hallsteen, he inspected a mock-up of a new six-family metal shelter at Consolidated Steel. Stewart visited thirteen Region IX projects; he reported on maintenance and upkeep and evaluated how well products and materials were weathering in the field. He singled out the multifamily units' "functional design and econom[y]" and congratulated the District Office for its "excellent work."

47. Letter from N. S. Perkins to Major J. O. Walker, Aug. 1, 1938, Farmers Home Administration Collection, box 220, folder "California Migrant Camps." Vernon DeMars recounted Plywood Structures' interest in an interview by the author, Dec. 17, 1988, Berkeley, Calif.

48. FSA 1938, 18–19.

49. Baird Snyder to Vincent Smith, Oct. 19, 1939, Farmers Home Administration Collection, box 4, folder RP-M-124. Snyder contrasted "industrialized building methods" with a project where the contractor was "nailing up studs and rafters in the regular old-fashioned way. There was no question but that he was throwing away at least forty dollars on forty buildings."

50. Baird Snyder to Vincent Smith, Sept. 7, 1939, Farmers Home Administration Collection, box 4, folder AD-124.

51. The double-loaded hexagon was a compromise. FSA staff feared that a circular scheme, their preferred plan, would exacerbate problems with speeding automobiles. Vernon DeMars, interview by the author, Oct. 14, 1988, Berkeley, Calif.; "Summary of Migratory Labor Conference," Farmers Home Administration Collection, box 1, folder RP-M-031; "Notices" 1940.

52. See Kostof 1991 for an overview of city form and ideal geometries.

53. Jonathon Garst to Rexford Tugwell, Sept. 15, 1936, Farmers Home Administration Collection, box 206, folder "Arvin." Garst estimated a per unit cost of fifteen hundred dollars, which, when amortized along with equipment, utilities, and maintenance, produced a monthly rental of $8.20.

54. This configuration was a variant of German *Zeilenbau* planning. German modernists sited apartment blocks in a strict north-south orientation to maximize sun exposure. In California, the FSA inverted these principles. Site planning alone offered scant relief from the Central Valley's extreme summer heat. Landscaping became a priority to mitigate these oppressive conditions. Garrett Eckbo, interview by the author, Nov. 18, 1988, Berkeley, Calif.

55. Gregory Silvermaster to C. B. Baldwin (n.d.), in Farmers Home Administra-

tion Collection, box 4, folder "RP-M-124-Housing." See also FSA *Reports* (1938–43), particularly the section "Migratory Labor Camps." Reviewing them chronologically reveals the transition from assisting "displaced farmers . . . who have lost their foothold on the land as the result of mechanization or natural disaster" to the "anchoring of people to the land—helping them become secure as independent farmers." Quotes from FSA 1941, 21. However, not all FSA personnel supported these proposals. Jonathan Garst had argued early on against poor farmers owning land. In a letter to Gardner Jackson (Nov. 10, 1936), Garst promoted cooperatives as the "only possibility for helping those who actually do the farm work to have decent living conditions and security and a half reasonable income." He continued: "Our resettlement projects are designed to set the stage for group farming but I should not like to experiment very fast along that line. The greatest possibilities we have toward cooperation are first of all, the self-help coops which we are setting up with loans, and secondly, loans to small farmers or even part-time farmers or part-time agricultural workers for buying mechanical equipment in common and for purchasing and selling in a cooperative." Jackson Papers, box 31.

56. Although changing priorities altered the course of the FSA program in California, the shift brought the labor camp experiment more closely in line with the agency's national objectives. This occurred as the entire program came under increasing attack from organized farm groups such as the Associated Farmers and from conservative ideologues who found the FSA a convenient vehicle for criticizing the perceived excesses of New Deal social policy. See the La Follette Committee hearing reports on the "migrant problem" (San Francisco, Jan. 1940), in FSA San Francisco Collection (carton 3, folder 89). Professor B. H. Crocheron, director of agricultural extension, University of California at Berkeley, Walter Packard, William L. Ellis, manager, Farm Credit Administration, and Carey McWilliams testified concerning the benefits of homesteading or cooperative farms.

57. DeMars 1941b, 8.

58. In an interview by the author (Oct. 14, 1988), DeMars stated that the "change in site plan reflected a changing conception of community." Hamlin (1941b) also noted this shift: "What started out to be a mere matter of furnishing shelters for wandering laborers and their families became a matter of building highly developed communities with permanent populations" (710).

59. Woodville opened during the first week of July 1940. Many residents transferred from FSA Mobile Unit 6 in Porterville. The settlement was located in a cotton, grape, asparagus, and citrus region. During the peak of the agricultural season, 1,240 persons on average resided at Woodville. In its first year of operation, the new community housed over 3,000 individuals. On the camp opening, see the "FSA Opens New Migrant Town Near Porterville" and "Press Release: Porterville," FSA San Francisco Collection, carton 8, folder 325. For a first-year overview, see "Over 3,000 People Live Here during Year" 1942 and the other articles in the aniversary edition (June 15) of the *Woodville Community News*.

60. DeMars 1941b, 9. The landscape plan called for a greenbelt buffer with fruitless mulberries paralleling the roadway, two reservoirs, and alfalfa ground cover.

The general camp plan had over twenty-four hundred trees of fifty species, chosen to provide shade and privacy. Garrett Eckbo, interview with author, Oct. 25, 1988, Berkeley, Calif.

61. The *Woodville Community News* is the best source for activities and programs. Residents based the cooperative store on Roachdale principles; the *News* carried a series of articles on the cooperative movement and the benefits for residents who patronized their own store. There was an additional baseball diamond just south of the central utility building.

62. DeMars 1941b, 9; Montgomery 1988.

63. Nathan Straus to Will Alexander, Nov. 9, 1939, Farmers Home Administration Collection, box 4, folder AD-124.

64. Baird Snyder to Nathan Straus, Nov. 11, 1939, Farmers Home Administration Collection, box 4, folder AP-124. The only additional cost Snyder cited was "operating the engineering organization to design and supervise construction which to date has not run more than 2¼ percent."

65. See "What Camp Life Means to the Women" 1940, 4, and the transcript of Irene Taylor's dedication at Yuba City, ("*REQUESTED*" 1940). However, the Dust Bowl migrants were, on the whole, adamant that the FSA communities were a useful but temporary way station on the road to a better future. In this sense, the FSA's later emphasis on labor homes and individual farmsteads was consistent with the aims of numerous Okies and Arkies. These newcomers were quick to imply that, unlike the smaller California farmers for whom they occasionally labored, left to their own devices on fifteen acres of rich land they could become self-sufficient. "Farmersville, California" interviews with farmworkers, in MPSR. "The Migrant Agricultural Worker Faces His Problems," Farmers Home Administration Collection, box 8, folder RP-M-124 "Housing."

66. The Vallejo two-story dormitory blocks used a panel system that extended the experiments first undertaken at Yuba City. Floors, walls, and roofs were stressed-skin construction and demountable. Double-headed nails secured adjoining panels; the FSA planned to reuse these sections for rural housing after the war.

67. Coincident with the first boom of the defense effort, rural labor camps became "Labor Supply Centers"; the change in nomenclature was indicative of a greater transformation. The community center retained its location as first point of contact, but it housed a new program; here, day laborers gathered to be collected by growers' agents. Once the site of an experiment in collectivism and social democracy, the camps were reduced to labor "hotels" whose residents, primarily Mexican nationals brought to the United States through the Bracero program, were individual participants in the "Food for Defense" effort. On the transition to "Aviation Arkies," see "National Defense Holds Big Opportunities for Our Young Men" 1942 and "Okies Leave San Joaquin Valley for Defense Projects," *San Francisco Chronicle*, Nov. 9, 1941. Higher wages and steady work did not mean the end of discrimination; see Archibald 1947 and Johnson 1991. DeMars (interview, Oct. 14, 1988) provided information on the shift to Labor Supply Centers. For the Bracero program, see Gamboa 1990.

68. "Migration to California at New Peak," *Oakland Tribune*, Oct. 27, 1941.

69. Transcript printed in *Architect and Engineer* (Oct. 1942): 33.

70. *Lanham Act*, 76th Congress, 3d sess., H.R. 10412. For the impacts of the defense in-migration, see Division of Defense Housing Coordination and the reports of the U.S. Committee for Congested Production Areas (1943–44), particularly San Francisco (June 22, 1944), San Diego (Mar. 2, 1949), and Los Angeles (Mar. 15, 1944), as well as U.S. House 1943. On demographics, dwellings, and employment, see the series of surveys conducted by the Bureau of the Census for Los Angeles, San Diego, and the San Francisco Bay Area (Department of Commerce 1944a).

71. DeMars 1941a. Construction figures are drawn from Division of Defense Housing Coordination, "Locality Construction Tables," Region V: California, in the National Housing Agency Collection. FSA 1941, 26. Others praised the FSA and its patriotic effort. The editors of *Architectural Forum* wrote: "Today, in face of a national emergency, Farm Security stands out as the agency most experienced and successful in the work of building houses quickly and cheaply." Editorial 1941, 2.

72. The Marinship Project at the former Bechtal Liberty Ship yard in Sausalito has in its possession publications ("Fore and Aft" and "Marinship") and oral interviews with former residents. See "Marin City Dedication Tomorrow," *San Francisco Chronicle;* Sept. 12, 1942, "Marin City Will Be Dedicated at Special Program Today"; *San Francisco Chronicle*, Sept. 13, 1942; and "Marin's New City Opened," *San Francisco Examiner*, Sept. 14, 1942, for the dedication. Wollenberg 1990. On the FSA trailers, see "Twenty Families Move into Trailer Homes Today: Projects to Provide Housing for Certified Defense Workers," *San Diego Union*, June 1, 1941.

73. Individual staff influential in the Region IX office went on to assume prominent positions in other federal housing agencies, and many continued to practice and promote social design in the postwar period.

Chapter Four: The Airplane and the Garden City

1. Editorial 1929, 7.

2. In four years (1940–43), California's share jumped from 4.6 percent to 9.54 percent. During that period, the federal government invested $800 million in more than five thousand new industrial plants in Southern California alone. See McWilliams 1990, 371. In 1941, the Tolan Committee reported that Los Angeles had received 4.3 percent, San Francisco 2.3 percent, and San Diego 1.7 percent of the national total in population growth; see U.S. House 1941. San Diego (+111 percent) topped the list. San Francisco (+40 percent), Portland-Vancouver (+34 percent), the Puget Sound area (+31 percent), and Los Angeles (+18 percent) numbered five through eight.

3. U.S. House 1940, 1941–42. Hereafter cited as the Tolan Committee. On the Office of Production Management, see Nichols 1941. Nichols was chief of the supply section, Production Division, OPM.

4. Department of Commerce 1975. James N. Gregory (1989) analyzed the 1930s migration, including the "tumbleweed circuit," a round-trip route southwest mi-

grants pursued prior to the Dust Bowl. See "Okies Leave San Joaquin Valley for Defense Projects," *San Francisco Chronicle*, Sept. 5, 1941. See also the FSA camp publications, especially the *Happy Valley* (Indio, Calif.), Jan. 18, 1941, and the *Woodville Community News*, Jan. 17, 1942, which reported a "mechanics instructor from San Diego" offering vocational training in sheet metal work, riveting, and reading blueprints leading to a "diploma and job."

5. U.S. House 1941, 95.

6. See, for example, "From Line-up to Job at Busy Aircraft Factories," *Los Angeles Times*, Nov. 12, 1939.

7. "No Housing in California for New Defense Migrants," *PM Magazine*, March 26, 1941, in the scrapbooks in the Nathan Straus Papers.

8. Foster 1980.

9. Reported in "West Leads in War Work, Says Downey," *Los Angeles Examiner*, Apr. 27, 1943. Beaman represented the Aircraft War Production Council, a consortium composed of Boeing, Consolidated Vultee, Douglas Aircraft, Lockheed, North American Aviation, Northrop, Ryan, and Vega. See also John C. Lee's testimony to the Naval Affairs Subcommittee, U.S. House 1944; and CCPA 1944.

10. U.S. House 1940, 888.

11. Murphy 1942. Murphy noted that by May 1942, home builders in 210 localities had received priority assistance based upon actual or anticipated population increases.

12. California State Planning Board, "Hearing on the Establishment of a San Francisco Bay Regional Planning District, March 28, 1941," 35; quoted in Lotchin 1993, 147.

13. Mrs. Darrell Ratzlaff, handwritten statement from 1981, in the Westchester Historical Society Collection. Copy in author's possession.

14. Expansions 1941a.

15. For unit output and employment, see Department of Commerce 1946. Floor space is noted in North American Aviation 1945.

16. Department of Commerce 1940a, 94, 540–52. North American Aviation 1945; Cunningham 1951; Maynard 1962; Rae 1968. For recent interpretive accounts, see Bloch 1987; Scott 1991; Lotchin 1992; Castells and Hall 1994, 182–92.

17. Clark 1934. In 1934, Frank G. Mittelbach mapped the extent of "urban" land use, defined as single-family and multifamily housing, commercial, industrial, and miscellaneous (the latter included schools, golf courses, parks, and public beaches). Only 13.4 percent of the land between 8.6 and 10.3 miles from downtown was urban. A decade later the Regional Planning Commission (RPC) found the share of urban land had increased to 27.8 percent. See acting RPC chair A. H. Adams' response to an editorial in the *Daily News*, Oct. 9, 1941, arguing in favor of the commission's restrictions on the oversupply of "small town lots" and the unnecessary subdivision of property.

18. *American Builder* is a good source for articles showcasing private builders engaged in defense housing. See especially the October special issue, "Home Building—Its Part in Defense," which examined Bridgeport and New Haven, Conn.,

ashville, Tenn., Pensecola, Fla., Chicago, Ill., Dallas and Fort Worth, Tex., and Los Angeles and included as well articles devoted to community planning, quality construction, and "mass production methods."

19. President Roosevelt established the NHA by executive order on February 24, 1942. John B. Blandford served as administrator, Eugene Weston Jr. was the regional director (of Region X, comprising California, Nevada, and Arizona) responsible for Los Angeles. See the agency records (NHA Collection), accessioned as United States National Housing Agency (Records 1943–45) C-A 374.

20. "Effect of Wartime Housing Shortages" 1946. The majority of publicly financed housing for war workers was completed before Pearl Harbor. On February 24, 1942, President Roosevelt consolidated all federal housing agencies into the National Housing Agency (NHA). Charles F. Palmer, defense housing coordinator, was a real estate developer and past president of the National Association of Real Estate Boards who responded favorably to the pressure private builders applied. For a participant's perspective on this transition, see the letters and memos in the Carmody Papers, box 103, folder "FWA Defense Housing Reports, 1940–41."

21. A set of survey volumes are in the Huntington Library, San Marino, California. To cite just one example of the land use designation, aircraft manufacturing fell under the category Industry (5), which was broken down into Transportation (54) and Transportation Machinery Manufacturing (548). "Aircraft Factories—including balloons, dirigibles, etc." had a four-digit designation of 548.2. The quote concerning the purpose of the survey is from the cover letter signed by A. H. Adams, acting chief engineer of the RPC, addressed to the Los Angeles Board of Supervisors, Oct. 7, 1940. The letter is bound in the *Land Use Report* (1941), also in the Huntington Library.

22. WPA 1941.

23. Viehe 1981. Viehe argues that the extractive industry was responsible for both suburban dispersal and metropolitan fragmentation in Los Angeles and, further, that dispersal was motivated by a "desire to fulfill an industrial ideal based on manufacturing and the work ethic rather than a rural ideal based on the home and open spaces." For the distinction between suburbs of production and suburbs of consumption, see Harris 1943 and Douglass 1925.

24. Schleicher 1928; Poole 1929; Cunningham 1951; Biddle 1991.

25. Cunningham 1943; Maynard 1962; Don Hansen, media specialist, McDonnell Douglas, Long Beach, Calif., letter to author, June 3, 1994.

26. Department of Labor 1944c, 11.

27. "Aviation Boom: Plane-Building Sets New Altitude Mark on the Coast," *Newsweek*, Feb. 15, 1936, 29. The figures on industrial employment are drawn from Security–First National Bank 1941a, 3. In-migration and population data were collected for the Department of Commerce 1944a. While most sectors of the national economy were slumping following the mild recovery of 1935–36, aircraft manufacturers in Los Angeles were recruiting employees from outside the region.

28. Gershenson 1947.

29. Wilburn 1971.

30. "Burbank Has Become a Hive of Aerial Industry," *Los Angeles Times*, Feb. 17, 1941, sec. B, p. 1. The report also cited a population increase for the city of Burbank, from 16,662 in 1931 to an estimated 41,000 in 1941. New housing lagged behind this growth. Builders constructed only 256 units in 1938. That number increased to 2,156 in 1939 and to 2,368 in 1940.

31. Weston, July 9, 1943, 7, in NHA Collection, C-A374, vol. 2.

32. Security–First National Bank 1941b, 1.

33. For example, Security–First National Bank reported the approval of a $200,000 building permit for Douglas plant expansion in October 1937 (Security–First National 1937). In August 1940, North American, Vega, and Vultee filed construction permits for $556,376 worth of new facilities. Douglas followed in September with county approval of a $20 million construction program that included additions to existing plants at Santa Monica and El Segundo plus a new facility in Long Beach. In July 1940, the Big Six prime contractors projected a total increase in floor area of 51 percent, from 3.56 million square feet to 5.4 million. This proved to be an underestimate of 14.5 million; by 1944 there was 19.9 million square feet of floor space in the Los Angeles region. Projections are from Security–First National Bank 1940b; 1944 floor space totals can be found in Cunningham 1951.

34. Los Angeles Chamber of Commerce 1940, 127. The War Production Board figured the median construction cost for airframe plants at four dollars per square foot for the structure and an additional eight dollars per square foot for tools and equipment. Nelson Papers, box 11, folder IV.

35. As labor shortages increased and housing conditions deteriorated in Los Angeles, firms attempted to "move work out to the workers." Lockheed set up feeder plants in Bakersfield, Fresno, Taft, Pomona, and Santa Barbara. Douglas created an entire new town for its modification center near Daggett, in the Mojave Desert. See Miller 1943a and a follow-up article on life for the "Daggetteers" (Miller 1943b). Modification centers were an innovation from this period. Prime contractors incorporated design changes into finished planes at these outlying facilities until the new specifications could be introduced at the point of production. Dispersed assembly aligned with the federal government's objective of decanting industry away from the coasts, particularly critical for the West Coast due to fear of Japanese aerial bombardment. See Department of Labor 1944c, 1–3.

36. Subcontracting as a share of all work performed increased from 10 percent in 1940 to 38 percent in 1944. Cunningham 1951.

37. The shifting landscape of industry is revealed in contemporary photographs; see the illustrations in Maynard 1962. The number of employees by occupation group in 1939 was recorded in Department of Commerce 1946, 34, table 9. The Bureau of Labor Statistics' figures for December 1943 are in Department of Labor 1944a, 1, 7, 8–11. A complete index of classified occupations with the job descriptions of operatives in aircraft and parts was published with the 1940 census as "Classified Index of Occupations." See "Transportation Equipment: 496 38 Aircraft and Parts" (Department of Commerce 1942, 155–56). *Aviation Facts and Figures 1945* includes a breakdown of occupations; see table 3.5, "Workers in Selected Oc-

cupations in Metal-Airframe Plants, December 1943" (23). The greatest share of employees were classified as "Assemblers, general" (20.8 percent), followed by "Riverters" (10.5 percent), and "Installers, general" (6.5 percent). Following the census rankings, I calculated 65.6 percent of the workers enumerated in this table fell within the categories "Operatives" and "Lesser" occupations.

38. North American Aviation 1945; Rae 1968.

39. "Harvill, Former L.A. Soda Clerk, Is Genius of Plant Vital to Nation's Air Defense," *Los Angeles Examiner,* Mar. 19, 1941. Expansions 1939 and 1940.

40. Expansions 1941b; "New Hughes Plant" 1941.

41. For Los Angeles, see U.S. House 1944, particularly the testimony of Eugene Weston Jr., John C. Lee, and Clement Markert, a representative for the residents of Banning Homes, a public war housing project. The Bureau of the Census issued a series of sample enumerations of population, migration, family characteristics, and housing in metropolitan areas designated as congested. For Los Angeles, see Department of Commerce 1944a and 1944b. The figures on housing are from the latter (Department of Commerce 1944a, 17, table 20, "Type of Household," and 19, table 25, "Resident-Occupied Dwelling Units"). The term *hotbedding* referred to a common practice of renting accomodations in hourly shifts. Cartoon published in U.S. Committee for Congested Production Areas 1944, 1.

42. The Regional Planning Commission reported 962,727 dwelling units in Los Angeles County in April 1940. At that time, the Security–First National Bank placed the number of vacant units for sale or rent at 60,030, for a vacancy rate of 6.2 percent. Security–First National Bank 1940a. Beginning in May 1939, the bank published a series of passing references to vacancy rates, a measure of the business and investment communities' concern about the current rate of vacancies and possible increases. In December 1942 the bank reported that vacancies had dropped by 25,000, bringing the rate to approximately 3 percent. Security–First National Bank 1942b.

43. On Douglas El Segundo and the company's association with John Northrop, see Wilburn 1971, 9–10; and Cunningham 1943, 24.

44. Security–First National Bank 1938. FHA *Annual Report* 1943, 32, table 14, "State Distribution of New and Existing Home Mortgages, 1935–1942."

45. Jacobs 1982.

46. By 1940 Southern California's total of 18,849 new FHA units was first in the nation, and the 384 new subdivisions containing 23,775 lots filed between May 1940 and May 1941 not only led the nation but was 103 units higher than the San Francisco Bay Area total of 281 subdivisions, which was second. FHA *Annual Report* 1940. The 1940 housing and subdivision numbers were published in "California Subdivision Activity Reaches Peak: Number of Tracts Placed on Market in Year Just Ended Sets All-Time Record with 854," *Los Angeles Times,* May 25, 1941, 1.

47. "Southland Leads the Entire Nation in FHA Insured Housing: Early 1941 Volume Indicates Total Will Exceed All-Time Peak Recorded Last Year," *Los Angeles Times,* Mar. 9, 1941, 13.

48. Security–First National Bank 1942b, 2.

49. FHA *Annual Report* 1940, 146.

50. Weiss 1987; Department of Labor 1954; Security–First National Bank 1939 and 1940b, 3.

51. According to a biographical sketch written by a publicist, Burns began his career in real estate as a high school student distributing circulars for a Minneapolis firm. Burns moved to Los Angeles to open a branch office and reportedly sold out thirty-six subdivisions during the 1920s real estate boom. In 1924 he bought out Dickenson and Gillespie, developers of Del Rey Estates and Del Rey Palisades. When the speculative real estate market soured, Burns sold the depleted oil deposit under his land holdings in Playa Del Rey to the Southern California Gas Company for natural gas storage. Henry Kaiser Papers, carton 180. See also an unpublished corporate biography written by Jack Tobin and Associates, Inc. (Apr. 28, 1986), which I read in the Fritz B. Burns Foundation office. The personal background on Fred Marlow comes from a self-published autobiography, *Memoirs and Perceptions* (Marlow 1981), a copy of which is in my possession, and Fred Marlow, interviews by author, Feb. 24, 1991, and July 23, 1991, Los Angeles, Calif.

52. Reported in "Lower Priced Houses Needed," *Los Angeles Examiner*, Oct. 12, 1936. For other examples of Marlow's advocacy of the "volume market," see "Southern California Home Program at New Climax," *Los Angeles Examiner*, May 18, 1935; and "Homebuilding in Southland May Double," *Los Angeles Examiner*, Feb. 8, 1938. In his address to the CREA, Marlow stated that "the plain fact is the building and real estate industries are overshooting the market, and altogether too many houses are being built which must sell exclusive of land costs above $3,500." Marlow resigned his position as FHA regional director in May 1938 after the Inglewood Realty Board declared a resolution protesting his "engaging in private enterprise [i.e., real estate development] while employed by the Federal Government." "Marlow Out; Bingham New FHA Director," *Los Angeles Examiner*, May 17, 1938. In his autobiography, Marlow wrote that after returning from his FHA training in Washington, D.C., he called a meeting of Los Angeles bankers and financiers to impress on them the need to adopt FHA interest rate guidelines and extended mortgage periods. After meeting "predictable resistance," Marlow turned to smaller institutions "throughout the state." But in August 1934 he received an invitation to meet with A. P. Giannini of Bank of America. According to Marlow, Giannini announced that Bank of America would adopt the program. "Within a matter of days practically all the other large institutions joined in." Marlow 1981.

53. "Burns Elected by Subdividers," *Los Angeles Examiner*, Jan. 11, 1930; and "New Builders' Unit Formed: Southland Branch Will Aid National Move to Benefit Home Owner," *Los Angeles Times*, Mar. 23, 1941. See NAHB 1957, 50–52, for an institutional history. In the Burns biography (by Jack Tobin and Associates) D. C. Slipher credits Burns with the key organizational role.

54. Advertisements in the Burns Collection.

55. William Hannon, interview by author, July 29, 1991, Los Angeles, Calif.

56. Henry Kaiser Papers, photo collection.

57. The Westside Village site plan is in the Henry Kaiser Papers, carton 34, folder "Housing Development Standards."

58. See FHA 1936c and chapter 2, above, for the roots of the small-house type.

59. "California 4-in-1 Design" 1940.

60. Burns spoke about the importance of architectural sequencing at a conference, "Housing: Mass Produced," sponsored by MIT. Burns 1952, 17.

61. Bohannon 1944. The attention to siting and landscaping as a strategy for creating visual interest continued as an essential component of community building in the postwar period. In their announcement for Kaiser Community Homes, Burns and Henry J. Kaiser offered these formal dictates: "Communities will be landscaped as a whole. Home sites will be arranged for maximum attractiveness within and in relationship to the community. The main streets and minor residence streets will be laid out to provide vistas, which will be given variety and charm by the arrangement of homesites, variations in setback of houses from the street, and landscaping. *Lack of symmetry, weedy vacant lots, and unrelated residences will be things of the past*" (emphasis added). "Henry J. Kaiser–Fritz B. Burns Announce the Organization of Kaiser Community Homes: A National Home and Community Building Enterprise," Henry Kaiser Papers, carton 311, folder "Housing."

62. "Toluca Wood: A Fritz B. Burns Streamlined Housing Project," Henry Kaiser Papers, carton 369, folder 8. FHA 1936b and the sections on "Exterior Design" and "Site and Plot Plans" in FHA 1936c are the best sources for the agency's recommendations concerning site planning and neighborhood design. One measure of the significance of these guidelines for home builders can be gauged in their repeated reference to identical formal attributes in advertising campaigns, newspapers, speeches, and articles. This practice was continued by Kaiser Community Homes. Hannon, interview, July 29, 1991; "Greatest House-Building Show on Earth" 1947, 152. In addition, KCH "compiled and published" a twenty-eight-page booklet, "Keeping Up with the Joneses," to teach owners how to "build fences, plant lawns, fix faucets, etc." Henry Kaiser Papers, carton 311, folder "Housing."

63. Hannon, interview, July 29, 1991.

64. Kenneth Skinner, a Burns associate and member of the Kaiser Community Homes staff now with the Burns Foundation, outlined the cost control measures in an interview by the author, Feb. 25, 1991.

65. For the breakdown of home builders by size of operation, see Department of Labor 1940, 738, table 7, "Number and Percent of Builders of 1–Family Houses in 72 Cities, by Size of Builder."

66. Toluca Wood sales brochure, Henry Kaiser Papers, carton 369, folder 8. A Security–First National Bank vice president quoted the findings of the Residential Research Committee (an organization founded in 1939 to collect and disseminate information on housing, mortgage lending, construction, and real estate in Los Angeles County) who found that as of October 10, 1940, over 50 percent of Lockheed employees lived in the San Fernando Valley and 80 percent lived within ten miles of the plant. *Insured Mortgage Portfolio* (4th quarter 1940, 8–10).

67. Department of Commerce 1942, vol. 4, *Block Statistics*, 5, table 1, "Characteristics of Housing for the City, Los Angeles: 1940." Robbins and Tilton 1941,

photo and caption opposite p. 64. Population figures can be found in City of Los Angeles 1949.

68. FHA *Annual Report* 1942, 30, table 12, "State Distribution of New and Existing Home Mortgages." In the Los Angeles office, FHA-insured loans for new home construction reached 27,680 in 1941. Twenty-seven percent of these were commuted under Title VI. The following year, this increased to 85 percent.

69. Quote from Federal Reserve Bank of San Francisco 1941, 56. The Bureau of Labor Statistics assessed the effects of the defense effort on home-building operations; see Department of Labor 1945.

70. "Westchester—Born in Time for Space Age Boom," *Los Angeles Herald-Examiner*, Apr. 12, 1963; Fred Marlow, interview by author, July 29, 1991, Los Angeles, Calif.

71. Fred Marlow alerted me to Security Bank's role in Westchester's development. The California Trust Company ran an ad in the *Los Angeles Times* to sell 149 acres "ripe for subdivision" at five hundred dollars an acre. They described the property as "good level land within three miles of Los Angeles Municipal airport and aviation plants where millions are being spent. [The parcel is] located at the intersections of two major boulevards in a district partly built-up and improved with streets on all four sides" (May 18, 1941, pt. 5, p. 1). See RPC 1945 for population and dwellings. The RPC recorded an influx of 9,444 people and construction of 3,227 units between April 1940 and January 1945.

72. Marlow and Hannon, interviews, July 29, 1991. Marlow-Burns constructed two hundred duplexes called "double bungalows." The Ford Papers contain a set of National Housing Agency referral forms from the Los Angeles War Housing Center, in box 65, folder "Housing."

73. Marlow, interview, July 29, 1991. On the building restriction, see Security–First National Bank 1942a, 1.

74. After this project Marlow and Burns included sites for schools and churches in their community-scale developments. Parcels for schools were turned over to the district; church sites were offered for sale. Dedications and purchases were noted on property maps. See Kaiser Community Homes Property Maps, tract 13711, Trefethen Papers, carton 11, folder 9.

75. The Spence and Fairchild Aerial Photo Collections contain a diachronic series of low-altitude oblique images of Westchester. On the development of the business center, see Holmes 1942, 12. Data on "Homes at Wholesale" and the other Westchester tracts can be found in the "Finest Community Development in 20 Years" and "Typical Homes in Westchester District," *Los Angeles Evening Herald and Express*, Mar. 28, 1942; and "60th House Finished in Westchester," *Los Angeles Examiner*, Apr. 12, 1942.

76. "City Planners Flock to Study Westchester," *Los Angeles Daily News*, May 8, 1942, 27; Holmes 1942, 12. Architect and Planning Commissioner Robert Alexander noted the approval of a 3,332-acre community development plan for Westchester in "close collaboration with the planning department" (Alexander 1989, 1:172).

77. Warner 1962; Jackson 1985; Stilgoe 1988.

78. Lynnwood Park was a 125-unit project at Imperial Highway and Bullis Road. H. H. Hagge was the developer, and Tailored Homes Building Company constructed houses for sale at $3,795. In "Sheehan Tells Rapid Growth of Lynnwood Tract," the *Los Angeles Evening Herald and Express* noted that the location was "readily accessible to all defense industries" and that the community provided "safe streets for children and an ideal family environment," including access to a proposed 38-acre park (Mar. 28, 1942).

79. Lot coverage in these projects ranged from four units to as high as six units per acre; Lakewood Village had twenty-five hundred units on a four-hundred-acre site.

80. Department of Commerce 1940c, 83, table A-3. Department of Commerce 1950, 85, table 2. In the 1940 census, the Westchester district was in tract 230. The tracts were redrawn for the 1950 census. The figures in the text are from tracts 230-B and 230-D, which correspond to "Homes at Wholesale."

81. "Crowd Attracted to Lakewood," *Los Angeles Times*, Mar. 27, 1942. The article praised Lakewood Village as the "largest community development of its kind ever undertaken in Southern California." See the notice in *Monthly Summary* regarding housing location and industry. The author states: "There is a need for considerable low-cost housing in the vicinity of aircraft plants and shipyards. It was to meet just such needs that Title VI of the National Housing Act was passed last March. Construction of the first units under Title VI started last May. . . . One such project [Lakewood Village] entailing 2,500 small homes near the Douglas Long Beach plant is reported to be in an advanced stage of planning." Security–First National Bank 1941b, 3. The Douglas–Long Beach plant became the company's main production facility during the war. Employment growth at this site was exceptional, even by the relative standards of defense manufacturing and the aircraft industry in Los Angeles. An NHA "Locality Report" from December 1942 (in the NHA Collection) shows that the number of employees at Douglas–Long Beach went from 7,723 in November 1941 to 33,500 the following year, an increase of 25,777, or 338 percent. The NHA projected further growth to 43,000 (Feb. 1943) and 47,250 (May 1943).

82. Department of Labor 1945, 10–11.

83. Ibid., 10. During the war, productionists pushed for dimensional standardization. Tyler Rogers, technical director for Owens Corning Fiber Glass and technical editor of *American Architect*, argued for adopting the modular measure in a presentation at the National Conference on Postwar Housing.

> Manufacturers who have converted their processing equipment to war needs know that they must retool for postwar production. . . . Thus the opportunity has come to suggest that building elements be brought into a coordinated pattern. Details are being developed by a committee of the American Standards Association, under joint sponsorship of the AIA and the Producers' Council. . . . [Eventually] people will adopt the new pattern simply because it will mean money in their pockets. (National Committee on Postwar Housing 1944, 166–67)

See also U. S. Housing and Home Finance Agency 1948, which listed 608 firms producing building materials in modular sizes, and Lendrum 1948.

84. Department of Labor 1945, 21.

85. On the "Postwar House," see *House Beautiful* 88, no. 5 (May 1946) and a letter from W. C. Rodd, public relations director for Kaiser Community Homes, to Howard Myers, publisher of *Architectural Forum*, Oct. 9, 1945, Henry Kaiser Papers, carton 180, folder "KCH." On the postwar miracle house, see Vermilya 1943.

86. Vermilya 1943.

87. The Bureau of Labor Statistics reported over 20 percent of new nonfarm dwelling units constructed in 1944 and 1945 were in California. The California total was 53,800 units. See Department of Labor 1947, 21, table 5, "Number of New Dwelling Units Started in Nonfarm Areas and Percent of Change, by Source of Funds, Population Group, and Region, 1944 and 1945."

88. Mumford 1945, 73.

89. Johnson quoted in Department of Commerce 1929; Hubbard, McClintock, and Williams 1930; Keally 1929; University of Chicago 1943; County of Los Angeles 1932a; Los Angeles Chamber of Commerce, Aviation Department publication, *Aviation Progress*, Sept. 1932 and subsequent issues (1932–46).

90. The President's Page, *Southern California Business* 8, no. 4 (May 1929): 7; "Let's Face the Airplane Problem" 1947, 1, 3–6; Prokosch 1951.

91. Mumford 1945, 74.

Chapter Five: Kaiser Community Homes

1. See U. S. Congress, Senate 1945; Wyatt 1946; Ihlder Papers, box 96, "Housing for the United States After the War"; and C. B. Wurster Papers, carton 2, "Notes on a Post-War Housing and Planning Program," for assessments of postwar housing need. See the "Mayor's Emergency Housing Committee Report," Bowron Papers, box 49, for conditions in Los Angeles.

2. State of California 1944b, 1–5. Corporate officers at Kaiser tracked the commission's forecasts to gauge housing need. See memo from Mildred Bareis to Vance Fawcett (Feb. 20, 1947) in which she noted the commission's highest population estimate for 1950 had already been exceeded. She determined a "need for a million homes over the next few years is easily foreseen by authorities in the field. This compares with 300,000 houses built in California between 1935 and 1940, and with 105,000 houses completed here during 1946. The office of the Housing Expediter in this area is of the opinion that we will have to work hard to attain the 1946 rate. . . . At such a rate, it is obvious that it would take ten years to fill even the present forecasted need." Henry Kaiser Papers, carton 180. Butterfield 1943, 118.

3. State of California 1946a, 1. The Kaiser Company conducted surveys to assess housing demand, polling employees at the Portland, Oreg., shipyard concerning their postwar plans in January 1944. Of 81,881 respondents over 50 percent of those who had been in the region less than three years expressed a desire to remain. See the transcript of Kaiser's keynote address to the National Conference on Postwar Housing (published in *Proceedings* [National Committee on Postwar Housing 1944]).

4. On the veteran housing programs, see Nenno 1979 and Beyer 1965, especially

chapter 14, "History of the Government's Role in Housing." The U.S. Office of the Housing Expediter's monthly reports, *Veterans' Emergency Housing Program,* contain statistical accounts of building material production, construction starts, housing costs, and related policy.

5. Department of Labor 1945, 7–8. The bureau issued a series of reports on the construction industry and reconversion. See Department of Labor 1943, 1944b, and 1947.

6. Department of Labor 1946, 560–61. See also Murphy 1942. For longer home ownership trends, see Department of Commerce 1975, 616, Series N 238–45, "Occupied Housing Units and Tenure of Homes: 1890–1970."

7. See Fishman 1987a; Harris 1988; Gillette 1990.

8. Kaiser Community Homes, held jointly by the Henry J. Kaiser Company and Kaiser Industries, was incorporated in California on May 22, 1945. Kaiser and Burns were equal partners; each made an initial fifty-thousand-dollar investment. The corporation was authorized to sell between fifty thousand and five million shares. Corporate officers were Fritz Burns, president; Edgar F. Kaiser, vice president (Kaiser Community Homes, Inc., Oreg.); E. E. Trefethen Jr. (Kaiser), vice president (Operations); and G. G. Sherwood (Kaiser), secretary and treasurer. Henry Kaiser Papers, carton 311, folder "KCH—Financial Survey." A January 7, 1952, letter to the Bank of America revealed that Henry Kaiser still owned 50 percent of the common and 50 percent of the preferred stock in the corporation. The letter, signed by William Marks, a Kaiser Company vice president, described the management structure at that time. "Fritz Burns is President of KCH and he and his associates actually manage and operate KCH and its business in all respects, except as to those matters which are submitted to the Board of Directors for action." Trefethen Papers, carton 11, folder 5.

9. "Henry J. Kaiser–Fritz B. Burns Announce the Organization of Kaiser Community Homes: A National Home and Community Building Enterprise," Henry Kaiser Papers, carton 311, folder "Housing"; and "Remarks in Appearance before Senator O'Gara's State Housing Committee," Henry Kaiser Papers, carton 180.

10. See state director Harrison R. Baker's address to the California Real Estate Association's Appraisal Division, "How to Appraise Acreage Suitable for Land Subdivision" (Aug. 1, 1940). Copy in author's possession, obtained from Fred Marlow, July 23, 1991.

11. State of California 1945b, 38. David D. Bohannon was the chair for northern California. Community builders, including Burns and Kaiser, limited their vision of social mixing to "industrious" white workers. Both supported restrictive covenants in their developments. See Berger 1960 for an examination of the behavior and beliefs of new working-class home owners in Fremont, California.

12. Hoyt 1943. See also Meyerson and Mitchell 1945. On the Los Angeles City Planning Commission, see chapter 6, below.

13. Department of Labor 1945, 20. See also Vermilya 1943.

14. The Henry Kaiser Papers provided only one oblique reference to the industrialist's study of housing, an article titled "What About Little Houses," which

Kaiser sent to Burns with the note, "I thought this might be of interest to you." In the margins Kaiser wrote: "I still wonder whether little houses, having a living room, bath, kitchen, wall beds in the living room—low-cost—prefabricated—with grooved plywood on the inside—might not have a profitable market; and whether you have any area where you could do this and thus use the [Manchester] plant to advantage." Henry Kaiser to Fritz Burns, Nov. 13, 1947, Henry Kaiser Papers, carton 180. For Kaiser's role in the National Committee on Housing, see the correspondence in the Henry Kaiser Papers, carton 180. Progressive housers expressed their suspicion of the committee's agenda and of Rosenman. See the letters between Rexford Tugwell and Vernon DeMars in the Tugwell Papers, box 7, folder "DeMars, 1944–64." On Kaiser's lukewarm response to housing reformers, see the correspondence in carton 180, folder "KCH, 1944–48," particularly a letter from E. W. Blum, president of the National Association of Housing Officials, Oct. 16, 1947. Burns on the other hand was outright hostile. When Eugene Trefethen asked him to comment on a questionnaire developed by Senator Wagner's staff, Burns angrily wrote that he was fundamentally opposed; "I do not compromise in my stand against Federal Government participation in housing." In his letter, Burns argued that the FHA had ushered in a "revolutionary new cycle" in housing that had "not yet had the opportunity to fully express itself. . . . The important thing is that there be a continuous and ample supply of new houses of the FHA Title VI type." Fritz Burns to Eugene Trefethen, Dec. 5, 1947, Trefethen Papers, carton 11, folder 4.

15. Bauer 1944; Rosenman 1945; Colean 1944, 1947; Wyatt 1946; State of California 1946a; and Keyserling 1946.

16. Kaiser estimated the construction of 2 million housing units would provide direct employment to 1.75 million workers and indirect employment in allied fields for another 2.5 million ("Henry J. Kaiser–Fritz B. Burns Announce the Organization of Kaiser Community Homes: A National Home and Community Building Enterprise," in Henry Kaiser Papers, carton 311, folder "Housing"). Kaiser was not alone in his concern. Many analysts feared the end of military engagement and wartime production would create the conditions for a return to the Depression. See State of California 1945a, 1944a, and 1946b. The *Annals of the American Academy of Political and Social Scientists* published the proceedings of a conference, "Planning for Postwar Reconstruction in Southern California" (1942) held by the Pacific Southwest Academy on April 11, 1942. See Coons 1942 and Earl and Trynin 1942. The Haynes Foundation also sponsored a series of studies. On industry and employment see Kidner and Neff 1945. Lasch 1946, 267, made the link between home building and full employment.

17. Henry Kaiser to Walter McCornack, June 15, 1945, Henry Kaiser Papers, carton 177, folder "Postwar Housing, 1945."

18. "Kaisercraft Homes," 2, Henry Kaiser Papers, carton 180. Kaiser told the National Committee on Housing, "Housing can and must be as modern as transportation, education, and medicine. The shacks and sheds of our rural areas and the slums in our cities must go. They stand today as an indictment against our boast of progress. . . . City managers and municipal officials are fully aware that slum areas

and all other forms of unwholesome housing will be directly reflected in the tone, character, and morale of the community," Dec. 7, 1944, 2–3, Henry Kaiser Papers, carton 180. Print media covered Kaiser's forecasts. The *New York Times* carried the "output expert['s]" comparisons to the auto industry: "What the auto did for us in the 1920s, residential construction will do for the economy after the war," Henry Kaiser Papers, carton 369, folder "News Clippings, 1942–45." Supportive clippings from around the country, including the labor press, are in the scrapbooks in the Henry Kaiser Papers.

19. Quotations are from an interview in France published in translation as "Henry J. Kaiser: The Man of Large Horizons," Henry Kaiser Papers, carton 348, folder "Personal Archives." See also "Today's Story on Tomorrow's Job: Kaiser Reveals $70 Million Program to Build 10,000 Homes This Year," *San Francisco News,* Jan. 2, 1946; and "Kaiser Community Homes Will Use 25,000 Tons of Steel Studs in 10,000 Housing Units This Year," in Henry Kaiser Papers, carton 369, folder "Iron Age."

20. Foster 1986 reviews Kaiser's postwar plans. See, in particular, Henry Kaiser Papers, cartons 170, 171, 310, 348, and 369, for material on the industrialist's postwar enterprises.

21. Irving W. Clark, manager of Westinghouse Electric Company's Better Homes Department, offered a concise definition of the package community in an address to the National Conference on Postwar Housing. "It is therefore only sound, sensible thinking for the [housing] industry to meet its major problem by developing a complete package of living with . . . a [dwelling of] maximum appeal . . . located on streets free from through traffic and convenient to schools, churches, theaters, parks, stores, commercial buildings, and easily accessible to industry. Home builders must develop . . . for the various economic and social levels . . . within the means of each major income bracket" (National Committee on Postwar Housing 1944, 192). At the conference Bohannon addressed the need to complete all these requirements "at once" by spreading the cost over each unit "to the end that the homeowner may enjoy the amenities immediately" (162). Note that Clark's definition underscores an acceptance of modern community planning principles.

22. Chandler (1977, 315–36) referred to the latter as "horizontal combination," a strategy "aimed at maintaining profits by controlling the price and output of each of the operating units" (315).

23. "Kaiser Community Homes: A Statement," Henry Kaiser Papers, carton 848, folder "KCH."

24. The six strategies were: (1) outright purchase, (2) landowner participation in profits, (3) lease option, (4) joint venture with land developer, (5) joint venture with local builder, (6) sale of products. "Basic Development Plan," Henry Kaiser Papers, carton 311, folder "Housing—Development Standards, 1945." See also the document "Kaiser Community Homes" in carton 369, especially the sections "Type of Initial Homes" and "Features Offered by KCH to Associates and Consumers." The former addressed the lag-time between the announcement of KCH and the "as-soon-as-possible" starting date for the "ultimate" Kaiser home. The report suggested

"forming local combinations with builders and land developers throughout the United States" and "lining up sources of materials and preparing manufacturers to produce for us in quantity" as useful strategies for the interim period. "Features" spelled out twelve control functions including administration (accounting, systems, forms, and ledgers) and selling and advertising (promoting a trademarked product— the Kaiser Home—national advertising and public relations programs, model communities to point to, scale models, and department store campaigns).

25. Ibid. (emphasis added).

26. Ibid. In terms of financing, Lindbergh argued that KCH should "work out a plan to handle [it] under a subsidiary mortgage company or on some other wholesale basis." The intention was to sell these mortgages off in blocks at a premium while retaining the servicing charge of one-half percent. This tied into Kaiser's plans for insurance. "Insurance companies or building and loan associations usually claim the right to the insurance business as a prerequisite to taking a loan. By handling our own mortgages there would be no question about our being privileged to write hazard insurance." "Basic Development Plan," in Henry Kaiser Papers, carton 311, folder "Housing—Development Standards, 1945."

27. See the report "Engineering for Kaiser Community Homes," Henry Kaiser Papers, carton 311, folder "Housing—Development Studies," which argues that "in order to make available these designs to constructors anywhere in the country, where the personal supervision of the creator of the plan is not available, it is necessary that details be worked out to a much greater extent than would be required normally." To assist builders, Kaiser engineers developed standard layouts to indicate "typical subdivisions, landscaping, and architecture."

28. Wittausch 1948, 709.

29. Until formal incorporation of KCH in May 1945, postwar housing was designated "Kaisercraft homes."

30. "Kaisercraft Homes," Henry Kaiser Papers, carton 312, folder "Housing—Kaisercraft Report."

31. The Kaiser companies tried to copyright the name Kaiser and in one case initiated and won a legal case brought against a Long Island builder who advertised himself as Kaiser Homes, Inc. In this case, a local Kaiser-Frazer auto dealer who received requests for information regarding prefabricated housing alerted the parent company. See the correspondence in Henry Kaiser Papers, carton 180.

32. When the Kaiser Publication Department alerted employees to the rebroadcast of opening ceremonies at Homes at Wholesale on radio station KQW, it stressed these were the "first 200 homes. . . . 1,000 more are underway and 2,000 will be complete by the end of the year," Sept. 16, 1946, in Trefethen Papers, carton 11, folder 2.

33. On the Richmond shipyard housing, see the section "War Housing" in a Housing Division report, Henry Kaiser Papers, carton 369, folder 6; and a September 1946 report prepared by E. C. Anderson in an oversized folio, "Wartime Housing," carton 311, folder "Housing." The summary stated that "all war housing construction at Richmond was done by the Kaiser Co. for the U.S. Maritime Commission. The first

project consisted of 6,000 units and a school building ($15,691,200 total construction). Later 4,000 units, 4,000 dormitory rooms, two schools, three markets, a hospital, fire house, recreation center, and two nurseries were added. Actual cost for both projects: $24,142,557." For a comparison with Portland, see Maben 1987.

34. The Fontana case study is drawn from material in the Henry Kaiser Papers, carton 369, folder "War Housing" and oversized volume "War Housing," and State of California 1944c. Similar developments can be found in other parts of the country. Nine miles southeast of Oklahoma City, W. P. Atkinson developed Midwest City on a 330-acre tract across from a new Douglas cargo plane plant. With the cooperation of the Army Air Service Command, Douglas Aircraft officials, and the state FHA office, Atkinson created a community project for defense workers, which *Insured Mortgage Portfolio* promoted as the "first FHA city" ("FHA City Rises from the Prairie" 1943). The ULI featured an aerial view of Midwest City on the cover of *Urban Land* 3 (Aug. 1944) under the heading "Model Community." See also "FHA Housing in Utah" 1943 for a description of Sunnydale, a Kaiser Industries community for mineworkers in the Carbon Mountains.

35. The unit mix was to have included 400 one-bedroom, 240 two-bedroom, and 160 three-bedroom dwellings.

36. FHA 1936b.

37. Bohannon 1944, 164.

38. Schulte recounted the visit in an unpublished (1986) biography of Burns, which I read at the Fritz B. Burns Foundation office. Various individuals in this network cycled through agencies, foundations, and businesses engaged in quantity-produced housing. For example, soon after the 1944 conference, Slipher joined Burns as an employee of Kaiser Community Homes. Years after KCH folded, Slipher assisted Henry Kaiser as construction supervisor for the Hawaii Kai Development Company, marina and resort developers on the island of Oahu.

39. See the report "Housing" in Henry Kaiser Papers, carton 348, folder "KCH." In another report, "Homes," a section titled "Materials and Methods of Construction" concluded that "one of the greatest contributions any organization could make to the housing industry is through better employment of materials and methods of construction. . . . Houses need engineering to modern standards and the application of new methods of construction. For example, there is a veritable forest of two-by-fours in the average house. Properly engineered they would need less. Our goal is to provide more houses with less weight, fewer pieces, lower man-hours, and lower costs." Henry Kaiser Papers, carton 369, folder 5.

40. The report "Homes" includes a chart, "Comparison of Quantities and Costs of Two-Bedroom House by Various Construction Methods," which considered conventional framed, plywood cell, plywood sheet, steel wire, steel channel, and gypsum systems. A breakdown by subsystem, with materials quantified and priced to the nearest dollar, resulted in a final ranking by "total direct costs" (which did not include insurance, permits, cost of lot, garage, and builders' overhead and profit) with plywood sheet ($2,837), followed by conventional framing ($2,878) and steel channel ($3,331). Henry Kaiser Papers, carton 369, folder 5. These findings must

have influenced the choice of plywood panels for factory production at the Manchester facility. One of the more interesting areas of research conducted by Kaiser engineers was the feasibility of aluminum for a structural system and an all-aluminum house. In June 1946, Kaiser Engineers published two reports, "Comparative Cost Estimate for Kaiser Community Homes' House Built of Aluminum Prefabricated Materials" and "Calculations for an Aluminum House for Henry J. Kaiser Co. Experimental Division." The former projects a final cost of $5,943, $135 less than the $6,078 price forecasted for a house built by standard construction. Another study, "Preliminary Estimate of the Cost of an Aluminum House," breaks down the analysis to 4,265 pounds of aluminum with 186 pounds of waste ($1,679.57), shop fabrication ($426.50), crating ($135.00), and field erection ($160.00) for a total of $2,401.07, which compares favorably with plywood sheet and conventional framing. Henry Kaiser Papers, carton 311, folder "Housing—Aluminum House."

41. "Percentages of a House (from NHA data) as Applied to a $5,000 House and Lot," table 3 in "The Effect of Mass-Production on the Cost of Houses," Henry Kaiser Papers, carton 311, folder "Aluminum House—1944–46."

42. "Comparison of Kaiser and NHA Cost Estimates for House and Land," ibid.

43. "Digest of Housing Notes," Henry Kaiser Papers, carton 369, folder "Miscellaneous—Notes on Housing." Wittausch (1948) forecasted a national market of 100,000 manufactured homes for that year, 17,300, or almost one-fifth of the total, for California. Texas, at 8,000, and New York, with 6,150, were the nearest competitors. See Wittausch 1948, 700, Exhibit 1: "The Market for 100,000 Manufactured Houses."

44. "Digest of Housing Notes," Henry Kaiser Papers, carton 369, folder "Miscellaneous—Notes on Housing."

45. Henry Kaiser Papers, carton 369, folder "Miscellaneous—Notes on Housing." In the section "Housing Trends," Lindbergh made explicit reference to Burns and David Bohannon as "large-scale operators . . . able to compete with small contractors [by] taking advantage of factory methods, mass purchasing, and low land costs due to volume developments."

46. At the same time that engineers and designers were at work on the mechanical heart, a parallel strategy involving the distribution and sales of individual components was under discussion. According to a summary document ("Household Appliances—Manufacturing Cost and Facilities, Vol. 2" [1945]), Kaiser managers proposed three schemes for independent distribution: (1) direct manufacture by Kaiser and distribution under the Kaiser name through an organization of local, established home appliance distributors or utility companies; (2) direct manufacture by Kaiser but distribution through established appliance manufacturers such as Philco, Servel, Nash-Kelvinator, and Frigidaire; and (3) manufacture for leading retailers like Macy's, Gimbel's, or Marshall Field. The authors endorsed the second option because it minimized risk while "allow[ing] development of the Kaiser name should we determine to come out with other commodities." Henry Kaiser Papers, carton 310.

47. Designers planned the bathroom to include a Kaiser bathtub-shower unit, lavatory, and toilet. A Kaiser clothes washer, laundry tray, and furnace comprised

the utility room. A Kaiser air conditioner was optional equipment. Other production and installation options included the manufacture of walls, floors, and ceilings as knock-down items to be shipped and assembled. See "Prefabrication of Mechanical Cores for Postwar Homes," Henry Kaiser Papers, carton 312. See also the files "Household Appliances," particularly the brochure "Proposed Line," Henry Kaiser Papers, carton 310. The line was scheduled to include six refrigerator models (three "standard" and three "deluxe"), a vertical and chest-type freezer, floor and window air conditioners, a conventional and an automatic clothes washer, three models of electric and two gas ranges, an electric and a gas lawnmower, two vacuum cleaners, and twenty cabinet models with a choice of four sinks. Prices were estimated to range from $809 to $1,584.

48. Tom Price to Howard Lindbergh, May 3, 1945, Henry Kaiser Papers, carton 171, folder "Stoves." On the garbage disposal, see a memo from Lindbergh to Joe Schulte, Jan. 14, 1947, advising him to install the unit into Kaiser housing. The "Deep Freeze," a Kaiser food freezer, illustrates the first strategy. After determining they would not design a new unit for the mechanical heart, Kaiser engineers worked from a twelve-cubic-foot unit already on the market. They proceeded to strip it down in order to redesign the core and restyle the exterior; Henry Kaiser Papers, carton 170, folder "Deep Freeze—1945." In the same carton an agreement between the Kaiser Company and E. H. Daniels, an industrial designer with offices in Los Angeles and Oakland, details a "redesigning and styling for the . . . console type Deep Freeze unit." Price sent Lindbergh the memo regarding the Graham Company (May 3, 1945). On the Housing Division's dealings with Southern California Gas, see the series of memos between the latter's Gas Appliance Lab and Tom Price, in Henry Kaiser Papers, carton 171, folder "Stoves." Efforts to cut housing costs by either contracting directly with manufacturers or buying patents and entering into direct production had earlier proponents. See, for example, Perry 1939, chapter 8, "Cheaper and Better Dwellings" especially the section "Household Machines," 182–83.

49. On the Teller connection, see a Sept. 1, 1945, letter from W. C. Rodd, director of public relations at KCH, and L. H. Oppenheim, of the Kaiser Company (Schulte had introduced Teller to Oppenheim), Henry Kaiser Papers, carton 171, folder "Stoves." Kaiser personnel had also investigated the possibility of purchasing Western Stove Company, of Culver City, outright early in 1945. However, after visiting the plant in May, Price wrote to Trefethen that Western Stove "would not be the company we would want to work with . . . on the mechanical core." Company president Henry Horner aligned himself closely with Burns. The only information he offered Price regarding the design was that it would be similar to their present product, a "very cheap stove . . . that he has been selling Sears, Roebuck." This exchange provides a rare glimpse into the mindset of Kaiser engineers. Price noted contemptuously that Horner "has a very haphazard type of plant which has been added to and added to many times so that there is no regular planning involved in it." Henry Kaiser Papers, carton 171, folder "Stoves."

50. Kaiser Engineers, "General Summary," Henry Kaiser Papers, carton 312. This report is notable also for the detailed accounting of constructing and equipping

a facility and the labor costs for manufacturing the mechanical core. At this point a decision had been made to focus production in Los Angeles and ship assembled units to San Francisco. The estimated cost of plant and facility to be in full operation in eight months was put at $7 million. Kaiser staff projected a six-day, three-shift schedule to produce 120,000 units annually. The work schedule and production totals certainly respected Kaiser's admonition to think big. It is quite possible they also reflected his paeans to creating employment opportunities and a holdover from wartime production on the part of Kaiser personnel.

51. Fritz Burns to Henry Kaiser, June 26, 1945, Henry Kaiser Papers, carton 180.

52. "Kaiser Community Homes," Henry Kaiser Papers, carton 369.

53. Henry Kaiser to Eugene Trefethen, Jan. 14, 1946, Trefethen Papers, carton 11, folder 4. Three months later a memorandum between Trefethen, Price, and George Havas reveals that Kaiser officials in Oakland had finalized plans to establish a Bay Division of KCH to operate in northern California. This did not include the KCH project already under way in San Jose under Burns' control. The intention was to "obtain all the information available from the Los Angeles operations," including house plans, financing information, bills of materials, "particularly for the mass-produced houses," and prefabrication information and plans. But the Bay Division would have been as "self-contained and self-administrative as is possible to work out with Mr. Burns." After describing a memo sent to Burns in which he laid out his concerns "in the nicest way I could," Kaiser advised Trefethen that if things did not change in the next two weeks he had better come down and review the situation, because "otherwise the Kaiser organization is going to take an awful black eye." Trefethen Papers, carton 11, folder 1.

54. *American Home,* Oct. 1947, 166. The ads also promised improved hygiene through the use of hotter water, a more thorough wash and rinse, and dishes dried "untouched by human hands." Both Kaiser models garnered the Good Housekeeping "Seal of Approval." The Kaiser unit was featured in Ramsay 1947, 91. See also the series of illustrated ad copy generated by Kaiser publicists in Henry Kaiser Papers, carton 310, folder "Appliance."

55. For the patent rights, see Henry Kaiser Papers, carton 170, folder "Dish-washer—1945." Production scheduling was presented in carton 170, folder "Household Appliances: Dishwasher Manufacturing Cost and Facilities, Vol. 1," (1945). A history of Kaiser-Fleetwings is in the Trefethen Papers, carton 204, folder 2. Kaiser Cargo purchased a controlling interest in the Fleetwings Corporation on March 29, 1943. In 1948 the company was renamed Kaiser Metal Products.

56. On the Kaiser-Fleetwings facility, see "Report and Forecast," in Henry Kaiser Papers, carton 310, folder "Appliance." In the same report, "current products and work" describes the cabinet line, garage door, and a contract for the cabinet and control panel of General Electric's air conditioners. Two problems plagued the dishwasher: the jets tended to plug and the aluminum inner drum scratched easily. The *New York Times* reported the Sears, Roebuck stock purchase on Sept. 30, 1948.

57. On February 18, 1947, Kaiser presented the state Housing Commission an overview of corporate structure and building materials.

58. "List of Kaiser Products Now Being Manufactured or to Be Manufactured," Henry Kaiser Papers, carton 170, folder "Miscellaneous Appliances." In a letter to Burns, Trefethen requested that he revise the specifications and replace bronze screening with aluminum, one means for introducing new materials and products. Trefethen Papers, carton 11, folder 2.

59. Joseph Schulte to Fritz Burns, Oct. 30, 1946, Trefethen Papers, carton 11, folder 2.

60. D. C. Slipher to Eugene Trefethen, Oct. 7, 1946, Trefethen Papers, carton 11, folder 4. According to Slipher, the Architectural Division estimated that KCH might use between 50,000 and 280,000 square feet of 24-gauge aluminum sheet per month.

61. Joseph Schulte to Eugene Trefethen, Jan. 17, 1949, Trefethen Papers, carton 11, folder 8. There were numerous forecasts of new materials and probable acceptance. For example, the Bureau of Labor Statistics suggested that "it is quite probable that war-expanded capacity for production of light metals may lead to considerable increase in their use in construction." Department of Labor 1943, 10. At the same time, pundits warned that the "public accepts new items, new things, major changes, slowly. Proper mind conditioning to new commodities and techniques . . . through carefully planned educational programs is a must for the goal of public acceptance." Clark 1944, 191. One method builders chose to introduce new materials, educate the public, and monitor their response was the exhibit or model house. Burns "tested the water" of public acceptance with the construction of the "Postwar House." In a letter to Howard Myers, publicist for *Architectural Forum*, W. C. Rodd, head of publicity for KCH, wrote that Burns was building the home from products donated by two hundred manufacturers as his contribution toward ascertaining public reaction. "The Postwar House will include the very latest and best the industry has to offer. No expenditure of time or money has been spared. The total cost of the house, including the lot [on the corner of Wilshire Blvd. at Highland Ave.] will be close to $150,000. . . . We are building this house in order to make everybody in America dissatisfied with the homes they are living in now." Henry Kaiser Papers, carton 180, folder "KCH." The house was open from 1946 to 1956. In his statement at an MIT-sponsored conference on "mass-produced" housing, Burns asserted that he had wired the house with dictographs "to pick up the comments of the public [as] our share of research on consumer acceptance." Kelly and Hamilton 1952, 37.

62. *Tomorrow's Town* 5, no. 3 (June 1947): 1. Clipping from July 29, 1945, in the scrapbooks in Henry Kaiser Papers, vol. 40.

63. "First Kaiser Community Homes Project Scheduled for Northern California," Henry Kaiser Papers, carton 180.

64. For a general discussion of operations at the Manchester plant and its output, see "The Greatest House-Building Show on Earth" 1947; "Industrialized Housing" 1947; and "Kaiser's "Chassis" Homes" 1947. A photograph in the Whittington Collection at the Huntington Library (Whittington 2037, negative 1808) shows workers applying a finished wallcovering to a panel suspended from an overhead monorail. The product was Wallkraft, a treated finish that was washable if left

uncovered but could serve as a prime coat for wallpaper or paint. In my interview with Bill Hannon (July 29, 1991), he described this practice as "experimental." It was short-lived. The Wallkraft tended to shift and disadhere when the panels were stacked and shipped.

65. "First Kaiser Home Finished," *Los Angeles Examiner*, Sept. 17, 1946. Kaiser Community Homes officials were fond of stating that the plant had a "quarter-mile long assembly line." While it is difficult to assess the end-to-end length of the lines, the discrepancy between the image this claim invokes and the plant operation is clear.

66. Burns, quoted in press release, "First Kaiser Community Homes Project," Henry Kaiser Papers, carton 180, folder "KCH 1944–47."

67. National Committee on Postwar Housing 1944, 158.

68. Henry Kaiser was a member of the Citizens Advisory Committee on the Development, Preservation, and Restoration of Industry, in addition to the role he played in housing organizations. See Henry Kaiser Papers, carton 171, folder "Postwar," for correspondence between Kaiser and Senator Robert Taft, chair of the Sub-Committee on Housing and Urban Redevelopment under the Senate Postwar Planning Committee. For example, Taft sent a draft of the subcommittee's outline for housing to Kaiser on June 6, 1944, for comment; Kaiser responded on June 30, 1944.

69. Gerald Piel to Henry Kaiser, Feb. 1, 1946, Henry Kaiser Papers, carton 180. A 1947 report issued by the FHA, titled "California Residential Construction: December 24, 1946–April 25, 1947," indicated that 61 percent of owner-occupied units had less than eleven hundred square feet.

70. Gerald Piel to Henry Kaiser, Feb. 2, 1946, Henry Kaiser Papers, carton 180. Piel based his estimates on figures developed by Burns. He projected total material and labor costs of $459.5 million for 150,000 Kaiser Homes. Kaiser Papers, carton 180.

71. NHA 1946. On the FHA program, see the series of memos from Bradford Hollingsworth, a Burns operative, to G. G. Sherwood, a KCH official in Oakland. An April 24, 1946, memo included a copy of an FHA document, "Housing Goals: Channeling Materials into Moderate and Low-Cost Homes," a confidential report that Hollingsworth secured from Mr. McGovern, the district director. Trefethen Papers, carton 11, folder 1.

72. D. C. Slipher to Fritz Burns, Oct. 23, 1946, Trefethen Papers, carton 50, folder 30. Slipher's letter was forwarded to Trefethen.

73. See an unidentified clipping dated October 1946 in the Trefethen papers (carton 50, folder 8) titled "Battle for Aluminum Discounted by NHA" that reported on these developments following a visit by Wyatt to Los Angeles.

74. In a letter to Kaiser, Sept. 21, 1946, Burns noted that "we shipped 66 houses from the factory to the field during the five-day week ending yesterday which fulfills the representation we made at the press conference last Monday. Wyatt will be here next Saturday morning and we are planning on working overtime so that he will see the plant in operation. We have already gotten valuable assistance from his office during the past few days in the procurement of electrical equipment."

75. Undated memo, Henry Kaiser to Eugene Trefethen, Trefethen Papers, carton

11, folder 4. In a personal letter to Burns (July 14, 1946), Henry Kaiser Jr. outlined a similar set of issues although he framed it as a health concern, suggesting that Burns was "running himself into the ground." Ibid.

76. Ekrid and Browne succeeded in introducing and regulating production scheduling and inventories. See, for example, the records in Henry Kaiser Papers, carton 11, folder 3, in particular the "Inventory of Materials," which lists the quantities and dollar values of lumber, fixtures, hardware, doors, and paint in the warehouse and yard. Folder 4 contains a series of weekly construction schedules that track the number of buildings in each project, their financing, estimated starting and completion dates, and sales. Six-month summaries included sales and gross profits from each tract, broken down by average price per house, cost per lot, and average gross profit per unit.

77. Fred Pike to Eugene Trefethen, Nov. 12, 1946, Trefethen Papers, carton 11, folder 2.

78. Tom Price to Fritz Burns, Mar. 8, 1946, Trefethen Papers, carton 11, folder 4. In response, Donald Colwell, director of land planning, argued that "Mr. Burns has several men out buying land and there is considerable acreage being purchased at this time." This letter was an undated "Copy" in the same folder; however, it began, "I am sorry to be so late in answering your letter . . . and hope you will excuse it this time." Colwell went on to state that Kaiser Engineers now had 546 acres assigned to them, so the letter must have been sent at least a month later.

79. This is not to belittle the accomplishments of Burns, who, as the builder of record for over two thousand units a year, was in the top one-half of one percent (.5%) of operative builders in the country. See "Homebuilding and Homebuilders," NAHB 1957, 74, table C-4, drawn from the Bureau of Labor Statistics study in Department of Labor 1954.

80. Burns commented on the two systems at an MIT conference in 1952. "There is an advantage to panelizing [if] you want to hold together a crew over a longer period of time. . . . On our particular operation, the same crew builds the cabinets so it stretches out a minimum of men rather than having peaks and valleys in the number employed. Other than that, [there is] very little difference in cost." Kelly and Hamilton 1952, 16. Interviews with Burns' former associates reinforced this interpretation. Both Hannon and Skinner referred to the Manchester plant as an "experiment." According to Skinner, "we couldn't quite get the prefab to gel." William Hannon and Ken Skinner, interviews by author, Feb. 28, 1991, Los Angeles, California. In response to a letter requesting information on the Manchester plant, J. G. Stollery (publicist for KCH) wrote: "We did have a plant where units and some of the walls were built in sections and then taken to the site for final assembly. As I recall, this plant was only in operation for about six months when the entire building operation was moved to the tract site *where it was found that more economies could be affected to our large building program*" (emphasis added). In March 1948, Trefethen met with Burns and Pike in Los Angeles to discuss "their program" and the possible liquidation of property in order to meet outstanding loan agreements. The second of four objectives they established was the sale of the Manchester property and plant at

the "best possible price without making a sacrifice." They estimated proceeds of $250,000. "The total of this liquidation [all four items] would bring in about $1 million, and in view of the fact that *none of these properties are essential to the present building programs,* it was concluded that every effort should be made to bring this about" (emphasis added). Trefethen letter of Mar. 13, 1948, Trefethen Papers, carton 11, folder 4. By 1949, KCH had moved out of the Manchester plant, which was then leased to Restwell, a furniture manufacturer who eventually bought the property. Skinner, interview, Feb. 25, 1991.

81. The press release for the Westchester move-in alerted the media that "On Friday, February 21, 1947 at 2:00 Fritz B. Burns, President of KCH will welcome forty GI families into their new homes." Henry Kaiser Papers, carton 180, folder "KCH—1944–47." See also the *Los Angeles Examiner,* "40 GI Families Will Move into Kaiser Project Friday," Feb. 18, 1947; and "40 GI Families Move into New Kaiser Houses," Feb. 22, 1947 (ibid.). The reporter noted that the "houses were partly built on the Kaiser Community Homes assembly line and then finished in the field. The method has been perfected to the point where ten homes are being finished daily." "40 GI Families Will Move into Kaiser Project Friday," Feb. 18, 1947 (ibid.).

82. For example, General Houses advertised itself as the "General Motors of the new industry of shelter" and offered eighteen models of its houses with names like K2-H4-O. See Thomas 1973 for obsolescence as a marketing tool.

83. Gerald Piel to Albany Chamber of Commerce, June 26, 1945, Henry Kaiser Papers, carton 177, folder "Postwar Housing."

84. Although a press release for Panorama City claimed that the "complete, intact community has been the Kaiser goal from the start" and pointed to the "accumulation of business frontage" as an important factor in the "overall design of Kaiser communities which have been located and planned with the end in view of establishing complete business centers and entire community facilities," the creation of a "complete" community eluded KCH until Panorama City. Press release dated Mar. 30, 1950, in Henry Kaiser Papers, carton 311, folder "KCH." To cite just one example, Burns did own a considerable amount of commercially zoned property adjacent to the North Hollywood tract. However, because of the proximity of another business district "about a mile away from ours," Burns advised that KCH sell off the property in lots "rather than develop it for further investment." "Summary Report of Visit to Kaiser Community Homes' Operations in Los Angeles Area on April 24, 1951," Trefethen Papers, carton 11, folder 5.

Chapter Six: "Building a City Where a City Belongs"

1. "Contest Wins Future for American Couple and Aid to Europeans," *Los Angeles Examiner,* Clippings File, folder "Kaiser"; "Contest Winner Starts 'New Future' in Southern California," Henry Kaiser Papers, carton 312, folder "Panorama City."

2. Department of Commerce 1940b, pt. 2, 321, table 5.

3. "Kaiser to Build Two Million Complete Community Homes" 1945. For adver-

tisements, see clippings from the *Los Angeles Evening Herald and Express, Los Angeles Examiner*, and *Van Nuys News*, as well as the "Panorama City Advertising Manual," in Trefethen Papers, carton 11, folder 8. Proximity to employment was noted in everything from the Bank of America's preliminary appraisal, Apr. 28, 1946, to the final phase of commercial development in 1959. See Trefethen Papers, carton 11, folder 1, "KCH Corporate Files," "Distance to Employment," and "Panorama City Shopping Center: The Center of the San Fernando Valley."

4. The National Association of Home Builders awarded Panorama City its first prize in the "Best Neighborhood Development" category in 1949, and both the building trades and architectural press showcased the project. In 1952 the Building Contractors Association named Fritz Burns "Builder of the Year." Lightfoot 1960, 19.

5. RPC 1946a, 20–21.

6. RPC 1946a, 7, 12.

7. RPC 1946b. From 1946 to 1950 the RPC statistical area reports tracked population growth and dwelling units in the San Fernando Valley. There were, however, only occasional mentions of this development in the textual summaries. When the authors did mention the Valley it was to locate specific projects and comment on the scale of these developments. These notices coincide with KCH community building at Panorama City.

8. Bennett and Breivogel 1945, 96.

9. Pappas 1952, 170–72; City of Los Angeles 1955, 23.

10. City of Los Angeles 1943, 5.

11. Bennett and Breivogel 1945, 97.

12. See, for example, Bennett 1946, 2–3.

13. Bennett and Breivogel 1945, 94. See the "Suggested Master Plan" for Chatsworth, published in City of Los Angeles 1944, 12; and the plan for Reseda, in Bennett and Breivogel, 97.

14. City of Los Angeles 1943, 6.

15. City of Los Angeles, 1945, 41. See City of Los Angeles 1947, 37–39, for another "special study," this one of a 160-acre Valley parcel in which planners reconfigured the lot and street systems from the "promiscuous [and] unsatisfactory metes and bounds division [to] what many will consider the ideal platting of the area, the type of development that might have been achieved had there been no metes and bounds divisions." Charts identified the savings in total area and costs for the alternative schemes.

16. "Panorama Ranch," Trefethen Papers, carton 11, folder 1, "KCH Corporate Files: Bank of America." Bank appraisers described the surrounding district as "raw acreage and scattered small farms with recent four- and five-room stucco and old three-, four-, and five-room frame houses" to the north and west and "raw acreage" to the south and east. They noted the surrounding "old residential districts and old farm sites" as liabilities.

17. See *Los Angeles Examiner*, "New Chevrolet Assembly Plant to Rise in Van Nuys," Nov. 9, 1945; "L.A. Chevrolet Assembly Plant Opens This Week," Feb. 15,

1948; "New Car Plant to Cut Order Backlog," Feb. 17, 1948; "How Chevrolet Builds Autos," Feb. 18, 1943; and "New Auto Plant Hailed in Valley: Big Chevrolet Assembly Factory Dedicated at Gala Ceremony," Feb. 19, 1948.

18. See the advertisements in Trefethen Papers, carton 11, folder 8.

19. Gerald Pike to Eugene Trefethen, May 13, 1946, Trefethen Papers, carton 11, folder 1. Pike had explained the intricacies of lease-options to Trefethen in a letter dated Feb. 14, 1946. Pike stated that "the practice of making loans on leasehold interests has been followed for many years in the Baltimore area. We [the Burns organization] pioneered it in the Los Angeles area." Trefethen Papers carton 11, folder 4. Kaiser Community Homes set up two overlapping corporations to purchase and develop the Panorama Ranch. Panorama Community Homes purchased 325 acres of the 400-acre site for residential development. Panorama City purchased the remaining 75 acres for the main business center. The common stock of each corporation was owned 78.5 percent by KCH and 21.5 percent by the Pellissier family. Gerald Pike to F. A. Ferroggiaro, June 27, 1952, Trefethen Papers, carton 11, folder 8. See a *Los Angeles Examiner,* Apr. 17, 1947, clipping for coverage of the purchase. "In a $1 million transaction Kaiser Homes became owner yesterday of 411 acres of the Panorama Ranch. Officers of the firm, headed here by Fritz Burns, disclosed that they will start construction of 2,000 homes and other buildings as soon as possible." Trefethen Papers, carton 11, folder 8.

20. City of Los Angeles 1946, 34–35. The Panorama City site plan was labeled thus: "This development is also in the San Fernando Valley, near the new General Motors and Jergens industrial plants. Well-planned shopping areas, church sites and an elementary school and playground are an integral part of the development." Ibid.

21. State of California 1945b, 38. By the mid-1940s there were a number of short, inexpensive, illustrated, nontechnical guides to community planning in addition to the FHA bulletins. See, for example, the Small Homes Council of the University of Illinois pamphlet, "Selecting A Livable Neighborhood" (1946), in McNamara 1948.

22. Dawson 1933; Smutz 1930.

23. Ken Skinner, interview by author, June 7, 1993, Los Angeles, Calif.

24. State of California 1945b, 33–34.

25. Drawing framed and mounted on the wall at the Fritz B. Burns Foundation offices; copy in author's possession (see fig. 6.11).

26. "Henry J. Kaiser–Fritz B. Burns Announce the Organization of Kaiser Community Homes: A National Home and Community Building Enterprise," Henry Kaiser Papers, carton 311, folder "Housing."

27. Your Town, *Mirror-Times,* Mar. 19, 1957. "Industrialized Housing" 1947, 200, included a diagram illustrating how KCH rearranged the variables to produce "740 different appearances with only the one standardized floor plan."

28. State of California 1945b, 38; Marlow 1981; Department of Commerce 1952, 57, table 2, tracts 9 and 18-A.

29. Henry Kaiser Papers, carton 311, folder "Housing."

30. Advertisement in Trefethen Papers, carton 11, folder 8.

31. Lightfoot 1960, 20.

32. "Shop Center Work Starts," *Los Angeles Examiner,* Dec. 8, 1957; Mayers 1976, 180.

33. Henry Kaiser Papers, carton 348, folder "KCH Assoc. with Fritz Burns."

34. Gerald Pike to F. A. Ferroggiaro, June 27, 1952. Trefethen Papers, carton 11, folder 8.

35. The property data is drawn from a series of tract maps in the Trefethen Papers, carton 11, folder 9. See also "Built-In Salesmanship and Canny Construction" 1949.

36. "Development Plan Praised, National Writer Discusses Community Idea," *Los Angeles Times,* Dec. 1, 1929; Lightfoot 1960, 19.

37. "Henry J. Kaiser–Fritz B. Burns Announce the Organization of Kaiser Community Homes: A National Home and Community Building Enterprise," Henry Kaiser Papers, carton 311, folder "Housing."

38. NAHB 1957.

39. Murphy 1958, 3.

40. "Suburbia-Exurbia-Urbia" 1957, 42,

41. Garreau 1991; Jack Rosenthal, "The Outer City: U.S. in Suburban Turmoil," *New York Times,* May 30, 1971; Kling, Olin, and Poster 1991; Fishman 1987a and 1987b.

BIBLIOGRAPHY

Archival and Manuscript Collections

Agencies for Economic Opportunity and Legal Services. Record Group 381. National Archives and Records Administration, Washington, D.C.

Bowron, Fletcher. Papers. Huntington Library, San Marino, California.

Burns, Fritz B. Collection. Fritz B. Burns Foundation, Burbank, California.

California Department of Industrial Relations. Division of Immigration and Housing. Bancroft Library, University of California, Berkeley.

Carmody, John. Papers. Franklin D. Roosevelt Library, Hyde Park, New York.

City Planning and Housing Documents. Institute for Governmental Studies, University of California, Berkeley.

Department of Housing and Urban Development. Record Group 207. National Archives and Records Administration, Washington, D.C.

Division of Defense Housing Coordination. National Housing Agency Collection. Record Group 214. National Archives and Records Administration, Washington, D.C.

Housing Folio. Doe Library, University of California, Berkeley.

Farmers Home Administration Collection. Record Group 96. National Archives and Records Administration, Washington, D.C.

Farmers Home Administration, Pacific Sierra Branch. Record Group 96. National Archives and Records Administration, San Bruno, California.

Ford, John Anson. Papers. Huntington Library, San Marino, California.

FSA (Farm Security Administration) San Francisco Collection. Bancroft Library, University of California, Berkeley.

FSA-OWI Collection. Prints and Photographs Division. Library of Congress, Washington, D.C.

Ihlder, John. Papers. Franklin D. Roosevelt Library, Hyde Park, New York.

Jackson, Gardner. Papers. Franklin D. Roosevelt Library, Hyde Park, New York.

Kaiser, Edgar F. Papers. Bancroft Library, University of California, Berkeley.

Kaiser, Henry J. Papers. Bancroft Library, University of California, Berkeley.

Los Angeles Examiner Clippings Files. Hearst Collection. Department of Special Collections, University of Southern California.

MPSR (Division of Motion Pictures, Sound Recordings, and Video Recordings).

Records of the Agencies for Economic Opportunity and Legal Services. Record Group 381. National Archives and Records Administration, Washington, D.C.

Nelson, Donald Marr. Papers. Huntington Library, San Marino, California.

New York World's Fair Collection. New York Public Library.

NHA (U.S. National Housing Agency) Collection. Bancroft Library, University of California, Berkeley.

Public Housing Administration. Record Group 196. National Archives and Records Administration, Washington, D.C.

San Fernando Valley Clippings Files. San Fernando Valley Historical Society, Mission Hills, California.

Seaver Collection. Los Angeles County Museum of Natural History, Los Angeles, California.

Southern California Urban Planning Collection. Huntington Library, San Marino, California.

Spence and Fairchild Aerial Photo Collections. Department of Geography, University of California, Los Angeles.

Straus, Nathan, Jr. Papers. Franklin D. Roosevelt Library, Hyde Park, New York.

Todd-Sonkin Recordings. American Folklife Center. Library of Congress, Washington, D.C.

Trefethen, Eugene E. Papers. Bancroft Library, University of California, Berkeley.

Tugwell, Rexford. Papers. Franklin D. Roosevelt Library, Hyde Park, New York.

Westchester Historical Society Collection. Loyola Marymount University, Los Angeles, California.

Whittington, "Dick." Collection. Department of Special Collections, University of Southern California.

Wood, Edith Elmer. Papers. Avery Library, Columbia University.

Wurster, Catherine Bauer. Papers. Bancroft Library, University of California, Berkeley.

Wurster, William Wilson. Papers. Special Collections, College of Environmental Design, University of California, Berkeley.

Newspapers and Periodicals

FSA Camp Newsletters
Migratory Clipper (Arvin).
Tent City News (Gridley).
Hub (Visalia).
Woodville Community News.
Voice of the Agricultural Migrant (Yuba City).
Los Angeles Chamber of Commerce. *Southern California Business.*
Los Angeles County RPC (Regional Planning Commission). *Statistical Area Reports: Dwelling Units and Population.*
Los Angeles Downtown Shopping News.
Los Angeles Examiner.
Los Angeles Herald and Express.

Los Angeles Realtor.

Los Angeles Times.

National Bureau of Standards. *Commercial Standards Monthly.*

National Committee on Housing, Inc. *Tomorrow's Town.*

Security-First National Bank. *Monthly Summary of Business Conditions in Southern California.*

Southwest Builder and Contractor.

United States Office of the Housing Expediter. *Veterans Emergency Housing Program.*

Urban Land Institute. *Urban Land.*

Government Publications

CCIH (California Commission of Immigration and Housing). 1915. *First Annual Report of the Commission of Immigration and Housing.* Sacramento: State Printing Office.

——. 1916. *Second Annual Report of the Commission of Immigration and Housing.* Sacramento: State Printing Office.

City of Los Angeles. 1928. *Annual Report of the Building and Safety Commissioners.* Los Angeles: Building and Safety Department.

——. 1929. *Accomplishments.* Los Angeles: City Planning Commission.

——. 1943. *Accomplishments.* Los Angeles: City Planning Commission.

——. 1944. *Accomplishments.* Los Angeles: City Planning Commission.

——. 1945. *Accomplishments.* Los Angeles: City Planning Commission.

——. 1946. *Accomplishments.* Los Angeles: City Planning Commission.

——. 1947. *Accomplishments.* Los Angeles: City Planning Commission.

——. 1949. *Accomplishments.* Los Angeles: City Planning Commission.

——. 1955. *Accomplishments.* Los Angeles: City Planning Commission.

County of Los Angeles. 1922. *Proceedings of the First Regional Planning Conference of Los Angeles County.* Los Angeles: Regional Planning Commisssion.

——. 1932a. "Regional Plan of Highways, 2-E" (1929). In County of Los Angeles, *Regional Planning Notes,* vol. 1, *1929–31.* Los Angeles: RPC.

——. 1932b. *Regional Planning Notes.* Vol. 1, *1929–31.* Los Angeles: RPC.

——. 1933. *Regional Planning Notes.* Vol. 2, *1931–32.* Los Angeles: RPC.

——. 1935. *Regional Planning Notes.* Vol. 3, *1932–33.* Los Angeles: RPC.

——. 1940. *Land Use Survey, County of Los Angeles: A Report on WPA Project L9785.* Los Angeles: RPC.

——. 1945. *Annual Report 1944.* Los Angeles: RPC.

Department of Agriculture. 1940. *Consumer Purchases Study: Urban, Village, and Farm.* Washington, D.C.: GPO.

Department of Commerce. 1923. *How To Own Your Home: A Handbook for Prospective Home Owners.* Prepared by John M. Gries and James S. Taylor, Division of Building and Housing, National Bureau of Standards. Washington, D.C.: GPO.

——. 1926. "Seasonal Operation in Construction Industry." National Bureau of Standards Technical News Bulletin 107. Washington, D.C.: GPO.

——. 1929. *Air Commerce Bulletin* (Oct. 1).

——. 1932a. *A Brief Description of the Activities of the Several Bureaus of the Department*. National Bureau of Standards. Washington, D.C.: GPO.

——. 1932b. "Standardization Aids Home Building." *Commercial Standards Monthly* 7, no. 9 (Jan.): 209.

——. 1936. *Guide for Local Planning Commissions in the Preparation of Local Regulations Governing the Subdivision of Land*. Advisory Committee on City Planning and Zoning. Washington, D.C.: GPO.

——. 1940a. *Census of Manufactures: 1939*. Bureau of the Census. Washington, D.C.: GPO.

——. 1940b. *Housing*. Vol. 2, *General Characteristics*. Bureau of the Census. Washington, D.C.: GPO.

——. 1940c. *Population and Housing*. Vol. 3, *Los Angeles*. Bureau of the Census. Washington, D.C.: GPO.

——. 1942. *Sixteenth Census of the United States: 1940*. Bureau of the Census. Washington, D.C.: GPO.

——. 1944a. "Wartime Changes in Population and Family Characteristics: Los Angeles Congested Production Area, April, 1944." Series CA-2, no. 5: Aug. 4. Bureau of the Census. Washington, D.C.: GPO.

——. 1944b. "Characteristics of the Population, Labor Force, Families, and Housing: Los Angeles Congested Production Area, April 1944." Series CA-3, no. 5: Aug. 9. Bureau of the Census. Washington, D.C.: GPO.

——. 1946. *United States Military Aircraft Acceptances, 1940–1945: Aircraft, Engine, and Propeller Production*. Civil Aeronautics Administration. Washington, D.C.: Office of Aviation Information, Division of Aviation Statistics.

——. 1950. *Population Census: Census Tract Statistics*. Vol. 3, *Los Angeles and Adjacent Area*. Bureau of the Census. Washington, D.C.: GPO.

——. 1952. *Seventeenth Census of the United States: 1950*. Bureau of the Census. Washington, D.C.: GPO.

——. 1960. *Historical Statistics of the United States: Colonial Times to 1957*. Bureau of the Census. Washington, D.C.: GPO.

——. 1975. *Historical Statistics of the United States: Colonial Times to 1970*. Bureau of the Census. Washington, D.C.: GPO.

Department of Labor. 1939. *Study of Money Disbursements of Wage Earners and Clerical Workers in Five Cities of the Pacific Region, 1934–36*. Bureau of Labor Statistics. Washington, D.C.: GPO.

——. 1940. "Building Operations: Builders of One-Family Houses in Seventy-two Cities." Bureau of Labor Statistics. *Monthly Labor Review* (Sept.): 732–45.

——. 1941a. *Family Expenditures in Selected Cities, 1935–36*. Vol. 1, *Housing*. Bureau of Labor Statistics. Washington, D.C.: GPO.

——. 1941b. *Study of Money Disbursements of Wage Earners and Clerical Workers: Summary Volume*. Bureau of Labor Statistics. Washington, D.C.: GPO.

——. 1943. "Post-War Capacity and Characteristics of the Construction Industry." Bureau of Labor Statistics Bulletin 779. Washington, D.C.: GPO.

——. 1944a. "Average Hourly Earnings in the Airframe Industry, 1943." Bureau of Labor Statistics Bulletin 790. Washington, D.C.: GPO.

——. 1944b. "The Construction Industry in the United States." Bureau of Labor Statistics Bulletin 786. Division of Construction and Public Employment. Washington, D.C.: GPO.

——. 1944c. "Wartime Development of the Aircraft Industry." Bureau of Labor Statistics Bulletin 800. Division of Construction and Public Employment. Washington, D.C.: GPO.

——. 1945. "Probable Volume of Postwar Construction." Bureau of Labor Statistics Bulletin 825. Washington, D.C.: GPO.

——. 1946. "Effect of Wartime Housing Shortages on Home Ownership." Bureau of Labor Statistics. *Monthly Labor Review* (Apr.): 560–66.

——. 1947. "Trends in Housing during the War and Postwar Periods." Bureau of Labor Statistics. *Monthly Labor Review* (Jan.): 11–23.

——. 1954. "Structure of the Residential Building Industry in 1949." Bureau of Labor Statistics Bulletin 1170. Washington, D.C.: GPO.

FHA (Federal Housing Administration). 1936a. *Circular L: Property Standards* (June 15). Washington, D.C.: GPO.

——. 1936b. "Planning Neighborhoods for Small Houses." FHA Technical Bulletin 5. Washington, D.C.: FHA.

——. 1936c. "Principles of Planning Small Houses." FHA Technical Bulletin 4. Washington, D.C.: FHA.

——. 1936d. "Recent Developments in Dwelling Construction." FHA Technical Bulletin 1. Washington, D.C.: FHA.

——. 1940. *Homes in Metropolitan Districts*. Washington, D.C.: GPO.

——. 1941. "An Analysis of the Distribution of Critical Materials Used in a Typical Housing Development." Technical paper in City Planning and Housing Documents, Institute for Governmental Studies, University of California, Berkeley.

——. *Annual Reports.* 1936–42, 1950, 1951. Washington, D.C.: GPO.

FSA (U.S. Farm Security Administration). 1938–43. *Reports.*

NHA (U.S. National Housing Agency). 1946. *Veterans Emergency Housing Program: Statement by Wilson W. Wyatt before the Special Committee of National Housing of the American Legion.* Washington, D.C.: Office of the Housing Expediter.

NRA (U.S. National Recovery Administration). 1934. *Division of Research and Planning, Chronological History of the Construction Industry, 1920–1934.* Washington D.C.: The Administration.

RPC (Regional Planning Commission). 1945. *Statistical Area Report,* no. 16 (July).

——. 1946a. *Annual Report.* Los Angeles: County Board of Supervisors.

——. 1946b. *Statistical Area Report: Dwelling Units and Population,* no. 19 (July).

——. 1949. *Statistical Area Report: Dwelling Units and Population,* no. 30 (Apr.).

——. 1950. *Statistical Area Report: Dwelling Units and Population,* no. 34 (Apr.).

RPC and WPA (Los Angeles Regional Planning Commission and Works Progress Administration). 1941. *Land Use Analysis: Final Report.* Los Angeles: RPC.

State of California. n.d. "Employee Housing: Labor Camps: Minimum Requirements." Department of Industrial Relations, Sacramento.

——. 1940. "Migrants: A National Problem and Its Impact on California." State Chamber of Commerce, Sacramento.

——. 1942. *Testimony of Carey McWilliams, Chief of the Division of Immigration and Housing, 1939–1942.* Sacramento: Department of Industrial Relations, Division of Immigration and Housing.

——. 1944a. "The Bay Region Takes Stock: An Account of Public Hearings on Postwar Problems of the San Francisco Bay Region." State Reconstruction and Reemployment Commission, Sacramento.

——. 1944b. "How Many Californians? How Much Postwar Income?" State Reconstruction and Reemployment Commission, Sacramento.

——. 1944c. "Postwar Planning: A Case Study, San Bernardino County." State Reconstruction and Reemployment Commission, Sacramento.

——. 1945a. "Matching Men and Jobs." State Reconstruction and Reemployment Commission, Sacramento.

——. 1945b. "Postwar Housing in California." State Reconstruction and Reemployment Commission, Sacramento.

——. 1946a. "California's Housing Crisis." State Reconstruction and Reemployment Commission, Sacramento.

——. 1946b. "New Factories for California Communities." State Reconstruction and Reemployment Commission, Sacramento.

State of New York. 1926. *Report of the Commission of Housing and Regional Planning to Governor Alfred E. Smith and to the Legislature of the State of New York, December 23, 1926.* Commission of Housing and Regional Planning. Albany: J. P. Lyon.

U.S. Committee for Congested Production Areas. 1943–44. *Area Reports.* Washington, D.C.: GPO.

——. 1944. *Final Report.* Washington, D.C.: GPO.

U.S. Congress. House. 1940, 1942. Select Committee to Investigate the Interstate Migration of Destitute Citizens. *Hearings on H.R. 63, 491, 629.* 76th Cong., 3d sess. Washington, D.C.: GPO.

——. 1941. Select Committee to Investigate the Interstate Migration of Destitute Citizens. *First Interim Report.* Washington, D.C.: GPO.

——. 1941–42. Select Committee Investigating National Defense Migration. *Hearings on H.R. 113.* 77th Congress, 1st sess. Washington, D.C.: GPO.

——. 1943. Committee on Naval Affairs. *Investigation of Congested Areas: Hearings on H.R. 30.* 78th Cong., 1st sess. Washington, D.C.: GPO.

——. 1944. Hearings before the Committee of Naval Affairs, Naval Affairs Subcommittee, *Investigation of the Progress of the War Effort, Part 8: Los Angeles–Long Beach, Calif., Area, November 10, 11, 12, and 13, 1943: Hearings on H.R. 30,* pt. 8. 77th Congress, 1st sess. Washington, D.C.: GPO.

U.S. Congress. Senate. 1945. Subcommittee on Housing and Urban Redevelopment. *Report on Postwar Housing: Hearings on S.R. 102.* 78th Cong., 1st sess. Washington, D.C.: GPO.

U.S. Housing and Home Finance Agency. 1948. "Technical Bulletin" (Mar.). Washington, D.C.: GPO.

WPA (Works Progress Administration). 1935. *Index of Occupations: Occupational Classification and Code*. Washington, D.C.: WPA.

——. 1938. *Urban Housing: A Summary of Real Property Inventories*. Washington, D.C.: GPO.

——. 1941. *Classification of Land Uses: A Report on WPA Project L9785*. Washington, D.C.: GPO.

Primary Sources

Abrams, Charles. 1971. *The Language of Cities*. New York: Viking Press.

Alexander, Robert. 1989. *Architecture, Planning, and Social Responsibility: Oral History Transcript*. 2 vols. Los Angeles: Oral History Program, University of California, Los Angeles.

Alfred, Helen. 1932. *Municipal Housing*. New York: League for Industrial Democracy.

American Engineering Council. 1921. *Waste in Industry*. Committee on the Elimination of Waste in Industry of the Federated Engineering Societies. New York: McGraw-Hill.

". . . And 400 New Angels Every Day." 1953. *Life*, July 13, 23–29.

APHA (American Public Health Association). 1936. *Housing for the Family*. Committee on the Hygiene of Housing. Lancaster, Penn.: Science Press.

——. 1939. *Basic Principles of Healthful Housing*. Committee on the Hygiene of Housing. New York: APHA.

——. 1945. *An Appraisal Method for Measuring the Quality of Housing: A Yardstick for Health Officers, Housing Officials, and Planners*. Committee on the Hygiene of Housing. New York: APHA.

——. 1948. *Planning the Neighborhood: Standards for Healthful Housing*. Committee on the Hygiene of Housing. New York: APHA.

——. 1950. *Planning the Home for Occupancy*. Committee on the Hygiene of Housing. New York: APHA.

Archibald, Katharine. 1947. *Wartime Shipyard: A Study of Social Disunity*. Berkeley: University of California Press.

Aronovici, Carol. 1920. *Housing and the Housing Problem*. Chicago: McGlurg.

Atterbury, Grosvenor. 1912. "Model Towns in America." *Scribner's Magazine* 52, no. 1 (July): 20–35.

Auger, Tracy. 1936. "Some Minimum Standards in Site Planning for Low-Cost Housing." In *Proceedings of Joint National Conference on Housing*. Chicago: National Association of Housing Officials.

——. 1941. "Defense Housing—Now and Afterward." In *Proceedings of the National Conference on Planning*. Chicago: American Society of Planning Officials.

Aviation Facts and Figures. 1945. New York: McGraw-Hill.

Bailey, William L. 1924. "The Twentieth Century City." *American City* 31, no. 2 (Aug.): 142–43.

Bauer, Catherine. 1934. *Modern Housing*. Boston: Houghton Mifflin.

———. 1944. "Toward Postwar Housing in the United States." *Transatlantic* 16 (Dec.): 35–44.

Baxter, Sylvester. 1919. "The Government's War-Housing Program at Bridgeport, Connecticut." *Architectural Record* 45: 123–41.

Baxter, W. F. 1937. "Migratory Labor Camps." *Quartermaster Review* 17, no. 1 (July–Aug.): 10–15.

Bemis, Albert Farwell. 1936. *The Evolving House*. Vol. 3, *Rational Design*. Cambridge: MIT Press, Technology Press.

Bennett, Charles. 1946. "Los Angeles Takes Lead in Land Usage with New Zoning Act." *Tomorrow's Town* 4, no. 3 (June 1946): 2–3.

Bennett, Charles, and Milton Breivogel. 1945. "The Plan for the San Fernando Valley Developed by the Los Angeles Planning Commission." *Pencil Points* 26 (June): 93–98.

Bing, Alexander M. 1925. "New Towns for Old: Can We Have Garden Cities in America?" *Survey Graphic* 7 (May): 172–73, 190.

Black, Russell Van Nest. 1933. *Planning for the Small American City: An Outline of Principles and Procedures*. Chicago: Public Administration Service.

Blake, Peter. 1964. *God's Own Junkyard: The Planned Deterioration of America's Landscape*. New York: Holt, Rinehart and Winston.

Blum, Milton, and Beatrice Candee. 1944. "Analysis of the Problem." In *Family Behavior, Attitudes, and Possessions*. New York: John B. Pierce Foundation.

Bohannon, David D. 1944. "Site Methods versus Factory Production." In National Committee on Postwar Housing, *Proceedings of the National Conference on Postwar Housing, Chicago, March 8–9–10, 1944*. New York: National Committee on Housing.

Boyd, John Taylor, Jr. 1927–28. "How Intensively Must We Use the Land? A Study of the Economics of Housing Development and Land Subdivision." *American City* 37, no. 5. (Nov.–Jan.): 587–90.

Bruce, Alfred, and Harold Sandbank. 1943. *A History of Prefabrication*. New York: John B. Pierce Foundation.

"The Builders' House 1949." 1949. *Architectural Forum* 90, no. 4 (Apr.): 81–82.

"Built-In Salesmanship and Canny Construction Gear This 2,000 Unit Development for a Bearish Market." 1949. *Architectural Forum* 90, no. 4 (Apr.): 118–22.

Burnham Kelly and Associates. 1959. *Design and the Production of Houses*. New York: McGraw-Hill.

Burns, Fritz B. 1952. "Housing: Mass Produced." In *Housing Mass Produced; 1952 Housing Conference Held January 14, 1952*, ed. Phyllis M. Kelly and Richard W. Hamilton. Cambridge: Albert Farwell Bemis Foundation.

———. 1963. " 'Total' Community is Not New!" *Industrial News*, Nov. 4.

Butterfield, Roger. 1943. "Los Angeles Is the Damnedest Place . . . : The City That Started with Nothing but Sunshine Now Expects to Become the Biggest in the World." *Life*, Nov. 22, 102–18.

Cahalin, V. 1929. "Spanish Type Houses Pay." *Building Age* (May): 37–40.

"California 4-in-1 Design." 1940. *American Builder* 62 (May): 55.

Callaghan, Jane, and Catherine Palmer. 1944. *Measuring Space and Motion*. New York: John B. Pierce Foundation.

Callender, John Hancock. 1943. "Present Methods of Designing Low-Cost Housing." In *Introduction to Studies of Family Living*. New York: John B. Pierce Foundation.

———. 1944. "The Scientific Approach to Design." In *The Engineered Dwelling: The Pierce Foundation*, by Robert L. Davison, John H. Callender, and C. O. Mackey. New York: John B. Pierce Foundation.

"The City: A World's Fair Film." 1939. *Architectural Review* 86 (Aug.): 93–94.

Clark, Charles D. 1934. "Penalties of Excess Subdividing." *City Planning* 10 (Apr.): 50–61.

———. 1941. "Land Subdivision." In *Los Angeles: Preface to a Master Plan*, ed. George W. Robbins and L. Deming Tilton. Los Angeles: Pacific Southwest Academy.

Clark, Irving W. 1944. "The Manufacturers' Problems and Contributions." In National Committee on Postwar Housing, *Proceedings of the National Conference on Postwar Housing, Chicago, March 8-9-10, 1944*. New York: National Committee on Housing.

Colean, Miles L. 1940. *Housing for Defense: A Review of the Role of Housing in Relation to America's Defense, and a Program for Action*. New York: Twentieth Century Fund.

———. 1944. *American Housing: Problems and Prospects: The Factual Finding*. New York: Twentieth Century Fund.

———. 1947. "Is There an Answer to the Housing Shortage?" *House Beautiful* 89 (Apr.): 105, 211–12.

Comey, Arthur C., and Max S. Wehrly. 1939. *Report of the Urbanism Committee to the National Resources Committee, Urban Planning and Land Policies*. Vol. 2. Washington, D.C.: GPO.

Conference on Unemployment. 1924. *Seasonal Operation in the Construction Industries, the Facts and Remedies*. New York: McGraw-Hill.

Coons, Arthur G. 1942. "The Changing Pattern of California's Economy." *Annals of the American Academy of Political and Social Science* 222 (July): 137–42.

Cornick, Philip H. 1938. *Premature Subdivision and its Consequences: A Study Made for the State Planning Council of New York on the Problems Created by the Premature Subdivision of Urban Lands in Selected Metropolitan Districts of New York State*. Albany: New York State Planning Council.

Davison, Robert L. 1943. "The Engineered Dwelling." *Prefabricated Homes* 5, no. 9 (Apr.): 6–11.

Davison, Robert L., John H. Callender, and C. O. Mackey. 1944. *The Engineered Dwelling: The Pierce Foundation*. Research Study 8, *Methods*. New York: John B. Pierce Foundation.

Dawson, Mitchell. 1933. "Home Sweet Home." *Harpers Magazine* 166 (Apr.): 564–74.

DeMars, Vernon. 1941a. "Duration Dormitories." *California Arts and Architecture* 58 (Dec.): 34–35.

——. 1941b. "Social Planning for Western Agriculture." *Task* 2: 5–9.

Dobriner, William, ed. 1958. *The Suburban Community*. New York: G. P. Putnam.

Douglass, Harlan Paul. 1925. *The Suburban Trend*. New York: Century.

"Down Payment to Suit." 1941. *American Builder* 63 (Sept.): 62–69.

Dryden, Hugh L. 1938. "Research on Building Materials and Structures for Use in Low-Cost Housing." National Bureau of Standards, *Building Materials and Structures Report: BMS1* (June 16): 1–2.

Dykstra, Clarence. 1926. "Congestion DeLuxe: Do We Want It?" *National Municipal Review* 6 (July): 394–98.

Earl, Albert, and Ben S. Trynin. 1942. "The Aircraft Industry after the War." *Annals of the American Academy of Political and Social Science* 222 (July): 168–72.

Eberle Economic Service. 1932. *Weekly Letter* 9 (Mar. 28).

Eckbo, Garrett. 1942. "Site Planning." *Architectural Forum* 76 (May): 263–67.

——. 1993. *Landscape Architecture: The Profession in California, 1935–40*. Berkeley: Regional Oral History Office, Bancroft Library, University of California.

Editorial. 1929. *Southern California Business* 8, no. 4 (May): 7.

Editorial. 1941. *Architectural Forum* 74 (Jan.): 51–52.

Ely, Edwin W. 1930. "Simplified Practice—A Clearing House." *Commercial Standards Monthly* 7, no. 5 (Nov.): 134–36.

"Evolution of RPC Attracts International Attention." 1923. *Los Angeles Realtor* 2, no. 6 (Mar.): 7, 25.

Expansions. 1939. *Southern California Business*, 1st ser., no. 13 (Aug. 7).

——. 1940. *Southern California Business*, 2d ser., no. 9 (July 8).

——. 1941a. *Southern California Business*, 2d ser., no. 44 (Jan. 20).

——. 1941b. *Southern California Business*, 2d ser., no. 47 (Feb. 10).

Federal Reserve Bank of San Francisco. 1941. *Monthly Review of Business Conditions* (Nov. 1).

"An FHA City Rises from the Prairie." 1943. *Insured Mortgage Portfolio* (4th quarter): 20–22, 40–41.

"FHA Housing in Utah." 1943. *Insured Mortgage Portfolio* (1st quarter): 20–21.

Fisher, Howard T. 1948. "Prefabrication, What Does It Mean to the Architect?" *Journal of the American Institute of Architects* 10 (Nov.): 219–27.

Ford, James. 1929. "How National Attention Was Directed to Better Homes in America." *American Civic Annual* 1:37–43.

——. 1931. Introduction to *Better Homes Manual*, ed. Lydia J. Roberts.

"Former Dairy Farm Now a Thriving City." 1953. *Southwest Builder and Contractor* (Dec. 25): 20–21.

Fuller, R. Buckminster. 1934. "Dymaxion Houses." *Architectural Review* 75 (Jan.): 9–11.

Fuller, Varden. 1939. "The Supply of Agricultural Labor as a Factor in the Evolution of Farm Organization in California." Ph.D. diss., University of California, Berkeley.

Geddes, Patrick. 1915. *Cities in Evolution*. London: Williams and Norgate.

Gershenson, M. I. 1947. "Wartime and Postwar Employment Trends in California." *Monthly Labor Review* (Apr.): 567–98.

Glacken, Clarence J. 1940. "Tents, Trailers, and Culture in Migratory Camps." *Labor Information Bulletin* 7, no. 8 (Aug.): 1–3.

"Greatest House-Building Show on Earth." 1947. *Architectural Forum* 86 (Mar.): 105–13.

Gries, John M., and James Ford, eds. 1932a. *Final Reports of the President's Conference on Home Building and Home Ownership.* Vol. 1, *Planning for Residential Districts: Reports of the Committees on City Planning and Zoning.* Washington, D.C.: President's Conference on Home Building and Home Ownership.

——. 1932b. *Final Reports of the President's Conference on Home Building and Home Ownership.* Vol. 2, *Home Finance and Taxation.* Washington, D.C.: President's Conference on Home Building and Home Ownership.

——. 1932c. *Final Reports of the President's Conference on Home Building and Home Ownership.* Vol. 3, *Slums, Large-scale Housing, and Decentralization.* Washington, D.C.: President's Conference on Home Building and Home Ownership.

——. 1932d. *Final Reports of the President's Conference on Home Building and Home Ownership.* Vol. 4, *Home Ownership, Income, and Types of Dwellings.* Washington, D.C.: President's Conference on Home Building and Home Ownership.

——. 1932e. *Final Reports of the President's Conference on Home Building and Home Ownership.* Vol. 9. *Household Management and Kitchens.* Washington, D.C.: President's Conference on Home Building and Home Ownership.

——. 1934. *Final Reports of the President's Conference on Home Building and Home Ownership.* Vol. 5, *House Design, Construction, and Equipment.* Washington, D.C.: President's Conference on Home Building and Home Ownership.

Ham, W. H. 1929. "Factory-Made Homes." *Survey* 61 (Feb.): 656–67.

Hamlin, Talbot F. 1941a. "Farm Security Administration." *Architectural Forum* 74 (Jan.): 2–16.

——. 1941b. "Farm Security Architecture: An Appraisal." *New Pencil Points* 22 (Nov.): 709–20.

Harris, Chauncy D. 1943. "Suburbs." *American Journal of Sociology* 49 (July): 1–13.

Henry, D. E., ed. 1946. "California Looks Ahead: Papers Presented before the Pacific Southwest Academy, June 15, 1946." *Annals of the American Academy of Political and Social Science* 248 (Nov.): 199–267.

Hodgkin, G. B. 1920. "Some Essential Features of Housing Employees." *California Citrograph* 5 (Sept.): 346–76.

——. 1921. "Attractive Houses for Employees." *California Citrograph* 5 (May): 248–49.

Holmes, Helen. 1942. "Ground Broken for Up-to-the-Minute Business District in Westchester." *Los Angeles Down Town Shopping News,* Aug. 15, 12.

"Home Building—Its Part in Defense." 1941. *American Builder* 63, no. 10 (Oct.).

Home Building Program of the Committee for Economic Recovery. [1934?]. "Meth-

ods for Men-Money-Management and Government." Pamphlet in Housing folio, Doe Library, University of California, Berkeley.

"Home Ownership Drive." 1930. *Commercial Standards Monthly* 7, no. 5 (Nov.): 149–50.

Hoover, Edgar M. 1937. "Industrial Location and the Housing Market." *Annals of the American Academy of Political and Social Science* 190 (Mar.): 138–44.

Hoover, Herbert. 1921. "Industrial Waste." *Bulletin of the Taylor Society* 6 (Apr.): 77.

———. 1927. "A Statement from Secretary Hoover to Readers of The American City." *American City* 37, no. 5 (Nov.): 575–76.

Howard, Ebezener. 1898. *To-Morrow: A Peaceful Path to Real Reform.* London: Swan Sonnenschein.

———. 1965. *Garden Cities of Tomorrow* (1902). Cambridge: MIT Press.

Howe, Frederic C. 1912. "The Garden Cities of England." *Scribner's Magazine* 52, no. 1 (July): 1–19.

Hoyt, Homer. 1939. *The Structure and Growth of Residential Neighborhoods in American Cities.* Washington D.C.: GPO.

———. 1943. "The Structure of American Cities in the Post-War Era." *American Journal of Sociology* 48 (Jan.): 475–81.

Hubbard, Henry V., Miller McClintock, and Frank B. Williams. 1930. *Aiports: Their Location, Administration, and Legal Basis.* Cambridge: Harvard University Press.

Hudson, Ray M. 1931. "Simplified Practice, 1921–1931." *Commercial Standards Monthly* 8, no. 6 (Dec.): 165.

"Industrialized Housing: The Bright New Hope of the Building Business." 1947. *House Beautiful* 89 (Apr.), 106–7, 117, 194–208.

"Infant of Valley, Panorama City, Giant in Business." 1957. *Valley Times Today.*

Johnston, Donald W., and Clarence J. Glacken. 1940. *A Social Survey of Housing Conditions Among Tulare County Relief Clients: April–June, 1939.* Tulare County, Calif.: State Relief Administration.

Jones, Robert T. 1925. "Omitting the Cellar to Cut Building Costs." *Small Home* 4, no. 9 (Nov.): 22.

———. 1926. "Fifty Ways to Lower Building Costs." *Small Home* 4, no. 12 (Jan.–Feb.): 3–4, 28–30.

"The Joyous Thought of a Metal Shelter." 1940. *Voice of the Agricultural Migrant,* Mar. 8.

"Kaiser to Build Two Million Complete Community Homes." 1945. *Retailing* (May 14).

"Kaiser's 'Chassis' Homes." 1947. *Science Illustrated* (Feb.): 76–79.

Keally, Francis. 1929. "How Airports Will Affect Zoning Laws: A Glimpse of Future Problems That Should Be Solved Today." *American Architect* 136 (Dec.): 20–21, 100, 102.

Kelly, Phyllis M., and Richard W. Hamilton, eds. 1952. *Housing Mass Produced; 1952 Housing Conference Held January 14, 1952.* Cambridge: Albert Farwell Bemis Foundation.

Keyserling, Leon H. 1946. "Homes for All—And How." *Survey Graphic* 35 (Feb.): 37–41.

Kidner, Frank L., and Philip Neff. 1945. *An Economic Survey of the Los Angeles Area.* Los Angeles: Haynes Foundation.

Klein, Alexander. 1931. "Judging the Small Home." *Architectural Forum* 55 (Aug.): 166–72.

———. 1935. *The Design of Plan and Space for Small Dwellings through New Methods in Examining Existing Plans.* New York: Housing Study Guild.

Lasch, Robert. 1946. *Breaking the Building Blockade.* Chicago: University of Chicago Press.

Lendrum, James T. 1948. "University Builds Small Homes to Compare Construction Materials." *Industrial Standardization* 19 (May–June): 32–35. Reprinted as "Modular Coordination in Frame Houses," in *Mid-Century Houses, with Technical Design Data and Details,* presented by the editors of the *Architectural Record.* New York: F. W. Dodge, 1953.

"Let's Face the Airplane Problem: A Symposium." 1947. *Urban Land* 6, no. 8 (Sept.): 1, 3–6.

Lightfoot, Herb. 1960. "Panorama City: Sweet Song of Success." *San Fernando Valley Realtor* 4 (Dec.): 18–20.

Los Angeles Chamber of Commerce. 1940. *Southern California and National Defense.* Los Angeles: Chamber of Commerce.

Loud, Laura McNair. 1922. *A Resumé of Culver City, California.* Los Angeles: Fred S. Lanig.

MacLeish, Archibald, ed. 1932. *Housing America: By the Editors of Fortune.* New York: Harcourt Brace.

Marlow, Fred W. 1981. *Memoirs and Perceptions.* Los Angeles: Fred W. Marlow.

Maverick, Lewis A. 1933. "Cycles in Real Estate Activity: Los Angeles County." *Journal of Land and Public Utility Economics* 9 (Feb.): 52–58.

Maxwell, W. Floyd. 1931. "The Building Industry since the War." *Review of Economic Statistics* 13 (May): 68–75.

Mayer, Albert, Henry Wright, and Lewis Mumford. 1934. *New Homes for a New Deal: A Concrete Program for Slum Clearance and Housing Relief.* New York: New Republic.

McLaughlin, Glenn E. 1945. "Industrial Expansion and Location." *Annals of the American Academy of Political and Social Science* 242 (Nov.): 25–29.

McMichael, Stanley. 1930. "Real Estate in 1940." *Los Angeles Realtor* 9, no. 6 (Mar.): 10–11, 27–30.

McNamara, John E. 1948. *How to Get the Most House for Your Money.* Chicago: American Technical Society.

McNeil, James F. 1930. "Benefits from Simplifying Varieties in Softwood Lumber." *Commercial Standards Monthly* 7, no. 5 (Nov.): 148–49.

McWilliams, Carey. 1939. *Factories in the Fields: The Story of Migratory Farm Labor in California.* Boston: Little, Brown.

——. 1940a. "The Housing of Migratory Labor in California." *Civic Affairs* 7 (Mar.): 1–2, 7–8.

——. 1940b. "The Housing of Migratory Labor in California." *Civic Affairs* 7 (Apr.): 3–6.

——. 1942. *Ill Fares the Land: Migrants and Migratory Labor in the United States.* Boston: Little, Brown.

——. 1949. "Look What's Happened to California." *Harper's Magazine* 199, no. 1193 (Oct.): 21–29.

——. 1990. *Southern California: An Island on the Land.* Salt Lake City: Peregrine Smith Books.

Mead, Richard R. 1937. "Merchandising Residential Properties." *Annals of the American Academy of Political and Social Science* 190 (Mar.): 60–74.

"Metal Shelters vs. Tents." 1940. *Voice of the Agricultural Worker,* Mar. 29.

Meyerson, Martin D., and Robert B. Mitchell. 1945. "Changing City Patterns." *Annals of the American Academy of Political and Social Science* 242 (Nov.): 149–62.

Miller, Chet. 1943a. "Douglas Town on the Mojave." *Douglas Airview* 10 (Mar.): 10–12.

——. 1943b. "It's No Mirage." *Douglas Airview* 10 (Sept.).: 9–10.

Mock, Elizabeth. 1944. *Built in USA, 1932–1944.* New York: Museum of Modern Art.

Mott, Seward H. 1938. "Land-Use Requirements and Subdivision Policy under Section 203." Paper presented at Realtors' Housing Conference, "Discussing the National Housing Act," National Association of Real Estate Boards, March 17–19, Washington, D.C.

——. 1939. "Planning Considerations in the Location of the Housing Programs: The Case for Fringe Locations." *Planners Journal* 5 (Mar.–June): 36–39.

Mumford, Lewis. 1919. "Attacking the Housing Problem on Three Fronts." *Nation* 109 (Sept. 6): 332–33.

——. 1925. "Regions—To Live In." *Survey Graphic* 7 (May): 151–52.

——. 1927a. "American Architecture." *Workers Education* 5, no. 3 (Dec.): 1–6.

——. 1927b. "Fate of Garden Cities." *Journal of the American Institute of Architects* 15 (Feb.): 37–39.

——. 1932. "The Plan of New York." *New Republic* 71 (June 15–22): 121–26, 146–54.

——. 1938. *The Culture of Cities.* New York: Harcourt, Brace.

——. 1939. "The Skyline in Flushing: Genuine Bootleg." *New Yorker* 15 (July 29): 38–41.

——. 1945a. "An American Introduction to Sir Ebenezer Howard's 'Garden Cities of Tomorrow.' " *New Pencil Points* 24 (Mar.): 73–79.

——. 1945b. "Mass Production and Housing." In *City Development: Studies in Disintegration and Renewal.* New York: Harcourt, Brace.

——. 1951. Introduction to *Toward New Towns for America,* by Clarence S. Stein. Cambridge: MIT Press.

——. 1954. "The Neighborhood and the Neighborhood Unit." *Town Planning Review* 24 (Jan.): 256–70.

——. 1961. *The City in History: Its Origins, Its Transformations, and Its Prospects.* New York: Harcourt, Brace and World.

——. 1976. "Regional Planning." An address before the Round Table on Regionalism, July 8, 1931, Institute of Public Affairs, University of Virginia. Reprinted in *Planning the Fourth Migration: The Neglected Vision of the Regional Planning Association of America,* ed. Carl Sussman. Cambridge: MIT Press.

Murphy, Kathryn R. 1942. "Housing for War Workers." *Monthly Labor Review* (June): 513–19.

——. 1958. "New Housing and Its Materials, 1940–1956." Bureau of Labor Statistics Bulletin 1231. Washington, D.C.: Department of Labor.

"Mushroom City: When General Motors Built a Chevrolet Plant, A City Followed." 1955. *Fortnight* (July): 55.

NAHB (National Association of Home Builders). 1957. *Housing Almanac: A Fact File of the Homebuilding Industry.* Washington, D.C.: NAHB.

National Committee on Postwar Housing. 1944. *Proceedings of the National Conference on Postwar Housing, Chicago, March 8–9–10.* New York: National Committee on Housing.

National County Roads Planning Commission. 1932. "The County Highway System: A Manual of Planning". Report, Jan. 1.

"National Defense Holds Big Opportunities for Our Young Men." 1942. *Woodville Community News,* Jan. 1.

National Public Housing Conference. 1934. *Speeches: Report of Speeches Delivered at the Washington Conference on Public Housing.* New York: Washington Conference on Public Housing.

"New Hughes Plant Will Be Largest Experimental Aircraft Works." 1941. *Southern California Business,* 3d ser., no. 12 (June 30): 1.

"A New Small-Home Ownership Program." 1940. *Insured Mortgage Portfolio* (Feb.): 3, 36–37.

Nichols, J. C. 1926. "The Planning and Control of Outlying Shopping Centers." In *NAREB, Home Building and Subdividing: Proceedings and Reports of the Home Builders and Subdividers Division III.* Chicago: National Association of Real Estate Boards.

——. 1941. "Industrial Production." In *Proceedings of the National Conference on Planning, May 12–14, 1941.* Chicago: American Society of Planning Officials.

Nolen, John. 1918. "The Housing Standards of the Federal Government." In *Housing Problems in America. The Proceedings of the Seventh National Conference on Housing,* by the National Conference on Housing. New York: National Housing Association.

North American Aviation. 1945. *A Brief History of Operations Immediately Prior to and during WWII.* Los Angeles: North American Aviation.

"Notices." 1940. *Voice of the Agricultural Migrant,* Mar. 22.

NRA (U.S. National Recovery Administration). 1934. *Chronological History of the Construction Industry, 1920–1934*. Division of Research and Planning. Washington, D.C.: NRA.

Ogburn, William F. 1937. *Social Characteristics of Cities: A Basis for New Interpretations of the Role of the City in American Life*. Chicago: International City Manager's Association.

Olmsted, Frederick Law, Jr., Harland Bartholomew, and Charles Henry Cheney. 1924. *A Major Traffic Street Plan for Los Angeles*. Los Angeles: Traffic Commission of the City and County of Los Angeles.

Pacific Ready-Cut Homes, Inc. 1925. *Pacific's Book of Homes: A Notable Exhibition of California Architecture 25*. Los Angeles: Pacific Ready-Cut.

Packard, Walter. 1970. *Land and Power Development in California, Greece, and Latin America: An Interview Conducted by Willa K. Baum*. Berkeley: University of California Press.

"Panorama City: Jewel of the Valley." 1957. *Van Nuys Mirror-News*, Mar. 19.

Park, Robert E. 1927. "The Urban Community as a Spatial Pattern and as a Moral Order." In *The Urban Community: Selected Papers from the Proceedings of the American Sociological Society*, ed. Ernest Burgess. Chicago: University of Chicago Press.

Park, Robert E., Ernest W. Burgess, and Roderick D. McKenzie. 1925. *The City*. Chicago: University of Chicago Press.

Parker, Carleton. 1914. "The Wheatland Riot and What Lay Back of It." *Survey* 31 (Mar. 21): 768–79.

———. 1920. *The Casual Laborer and Other Essays*. New York: Harcourt, Brace and Howe.

Perry, Clarence Arthur. 1929. "The Neighborhood Unit." Monograph 1 in *Regional Survey of New York and Its Environs*, vol. 7, *Neighborhood and Community Planning*. New York: Regional Plan of New York and Its Environs.

———. 1939. *Housing for the Machine Age*. New York: Russell Sage Foundation.

"Plan Elaborate Opening Program for New Leimert Park Theater." 1932. *Southwest Wave*, Apr. 19.

"Plan-itorial." 1949. *Urban Land* 8, no. 6 (June): 2.

"Planned 'City' in 11-Year Progress." 1959. *Valley Times*, Jan. 20.

"Planning for Postwar Reconstruction in Southern California." 1942. *Annals of the American Academy of Political and Social Science* 222 (July): 137–89.

Pomeroy, Hugh H. 1924. *Regional Planning Conference of Los Angeles County*. Los Angeles: RPC.

Poole, A. W. 1929. "Where the Aviation Industry Centers." *Southern California Business* 8, no. 4 (May): 9–10, 26–27, 43, 50.

Potter, Hugh. 1945. "Land Planning Draws Keen Builder Interest." *Urban Land* 4, no. 2 (Feb.): 3.

Pressey, Howard F. "The Housing and Handling of Mexican Labor in Rancho Sespe." 1929. *California Citrograph* 13 (Dec.): 51, 72.

Priest, Ernest L. 1926. *Elimination of Waste: A Primer of Simplified Practice.* Washington, D.C.: GPO.

Prince, John R. 1922. *Guide for the Preparation of Subdivisions of Land.* Los Angeles: RPC.

"Products and Practices." 1941. *California Arts and Architecture* 58 (Dec.): 36.

Prokosch, Walter. 1951. "Airport Design: Its Architectural Aspect." *Architectural Record: Building Types Study* 170 (June): 111–33.

Purdom, C. B. 1925. *The Building of Satellite Towns: A Contribution to the Study of Town Development and Regional Planning.* London: J. M. Dent and Sons.

Ramsay, Edith. 1947. "Dishwashing Is Easy." *American Home* 38 (July): 91–92.

Reed, Fred E. 1928. "Realtors and City Planning Progress." *City Planning* 4, no. 3 (July): 208–13.

Reid, Kenneth. 1943. "Editorial: The Invisible Client." *New Pencil Points* 24 (Mar.): 31.

"Rent Takes Half of Wages in Boom Town." 1941. *Public Housing* 3, no. 3 (Dec.): 2.

"*REQUESTED* (Speech by Irene Taylor at Dedication)." 1940. *Voice of the Agricultural Migrant,* May 21.

Riggleman, John H. 1933. "Building Cycles in the United States, 1875–1932." *Journal of the American Statistical Association* 28, no. 182 (June): 174–83.

Robbins, George W., and L. Deming Tilton, eds. 1941. *Los Angeles: Preface to a Master Plan.* Los Angeles: Pacific Southwest Academy.

Roberts, Lydia J., ed. 1931. *The Better Homes Manual.* Chicago: University of Chicago Press.

Rose, Walter W. 1926. "Planning a Subdivision and Carrying the Plan Through." *Annals of Real Estate Practice,* 3:1–14.

Rosenman, Dorothy. 1945. *A Million Homes a Year.* New York: Harcourt, Brace.

Schleicher, A. 1928. "Diversified Industrial Progress of Los Angeles District." *Southern California Business* 7, no. 10 (Nov.): 9–11, 42–3, 50.

Security–First National Bank. 1937. *Monthly Summary of Business Conditions* 16, no. 10.

——. 1938. *Monthly Summary of Business Conditions* 17, no. 5.

——. 1939. *Monthly Summary of Business Conditions* 18, no. 3.

——. 1940a. *Monthly Summary of Business Conditions* 19, no. 4.

——. 1940b. *Monthly Summary of Business Conditions* 19, no. 6.

——. 1941a. *Monthly Summary of Business Conditions* 20, no. 6.

——. 1941b. *Monthly Summary of Business Conditions* 20, no.7.

——. 1942a. *Monthly Summary of Business Conditions* 21, no. 8.

——. 1942b. *Monthly Summary of Business Conditions* 21, no. 12.

Shire, A. C. 1937. "The Industrial Organization of Housing: Its Methods and Costs." *Annals of the American Academy of Political and Social Science* 190 (Mar.): 37–49.

Simpson, Herbert D. 1933. "Real Estate Speculation and the Depression." *American Economic Review* 23, no. 1 (supplement) (Mar.): 163–71.

Smutz, Hubert Earl. 1930. "Subdivision Control." In *Regional Planning Notes*, vol. 1. Los Angeles: RPC.

Southern California Telesis. Ca. 1941. . . . *And now we plan*. Los Angeles: Los Angeles County Museum of Natural History.

Stein, Clarence S. 1925. "Dinosaur Cities." *Survey Graphic* 7 (May): 137–38.

———. 1951. *Toward New Towns for America*. Cambridge: MIT Press.

Steinbeck, John. 1939. *The Grapes of Wrath*. New York: Viking.

Straus, Nathan. 1944. *The Seven Myths of Housing*. New York: Alfred A. Knopf.

"Suburbia-Exurbia-Urbia." 1957. *Newsweek*, April 1, 35–42.

Sussman, Carl, ed. 1976. *Planning the Fourth Migration: The Neglected Vision of the Regional Planning Association of America*. Cambridge: MIT Press.

Taylor, C. Samuel. 1918. "The Future and Influence of American War Housing Developments." *American Architect* 114, no. 2243 (Dec.): 721–25.

Taylor, Frederick W. 1911. *The Principles of Scientific Management*. New York: Harper and Brothers.

Taylor, Graham Romeyn. 1915. *Satellite Cities: A Study of Industrial Suburbs*. New York: D. Appleton.

Taylor, James S. 1929. "New Trends in Home Design." Address before the Homebuilders' and Subdividers' Division, National Association of Real Estate Boards, June 26, Boston, Mass.

———. 1930. *Twelve-Month Construction*. Institute for Governmental Studies Collection, University of California, Berkeley.

Taylor, Paul. 1951. "Perspective on Housing Migratory Agricultural Laborers." *Land Economics* 27 (Aug.): 193–204.

———. 1983. *On the Ground in the Thirties*. Salt Lake City: G. M. Smith.

Tobin, Virgil. 1947. "Some Hope in the Housing Industry." *Consumer Reports* 12 (Sept.): 336–38.

Tugwell, Rexford. 1940. "Parts of a New Civilization." *Saturday Review of Literature* 25 (Apr.): 3–4.

University of Chicago. 1943. *Round Table: The Airplane and the Future*. Chicago: University of Chicago Press.

Urban Land Institute. 1943. *The Community Builders' Handbook*. Washington, D.C.: Urban Land Institute.

Urbanism Committee to the National Resources Committee. 1937. *Our Cities: Their Role in the National Economy*. Washington, D.C.: GPO.

Vermilya, Howard. 1943. "Potential Technical Development of Post-War Houses." *Insured Mortgage Portfolio* (3d quarter): 24–25, 37–39.

Vinton, Warren Jay. 1937. "A Survey of Approaches to the Housing Problem." *Annals of the American Academy of Political and Social Sciences* 190 (Mar.): 7–16.

Wells, H. G. 1901. *Anticipations of the Reaction of Mechanical and Scientific Progress on Human Life and Thought*. New York: Harper and Brothers.

Wendt, Gerald. 1939. *Science For the World of Tomorrow*. New York: Norton.

"What Camp Life Means to the Women." 1940. *Voice of the Agricultural Migrant*, May 21.

Wheeler, Dan H. 1933. *General Index to the Final Reports of The President's Conference on Home Building and Home Ownership*. Washington, D.C.: The President's Conference on Home Building and Home Ownership.

Whitaker, Charles J. 1918. "What is a House?" In *The Housing Problem in War and Peace*, ed. Charles Whitaker, Frederick L. Ackerman, Richard S. Childs, and Edith Elmer Wood. Washington, D.C.: Journal of the AIA.

Whitnall, Gordon G., 1924. "City and Regional Planning in Los Angeles." In *Proceedings of the Sixteenth National Conference on City Planning, Los Angeles, California*, April 7–10, 1924. Baltimore: Norman Remington Co., 105–10.

———. 1928. "Relation of Downtown Commercial Districts to Outlying Business Districts." *Pacific Municipalities* 42 (Mar.): 127–32.

Wilhelm, Donald George. 1934. *Your Home and the Government*. Farral B. Rinehart pamphlets, no. 5. New York: Farrar & Rinehart.

Wittausch, William K. 1948. "Marketing Prefabricated Houses." *Harvard Business Review* 26 (Nov.): 693–712.

Wood, Charles L. 1930. "Would the San Fernando Valley Be Fed or Drained by Rapid Transit Connection with the Metropolitan Center?" In *Conference on the Rapid Transit Question, Los Angeles, 1930*, by Los Angeles Board of City Planning Commission. Los Angeles: City of Los Angeles.

Wood, S. E. [Samuel Edgerton]. 1942. "The California Commission of Immigration and Housing: A Study of Administrative Organization and Growth of Function." Ph.D. diss., University of California, Berkeley.

Wright, Frank Lloyd. 1928. "In the Cause of Architecture." *Architectural Record* 64 (Oct.): 334–42.

Wright, Henry. 1926. "The Six-Cylinder House with a Streamline Body." *Journal of the American Institute of Architects* 14 (Apr.): 175–78.

———. 1927. "Exploiting the Land." *Journal of the American Institute of Architects* 15, no. 10 (Oct.): 305–6.

———. 1933. "The Sad Story of American Housing." *Architecture* 57 (Mar.): 123–30.

Wyatt, Wilson W. 1946. *Report to the President: Veterans Emergency Housing Program*. Washington, D.C.: National Housing Agency.

Secondary Sources

Archer, John. 1983. "Country and City in the American Romantic Suburb." *Journal of the Society of Architectural Historians* 42, no. 2 (May): 139–56.

Arnold, Joseph L. 1971. *The New Deal in the Suburbs: A History of the Greenbelt Town Program, 1935–1954*. Columbus: Ohio State University Press.

Babcock, Richard F. 1979. "Zoning." In *The Practice of Local Government Planning*, ed. Frank S. So, Israel Stollman, Frank Beal, and David S. Arnold. Washington, D.C.: International City Management Association.

Badger, Anthony J. 1989. *The New Deal: The Depression Years, 1933–1940*. New York: Noonday Press.

Baldwin, Sidney. 1968. *Poverty and Politics: The Rise and Decline of the Farm Security Administration*. Chapel Hill: University of North Carolina Press.

Banta, Marta. 1993. *Taylored Lives: Narrative Production in the Age of Taylor, Veblen, and Ford*. Chicago: University of Chicago Press.

Berger, Bennett. 1960. *Working-Class Suburb: A Study of Autoworkers in Suburbia*. Berkeley: University of California Press.

Beyer, Glenn H. 1965. *Housing and Society*. New York: Macmillan.

Biddle, Wayne. 1991. *Barons of the Sky: From Early Flight to Strategic Warfare, The Story of the American Aerospace Industry*. New York: Simon and Schuster.

Blackford, Mansel. 1993. *The Lost Dream: Businessmen and City Planning on the Pacific Coast, 1890–1920*. Columbus: Ohio State University Press.

Bloch, Robin. 1987. "Studies in the Development of the United States Aerospace Industry." Discussion Paper D875. UCLA Graduate School of Architecture and Urban Planning, Los Angeles.

Boyer, M. Christine. 1983. *Dreaming the Rational City: The Myth of American City Planning*. Cambridge: MIT Press.

Buder, Stanley. 1990. *Visionaries and Planners: The Garden City Movement and the Modern Community*. New York: Oxford.

Castells, Manuel, and Peter Hall. 1994. *Technopoles of the World: The Making of Twenty-First-Century Industrial Complexes*. London: Routledge.

Chan, Sucheng. 1986. *This Bitter Sweet Soil: The Chinese in California Agriculture, 1860–1910*. Berkeley: University of California Press.

Chandler, Alfred D., Jr. 1977. *The Visible Hand: The Managerial Revolution in American Business*. Cambridge: Harvard University Press, Belknap Press.

Conkin, Paul K. 1976. *Tomorrow a New World: The New Deal Community Program*. New York: Da Capo Press.

Cunningham, Frank. 1943. *Skymaster: The Story of Donald Douglas*. Philadelphia: Dorrance.

Cunningham, William Glenn. 1951. *The Aircraft Industry: A Study of Industrial Location*. Los Angeles: L. L. Morrison.

Cusker, Joseph P. 1988. "The World of Tomorrow: Science, Culture, and Community at the New York World's Fair." In *Dawn of a New Day: The New York World's Fair, 1939–1940*, ed. Helen A. Harrison. New York: New York University Press.

Daniel, Cletus E. 1981. *Bitter Harvest: A History of California Farmworkers, 1870–1941*. Ithaca: Cornell University Press.

Davis, Mike. 1990. *City of Quartz: Excavating the Future in Los Angeles*. London: Verso.

Dear, Michael. 1996. "In the City, Time Becomes Visible: Intentionality and Urbanism in Los Angeles." In *The City: Los Angeles and Urban Theory at the End of the Twentieth Century*, ed. Allen J. Scott and Edward W. Soja. Berkeley: University of California Press.

DeGraaf, Lawrence. 1970. "The City of Black Angels: Emergence of the Los Angeles Ghetto, 1890–1930." *Pacific Historical Review* 39: 323–52.

Doucet, Michael, and John Weaver. 1991. *Housing the North American City*. Montreal: McGill University Press.

Eichler, Edward P., and Marshall Kaplan. 1967. *The Community Builders.* Berkeley: University of California Press.

Fish, Gertrude, ed. 1979. *The Story of Housing.* New York: Macmillan.

Fishman, Robert. 1977. *Urban Utopias in the Twentieth Century: Ebenezer Howard, Frank Lloyd Wright, Le Courbusier.* New York: Basic Books.

———. 1987a. "American Suburbs/English Suburbs: A Transatlantic Comparison." *Journal of Urban History* 13 (May): 237–51.

———. 1987b. *Bourgeois Utopias: The Rise and Fall of Suburbia.* New York: Basic Books.

———. 1988. "The Postwar American Suburb: A New Form, A New City." In *Two Centuries of American Planning,* ed. Daniel Schaffer. Baltimore: Johns Hopkins University Press.

———. 1992. "The American Garden City: Still Relevant?" In *The Garden City: Past, Present and Future,* ed. Stephen V. Ward. London: Chapman and Hall, E and FN Spon.

Fogelson, Robert M. 1967. *The Fragmented Metropolis: Los Angeles, 1850–1930.* Cambridge: Harvard University Press.

Foster, Mark S. 1986. "Prosperity's Prophet." *Western Historical Quarterly* 17 (Apr.): 165–84.

Foster, Richard H. 1980. "Wartime Trailer Housing in the San Francisco Bay Area." *Geographical Review* 70 (July): 276–90.

Gamboa, Erasmo. 1990. *Mexican Labor and World War II: Braceros in the Pacific Northwest, 1942–1947.* Austin: University of Texas Press.

Garreau, Joel. 1991. *Edge City: Life on the New Frontier.* New York: Doubleday.

Ghirardo, Diane. 1989. *Building New Communities: New Deal America and Fascist Italy.* Princeton: Princeton University Press.

Gillette, Howard, Jr. 1983. "The Evolution of Neighborhood Planning: From the Progressive Era to the 1949 Housing Act." *Journal of Urban History* 9 (Aug.): 421–44.

———. 1990. "Rethinking American Urban History: New Directions for the Posturban Era." *Social Science History* 14 (summer): 203–28.

Grebler, Leo. 1950. *Production of New Housing: A Research Monograph on Efficiency in Production.* New York: Social Science Research Council.

Gregory, James N. 1989. *American Exodus: The Dust Bowl Migration and Okie Culture in California.* New York: Oxford University Press.

Guerin-Gonzales, Camille. 1994. *Mexican Workers and American Dreams: Immigration, Repatriation, and California Farm Labor, 1900–1939.* New Brunswick: Rutgers University Press.

Harris, Richard. 1988. "American Suburbs: A Sketch of a New Interpretation." *Journal of Urban History* 15 (Nov.): 98–103.

———. 1990. "Working-Class Home Ownership in the American Metropolis." *Journal of Urban History* 17 (Nov.): 46–49.

———. 1991a. "The Impact of Building Controls on Residential Development in Toronto, 1900–1940." *Planning Perspectives* 6:269–96.

——. 1991b. "Self-Building in the Urban Housing Market." *Economic Geography* 67, no. 1 (Jan.): 1–21.

Hawley, Ellis W. 1974. "Herbert Hoover, the Commerce Secretariat, and the Vision of an 'Associative State,' 1921–1928." *Journal of American History* 41: 116–40.

——, ed. 1981. *Herbert Hoover as Secretary of Commerce: Studies in New Era Thought and Practice.* Iowa City: University of Iowa Press.

Herbert, Gilbert. 1984. *The Dream of the Factory-Made House: Walter Gropius and Konrad Wachsmann.* Cambridge: MIT Press.

Hise, Greg. 1993. "Home Building and Industrial Decentralization in Los Angeles: The Roots of the Postwar Urban Region." *Journal of Urban History* 19, no. 2 (Feb.): 95–125.

——. 1995a. "The Airplane and the Garden City: Regional Transformations during World War II." In *World War II and the American Dream: How Wartime Building Changed a Nation,* ed. Donald Albrecht. Cambridge: MIT Press and National Building Museum.

——. 1995b. "From Roadside Camps to Garden Homes: Housing and Community Planning for California's Migrant Work Force, 1935–1941." In *Gender, Class, and Shelter: Perspectives in Vernacular Architecture,* ed. Elizabeth Cromley and Carter Hudgins, vol. 5. Knoxville: University of Tennessee Press.

Hounshell, David A. 1984. *From the American System to Mass Production, 1830–1932.* Baltimore: Johns Hopkins University Press.

Hutchison, Janet. 1986. "The Cure for Domestic Neglect: Better Homes in America, 1922–1935." In *Perspectives in Vernacular Architecture,* ed. Camille Wells, vol. 2. Columbia: University of Missouri Press.

Jackson, John Brinckerhoff. 1984. *Discovering the Vernacular Landscape.* New Haven: Yale University Press.

Jackson, Kenneth T. 1980. "Race, Ethnicity, and Real Estate Appraisal: The Home Owner's Loan Corporation and the Federal Housing Administration." *Journal of Urban History* 6 (Aug.): 419–52.

——. 1985. *Crabgrass Frontier: The Suburbanization of the United States.* New York: Oxford University Press.

Jacobs, Barry G. 1982. *Guide to Federal Housing Programs.* Washington, D.C.: Bureau of National Affairs.

Jandl, H. Ward. 1991. *Yesterday's Houses of Tomorrow: Innovative American Homes, 1850–1950.* Washington, D.C.: Preservation Press.

Johnson, Marilynn S. 1991. "Urban Arsenals: War Housing and Social Change in Richmond and Oakland, California, 1941–1945." *Pacific Historical Review* 60 (1991): 283–308.

Keith, Nathaniel S. 1979. *Politics and the Housing Crisis since 1930.* New York: Universe Books.

Kelly, Barbara M., ed. 1989. *Suburbia Re-examined.* New York: Greenwood Press.

Kling, Rob, Spencer Olin, and Mark Poster, eds. 1991. *Postsuburban California: The Transformation of Orange County since World War II.* Berkeley: University of California Press.

Kostof, Spiro, ed. 1977. *The Architect: Chapters in the History of the Profession.* New York: Oxford University Press.

——. 1991. *The City Shaped: Urban Patterns and Meanings through History.* Boston: Bulfinch Press.

——. 1992. *The City Assembled: The Elements of Urban Form through History.* Boston: Bulfinch Press.

Lamont, William, Jr. 1979. "Subdivision Regulation and Land Conversion." In *The Practice of Local Government Planning,* ed. Frank S. So, Israel Stollman, Frank Beal, and David S. Arnold. Washington, D.C.: International City Management Association.

Leuchtenburg, William E. 1963. *Franklin D. Roosevelt and the New Deal, 1932–1940.* New York: Harper and Row.

Lewis, Peirce. 1983. "The Galactic Metropolis." In *Beyond the Urban Fringe: Land Use Issues of Nonmetropolitan America,* ed. Rutherford Platt and George Macinko. Minneapolis: University of Minnesota Press.

Lloyd, Craig. 1972. *Aggressive Introvert: A Study of Herbert Hoover and Public Relations Management, 1912–1932.* Columbus: Ohio State University Press.

Loeb, Carolyn. 1989. " 'Associational Progressivism' and the Shaping of Suburban Subdivisions in the 1920s." Working Paper 211. Society for American City and Regional Planning History, Hilliard, Ohio.

Longstreth, Richard. 1986. "J. C. Nichols, the Country Club Plaza, and Notions of Modernity." *Harvard Architectural Review* 5:120–35.

Lotchin, Roger. 1992. *Fortress California, 1910–1961: From Warfare to Welfare.* New York: Oxford University Press.

——. 1993. "World War II and Urban California: City Planning and the Transformation Hypothesis." *Pacific Historical Review* 62, no. 2 (May): 143–71.

Lubove, Roy. 1960. "Homes and 'A Few Well Placed Fruit Trees': An Object Lesson in Federal Housing." *Social Research* 27:469–86.

——. 1963. *Community Planning in the 1920s: The Contribution of the Regional Planning Association of America.* Pittsburgh: University of Pittsburgh Press.

——. 1969. "The Urbanization Process: An Approach to Historical Research." In *American Urban History: An Interpretive Reader with Commentaries,* ed. Alexander Callow Jr. New York: Oxford University Press.

Maben, Manly. 1987. *Vanport.* Portland: Oregon Historical Society Press.

Mayers, Jackson. 1976. *The San Fernando Valley.* Walnut, Calif.: John D. McIntyre.

Maynard, Crosby. 1962. *Flight Plan for Tomorrow: The Douglas Story: A Condensed History.* Santa Monica, Calif.: Douglas Aircraft Co.

Miller, Roger. 1991. "Selling Mrs. Consumer: Advertising and the Creation of Suburban Socio-Spatial Relations, 1910–1930." *Antipode* 23: 263–301.

Mitchell, Don. 1992. "Fixing in Place: Progressivism, Worker Resistance, and the Technology of Repression in Agricultural California." Department of Geography, Rutgers University.

——. 1996. *The Lie of the Land: Migrant Workers and the California Landscape.* Minneapolis: University of Minnesota Press.

Montgomery, Roger. 1988. "Mass-Producing Bay Area Architecture." In *Bay Area Houses*, ed. Sally Woodbridge. Salt Lake City: Peregrine Smith Books.

Murray, Robert K. 1981. "Herbert Hoover and the Harding Cabinet." In *Herbert Hoover as Secretary of Commerce: Studies in New Era Thought and Practice*, ed. Ellis Hawley. Iowa City: University of Iowa Press.

Nenno, Mary K. 1979. "Housing in the Decade of the 1940s: The War and Postwar Periods Leave Their Marks." In *The Story of Housing*, ed. Gertrude S. Fish. New York: Macmillan.

Palen, J. John. 1995. *The Suburbs*. New York: McGraw-Hill.

Pappas, George R. 1952. "Some Socio-Geographic Factors Pertaining to the Spread of Urbanism in the San Fernando Valley, Los Angeles, California." Ph.D. diss., University of Maryland.

Potter, Jim. 1974. *The American Economy between the World Wars*. New York: Farrar and Rinehart.

Rae, John B. 1968. *Climb to Greatness: The American Aircraft Industry, 1920–1960*. Cambridge: MIT Press.

Rose, Mark H., and John G. Clark. 1979. "Light, Heat, and Power: Energy Choices in Kansas City, Wichita, and Denver, 1900–1935." *Journal of Urban History* 5, no. 3 (May): 340–64.

Rydell, Robert W. 1985. "The Fan Dance of Science: American World's Fairs in the Great Depression." *ISIS* 76: 525–42.

Schuman, Tony, and Eliot Sclar. 1996. "The Impact of Ideology on American Town Planning: From the Garden City to Battery Park City." In *Planning the Twentieth-Century American City*, ed. Mary Sies and Christopher Silver. Baltimore: Johns Hopkins University Press.

Schwartz, Barry. 1976. "Images of Suburbia: Some Revisionist Commentary and Conclusions." In *The Changing Face of the Suburbs*, ed. Barry Schwartz. Chicago: University of Chicago Press.

Scott, Allen J. 1988. *Metropolis: From the Division of Labor to Urban Form*. Berkeley: University of California Press.

———. 1991. "The Aerospace-Electronics Industrial Complex of Southern California: The Formative Years, 1940–1960." *Research Policy* 20 (Oct.): 439–56.

Soja, E. W. 1986. "Taking Los Angeles Apart: Some Fragments of a Critical Human Geography." *Environment and Planning D: Society and Space* 4, no. 3 (Feb.): 255–72.

Stein, Walter J. 1970. "A New Deal Experiment with Guided Democracy: The FSA Migrant Camps in California." In *A Selection from the Papers Presented at the 1970 Annual Meeting in Winnipeg*. Ottawa: Canadian Historical Association.

———. 1973. *California and the Dust Bowl Migration*. Westport, Conn.: Greenwood Press.

Stilgoe, John. 1988. *Borderland: Origins of the American Suburb, 1820–1939*. New Haven: Yale University Press.

Sudjic, Deyan. 1992. *The 100 Mile City*. London: Andre Deutsch.

Thomas, Robert Paul. 1973. "Style Change and the Automobile Industry during the Roaring Twenties." In *Business Enterprise and Economic Change: Esssays in Honor*

of Harold F. Williamson, ed. Lois P. Cain and Paul J. Uselding. Kent, Ohio: Kent State University Press.

Tobey, Ronald, Charles Wetherell, and Jay Brigham. 1990. "Moving Out and Settling In: Residential Mobility, Home Owning, and the Public Enframing of Citizenship, 1921–1950." *American Historical Review* 95 (Dec.): 1395–1422.

Topalov, Christian. 1990. "Scientific Urban Planning and the Ordering of Daily Life: The First 'War Housing' Experiment in the United States, 1917–1919." *Journal of Urban History* 17 (Nov.): 14–45.

Upton, Dell. 1984. "Pattern Books and Professionalism: Aspects of the Transformation of Domestic Architecture in America, 1800–1860." *Winterthur Portfolio* 19 (summer–autumn): 107–50.

——. 1991. "Architectural History or Landscape History?" *Journal of Architectural Education* 44, no. 4 (Aug.): 195–99.

Vance, James E. 1964. *Geography and Urban Evolution in the San Francisco Bay Area.* Berkeley, Calif.: Institute of Governmental Studies.

——. 1966. "Housing the Worker: The Employment Linkage as a Force in Urban Structure." *Economic Geography* 42:294–325.

Viehe, Fred W. 1981. "Black Gold Suburbs: The Influence of the Extractive Industry on the Suburbanization of Los Angeles, 1890–1930." *Journal of Urban History* 8 (Nov.): 3–26.

Walker, Richard. 1977. "The Suburban Solution: Urban Geography and Urban Reform in the Capitalist Development of the United States." Ph.D. diss., Johns Hopkins University.

——. 1981. "A Theory of Suburbanization: Capitalism and the Construction of Urban Space in the United States." In *Urbanization and Urban Planning in a Capitalist Society*, ed. Michael Dear and Allen J. Scott. London: Methuen.

Warner, Sam Bass. 1962. *Streetcar Suburbs: The Process of Growth in Boston, 1870–1900.* Cambridge: Harvard University Press.

Weiss, Marc A. 1987. *The Rise of the Community Builders: The American Real Estate Industry and Land Planning.* New York: Columbia University Press.

Whyte, William H., Jr. 1956. *The Organization Man.* New York: Simon & Schuster.

Wilburn, James Richard. 1971. "Social and Economic Aspects of the Aircraft Industry in Los Angeles during World War II." Ph.D. dissertation, Department of History, UCLA.

Williams, Raymond. 1976. *Keywords: A Vocabulary of Culture and Society.* New York: Oxford University Press.

Woirol, Gregory R. 1991. "Men on the Road: Early Twentieth-Century Surveys of Itinerant Labor in California." *California History* LXX (Summer): 192–205.

Wollenberg, Charles. 1990. *Marinship at War: Shipbuilding and Wartime Change in Sausalito.* Berkeley, Calif.: Western Heritage Press.

Worley, William S. 1990. *J. C. Nichols and the Shaping of Kansas City: Innovation in Planned Residential Communities.* Columbia: University of Missouri Press.

Wright, Gwendolyn. 1983. *Building the Dream: A Social History of Housing in America.* Cambridge: MIT Press.

INDEX

Greg Hise was born in Flushing, New York. After moving to California, he completed an A.B., with honors, in architecture and a Ph.D. in the history of architecture at the University of California, Berkeley. In 1993 he was awarded the John Reps Prize of the Society for American City and Regional Planning History for the best dissertation in planning history from 1991 to 1993. He is co-editor of *Rethinking Los Angeles* (Sage Publications, 1996) and is an associate professor of urban history at the School of Policy, Planning, and Development at the University of Southern California.

Illustrations were reproduced courtesy of the following:

Whittington Collection, Department of Special Collections, University of Southern California, figs. 1.1–1.3, 4.9, 4.12, 5.10, 5.11, 6.3, 6.8, and 6.14; the Huntington Library, San Marino, figs. 1.4, 2.1, and 4.4; Clarence Perry, *Housing for the Machine Age* (New York: Russell Sage Foundation, 1939), fig. 1.5; Compton Printing Company, Los Angeles, fig. 1.6; C. B. Purdom, *The Building of Satellite Towns: A Contribution to the Study of Town Development and Regional Planning* (London: J. M. Dent and Sons, 1925), fig. 1.7; Federal Housing Administration, "Principles of Planning Small Houses." *Technical Bulletin* 4 (May 1, 1936), fig. 2.2; National Archives, fig. 2.3; Lisa Padilla, figs. 3.1 and 4.6; FSA-OWI Collection, Library of Congress, figs. 3.2, 3.3, 3.5–3.7, 3.9; Editors, *Architectural Forum—1938 Small Houses* (1937), fig. 3.4, and March 1947 issue, fig. 5.8; Roger Montgomery/Peregrine-Smith Press, fig. 3.8; U.S. Department of Housing and Urban Development, fig. 4.1; Westchester/Playa Del Rey Historical Society, figs. 4.2, 4.10, 4.11, and 4.13; *Rockwell News*, fig. 4.3; R. H. Strosnider, "'Forward'—Burbank." *Los Angeles Realtor* 8 (1928): 32, fig. 4.5; Bancroft Library, University of California at Berkeley, figs. 4.7, 5.3–5.6, 5.9, 6.12, 6.13, 6.15, 6.16; Kiran Lalloo, fig. 4.8; Security Pacific Collection, Los Angeles Public Library, figs. 4.14 and 6.6; Revere Copper and Brass, *Revere's Part in Better Living*, no. 10 (1943), fig. 5.1; William C. Baer, fig. 5.2; *Tomorrow's Town* (June 1947), fig. 5.7; Hearst Collection, Department of Special Collections, University of Southern California, figs. 5.12, 6.1, and 6.2; Los Angeles City Planning Commission, *Accomplishments*, figs. 6.4 (1944), 6.5 (1945), 6.9 (1946), and 6.10 (1949); San Fernando Valley Historical Society, fig. 6.7; author's collection, fig. 6.11.